FIFTY MODERN AND CONTEMPORARY DRAMATISTS

Fifty Modern and Contemporary Dramatists is a critical introduction to the work of some of the most important and influential playwrights from the 1950s to the present day. The figures chosen are among the most widely studied by students of drama, theatre and literature and include such celebrated writers as:

- Samuel Beckett
- Caryl Churchill
- Anna Deavere Smith
- Jean Genet
- Sarah Kane
- Arthur Miller
- Heiner Müller
- Harold Pinter
- Sam Shepard

Each short essay is written by one of an international team of academic experts and offers a detailed analysis of the playwright's key works and career. The introduction gives an historical and theatrical context to the volume, which provides an invaluable overview of modern and contemporary drama.

John F. Deeney is Principal Lecturer in Contemporary Arts at Manchester Metropolitan University, UK.

Maggie B. Gale is Professor and Chair of Drama at the University of Manchester, UK.

ALSO AVAILABLE FROM ROUTLEDGE

Bible and Cinema: Fifty Key Films
Edited by Adele Reinhartz
978-0-415-67719-6

Fifty Hollywood Directors
Edited by Suzanne Leonard and Yvonne Tasker
978-0-415-50140-8

Fifty Key Postmodern Thinkers
Stuart Sim
978-0-415-52584-8

FIFTY MODERN AND CONTEMPORARY DRAMATISTS

Edited by
John F. Deeney
and
Maggie B. Gale

Routledge
Taylor & Francis Group

LONDON AND NEW YORK

First published 2015
by Routledge
2 Park Square, Milton Park, Abingdon, Oxon OX14 4RN

and by Routledge
711 Third Avenue, New York, NY 10017

Routledge is an imprint of the Taylor & Francis Group, an informa business

British Library Cataloguing in Publication Data
A catalogue record for this book is available from the British Library

Library of Congress Cataloging-in-Publication Data
Fifty modern and contemporary dramatists / edited by Maggie B Gale and John F Deeney.
pages cm
Includes bibliographical references and index.
1. English drama–20th century–Bio-bibliography. 2. English drama–21st century–Bio-bibliography. 3. American drama–20th century–Bio-bibliography. 4. American drama–21st century–Bio-bibliography. I. Gale, Maggie B. (Maggie Barbara), 1963- editor. II. Deeney, John F., editor.
PR737.F54 2014
822'.91409–dc23
2014019076

ISBN: 978-0-415-63036-8 (hbk)
ISBN: 978-0-415-63035-1 (pbk)
ISBN: 978-1-315-74573-2 (ebk)

Typeset in Bembo
by Taylor & Francis Books

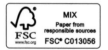

MIX
Paper from
responsible sources
FSC
www.fsc.org FSC® C013056

Printed and bound in Great Britain by
TJ International Ltd, Padstow, Cornwall

CONTENTS

ACKNOWLEDGEMENTS

The editors and publishers would like to thank the following for permission to reprint materials. Many thanks to Nick Hern of Nick Hern Books for permission to reprint from the work of Caryl Churchill, Tony Kushner and debbie tucker green. Texts from the work of the following dramatists have been reprinted by kind permission of Bloomsbury Methuen Drama at Bloomsbury Publishing PLC: Caryl Churchill, David Edgar, Terry Johnson, Sarah Kane, Bernard-Marie Koltès, Arthur Miller, Wole Soyinka and thanks also to Bloomsbury for securing permissions from Jim Cartwright. Thank you to M. Jackson for the US rights to reprint from the work of Wole Soyinka and to Samuel French for permission to reprint from the plays of Peter Shaffer and Eugène Ionesco; to PAJ Publications in New York for permission to reprint from the work of María Irene Fornés; to Oxford University Press for permission to reprint from the works of Athol Fugard; to SLL Sterling/Lord Literistic Inc. for permission to reprint from the plays of Amiri Baraka, © Amiri Baraka and with thanks to New Directions Publishing Corp for permission to reprint the following works by Tennessee Williams: *The Glass Menagerie*, ©1945 by The University of the South and Edwin D. Williams; *Cat on a Hot Tin Roof*, ©1954 by The University of the South; *Camino Real*, ©1953 by The University of the South and *A Streetcar Named Desire*, ©1947 by The University of the South.

The publishers have made every reasonable effort to contact all copyright holders as appropriate: any issues with permissions can be corrected in future editions of the volume.

The editors would like to thank all the contributors for their enthusiasm, thoughtful contributions and patience with this project. Thanks to Andy Humphries and to Iram Satti at Routledge for all their work on the book.

To Eamon McKay, Jenny Hughes, Sol and Oscar Partridge and Alfred and Millicent Hughes for all their loving support as ever.

ALPHABETICAL LIST OF
ENTRIES

NOTES ON CONTRIBUTORS

David Barnett is Reader in Drama, Theatre and Performance at the University of Sussex. He has published monographs on Heiner Müller (Peter Lang, 1998) and Rainer Werner Fassbinder (Cambridge University Press, 2005), the latter as a Fellow of the Humboldt Foundation. *A History of the Berliner Ensemble* will appear with Cambridge University Press in 2014 and is the major result of a project funded by a British Academy Research Development Award and an AHRC Fellowship. He has written several articles and essays on German, English-language, political and postdramatic theatre.

Stephen Berwind is Senior Lecturer at Manchester Metropolitan University, and holds a PhD from Louisiana State University and an MFA from the University of Washington. He has worked professionally as director, stage manager, arts administrator and theatre critic. His article, 'Reconstructing the Construction of the Royal Court Theatre', is published in *Theatre Survey*. He has a chapter about the Rockefeller Foundation in *Angels in the American Theatre* and contributed entries on William Inge and Stephen Foster in *The Gay and Lesbian Theatrical Legacy*.

Stephen Bottoms is Professor of Contemporary Theatre and Performance at the University of Manchester His books include *The Theatre of Sam Shepard* (Cambridge University Press, 1998), *Albee: Who's Afraid of Virginia Woolf?* (Cambridge University Press, 2000), *Playing Underground: A Critical History of the 1960s Off-Off-Broadway Movement* (Michigan University Press, 2004), *Small Acts of Repair: Performance, Ecology and Goat Island* (with Matthew Goulish; Routledge, 2007) and *Sex, Drag and Male Roles: Investigating Gender as Performance* (with Diane Torr; Michigan University Press, 2010). Steve is currently developing practice-based research around questions of environment and ecology.

David Bradby (1942–2011) was Emeritus Professor of Theatre at Royal Holloway, University of London. As well as editing the 'Studies in Modern Drama' series for Cambridge University Press and *Contemporary Theatre Review* for Routledge, he was the prolific author of many books, chapters and articles on modern European theatre. His book *Jean Genet*, written with Clare Finburgh in the Routledge Modern and Contemporary Dramatists series, was published in 2011.

Rachel Clements is Lecturer in Drama, Theatre and Performance at the University of Manchester. She writes about contemporary theatre practice, particularly British playwriting, and the relationships between performance, politics and philosophy. Her current research focuses on the late work of Derrida, and theatrical hauntings. Publications include the Methuen Student Edition of Joe Penhall's *Blue/Orange* (2012).

Brian Crow recently retired from the Department of Drama and Theatre Arts at the University of Birmingham. He has taught in universities in Scotland, Nigeria and Australia. His main research interest is in African drama and theatre. He is the author (with Chris Banfield) of *An Introduction to Postcolonial Theatre* (Cambridge University Press, 1996) and numerous essays on African theatre.

Scott T. Cummings is Associate Professor of Dramatic Literature and Playwriting and Chair of the Theatre Department at Boston College. He is the author of *Remaking American Theatre: Charles Mee, Anne Bogart and the SITI Company* (Cambridge University Press, 2006) and *María Irene Fornés* (Routledge, 2012) and co-editor with Erica Stevens Abbitt of *The Theatre of Naomi Wallace: Embodied Dialogues* (Palgrave Macmillan, 2014).

John F. Deeney is Principal Lecturer in Contemporary Arts at Manchester Metropolitan University. His publications include *Mark Ravenhill: Routledge Modern and Contemporary Dramatists* (2015), *The Routledge Drama Anthology and Sourcebook: from Modernism to Contemporary Performance* (with Maggie B. Gale, 2010), and *Writing Live: The Relationship Between Writing and Live Art* (London Arts Board/New Playwriting Trust, 1998). He has also worked as a director and has written numerous essays on performance, new writing, gender and sexuality.

Maria M. Delgado is an academic, critic and curator. Professor of Theatre and Screen Arts at Queen Mary, University of London,

she is co-editor of *Contemporary Theatre Review* and has published widely in the area of Spanish-language and European theatres and Spanish-language film. Her publications include *Federico García Lorca* (Routledge, 2008) and *'Other' Spanish Theatres* (Manchester University Press, 2003), as well as 11 co-edited volumes, including *A History of Theatre in Spain* (Cambridge University Press, 2012), *Contemporary European Theatre Directors* (Routledge, 2010) and a volume of plays by the French dramatist Bernard-Marie Koltès (Methuen, 2004).

Julia Dobson is Reader in French Film and Performance at the University of Sheffield. Her doctoral research compared the theatres of Hélène Cixous and Marina Tsvetaeva and she has published widely on Cixous' work including *Hélène Cixous and the Theatre: The Scene of Writing* (Peter Lang, 2002). Work on film includes first-person documentary, the work of Jacques Audiard and a recent book, *Negotiating the Auteur* (Manchester University Press, 2012) on the relationship between genre, gender and the figure of the auteur. She is currently working on performing objects in contemporary French theatre.

Kate Dorney is Senior Curator of Modern and Contemporary Performance at the Victoria and Albert Museum, London. She is a theatre historian interested in the role of institutions, including museums and archives, in shaping theatre practice and history. As part of an ongoing research project into arts funding, policy and practice, she edited *The Glory of the Garden: English Regional Theatre and the Arts Council* (with Ros Merkin, Cambridge Scholars Publishing, 2010). She is also the author of *The Changing Language of Modern English Drama* (Palgrave, 2009) and co-author, with Frances Gray, of the iPad app and book *Played in Britain: Modern Theatre in 100 Plays*, winner of the David Bradby Research Prize 2014 (TaPRA).

Clare Finburgh is Senior Lecturer in Modern Drama at the University of Essex. She has co-written *Jean Genet* (with David Bradby, 2011), on Genet's plays in production. She has also co-edited *Genet: Performance and Politics* (with Carl Lavery and Maria Shevtsova, 2006) and *Contemporary French Theatre and Performance* (with Carl Lavery, 2011). She has published widely both on Genet, and a range of contemporary French and Francophone theatre-makers, including Valère Novarina, Noëlle Renaude and Kateb Yacine. She has translated into English two plays by Noëlle Renaude, and *By the Way* was performed at the Edinburgh Fringe in 2008.

John Fleming is Chair of the Department of Theatre and Dance at Texas State University where he teaches theatre history. He has authored the books *Stoppard's Theatre: Finding Order amid Chaos*, *Romulus Linney: Maverick of the American Theater* and *Tom Stoppard's Arcadia*. He has contributed chapters to *Text and Presentation* and *Lectures de Tom Stoppard: Arcadia*. His articles have appeared in *The Drama Review*, *Latin American Theatre Review*, *The Journal of American Drama and Theatre* and *Text and Performance Quarterly*. He is now the co-author of Oscar Brockett's *The Essential Theatre* and its accompanying anthology *Plays for the Theatre*.

Maggie B. Gale is Chair of Drama at the University of Manchester. Her publications include: (with Gillie Bush-Bailey) *Plays and Performance Texts by Women 1880–1930* (2012, Manchester University Press); (with John F. Deeney) *The Routledge Drama Anthology and Sourcebook: from Modernism to Contemporary Performance* (2010); *J.B. Priestley: Routledge Modern and Contemporary Playwrights* (2008); *The Cambridge Companion to the Actress* (co-editor with John Stokes, Cambridge University Press, 2007); *Women, Theatre and Performance: Auto/Biography and Identity* (co-editor with Viv Gardner, Manchester University Press, 2004); *British Theatre between the Wars: 1918–1939* (with Clive Barker, Cambridge University Press, 2000) and *West End Women: Women on the London Stage 1918–1962* (Routledge, 1996).

Lynette Goddard is Senior Lecturer in the Department of Drama and Theatre, Royal Holloway, University of London. Her research focuses on contemporary black British theatre, looking in particular at new writing by black playwrights and black adaptations of Shakespeare and other canonical plays. Her publications include articles in *Contemporary Theatre Review* and *Women: A Cultural Review*, and the monograph *Staging Black Feminisms: Identity, Politics, Performance* (Palgrave, 2007). She is currently completing *Contemporary Black British Playwrights: Margins to Mainstream* (Palgrave, 2014), which examines the mainstream profile and politics of plays by Kwame Kwei-Armah, debbie tucker green, Roy Williams and Bola Agbaje.

Frances Gray is a former Reader in Drama at the University of Sheffield. She has written books on John Arden and Noël Coward for the Macmillan Modern Dramatists series, and a life of the actress Meggie Albanesi, as well as *Women and Laughter* (University of Virginia Press, 1994) and *Women, Crime and Language* (Palgrave, 2003). She also writes for theatre and radio and holds a *Radio*

Times award for comedy. Most recently she and Kate Dorney produced a study of British Theatre since 1945, *Played in Britain,* for the Victoria and Albert Museum.

Nadine Holdsworth is Professor of Theatre and Performance Studies at the University of Warwick. She has published *Joan Littlewood's Theatre* (Cambridge University Press, 2011), *Theatre & Nation* (Palgrave, 2010) and edited John McGrath's collected writings, *Naked Thoughts That Roam About* (Exeter University Press, 2002), as well as *John McGrath: Plays for England* (2005). She is currently completing an edited collection, *Theatre and National Identities* for Routledge (2014), and is embarking on research on amateur theatre in the Royal Navy for an AHRC-funded project *Amateur Dramatics: Crafting Communities in Time and Space.*

Jenny Hughes is Senior Lecturer in Drama at the University of Manchester. Her research to date has explored the relationship between theatre, performance and states of emergency and, at the time of writing, focuses on theatrical representations of and engagements with economic precarity. Her publications include a monograph, *Performance in a Time of Terror* (Manchester University Press, 2011), and a co-authored book (with James Thompson and Michael Balfour), *Performance in Place of War* (Seagull/Chicago, 2009).

Christopher Innes is Distinguished Research Professor at York University, Toronto; and Research Professor at Copenhagen University. Fellow of the Royal Society of Canada, and of the Royal Society of Arts (UK), and a Killam Fellow, he holds the Canada Research Chair in Performance and Culture. Author of 15 books – translated into eight different languages – he is General Editor of the Cambridge Directors in Perspective series, Co-Editor of the Lives of the Theatre series, and Contributing Editor to *The Cambridge Guide to World Theatre.* His most recent book is *The Cambridge Introduction to Theatre Directing* (Cambridge University Press, 2013).

Casey Kayser is a Visiting Assistant Professor of English at the University of Arkansas-Fayetteville, where she teaches courses in literature, drama, and medical humanities. Her research specialties include modern and contemporary American literature and drama; southern literature, drama and culture; folklore; and gender studies. Her work has been published in *Midwestern Folklore.*

Shane Kinghorn is a Senior Lecturer in Drama and Contemporary Theatre at Manchester Metropolitan University. He has previously worked in London as an associate lecturer, director and dramaturg. As a director and dramaturg his performance work has been shown in several international festival contexts and informs his specialist research area, documentary and 'verbatim' theatre practice in the UK and Europe, the subject of recent and forthcoming publications.

Carl Lavery is Professor of Theatre, Film and Television Studies at Glasgow University. He is the author of numerous books and articles on theatre, performance, ecology, landscape, and politics, including *The Politics of Genet's Late Theatre: Spaces of Revolution*, *Contemporary French Theatre and Performance* (with Clare Finburgh) and *Good Luck Everybody: Lone Twin – Performances, Journeys and Conversations* (with David Williams). He is the Principal Investigator on the AHRC-funded project 'Future of Ruins: Reclaiming Abandonment and Toxicity on Hashima Island'.

Ladrica Menson-Furr is Associate Professor of African-American Literature and Director of the African and African American Studies program at the University of Memphis. She is the author of *August Wilson's Fences* (Continuum, 2008) and articles/entries on Zora Neale Hurston and Pearl Cleage. Her current research interests include the intersections of dramatic literature and the domestic arts, particularly within African-American female authored play texts, and literary and dramatic representations of the south.

Brenda Murphy is Board of Trustees Distinguished Professor, Emeritus at the University of Connecticut. Among her 18 books on American drama and theatre are *Understanding David Mamet*, *The Provincetown Players and the Culture of Modernity*, *Tennessee Williams and Elia Kazan: A Collaboration in the Theatre*, *Congressional Theatre: Dramatizing McCarthyism on Stage, Film, and Television*, the Cambridge Plays in Performance Series volumes *O'Neill: Long Day's Journey Into Night* and *Miller: Death of a Salesman*, and *The Cambridge Companion to American Women Playwrights*. Her latest book, *The Theatre of Tennessee Williams*, will be published by Methuen in 2014.

Dan Rebellato is Professor of Contemporary Theatre at Royal Holloway, University of London. He has published widely on contemporary British theatre and philosophy. His books include *1956 and All That: The Making of Modern British Drama*, *Theatre & Globalization*, *Contemporary European Theatre Directors*, *The Suspect*

Culture Book and *Modern British Playwriting 2000–2009*. He is also a playwright and his plays for stage and radio – including *Here's What I Did With My Body One Day, Static, Chekhov in Hell, Cavalry* and *My Life Is A Series of People Saying Goodbye* – have been performed nationally and internationally.

Melissa Sihra is Assistant Professor at the School of Drama, Samuel Beckett Centre, Trinity College, Dublin. She researches and teaches in the field of Irish theatre, feminism, gender and women in performance. She is editor of *Women in Irish Drama: A Century of Authorship and Representation* (Palgrave Macmillan, 2009) and co-editor, with Paul Murphy, of *The Dreaming Body: Contemporary Irish Theatre* (Oxford University Press and Colin Smythe Ltd). She is President of the Irish Society for Theatre Research (ISTR).

Brian Singleton is Samuel Beckett Professor of Drama & Theatre and Academic Director of The Lir – National Academy of Dramatic Art at Trinity College Dublin. As well as publishing widely on Orientalism and interculturalism in performance, most notably in the monograph *Oscar Asche, Orientalism & British Musical Comedy* (Praeger, 2004), his most recent contribution to Irish theatre studies is his monograph *Masculinities and the Contemporary Irish Theatre* (Palgrave Macmillan, 2011). In 2012 he won the ATHE Excellence in Editing Award (along with Janelle Reinelt) for their book series 'Studies in International Performance' published by Palgrave Macmillan.

John Stokes is Emeritus Professor of Modern British Literature in the Department of English at King's College London and Honorary Professor of English and Drama at the University of Nottingham. His books include *The French Actress and her English Audience* (Cambridge University Press, 2005). Together with Maggie B. Gale he has edited *The Cambridge Companion to the Actress* (2007) and, together with Mark W. Turner, two volumes of Oscar Wilde's journalism for the Oxford English Texts edition of *The Complete Works* (2013).

INTRODUCTION

This volume aims to provide both a wide and a substantial coverage of key playwrights from the 1950s forward. These have worked from the middle of one century to the opening decades of another. The 50 playwrights included are familiar to theatre audiences and the general public. While some of them are more popular than others, all the playwrights included have made a significant contribution to the development of the craft of playwriting and theatre practice generally since the post-World War II period. The 50 entries in the volume have been written by key scholars working in the area of modern and contemporary drama, theatre and performance. The playwrights selected are mainly from Anglo-American and European contexts or indeed are those whose work is familiar to English-speaking audiences. While we have tried to include those whose work is most frequently and widely studied, we have also tried to reflect a demographic that is far more inclusive in terms of race and gender than it was in the opening decades of the period covered. We have also tried to include playwrights who traverse very different contexts for the production of plays – with work produced in the state-subsidized and mainstream commercial theatre placed alongside those whose work is produced in altogether more experimental spaces, such as the fringe in the UK, or Off-Off-Broadway in the USA.

The influence of Bertolt Brecht casts a long shadow over many of the dramatists included in the volume. Brecht's major dramaturgical output was before the mid-1950s, a point from which the majority of the playwrights included began their careers. Brecht was concerned to alter the cultural function of theatre, and convinced that the dominance of naturalism needed to make way for forms of dramatic writing that better reflected the complexities of the contemporary condition, and the need for an interventionist position by artists. Even those whose writing one might categorize under the umbrella of realism owe, in some ways, a debt to Brecht's deconstruction of the foundations of realist playwriting. So, for example, John Osborne's

work begins with the 'kitchen sink' drama *Look Back in Anger* (1956), but subsequently moves on to an analysis of greater historical breadth in *Luther* (1961). Even if their politics might be understood as being in stark contrast to Brecht's, many of the playwrights we have included have taken up his challenge to remould the function of the drama and the dramatist as author, auteur and cultural critic.

Many of the playwrights included commenced their careers in a fanfare of critical euphoria or dissent, and often came to be measured by their initial success, such as Samuel Beckett, Harold Pinter and Tennessee Williams. While others, who refused to comply to the critical framing of a particular dramatic movement in terms of playwriting, have managed to sustain careers through more than four decades – in the case of Peter Shaffer, Edward Bond, Howard Barker and Caryl Churchill. During these decades theatre, on both sides of the pond, as an industry and as institution, has been transformed both economically and aesthetically. The more contemporary playwrights whose work is included in this volume have had to operate in a very different professional environment. With few exceptions, such as Howard Barker, playwrights now have to rely on the good functioning of a professional hierarchy, which constantly promotes the singular currency of a playwright without in reality placing their actual work at the centre of a production process. Some of the playwrights included here benefitted from being effectively 'adopted' as 'house dramatists' by leading theatres – David Hare and Alan Bennett at the National Theatre, and Caryl Churchill at the Royal Court. This has impacted on their work in terms of the possibility for their plays to be collaboratively constructed and developed. Others found early success in translations to film of their work – Shaffer and Mamet are particular cases in point – whereby they have become more familiar in the public mind as screenwriters rather than stage dramatists, even though the latter has proved a far more prolific environ for their work in production. Writers now have perhaps less immediate access to production contexts, and often their work has to go through a series of, not always helpful, interventions by literary managers, dramaturgs and directors, before it reaches the stage. This culture of 'development' has been prevalent through the subsidized sectors particularly in the UK. While London's Royal Court Theatre opened in the 1950s as a 'writers' theatre', it was not long before the writers became one of many involved in the collective nature of theatre production. Some playwrights sustained professional relationships with singular directors – Tennessee Williams with Elia Kazan, Harold Pinter with Peter Hall, David Hare with Richard Eyre, and as a one-off, David Mamet with

David Mamet – but it remains difficult now for the kind of 'new voice' represented by Shelagh Delaney in the 1950s to find its way onto our stages without overcoming a series of artistic, financial and professional hurdles.

Some of the playwrights whose work was produced at the opening decades of the period covered here found their professional roots in acting, or directing. Later playwrights, such as Sarah Kane, entered the professional theatre via one of the many university playwriting courses that have burgeoned since the 1980s. Similarly, in a fickle and unreliable economy of craft, many playwrights find work teaching on such courses, during periods when their plays are less popular with production companies or there are no commissions in the offing. Some playwrights whose work would have sold out during the 1990s, like David Mamet, are now finding it hard to get their work produced at all. Others such as Yasmina Reza, while relatively dismissed by the academy, continue to find mainstream venues and leading performers hungry for the opportunity to be a part of her work in production. A number of the playwrights included have found more mainstream success relatively late into their careers: thus April De Angelis makes a sustained graduation from fringe, to the Royal Court, the National Theatre and onto the West End after some 30 years. However, a twenty-first-century West End hit eludes Caryl Churchill, who remains committed to experimenting with form, pushing at the boundaries of the theatrical experience and still considered one of the major innovators of theatre. Other playwrights included here – David Hare, Anna Deavere Smith and Mark Ravenhill – have extended the definition of the playwright by writing their own solo performances. These works explicitly question the power and function of language in performance, its reliability in reflecting social and experiential realities, and blur the boundaries between the origin of the text and its utterance. Questions of authenticity and reliability sit at the base of the recent trends for testimonial and verbatim theatre, forms that have also been embraced by some of the playwrights included in the volume.

The volume therefore invites an inclusive mapping of key playwrights across time and geography. The intention is that the work of those included also captures the enormous and significant cultural changes since the 1950s. From the modernist experiments of Eugène Ionesco, Jean Genet and Samuel Beckett, through to the formal innovations of María Irene Fornés, Bernard-Marie Koltès and Peter Handke, and on to the responses to postmodernism fashioned by the likes of Martin Crimp and Heiner Müller, the volume reflects

the enormous diversity of challenges that have faced modern drama during the period. Similarly, a strong feature of the volume is the number of playwrights who, from very different positions and political perspectives, explore and critique ideas of nation and nationhood, and their relation to subjectivity. Questions of subject formation, whether framed by issues of race, gender or sexuality, also lie at the centre of many of the plays discussed in the volume. These questions arise and haunt the creative agenda over a 60-plus year period, which has taken us from the Cold War, through the postcolonial, globalization and the establishment of neo-liberalism as the ruling ideology.

In terms of the composition of the volume, the entries are ordered alphabetically, rather than by era or country, and the essays for each include a select bibliography for individual dramatists. Each entry is structured so as to offer information on the playwrights' career and to give a contextual overview through a discussion of key works. The essays explore key innovations central to the playwright's work both in terms of form and dramaturgical approach. The critical reception of their work is approached through an analysis of the impact of key plays and their contribution to theatre production and culture more generally.

<div style="text-align: right">

John F. Deeney and Maggie B. Gale
Manchester, UK
February 2014

</div>

FIFTY MODERN AND CONTEMPORARY DRAMATISTS

EDWARD ALBEE (1928–)

Writing in 1960, Albee remarked: 'Careers are funny things. They begin mysteriously and, just as mysteriously, they can end; and I am at just the very beginning of what I hope will be a long and satisfying life in the theatre' (Albee 1963: 9). Albee's career has certainly been a long one with his most recent play, *Laying An Egg*, awaiting its world premiere at the Signature Theatre in New York. But satisfying? Only Albee would know, but it is certainly true that his career has had its ups and downs, the latter marked by sometimes savage rejection by American reviewers and audiences. As for the ups, few dramatists have enjoyed such a meteoric rise to success so relatively early in their careers. *The Zoo Story* made Albee's name when it was produced Off-Broadway in 1960 followed with considerable success by *The American Dream* in the following year, but it was *Who's Afraid of Virginia Woolf?* that made him famous when it was produced on Broadway in 1962, running for 664 shows. *Who's Afraid of Virginia Woolf?* was followed by a respectfully received adaptation of Carson McCullers' novella *The Ballad of the Sad Café* (1963) and then by *Tiny Alice*, which seemed to baffle the New York reviewers, and perhaps its audiences too, when it ran on Broadway in 1964. Worse was however to come: *Malcolm*, another adaptation, was critically panned and closed within a week in 1966; and over the next decade and a half a succession of his plays received at best mixed reviews and closed after brief or decidedly modest runs, while Albee himself struggled with his alcohol dependency. Only one of the plays of this period, *A Delicate Balance* (1966), has since been rehabilitated as a major work in his oeuvre, even if its merits are still critically debated. This long 'down' in Albee's career saw him turn his back on the mainstream American theatre world in favour of writing for small provincial, university or even foreign theatres. This decision eventually resulted in a revival of Albee's fortunes, initiated by the New York success of *Three Tall Women* (1994; premiered 1991, Vienna) and followed by a successful revival of *A Delicate Balance* and the American and British premieres of *The Play About the Baby* (1998, London; 2001, New York) and *The Goat or Who is Sylvia?* (2002, New York; 2004, London).

The early short plays that established Albee's reputation as a dramatist were experimental in form and in content savagely attacked the status quo of the post-war Eisenhower years in America. Introducing elements of surrealism and the fashionable absurdism associated with Beckett and Ionesco – both of whom he admired – Albee created dramatic parables of the human condition and at the

3

same time satirized what he saw as the American enslavement to consumerist materialism and the breakdown of authentic commu-nication and genuinely meaningful relationships. *The Zoo Story* (1960) dramatizes the meeting of two men on a park bench in Central Park: one, Jerry, is socially marginalized, a volatile existentialist philosopher of the streets; the other, Peter, is the embodiment of educated, middle-class, conformist and – as it turns out – deeply repressed American manhood. Subjected to Jerry's verbal interrogation and storytelling and eventual physical attacks – first tickling and then pushing and punching – Peter is provoked out of his habitual passivity and, in a fury, struggles with his antagonist for possession of the park bench, culminating in Jerry's impaling of himself on his own knife, which Peter is using to defend himself. Central to the play's meaning, however construed – and *The Zoo Story* has been subjected to a variety of interpretations – is the story of Jerry and the dog, which Jerry narrates and performs as something like a play within the play. The dog belongs to the landlady of the hellish brownstone rooming-house where Jerry has a room and it terrorizes him every time he passes through the entrance hall of the building. He tells of how he tries to make the dog love him through kindness, feeding him hamburgers when they meet. When this fails to curb the animal's aggression Jerry decides to kill him by mixing the meat with rat poison. This strategy also fails, as the dog miraculously recovers. But Jerry is glad that his 'friend' – for that is how he has come to think of him – has survived since he hopes that they can now make genuine contact, even love each other. But although they now look at each other and have achieved a kind of understanding that allows Jerry to pass unchallenged, they have failed to make genuine contact. Instead, they 'feign indifference' when they meet, each pursuing his solitary existence, no longer trying to reach each other. The moral of the story, Jerry tells Peter, is that neither kindness nor cruelty 'creates any effect beyond themselves' (Albee 1963: 35); it is the two combined that makes 'the teaching emotion' (Albee 1963: 36). Jerry regards his experience with the dog as possibly the first attempt at genuine con-tact with another, since to start with people is too difficult; and it may be that his encounter with Peter, even though it ends in his death, should be seen as his application of this moral to human relationships.

Who's Afraid of Virginia Woolf? (1962) is preoccupied by many of the same themes that animated Albee's early short plays but in a different key. Working this time within the conventions of naturalism, he once again explores the need for a genuine form of human contact and how the 'teaching emotion' that combines cruelty

and the desire to love can exorcize illusion and give way, however precariously, to the recognition of reality. George and Martha are trapped in a life of mutual verbal laceration on a small New England college campus, where George is a failed professor of history and Martha is the deeply dissatisfied daughter of the college president. The action of the play consists of a late-night drinking session with a younger couple, Nick and Honey, who have been invited back by Martha after a faculty party. Energized by having an audience, George and Martha perform their destructive verbal routines with particularly cruel inventiveness, at first to the embarrassment of the younger couple but, as the alcohol flows and their own façade of marital contentment is removed, increasingly with their participation and collusion.

Central to George and Martha's tortured relationship is their childlessness – a lack they have compensated for through their elaborate and long-held fantasy of having brought up a son. When George discovers that Martha has broken the rules of the game by revealing the child's 'existence' to Honey their ritualized verbal game-playing takes a new and decisive turn – George decides to kill off their imagined child and bring their hitherto sustaining mutual fantasy to an end. In Act III, which Albee titles 'Exorcism', this is what happens. Supposedly having received a telegram from Western Union informing them of his death, George forces Martha – whose attachment to the fantasy amounts to a kind of possession – to accept his demise as he recites in Latin the words of the 'Mass of the Dead'. Albee's stage direction indicates a *'hint of communion'* (Albee 1965: 138) between them as the exorcism takes effect, although it remains to be seen whether George and Martha, and perhaps even Nick and Honey, can put their marriages on a new and better footing as a result of what has passed between them. Bereft of the fantasized son, Martha's answer to the question posed by the play's title is an honest but deeply anxious admission that 'I ... am ... George. I ... am ... ' (Albee 1965: 140).

Failed marriage, a dead son (this time a real one) and a profound fear of the existential void are again much in evidence in *A Delicate Balance* (1966). The death of their boy Teddy signalled the sexual and emotional end of Tobias and Agnes' marriage; the fact that they still have a daughter, Julia, has been no consolation, especially as she has returned home again after the failure of yet another of her marriages. And when their best friends Harry and Edna arrive on a visit it is because, amid the genteel desolation of their own sexless and loveless life together, they have been overcome by a nameless fear that drives

them from their home. The main action of the play concerns what Tobias and Agnes will do with their friends, who seem ready to leave their own house for good and move in permanently with their reluctant hosts. In the end, Harry and Edna leave, aware that even their lengthy friendship is not enough to ensure a decisive commitment by Tobias and Agnes to their continuing refuge against the existential void. The 'delicate balance' Tobias and Agnes have achieved, which makes anything in the nature of significant change impossible, allows – indeed compels – Tobias to remain weak and indecisive, unable to take on the burdens of love and responsibility, and permits Agnes to stay protected by an armour-plating of elaborate verbiage. Only Agnes' alcoholic sister Claire speaks the truth of their death-in-life condition, even if she cannot rise above it herself.

However mixed Albee's critical fortunes have been, at least in America, he has remained at the forefront of stylistic and dramaturgical experiment in contemporary American theatre. If the naturalism of *Who's Afraid of Virginia Woolf?* or *A Delicate Balance* has been his mainstay, audiences have also encountered the absurdism of *The American Dream*, the theatricalist 'postmodernism' of *Fragments* (1993) or *The Play About the Baby* (1998), the brilliantly inventive device of presenting one character at different stages in her life as if they were distinct persons in *Three Tall Women*. In terms of genre, Albee has ceaselessly forged new and distinctive ways of blending seriousness with humour, the tragic and the comic, often insisting that however grim the subject matter – isolation, non-communication, irretrievable loss, death and dying – an element of slapstick is essential to the success of his work. *The Goat or Who is Sylvia?*, which reinforced Albee's return to public and critical favour when it won the Tony award for Best New Play on Broadway when it premiered there in 2002, demonstrated that the 74-year-old playwright had lost none of his commitment to extending the boundaries of mainstream American theatre. Subtitled 'notes toward a definition of tragedy', *The Goat* makes its provocative contribution to the ongoing debate on sexuality and the nature of marriage in America by dramatizing what happens when a long and happily married man, a successful and respected member of the professional bourgeoisie, is forced to confess to having fallen in love with and having had sexual relations with a goat, whom he has named Sylvia. Martin's wife, Stevie, previously so assured in her marital contentment, is distraught; even Billy, Martin's teenage son who has discovered his own homosexuality, is horrified by his father's revelation of his feelings and actions. Absurd but not absurdist, at times hilarious but also deeply painful, *The Goat* suggests that even tolerant

liberal Americans (and of course others) have not come to terms with the mysteries of sexuality and its attendant emotions. As it was in the early 1960s, with Jerry and Peter on their benches in Central Park, the stage for Edward Albee is the place that must take everyone, even the most aware, out of their comfort zones.

Brian Crow

Key works

Albee, Edward (1963) *The American Dream and The Zoo Story*, New York: Signet.
——(1965) *Who's Afraid of Virginia Woolf?*, Harmondsworth: Penguin.
——(1968) *A Delicate Balance*, London: Cape.
——(2004) *The Goat or Who is Sylvia?*, London: Methuen Drama.

Further reading

Bigsby, C.W.E. (ed.) (1975) *Edward Albee: A Collection of Critical Essays*, Englewood Cliffs, NJ: Prentice-Hall.
Bottoms, Stephen (ed.) (2005) *The Cambridge Companion to Edward Albee*, Cambridge: Cambridge University Press.

APRIL DE ANGELIS (1960–)

April De Angelis announced her opposition to the present UK government's educational policies by discussing her school experience in terms of theatrical values that remain a constant in her career. 'Being inside the complex world of a play with its debates, strategies, motivations and allegiances was brilliant for confidence and developing a love of language.'[1] She began her career as an actress with the London-based feminist company Monstrous Regiment and it was to feminist companies of the 1980s that she owed her early writing opportunities. Her first play *Breathless* (1987) was a prizewinner at the Second Wave Young Women's Writing Festival at the Albany Empire, London. In 1991, as writer-in-residence for subsidized company Paines Plough, she co-organized a 'salon' to explore the current upsurge of modern critical theory, already impacting upon cinema (and, as she noted, 'bloody hard to grasp')[2], in terms of its implications for feminist playwrights. The fluidity of her own dramaturgy, with its constantly shifting performance styles – from crosstalk to poetry, cartoonish surrealism to naturalism – has made it possible to explore the formation of female

identity and show the interactions between political power and personal motivation within a range of theatrical spaces. Her preference for writing to commission has led to her engagement with an unusually wide variety of topics, from erotica in her adaptation of *Fanny Hill* (1991) to eighteenth-century theatre politics in her companion piece to Goldsmith's *She Stoops to Conquer*, *A Laughing Matter* (2002), and from her libretto for Errolyn Wallen's opera *The Silent Twins* (2007) to her West End success *Jumpy* (2011).

Many of her plays explore lives obscured and marginalized in conventional histories. Rather than adopting a single viewpoint, however, her approach is to probe the conflicts and contradictions within them. The most critically acclaimed of her early plays, *Ironmistress* (1989), about the nineteenth-century industrialist Martha Darby, explored a woman's enterprise as both empowering and corrupting. Although the budget only permitted two performers, one of its strengths, as Geraldine Cousin points out, is a breadth of vision, the way it is 'haunted by the lives of other women … marginalised and abandoned' (Cousin 1996: 60). Martha has the drive to run an ironworks but never breaks the cycle of profiteering; her daughter, Little Cog, replicates the experience that shaped her mother's harshness by entering a loveless marriage. However, inescapably lodged within the imagination of both players in this individual tragedy is Shanny Pinns, worker and whore, her hands scarlet and cracking from washing the ironstone in freezing water – a spectre born of Martha's capitalist guilt and her sexual rage at the sight of her husband making love to an iron statue of Shanny. Little Cog enters the persona of Shanny to imagine different fates for her, enacting a statue, a ghost, and a highway-woman on a powerful horse. In her century, Little Cog can only dream of a woman who might reshape the fragments of the past in order to 'fly'. But to the audience this is in the realm of possibility – precisely because the vision is mediated through informed and committed actors, whose constant self-transformations reflect that hope for self-determination and freely exercised talent.

Playhouse Creatures (1993), the play for which De Angelis is best known, was commissioned at a point when explicitly political and feminist theatre were in decline. De Angelis felt she was writing 'against the grain of the times',[3] and this is reflected in the cross-currents of the action. On the one hand there is the energy inherent in the story of a new art form creating itself, as the Restoration theatre gets under way and actresses appear on public stages for the first time. There is a celebratory pleasure in the exploration of seventeenth-century styles from the backstage perspective; Charles

Spencer wrote of the temporary structure that housed the production at Chichester, all its machinery shamelessly visible, that 'theatre and play have found their perfect match'.[4] But the structure – the play is framed as a flashback – means an ever-present awareness that, while actresses were central to this process, their identities were never fully their own. Rather, as de Beauvoir remarked of womanhood, each is seen to be 'determined ... by the manner in which her body and her relation to the world are modified through the action of others'.[5] The tension between successful player and embattled identity is embodied in a character even non-theatregoers in England recognize (and patronize), Nell Gwyn. Like all the women in the play, Nell is a 'ghost' in that contemporary actors are re-creating performances, both familiar and alien in style: the raw star quality of Nell, the fragile charisma of former hell-fire preacher Mrs Farley, and the mannered power of Mrs Betterton. But Nell is also a 'ghost' in that her story is evoked within an empty space, which may be 'hell' and/or the former bear-pit on which the theatre once stood, a place where 'playhouse creatures' have always been exploited and tormented. The absence of men onstage underlines rather than diminishes the sense of their control over the women even during the confident exercise of their talent. Mrs Betterton's husband casts a younger woman in her place; Nell wins the king but loses the chance to excel in her profession. Male violence and social exclusion generate both ruthless competition between the women and a rough kindness in painful emergencies, such as the unwanted pregnancy that wrecks Mrs Farley's career. What these women can control is language – the language of the stage, the language acquired through their own restless curiosity, the language that fits the harshness of their lives. Mrs Marshall, for instance, discovers the discourse of science; assaulted with dung at the instigation of the Earl of Oxford, she transforms the *Macbeth* witches' rhyme into a ritual of personal revenge; she later comments on the result: 'Fuck knows the state of his bollocks' (De Angelis 1999a: 222). This ferocious articulacy in the face of political vulnerability is the driving force behind the nascent profession. *Playhouse Creatures* has become a staple of repertory and student companies. With each production the players 'ghost' not only the individual pioneers of female performance, but that profession itself. They impose an image of the past upon a present that matches it somewhat too closely: as De Angelis says, 'the central bastions of theatrical power radically underrepresent women'.[6]

A Warwickshire Testimony (1999) negotiates a more circumscribed social and linguistic territory which is also on the margins of recorded history, the story of life in the English Midlands village of Clifford Chambers.

The title implies both accurate reporting of the words of others – it is grounded in community records – and the existence of a 'trial' to which these words are addressed. In the 1980s cultural materialist scholars of Shakespeare found much to say about the heritage industry and its exploitation of rural Warwickshire; this Royal Shakespeare Company commission invites our judgement on it – 'paying its dues to the local community' as one reviewer remarked.[7] Characters struggle not only with the wealthy commuters whose impact on property prices jeopardizes deep-rooted traditions, but also with the psychic cost of those traditions. This conflict resonates through three generations of one imagined family. Dorothy, clinging to her cottage-cum-Post-Office because to leave would be to acknowledge her vanished daughter as dead, says: 'Sometimes you have to take sides to stay human' (De Angelis 1999b: 18). While the narrative bears out her contention that people are the product of their choices, the fragmented structure undermines such a purely individualistic understanding of cause and effect. Dorothy's grandmother, Gladys, racked with grief for her husband killed in the war, wants to abandon her unloved baby Edie but the (female) Squire exerts unspoken but powerful pressure to keep her. Nagged by Gladys to assume her role as village layer-out – 'Pennies on the eyes. Book under the chin. Cork up his back passage' (De Angelis 1999b: 21) – Edie hears a corpse sympathize in her father's voice and escapes into the energy of the 1960s as a hairdresser – but desire for her brother-in-law ties her to the old life 'like a bloody dinosaur'. Edie, unloved daughter, illicit mother, elderly chronicler, personifies the mixed impact of family and politics upon the most intimate aspects of life. Her narrative arc pushes the play out of the social-documentary genre of the 1970s and is the force that drives the final scene. A surreal mix of memories, history and tales from figures dimly glimpsed through the branches of a fallen tree, this is in .part a funeral rite for a way of life that is passing away. But ending with a beginning – 'Does anyone know a story. You do, Edie. Go on. Tell it' (De Angelis 1999b: 75) – makes vividly concrete the collective memory of a marginalized community: rather than a record of rural decline, it is evidence of the creativity that has sustained it.

De Angelis recently achieved West End success with a play that might also be seen as site-specific, but in this case it is coincidental: *Jumpy* was a transfer from the Royal Court. However, the occasional sour note in predominantly positive reviews tended to focus on the apparent conservatism of the form. 'Once upon a time,' wrote UK critic Michael Billington, 'a crisis would arise when a daughter would burst in through the French windows and announce "Mummy, I think

I'm preggers" ... I scented a strong whiff of the Shaftesbury Avenue of Yesteryear.'[8] But, of course, it was never like that. The West End of the mid-twentieth century drew a dividing line between comedies with French windows and public-school slang, moving smoothly to an ending both 'happy' and uncritical of the status quo and plays that – if the censor agreed – constructed teenage pregnancy as a 'problem'. The appeal of *Jumpy* in the West End lay in the fact that it applied these old-fashioned formats to precisely the kind of people who had exploded all the assumptions underlying them. The briskly feminist backchat reflects the revolution in comedy spearheaded by women exemplified by the groundbreaking Channel 4 sketch show *Smack the Pony* (which starred one of *Jumpy*'s cast, Doon Mackichan); but it takes on greater complexity as it is carried into a detailed narrative. Hence there are show-stopping entrances – for example, that of a daughter re-entering after a long emotional scene with her mother only to find her boyfriend, dressed in nothing but a post-coital rose, emerging from his hiding place. But while the stagecraft exuberantly parodies the 1950s, the conflicts it throws up have to be negotiated by a woman still experimenting with selves in middle-age; the moral cost is not loss of respectability but of identity as left-wing feminist and mother: 'I can't bear being in my own skin,' she says (De Angelis 2011: 94). The psychic cost is one that French-window comedy could not confront so nakedly because it presented the family as a given, rather than as one choice among a number of possible subject positions – a cost summed up by Charles Spencer as 'the inequality of love between parents and their children'.[9] Technically, this is as innovative a play as De Angelis has yet written.

Frances Gray

Notes

1 *The Guardian*, 14 December 2012.
2 April De Angelis and Anna Furse (1991) 'The Salon at Paines Plough', in Cheryl Robson (ed.) *Seven Plays by Women*, London: Aurora Metro, p. 27.
3 April De Angelis, 'Riddle of the Sphinx', *The Guardian*, 10 September 2005.
4 Charles Spencer, *Daily Telegraph*, 19 July 2012.
5 Simone de Beauvoir (1972) *The Second Sex*, trans. H.M. Parshley, New York: Penguin, p. 734.
6 *The Guardian*, 14 December 2012.
7 *What's On Stage*, 19 August 1999.
8 Michael Billington, *The Guardian*, 20 October 2011.
9 Charles Spencer, *Daily Telegraph*, 20 October 2011.

Key works

De Angelis, April (1999a) *Plays: 1*, London: Faber and Faber.
——*A Warwickshire Testimony* (1999b), London: Faber and Faber.
——*A Laughing Matter* (2002), London: Faber and Faber.
——*Jumpy* (2011), London: Faber and Faber.
De Angelis, April, Feehily, Stella, Gupta, Tanika, Moss, Chloe and Wade, Laura (2006) *Catch*, London: Oberon.

Further reading

Cousin, Geraldine (1996) *Women in Dramatic Place and Time,* London: Routledge.
Gray, Frances (ed.) (1990) *Second Wave Plays: Women at the Albany Empire,* Sheffield: Sheffield Academic Press.
Robson, Cheryl (ed.) (1991) *Seven Plays by Women,* London: Aurora Metro.

ALAN AYCKBOURN (1939–)

Alan Ayckbourn is certainly the most prolific British playwright, with at least 78 full-length plays staged since 1959 – more than twice as many as Shakespeare, and almost one-third more than Bernard Shaw. There are another ten plays that, while performed, have been withdrawn and never published. Ayckbourn is still going strong; *Arrivals and Departures,* appeared in 2013 and his 78th play, *Roundelay,* opend in September 2014. Throughout his career he has written an average of at least one play a year, with no fewer than three new plays appearing in 1990, 1994, 2001, 2003 and 2004. Indeed he had two plays produced by Stephen Joseph in Scarborough in 1959, his first official performances. Even though generally considered a dramatist specializing in farce, Ayckbourn himself only acknowledges one play as a farce: 1979's *Taking Steps.* Yet many of his plays have the geometric structure and flat characters of traditional farce, as well as the heavy fathers or husbands and revolving bedroom doors that characterize the work of French *Belle Époque* dramatist Georges Feydeau: an influence Ayckbourn implicitly acknowledges in a title like *Communicating Doors* (1994). Two very early – although now missing – plays signal other sources through their titles: *Pirandello Play* (c. 1957) and *Ionescu Play* (c. 1957).[1] At the same time, beneath their comic surfaces, Ayckbourn's plays contain trenchant social critiques; the director Sir Peter Hall brought Ayckbourn to the National Theatre precisely because his plays

presented 'an accurate reflection of English life' that in each case created 'a very important social document'.[2]

In Ayckbourn's hands the stock comic tropes of social conditioning and sexual politics take on a serious dimension; and his recurring thematic concerns can be summed up in the titles of his work, such as *Absurd Person Singular* (1972), *Private Fears In Public Places* (2004), *Woman In Mind* (1985) or *Things We Do For Love* (1997). These point to the promotion of personality and the consequent isolation of individuals in contemporary society – the male (and media/advertising) sexualizing and exploitation of women; the obsessive betrayal, deception (and self-deception), manipulation and sheer superficiality of personal relationships – that form the basis of his analysis of society. Throughout his focus has been on the middle class – with his characters epitomizing the upwardly mobile with low moral standards – the psychological cost of class distinctions and the challenge of contemporary lifestyles, bored suburbanites and insecure housewives, together with tyrannical parents, domineering or absent husbands and weak-kneed adulterers, cheerful philistines and social automata, to the extent that in the 1990s he was hailed as 'the laureate of the petit bourgeoisie, the rhapsodist of provincial life'.[3] The latter part of this characterization relates to Ayckbourn's links with northern England, where many of his earlier plays are set. Most of his plays are specifically written for the Stephen Joseph Theatre in Scarborough, North Yorkshire. Ayckbourn was also Artistic Director of the Stephen Joseph from 1972 to 2009, except for a two-year break in the 1980s when he accepted an invitation from Peter Hall to be a resident company director at the National Theatre. Most of Ayckbourn's plays are performed at the Stephen Joseph before transferring to the National Theatre or the West End.

Social commentary remains as relevant as ever in Ayckbourn's playwriting, with *Private Fears in Public Places* (2004), which is comprised of brief scenes, some of which are wordless tableaus – a woman sitting alone in a café, shrinking sadly into a cappuccino cup, a man moored in an armchair before a flickering television screen – being compared by the New York critics with Edward Hopper paintings; as one review commented: 'For audiences used to comedy that grabs you by the throat, if not in more private places, patience may be needed, but it is richly rewarded. By the end of this intermissionless evening, these quiet, loosely overlapping scenes gradually cohere to compose a collective portrait of contemporary urban isolation.'[4]

Indeed the titles Ayckbourn comes up with for his plays are unusually programmatic. Titles like *Improbable Fiction* (2005) and *If I Were You* (2006) reflect his Pirandellian focus on the interchangeable nature of personality and the artifice of stage performance, which is frequently highlighted in his work. Indeed, *Improbable Fiction*, where imagination becomes reality, offers insight into Ayckbourn's process of artistic creation. The title comes from a line in Shakespeare's *Twelfth Night* (c. 1601–1602), a play of reversals and wish-fulfilment. Elizabethan and Jacobean drama is a repeated reference for Ayckbourn, with *The Revengers' Comedies* (1989) – a double play set, like Caryl Churchill's *Serious Money* (1987), in London big business and the hunting/shooting set of the home counties – playing off the title of Cyril Tourneur's *The Revenger's Tragedy* (1607).

Improbable Fiction is set in his imaginary town of Pendon – first dramatized in *Relatively Speaking* (1965) and in *Time and Time Again* (1971), and most centrally in *A Chorus of Disapproval* (1984). Here the characters all belong to a 'Pendon Writers' Circle'. Based, as Ayckbourn admitted, on a local Yorkshire 'group, which shall remain nameless, whose members had never had anything published and I suspect they'd never written anything, but they always met and talked about writing',[5] the unwritten stories they obsessively discuss in the first half spring confusedly to life in part 2. The living room of the group's chairman, Arnold, a hack writer of instruction manuals, is invaded by competing fantasies as historical fiction about a damsel in distress melds with a crime investigation by a crass and incompetent policeman, while Arnold's mother-in-law gets abducted by aliens. And in fact these fictions encapsulate recurring themes in Ayckbourn's own work. Policemen – a standard trope of farcical comedy – are generally absent but he has written a trilogy entitled *Damsels in Distress* (2001), Ayckbourn has also written a number of plays about the supernatural, including *Haunting Julia* (1994), *Snake In The Grass* (2002) and *Life and Beth* (2008). Sci-fi is also a continual theme, with time-travel featured in his musical *Whenever* (2000) and *Miss Yesterday* (2004), and with mechanical beings as actoids in *Comic Potential* (1998), as robot gardeners in *Virtual Reality* (2000) and as an apparently normal girl in *My Sister Sadie* (2003). Notably these mechanical or cybernetic figures are the direct equivalent of the stock characters that inhabit standard farcical comedy, but here (since the robotic nature only gradually appears during the action) they also become a way of commenting on social conditioning and the degree to which contemporary existence blocks individuality. In addition, in *Improbable Fiction* Ayckbourn introduces discussion of artistic creativity, as when Arnold suggests

that all artists reinvent some significant personal trauma in their work. At the same time, there is a strong element of parody in the fictional fantasies that erupt in the second part of the play, which among other targets, 'send up Jane Austen, Dorothy L Sayers and *The Matrix*'.[6] This makes the aspect of parody that applies in most of the subjects or topics for his plays explicit, openly revealing Ayckbourn's working approach.

Similarly, his titles represent his dramatic approach and the way he uses comedy: for instance, *Joking Apart* (1978) and *Comic Potential* (1998) indicate the way humour in Ayckbourn's plays is mainly used as a tool for indicting the audience's laughter, revealing it to be an absence of compassion, but also as a way of exposing serious problems below the apparently cheerful social surface, while a title like *Body Language* (1990) both signals the physical nature of Ayckbourn's comedy, as well as the sexual objectification of women. In the same way, *Virtual Reality* (2000) or *RolePlay* (2001) point to the metadramatic element in Ayckbourn's work. This is present in *Life of Riley* (2010) – where the title character takes part in an amateur theatrical production, which we realize is Ayckbourn's own first West End hit, *Relatively Speaking* – but perhaps most obvious in *A Chorus of Disapproval* (1984).

Here, the central figure, Guy Jones – a widower searching for company – joins the Pendon Amateur Light Operatic Society, who perform *The Beggar's Opera* (1728). As Ayckbourn put it, the choice of Gay's classic work sets 'romantic pimps, prostitutes and highwaymen' against 'their modern equivalent as property developers, builders and bored housewives'.[7] Songs and scenes from *The Beggar's Opera* are intercut with episodes in the local community. The complete nonentity Guy becomes a tool for women to use against their husbands, while his well-meaning passivity means he allows himself to be used by the greedy and devious local citizens – leading him into unwilling involvement with shady business deals and the betrayal of a friend. It is an intended link between Ayckbourn's type of comedy and the traditional politically explosive style of comedy pioneered by Gay (*The Beggar's Opera*, parodying Walpole's government, provoked the introduction of stage censorship in England in 1737). Theatrical illusion overlaps with social reality; the folk-opera-within-the-play exposes the artifice and superficiality of life in contemporary society.

One of Ayckbourn's major thematic concerns overlaps with the technique of comedy itself. This is the role of chance. While the random effects of actions are fundamental to many of Ayckbourn's plays, in *Intimate Exchanges* (1982) this is extrapolated into a major theme. Two actors play ten roles in a cycle of eight plays – each

having two alternate final scenes. These all share a common opening scene, 'How it Began', but the actors and spectators have a choice of two possibilities at every scene's climax. As a whole then *Intimate Exchanges* deals with the consequences of choice, and how lives can take very different paths, from the smallest and least consequential outcomes to the most serious and damaging decisions. The original production underlined the element of choice:

> On any single night, the audience ... will see a comedy in four scenes extending over five years. They will also see a wall chart with that night's scenes lit up in red among a mass of others to be substituted on other nights. As things stand at present, there are thirty scenes, amounting to sixteen complete versions of the play which, incidentally, comprises eight characters, all played by the same two actors.[8]

This kind of experimentation with form is repeated in other plays – as in *The Norman Conquests* (1973) trilogy, about the same people in different locations of the same house over a single weekend, with three different women being seduced by the title figure. Again, overlapping the intrinsic nature of comedy with thematic concerns, as with the element of chance Ayckbourn highlights the arbitrary nature of comic action: most obviously in *If I Were You* (2006). Here gender roles are challenged through an arbitrary (and medically as well as psychologically impossible) switching of bodies during the night, with a husband waking up to find himself in his wife's body, while she inhabits his. Forced to take each other's roles changes their outlook, both of themselves and of the society around them.

Futuristic science fiction is Ayckbourn's method of disguising his most extreme social commentary through the frame of stock fantasy. So, in *Communicating Doors* (1994) all sex is virtual – 'mouse in one hand and a joy-stick in the other' – and prostitutes are state employees. But implied contemporary references are bleak. London, like Sarajevo or Aleppo, is a burning and Balkanized war zone, while a millionaire confesses to having both his wives murdered, then expires on stage. At the other end of Ayckbourn's range are lighter Christmas plays and musicals, including *By Jeeves* (with Andrew Lloyd Webber, 1975, which acknowledges another of the influences on his comedy: P.G. Wodehouse). Music is also a recurrent element in his plays, from his very first play *The Square Cat* (1959), to *Life of Riley* (2010) – which injects the songs of Pink Floyd between scenes of sexual infidelity.

<div align="right">Christopher Innes</div>

Notes

1 'Early Writing', *Alan Ayckbourn's Official Website*, http://plays.alanayck bourn.net/page17/styled/index.html [accessed June 2013].
2 *The Sunday Times*, 1 June 1986.
3 *The Sunday Times*, 13 February 1994.
4 Charles Isherwood, *The New York Times*, 15 June 2005.
5 Interview in *Yorkshire Evening Press*, 27 May 2005.
6 *Yorkshire Evening Press*, 2 June 2005.
7 Interview in *The Standard*, 26 July 1985.
8 *The Times*, 4 June 1982.

Key works

Alan Ayckbourn (1970) *Relatively Speaking*, London: Evans Plays.
——(1974) *Absurd Person Singular*, London: French.
——(1975) *The Norman Conquests*, London: Chatto and Windus.
——(1986a) *A Chorus of Disapproval*, Boston: Faber and Faber.
——(1986b) *Woman in Mind*, Boston: Faber and Faber.
——(1999) *Comic Potential*, London: Faber and Faber.
——(2000) *House and Garden*, London: Faber and Faber.
——(2002) *Damsels in Distress: GamePlan, FlatSpin, RolePlay*, London: Faber and Faber.
——(2003) *The Crafty Art of Playmaking*, New York: Palgrave Macmillan.
——(2011) *The Life of Riley*, in *Plays 5*, London: Faber and Faber.

Further reading

Allen, Paul (2002) *Alan Ayckbourn: Grinning at the Edge: A Biography*, New York: Continuum.
Billington, Michael (1990) *Alan Ayckbourn*, New York: St Martin's Press.
Kalson, Albert E. (1993) *Laughter in the Dark: The Plays of Alan Ayckbourn*, Rutherford NJ: Fairleigh Dickinson University Press.
Page, Malcolm (1989) *File on Ayckbourn*, London: Methuen Drama.

AMIRI BARAKA (1934–2014)

Born Everett LeRoi Jones, Amiri Baraka is best known as the leading theorist and writer of the Afro-American Black Arts Movement, which artistically complemented the rise of black social and political militancy in the USA of the 1960s. After university and a spell in the

US Air Force, LeRoi Jones (as he now was) lived in New York's bohemian Greenwich Village, where he came to attention as a poet and editor of 'little' magazines. Initially under the influence of the poets of the Beat Generation such as Allen Ginsberg, a trip to Cuba in 1960 was decisive in turning Jones into a politically committed, race-conscious artist. But it was his play *Dutchman*, which opened Off-Broadway in 1964 and won him an Obie for the best American play of the year, that made him famous and a major American literary figure in his own right. Leaving Greenwich Village and his white wife, Jones moved to Harlem and then to his hometown of Newark, New Jersey and embarked on the black cultural nationalist phase of his career, for which he is still chiefly known. In the course of the 1960s Amiri Baraka, as he renamed himself in 1967, wrote and directed a string of short, shocking plays – including *The Slave* (1964), *Experimental Death Unit #1* (1965), *A Black Mass* (1965) *Great Goodness of Life* (1967) and *Madheart* (1967) – that attacked 'whiteness' in all its aspects and advocated the violent destruction of the white race in America. In the course of the 1970s Baraka's political militancy took a new turn, from cultural nationalism to a version of Marxism-Leninism. He continued to write, teach, organize and make plays, although none with the power of his drama of the earlier period.

In the uncompromising statements of his cultural nationalist period, Baraka defines the role of the black artist in America and the need for an entirely new black aesthetic for its theatre. 'The black artist's role in America,' he says, 'is to aid in the destruction of America as he knows it' (in Harris 1991: 169). In his manifesto, 'The Revolutionary Theatre' of 1965 Baraka writes of his desire for a theatre of black people that will force change by identifying and attacking the evils of white-dominated America. It will be a theatre that 'looks at the sky with the victims' eyes, and moves the victims to look at the strength in their minds and their bodies'. Although it is 'now peopled with victims', Baraka says, it 'will soon begin to be peopled with new kinds of heroes' – 'new men, new heroes' whose enemies will be 'most of you who are reading this' (Baraka 1966). Theatre, in Baraka's account, is not a weapon in the struggle for racial integration and social justice, as conceived by the Civil Rights Movement under the leadership of Martin Luther King. It is, rather, the artistic expression of a separatist vision of a black American future, of the kind extolled by Elijah Muhammad, Malcolm X and the Nation of Islam. Whereas, for instance, Lorraine Hansberry's *A Raisin in the Sun* (1959) can be seen as powerfully advocating the Civil Rights Movement objective in a critically and commercially successful Broadway play that

observes the conventions of 'well-made' Euro-American drama, Baraka's manifesto demands a distinctively black aesthetic inherited from the allegedly ritualistic and functionalist characteristics of African art.

Dutchman (1964) has been generally regarded as the single most successful theatrical product of the Black Arts Movement. It presents a 'victim' – the young black bourgeois Clay – who in the course of the action is provoked by the white woman Lula into recognizing and articulating his 'heroic' black identity, only to die at the hands of his white antagonist. 'You're a well-known type,' Lula tells Clay early in their acquaintance (Baraka 1979: 78). And the type – presumably not unlike that of the younger, college student LeRoi Jones – is the educated, middle-class, smartly and conventionally dressed black male, who seeks assimilation within American society and who is flattered and pleased to be the object of the seductive attention of an attractive white woman. But from seduction Lula moves to insult and provocation – 'You ain't no nigger, you're just a dirty white man' – as the empty coach of the subway train in which they are travelling quickly fills up with other people (Baraka 1979: 91). As she humiliates him for the entertainment of the other passengers Clay slaps her repeatedly and makes a speech in which he reveals that 'I sit here, in this buttoned-up suit, to keep myself from cutting all your throats' (Baraka 1979: 93). Had black artists such as Bessie Smith and Charlie Parker resorted to murder, he claims, they would not have needed their music. The only thing that can cure black neurosis is the killing of white people, and some day, he predicts, black Americans will restore their sanity through violence. But as he leans over to retrieve his belongings and leave the train, he is stabbed by Lula with the connivance of the now full compartment of passengers. Lula commands them to throw his body out, makes a brief note in her notebook and, in the now empty coach, turns her attention to her next victim, a young black man with a couple of books under his arm who has boarded the train.

The Slave was premiered just a few months after *Dutchman* in 1964, but it marks a step away in Baraka's dramaturgy, from a drama of victimhood to a drama of heroes. If Walker, the protagonist of *The Slave*, is still a victim, he is a victim who, unlike Clay, has chosen active revolt as leader of a revolutionary army. An aspiring bourgeois, who has been married to a white woman, he sees the error of his ways, though he still has to pay for them. The confrontation between the black protagonist and his two white antagonists, his ex-wife Grace and her new husband Easley, ends in the deaths of the two whites, the poetry-loving Easley at Walker's own hands. Walker, who has

confessed to his ex-wife that he still loves her, finally liberates himself from the remnants of whiteness as Grace's house is destroyed by his army's shelling.

Baraka's subsequent plays from his cultural nationalist period are built on a Manichean worldview from which the elements of tragedy and psychological complexity apparent in *Dutchman* and *The Slave* are gradually – some might say, fatally – excluded. In *A Black Mass* (1966), the black magician-creator Yacoub's misguided compassion for his creation of a Frankenstein-like white creature is rewarded with his own, and his fellow blacks' death at the hands of his creation. The form here is that of the morality play, since Yacoub is warned all along about the folly of his enterprise, and the white monstrosity he creates is in every way repulsive. In *Great Goodness of Life* (1967), subtitled 'A Coon Show', the black protagonist, Court Royal, is arraigned before an invisible and thoroughly racist Voice, charged with harbouring a murderer. Court protests his innocence, explaining that he has lived an upright life working as a supervisor in the Post Office for 35 years.[1] Presented as an 'Uncle Tom' figure who has always kept out of politics, Court denies all knowledge of the faces of black victims of white racism in America such as Malcolm X, Martin Luther King and Medgar Evers, and ends up being found innocent and freed when he symbolically executes his own son. Court's final words in the play are a cheerful 'Hey, Louise, have you seen my bowling bag? I'm going down to the alley for a minute' (Baraka 1979: 156).

Extreme black victimhood, so evident in these two plays, gives way to the other side of the Manichean divide – the portrayal of black super-heroism – in subsequent plays. In *Madheart* (1967), in contrast with *Dutchman*, the black male protagonist loses no time in slaying the white female 'Devil Lady'. Assisted by the racially proud but sexually submissive Black Woman, the Black Man fights to save his sister and mother from their entrapment in the allure of the white world, embodied in the Devil Lady. Similarly in *Home on the Range* (1967) the Black Criminal invades the home of a white American family and kills them together with those blacks who have fraternized with them. As the loss of individualized names suggests, Baraka is no longer interested in the personal identity of his characters or in anything relating to psychological complexity; instead, his audiences were invited to witness a new form of political theatre in which scenarios of white destruction are played out by black male heroes conceived as models of authentic Afro-American liberation from everything that has oppressed them.

In the mid-1970s Baraka once more changed the direction of his ideological and artistic life, renouncing what he had come to regard as a narrow and hypocritical cultural nationalism in favour of commitment to his understanding of Marxism-Leninism. His one-act play, *What Was the Relationship of the Lone Ranger to the Means of Production?* (1979) gives a sense of his new priorities, which are to demonstrate how capital exploits the workers on the factory floor and how this oppression is to be overcome through proletarian solidarity. That iconic American hero, the Lone Ranger, becomes the sinister masked representative of capital, who loses no time in killing his native sidekick Tonto when the latter articulates the reality of Native American history. Although the Lone Ranger and his ally Tuffy, the corrupt union organizer, arrange to pay white workers more than their ethnic minority colleagues, the emphasis on black oppression is now entirely absent, replaced by a coalition of the exploited of all races and both sexes. The play ends, in time-honoured agitprop style, with the sudden and unexplained arrival of militant workers demanding strike action.

Not surprisingly, given his views, the ways he has expressed them and at times his actions, Amiri Baraka has been a consistently controversial figure who has divided critical opinion. Although as a playwright he is likely to be remembered mainly for *Dutchman*, his overall contribution to, and influence on, the American Black Arts Movement as writer, polemicist and founder of several arts organizations was certainly immense. If his influence on American theatre, even black American theatre, has declined in recent decades, Baraka has remained a central figure in American cultural life as a political and cultural activist to whom younger writers, and not only black ones, have been indebted.

<div align="right">Brian Crow</div>

Notes

1 Baraka's father, Coyt LeRoi Jones, to whom the play is dedicated 'with love and respect', was just such an official.

Key works

Baraka, Amiri (1979) *Selected Plays and Prose of Amiri Baraka/LeRoi Jones*, New York: Morrow.
——(1998) *Four Black Revolutionary Plays*, New York and London: Marion Boyars Publishers.

Further reading

Baraka, Amiri (1966) 'The Revolutionary Theatre', in *Home: Social Essays*, New York: pp. 210–215.

Benston, Kimberly W. (ed.) (1978) *Imamu Amiri Baraka (LeRoi Jones): A Collection of Critical Essays*, Englewood Cliffs, NJ: Prentice Hall.

Harris, William J. (ed.) (1991) *The LeRoi Jones/Amiri Baraka Reader*, New York: Thunder's Mouth Press.

Sollors, Werner (1978) *Amiri Baraka/LeRoi Jones: The Quest for a 'Populist Modernism'* New York and Guilford: Columbia University Press.

Watts, Jerry Gafio (2001) *Amiri Baraka: The Politics and Art of a Black Intellectual*, New York and London: New York University Press.

HOWARD BARKER (1946–)

Howard Barker is the singular figure in the post-war British theatre who has relentlessly, and with ruthless eloquence and prolificacy, challenged the entire foundations – aesthetic, moral, political, cultural, material – upon which the theatrical ecology is built. His emergence as a dramatist, initially surfing with some discomfort alongside the second wave of radicalized socialist post-war British dramatists – Howard Brenton, David Edgar and David Hare – hinted at an already individuated voice. Early plays, such as *Cheek* (1970), *Alpha Alpha* (1972) and *Claw* (1975), are frequently shot through with satire, a mainstay of many of Barker's contemporaries during this period. However, in their didactic assaults on the forces of capitalism these plays asserted not only the linguistic articulacy of working-class characters but also their cognizance and complicity in negotiating social and political forces. Plays such as *That Good Between Us* (1977) and *The Hang of the Gaol* (1978) take 'the nation', specifically contemporary England, as their subject matter; but whereas the likes of David Edgar in a play such as *Destiny* (1976) employs a form of epic social realism to disentangle (and therefore comprehend) the momentous forces of recent history, Barker's England is not simply moribund, these plays hold no glimpses of restorative hope for the forces of egalitarianism or social democracy. As David Ian Rabey observes of the plays of this period, '[t]he general impression ... is of a warring rodent world, mouths all blood and fur turned against each other in a caged era of soured hope and degradation, where the bizarre postures of political situations often have their origins in unlived sexuality' (Rabey 1989: 83). Significantly, if Barker's

contemporaries saw 'history' as a means of understanding the present, then it took a historian (Barker graduated in the subject from Sussex University) to question its fecundity as a cornerstone of political theatre.

In the 1980s Barker launched into the most productive and provocative stage of his career. The background to this period is important in illuminating Barker's response. In Britain, Prime Minister Margaret Thatcher initiated a liberal monetarist policy, borrowed from the USA, for running the economy. This accommodated the privatization of state-owned industries, and the deregulation of the financial markets, and was matched by a form of social conservatism that resulted in the gradual infringement of civil liberties, as in the notorious Section 28 of the 1988 Local Government Act, which outlawed the promotion of homosexuality. On the world stage President Ronald Reagan was vigorously replicating such a project in the USA, and both leaders spearheaded a nuclear arms build-up – with both their attentions firmly fixed on the common Cold War enemy of the Soviet Union, the cracks in Actually Existing Socialism now plain for all to see. In England, many left-wing political drama-tists faltered at this turn of events. And it was under the shadow of these rapidly changing ideological coordinates that Barker began to develop a dramatic, theatrical and aesthetic theory, continuing to this day, that not only critiqued the ideals and transformative, sometimes implicit, sometimes explicit, claims of modern political theatre. Commencing with the reclamation of 'tragedy' and evolving into a 'Theatre of Catastrophe', Barker set out to proffer a theatre that resists 'solidarity ... a theatre which is neither brief nor relentlessly uplifting, but which insists on complexity and pain, and the beauty that can only be created from the spectacle of pain' (Barker 1998 [1989]: 54). Barker turns from 'tragedy' to 'catastrophe' because the former, in its classical sense, 'was a restatement of public morality over the corpse of the transgressing protagonist'; whereas, in 'Catastrophe there is no restoration of certitudes, and in a sense more compelling and less manipulated in the Epic theatre, it is the audience which is freed into authority' (Barker 1998 [1989]: 54). Barker's theoretical writings, published under the title *Arguments for a Theatre* in 1989, and now spanning several editions, are comprised of aphorisms, articles, con-ference papers and so on. Since coming into print, it has represented the most sustained assault on both the subsidized and commercial establishments within British theatre and beyond. The book also promises a theatre that unshackles audiences, who Barker always regards through the individual, never the collective, from the

strangleholds of 'realism', 'satire', 'clarity', 'logic' and 'consistency'. *Arguments for a Theatre* thus reveals tacit ideological collusion between the harbingers of both 'serious' and 'popular' culture, through which disaffected artists and audience can only respond by sequestering themselves into the Catastrophist experience. This is also a radically elitist theatre, in which audiences have 'the right ... to be taken to the limits of tolerance and to strain and test morality at its source' (Barker 1998 [1989]: 37). One would be correct here to characterize Barker as a modernist, even an avant-gardist; *Arguments for a Theatre* is frequently reminiscent of the manifesto form. His is a theatre that also carries a 'politics beyond politics', in which the dramatist's function is both 'selfish' and 'heroic ... to revive the concept of [forbidden] knowledge', through seeing 'men and women as free, cognitive, and essentially autonomous, capable of witnessing pain without the compensation of political structures' (Barker 1998 [1989]: 49–50).

Barker's evolving dramaturgical innovations since the 1980s fully aspire to mirror the challenges presented by his theoretical writings. For example, *Victory: Choices in Reaction* (1983) is set in the aftermath of the English Civil War, and charts the pilgrimage of widower Susan Bradshaw to collect the dismembered remains of her revolutionary regicide husband. However, Bradshaw's itinerant journey is not internalized as one of spiritual and moral accretion leading to some form of epiphany, but one of liquidation, and the disintegration of former sympathies and alliances. Barker himself highlights the scene in which the widower assaults a supposed political ally, the blind and powerless poet Milton, as a seminal Catastrophic moment, generating 'a dramatic climate where political values are loosed into the air, and the audience, deprived of the predictable, is obliged to construct meaning for itself ... ' (Barker 1998 [1989]: 58). *Victory* also reveals Barker's attitude towards 'history' as a source of abject speculation, a means of depriving audiences of coherent dramatic universes, and of unveiling imagined landscapes that are peopled with invented subjects deprived of any authorized historical discourse – even when those subjects may have a documented source. *Hated Nightfall* (1994), for example, takes its cue from the discovery of two unidentified individuals found in 1991 with the remains of the Russian imperial family – executed at the hands of the Bolsheviks in 1918. The hero of *Hated Nightfall*, Dancer, is one of these anonymous corpses, resurrected by Barker as the tutor to the Romanov children. Caught in the turbulent turns of history, Dancer becomes the 'Doorman of the Century', and seizes the opportunity to temporally assert his own

explosive ludic and amatory will. Barker similarly commandeers extant classical dramatic sources, not merely to make such work pertinent to contemporary audiences, but to demonstrate, in a kind of aberrant aesthetic encounter with the original, the 'absences and silences' within them that demand interrogation (Barker 1998 [1989]: 153). *(Uncle) Vanya* (1993) is both a response to a specific text, and a retort to the 'uncontested authority' of Chekhov within the British theatre (Barker 1998 [1989]). Barker deconstructs the Chekhovian naturalistic paradigm, not only by allowing Vanya to step outside the virtual world of the play, but by giving expression to the repressed sexuality and potential for transgression that naturalism, in its philosophy of predetermination, contains. *(Uncle) Vanya* is also peopled by a chorus (an intermittent feature in Barker's plays) – the voices of consent and suppression – and even the ineffectual Chekhov himself, further coalescing to expose the aesthetic and ethical redundancy of naturalism. *Gertrude – The Cry* (2002) is Barker's reimagining of Shakespeare's *Hamlet* (c. 1601), in which the Gertrude/Claudius relationship takes centre-stage. Rabey identifies this play as 'Barker's most profound exploration of the themes of ecstasy and death'. If the characters of *Hamlet* are engaged in attempts to make sense of themselves and the world around them, in *Gertrude*, 'the principal activity is commentary', not to 'fathom meaning in terms of motivation' but 'rather observe, and render more intricately fascinating and/or offensive, each other's performative actions and appearances'. Thus, 'the cry' of the play's title 'becomes the ultimate form of expressive (rather than communicative) disorder' (Rabey 2009: 180).

This points to a core dimension of Barker's dramaturgy. 'Desire', as distinct from 'sexuality', foregrounded in and by the actions and utterances of the human body, detonates in the violent and irreconcilable, and self-consciously uncensored, collision between private and public worlds. *The Castle* (1985) and *The Europeans* (1987) are respectively set against the Christian Crusades of the Middle Ages and the aftermath of the failed Ottoman Islamic insurgence in Vienna in 1683. Each of these plays dramatizes characters that refuse to be contained by the forces of hegemony. Not unusually for Barker, it is also women's will to self-definition that most frequently threatens to overthrow the order of things.

Barker's dramatic texts are densely poetic and complex, linguistically sumptuous, darkly comic – although laughter is never intended to comfort, only unease us – epic in scale, and frequently bursting with narrative and imaginative leaps. The capacity for his characters to

endure is thrown back on to audiences, in a complicit pursuit. Many of his works have been produced by the Royal Shakespeare Company (RSC), once a natural home for Barker, if only in terms of the RSC's ability to provide the human and material resources the plays require in production. He became, however, increasingly coldshouldered by the critical establishment for his determined obscurity. Barker's status as an outsider reached something of an apotheosis in 1988 when the Wrestling School was set up.[1] Formed by a group of creative disciples, mainly actors, and funded by the Arts Council of Great Britain, it represented a unique development in British theatre: a touring theatre company dedicated to the production of work by just one living dramatist. Barker's dramaturgy, as implicit in his own theoretical writings, demanded the type of expertise and theatre practice not offered by the dominant realist traditions of the British theatre. He eventually assumed full creative control of the company, as director and designer, developing a production aesthetic of *mise en scène*, performance and compositional strategies that did not seek to interpretatively 'cohere' the texts, but facilitate the multiplicity of possibilities in their encounters with audiences. Although Arts Council funding was withdrawn in 2007, the altruism of a private donor meant that the Wrestling School could continue.

Barker's self-fashioned supra-*auteur* status is antithetical to many of the traditions of theatre-making within Britain, and his work carries markedly higher attention within continental Europe. He is also an accomplished visual artist and poet. In his home country he is more considered and celebrated within the academy, not least as a counteractive artistic and intellectual force to the dominant traditions of post-war British playwriting. There were signs in 2012 that some form of rehabilitation was in the offing; the National Theatre mounted a revival of his 1985 play *Scenes from an Execution*, in which the protagonist Galactia, a Renaissance artist, refuses to be assimilated by the body politic of the Venetian state in her insistence on painting the uncensored horrors of war. This ironic mirroring of art and life did not distract the dramatist, who regards *Scenes* as his most reachable play.[2] For Barker, the primacy of his practice persists in the non-utilitarian function of art. Distinguishing between 'the theatre' and 'the art of theatre', this perpetual iconoclast asserts: '*The theatre* gratifies when it gives no more than is expected of it … *the art of theatre* gratifies when it violates the tolerance of its public' (Barker 2005: 103).

John F. Deeney

Notes

1 www.thewrestlingschool.co.uk [accessed 20 December 2013].
2 Maddy Costa, 'Howard Barker: "I Don't Care if You Listen or Not"', *The Guardian*, 1 October 2012, www.theguardian.com/stage/2012/oct/01/howard-barker-scenes-execution [accessed 20 December 2013].

Key works

Barker, H. (1998 [1989]) *Arguments for a Theatre*, 3rd edition, Manchester: Manchester University Press.
——(2005) *Death, the One and the Art of Theatre*, London: Routledge.
——(2006a) *Plays: 1*, London: Oberon Books.
——(2006b) *Plays: 2*, London: Oberon Books.
——(2007) *A Style and Its Origins*, London: Oberon Books.
——(2009) *Plays: 5*, London: Oberon Books.

Further reading

Brown, M. (ed.) (2011) *Howard Barker Interviews 1980–2010: Conversations in Catastrophe*, Bristol: Intellect.
Gritzner, K. and Rabey, D.I. (eds.) (2006) *Theatre of Catastrophe: New Essay on Howard Barker*, London: Oberon Books.
Lamb, C. (2005 [1997]) *The Theatre of Howard Barker*, London: Routledge.
Rabey, D.I. (1989) *Howard Barker: Politics and Desire – An Expository Study of his Drama and Poetry, 1969–87*, Basingstoke: Macmillan.
——(2009) *Howard Barker: Ecstasy and Death – An Expository Study of His Drama, Theory and Production Work, 1988–2008*, Basingstoke: Palgrave Macmillan.

SAMUEL BECKETT (1906–1989)

The plays of the Nobel Prize-winning author Samuel Beckett are famous for their obsession with alienation, solitude and death. However, Beckett's fascination with despair is always counterbalanced with a cussed form of resilience, grounded in friendship, humour and playfulness. Despite his avowed interest in the gloomy philosophy of Arthur Schopenhauer it is, perhaps, more accurate to see Beckett as a Nietzschean writer, an artist who, in an eclectic and prolific body of work, attempted to defy tragedy's spirit of gravity, and to affirm existence while facing up to its fundamental meaninglessness.

After resigning a teaching post in French at Trinity College, Dublin, Beckett moved to Paris in the early 1930s, and remained

there, in self-imposed exile, for the rest of his life. In his early years in Paris, Beckett served as a secretary to his compatriot, the modernist writer James Joyce, and worked primarily on academic studies of Joyce, Proust and Dante, short stories, poetry, and his novel, *Murphy* (1938). Although his writing was initially hampered by Joyce's influence, as well as by time spent helping the French Resistance in World War II, Beckett was to find his own style in an epiphany, experienced in his mother's house in Dublin 1946. Here, Beckett discovered that whereas 'Joyce had gone as far as one could in the direction of knowing more ... I realised that my own way was in impoverishment, in lack of knowledge and in taking away, in subtracting rather than adding' (in Knowlson 1997: 352).

Beckett's art of subtraction produced a revolution in theatrical form. In his hands, character is stripped of psychology, agency and motivation; language becomes a tool for non-communication and narrative is fragmented, circular and repetitive – hence the reason why Beckett's theatre has often been described as a theatre where nothing happens.

Beckett's aesthetic position is perhaps best adumbrated in the short theoretical text 'Three Dialogues: Samuel Beckett and Georges Duthuit' published in 1949. Against an art that would purport to represent the world or to edify it, Beckett prefers an art that embraces its own failure. For Beckett, this is rooted in the belief that 'there is nothing to express, nothing with which to express, nothing from which to express, no desire to express, together with the obligation to express' (Beckett 1999: 103).

For all its intellectual game-playing and intertextual referencing, Beckett's theatre of failure is rigorously non-conceptual. The aim is not so much to make us think as to make us feel, to produce evocative atmospheres that get under the skin and produce intense, dislocating experiences. In this respect, it is surely no coincidence, that Roger Blin, who had worked on Antonin Artaud's *Les Cenci* in 1935, was one of Beckett's early champions, producing key productions of *Waiting for Godot* (1953) and *Endgame* (1957).

Written to solve a formal problem encountered while writing the novel *Watt* (1953), *Waiting for Godot* is one of the landmark plays of the twentieth century, and signals a shift from modernist seriousness to postmodernist irony. The play was first performed in French at the Théâtre de Babylone in Paris, and has been in constant production ever since. Unlike his first play *Eleutheria* (1947), Beckett's comic-tragedy is divided into two almost symmetrical acts, and centres on the repeated attempts of two tramps, Vladimir and Estragon, to keep

their appointment with the mysterious Godot of the title, who is endlessly referred to, but never appears. The play is tantalizingly allegorical, and the solitary tree on stage, along with numerous allusions to the Gospels, have led many critics to read it as an essentially Christian text. The enigmatic and elliptical nature of the play – it takes place on a non-descript country road in the evening – thwarts any singular reading; and in recent years, *Waiting for Godot* has been used to comment on seemingly intractable political situations in South Africa, Palestine and the former Yugoslavia.

Michael Worton has suggested that Godot is perhaps best thought of not as a 'figure', but as a 'function'.[1] This shift from *meaning* to *doing* highlights the intense metatheatricality of *Waiting for Godot*. Vladimir and Estragon dress in bowler hats and battered suits, the uniform of the music hall (and the same costumes worn by Laurel and Hardy); perform gags for each other; and, in their deliberately theatrical exchanges, often appear to address the audience directly. It is telling, too, that Pozzo frames Lucky's famous speech in Act I as a performance,

In *Waiting for Godot* – and arguably even more so in his one-act play *Endgame* – dialogue does not disclose information about the characters; it is a simple device for keeping the performance going, and for allowing time to pass. In this way, waiting is no longer metaphorical; rather, it has become literal, an experience that the spectators themselves undergo as they watch the play unfold. From this perspective, it is possible to see *Waiting for Godot* as a trap. By structuring his dramaturgy so that time – or rather its passing – becomes palpable, Beckett allows death, the void that haunts his characters, to be experienced as a process in itself, and not as mere representation, something that we can ignore when leaving the theatre. Fittingly, Beckett ends his play with an image of stalemate and non-resolution, with Vladimir and Estragon unable to depart the stage.

Krapp's Last Tape, created for the Irish actor Patrick Magee and premiered at the Royal Court Theatre in London in 1958, marks an important shift in Beckett's evolution as a playwright. Here the dialogues and ludic consolations of *Waiting for Godot* and *Endgame* give way to a darker, more elegiac mood that dominates both his middle and late periods. Dressed in a soiled shirt, waistcoat, and carrying a pocketwatch, the grey-haired and exhausted Krapp, aged 69, sits in his den, and eats bananas while listening to recorded reflections, made by his younger self on a tape machine. Like *Play* (1963), in which three nameless characters involved in an unhappy *ménage à trois* take turn to

blame each other while interred up to their necks in urns, and the TV play *Eh Joe*, where a solitary figure, Joe (Jack McGowran), is tormented by an internal voice of a woman (Siân Phillips), *Krapp's Last Tape* is a monologue that dramatizes the event – and also the painful *décalage* – between speaking and listening. Krapp, a writer, is both seduced and tormented by the sexual adventures and artistic aspirations of his younger self, and switches between laughing at his old jokes to sneering in disgust at his former pomposity. As the play progresses, Old Krapp shuffles off stage and returns with a microphone to make one last tape, in which he recounts his past year and tells of his sexual encounters with Fanny, a whore. The play ends ironically and tragically with the Old Krapp listening motionless to the younger Krapp musing optimistically on a potential that will never be fulfilled. Written during the same period as *All That Fall* (1956) – Beckett's first experiment with radio drama – *Krapp's Last Tape* is the first of Beckett's plays to abandon dialogue and to focus instead on the solipsistic play of a lonely consciousness attempting to identity with itself through memory. In so doing, Beckett shifts into the intimate territory conventionally associated with prose. *Krapp's Last Tape* is often regarded as Beckett's favourite play, and the one with which he is most closely associated as a director.

Ohio Impromptu is situated towards the end of Beckett's late period, and was first performed in 1981, in a production that combined the talents of two of Beckett's greatest, and most faithful, interpreters, the director Alan Schneider and actor David Warrilow. The plays of this period, which start with *Come and Go* (1965) and finish with *What? Where?* (1983), Beckett's enigmatic final play, are characterized by their extreme brevity, fragmentary language and crepuscular atmospheres. Beckett called these dramas – and others such as *Not I* (1972), *Footfalls* (1975), *A Piece of Monologue* (1979), *Rockaby* (1981), *Catastrophe* (1982) – 'dramaticules' or playlets. None of them lasts more than 30 minutes in performance and seldom does one take up more than four or five pages in print. *Ohio Impromptu* opens on a sparse, dimly lit stage, where a faint light illuminates the darkness to disclose the presence of two aged figures, with long white hair, the Reader and the Listener, each of whom are seated on a white deal table, at right angles to each other. In his stage directions, Beckett specifies that the two figures ought to resemble each as much as possible.

Like *Krapp's Last Tape*, the dramaturgy of *Ohio Impromptu* is structured around an opposition between speaking and listening. But with the difference that it is now impossible to tell if the Reader is a personification of the Listener – either his consciousness or soul – or

some messenger or angel sent in a dream to comfort him. The story read by the Reader narrates the failed attempts of the Listener to overcome his grief at the loss of his beloved partner. Variation in the Reader's narrative is produced through a series of 'knocks' made on the table by the Listener, the status of which are typically ambivalent. On the one hand, the knocks might be seen as pained attempts to abandon the narrative; however, they could equally signify a desire to defer its ending. The suspensive, deconstructed temporality of the 'knocks' is mirrored in the unfolding of the dramatic situation itself. Reflecting the condensed temporality of French neo-classical tragedy, *Ohio Impromptu* appears to dramatize a moment of extreme crisis that has been building for some time and is now coming to a resolution. The audience is led to believe that this will be the final apparition of the Reader, and that after this performance – or reading – has ended, the Listener will be left alone to face a black night of grief. Nevertheless, this interpretation is troubled by the fact that this 'last performance' has already been scripted in advance, and written down in the book, which the Reader faithfully reads from. That this 'last time' is a time that will be endlessly repeated in the future is underlined by the final image of the play, which, reminiscent of *Waiting for Godot*, shows the two figures turning to face each other and sitting motionless and silent, as the house lights go down.

Like all Beckett's late plays, but in particular *Rockabye* and *Footfalls*, *Ohio Impromptu* is concerned not so much with the finality of death, but with representing, in distilled fashion, the process of dying, of learning how to 'depart' the world. Here, language is no longer a device of torture or guilt as in plays such as *Eh Joe*, *Not I* and *Play*; rather, it is a medium of consolation, which, like the illuminated hand that gives succour to the anonymous dreamer in the short television work *Nacht und Träume* (1982), puts us in contact with ghosts who remain with us, as companions, in the insomnia that precedes the 'sleep' of death itself.

Beckett's influence on contemporary theatre and performance has been profound and for the novelist John Banville 'Beckett's novels and plays ... are the shattered song of our time'.[2] Beckett's legacy can be seen directly in the work of, for example, Harold Pinter, Mabou Mines, Valère Novarina, the Wooster Group, Robert Wilson, Forced Entertainment, Sarah Kane, Jérôme Bel, Lone Twin, Goat Island, and Butoh artist Katsura Kan. Beckett's theatre has also attracted the attention of many leading philosophers, including Theodor Adorno, Gilles Deleuze, Jean-François Lyotard, Jacques Rancière and, most recently, Alain Badiou.

Carl Lavery

Notes

1 Worton, Michael (1994) '*Waiting for Godot* and *Endgame*: Theatre as Text', in John Pilling (ed.) *The Cambridge Companion to Beckett*, Cambridge: Cambridge University Press, pp. 67–87 (quote from p. 71).
2 Banville, John (1989) 'Samuel Beckett Dies in Paris', *Irish Times*, 27 December.

Key work

Beckett, Samuel (1990) *The Complete Dramatic Works*, London: Faber and Faber.

Further reading

Beckett, Samuel (1999) *Proust and Three Dialogues with Georges Duthuit*, London: John Calder.

Kalb, Jonathan (1989) *Beckett in Performance*, Cambridge: Cambridge University Press.

Knowlson, James (1997) *Damned to Fame: The Life of Samuel Beckett*, London: Bloomsbury.

McMullan, Anna (1993) *Theatre on Trial: Samuel Beckett's Later Drama*, London and New York: Routledge.

West, Sarah (2010) *Say it: The Performative Voice in the Dramatic Works of Samuel Beckett*, Amsterdam and New York: Rodopi.

ALAN BENNETT (1934–)

A writer, actor and director, Bennett's career bears comparison with Noël Coward's (1899–1973). Bennett's star rose as Coward's was waning and at first glance, Coward – the epitome of metropolitan sophistication with his cigarette holder, dinner jacket and precise diction – would seem to be the antithesis of Bennett with his gentle northern accent, glasses and sensible raincoat. But both made careers spanning theatre, revue and film, and are considered to be somehow quintessentially English. Both are also closet subversives. Bennett has always dressed and behaved like a fogey but his work probes the structures of British society: treachery (*Single Spies*, 1988), the education system (*The History Boys*, 2004 and *40 Years* On, 1968), royalty (*The Madness of George III*, 1991), heritage (*Enjoy*, 1980 and *People*, 2012). Like Coward, his work has a strong autobiographical element, and celebrates fortitude and humour. Unlike Coward, however, Bennett's work is a sustained exploration and critique of

twentieth- and twenty-first-century Conservative ideology: the mindless acceptance of modernization in industry; the idealization of the past inherent in the heritage industry; the cult of individualism and the consequent diminution of community spirit and values.

Born in Leeds, Bennett did his National Service in the armed forces (then compulsory in the UK) in Cambridge in the Joint Services School for Linguistics (learning Russian alongside Michael Frayn and Dennis Potter) and studied History at Oxford. Although he wrote and performed a number of comic monologues for National Service revues, he did not join the university Dramatic Society or Experimental Drama Club, instead refining and performing his monologues, first at private college events and then by invitation elsewhere. In 1959 he was selected to perform at the Edinburgh Fringe festival in the Oxford Drama Group revue *Better Never* and in 1960 he contributed to and performed in *Beyond the Fringe*, a satirical revue that brought together the leading lights of Oxbridge comedy: Peter Cook and Jonathan Miller from Cambridge and Dudley Moore and Bennett from Oxford. First performed at Edinburgh *Beyond the Fringe* (1960) ridiculed reactionary Toryism, intellectual liberalism and left-wing activism. It was a hit in the West End and on Broadway, was broadcast on the BBC and transferred onto record, transforming the foursome into household names. Bennett went on to write and appear in a short-lived television sketch show, *On the Margin*, and other programmes before writing his play *Forty Years On* (1968).

Forty Years On continued *Fringe*'s theme of mocking Britain's fondness for gazing back on its golden authoritarian past. In celebration of their headmaster's retirement, the boys and staff of Albion House, a minor public school, perform *Speak for England, Arthur*. The frame is a play about Moggie and Hugh, an upper-class couple sitting out the Second World War in the basement of a grand hotel with their old nurse. Within this frame the schoolboys show the unfolding events of the twentieth century in a series of sketches – some almost identical to those in the earlier *Beyond the Fringe* – until they arrive at the Second World War (1939–1945). Bennett acknowledges that the play 'enshrines some terrible jokes', indulges his weakness for puns, and that its ambitious structure made it difficult to get right on stage (Bennett 1996: 8), but the play had a successful West End run and garnered Bennett his second *Evening Standard Award*. *Getting On* (1971) won him a third prize for Best Comedy, much to his discomfort and disappointment. He had intended a serious meditation on the defeat of the Labour government, but

Kenneth More, in the starring role, had reshaped the play to make his character a sympathetic one. *Habeas Corpus* (1973), an experiment in farce form without the accompanying set, examined changing attitudes to sex and the permissive society. The play has been much performed by amateur groups but commercial revivals have not been able to successfully overcome the dated feel of the material – a recurring issue with Bennett's early works.

In the 1970s and 1980s Bennett worked in theatre and television. His early television plays celebrate a lost, or vanishing, world, and a gradual crumbling of community into isolation: *A Day Out* (1972) focusing on a Halifax cycling club visit to Fountains Abbey in 1911; *Sunset Across the Bay* (1975) following a retired couple who move from Leeds to Morecambe and *An Englishman Abroad* (1983) showing British spy Guy Burgess in exile in Russia. Exile, alienation and marginalization are perpetual themes in his work. In *Enjoy* (1980), his first stage 'flop', he satirized all the clichés of northern working-class life. 'Mam' and Dad are living isolated and miserable in the last row of terraced houses in the Leeds slums waiting to move to a new flat. An observer from the city council comes to capture the details of their way of life, and after revealing herself to be their long-lost son, announces that their home will be moved brick-by-brick to a heritage park where visitors will 'alight from one of a fleet of trams to find themselves in a close-knit community where people know each other's names and still stop and pass the time of day' (Bennett 1996: 322). This apparently happy ending is their children's revenge on them for an allegedly abusive and miserable childhood. Bennett followed *Enjoy* with two one-act plays imagining the lives of the Cambridge Spies: *An Englishman Abroad* (broadcast 1983, first stage performance 1988) narrating actress Coral Browne's encounter with Guy Burgess in Moscow while on tour with the Royal Shakespeare Company, and *A Question of Attribution* (1988) imagining an encounter between the queen and her surveyor of pictures, Anthony Blunt, shortly before he was publicly exposed as the 'fourth man', spying for the Russians. The play explores the notion of fakes in art and life through their discussion of *Triple Portrait*, a disputed Titian in the royal collection that caused an art-historical intrigue when two extra figures were revealed by an x-ray. It transferred from the National Theatre to London's commercial West End and was later made into a film for television; Bennett's work has continued to cross stage and screen ever since.

Like Joe Orton, whose life he dramatized in his screenplay for the film *Prick Up Your Ears* (1987), Bennett's ear for the absurdities of

everyday dialogue and the delusions and aspirations it reveals evoke a rich vein of comedy and pathos. This linguistic sensitivity is a feature of all his work, and is most obvious in *Talking Heads* (1987), a series of monologues broadcast by the BBC and subsequently staged in the West End. All the protagonists in *Talking Heads* are solitary figures, even in company – abandoned or excluded by their eccentricities but unable, or unwilling, to acknowledge the fact. As Bennett notes, 'these narrators are artless. They don't quite know what they are saying and are telling a story to the meaning of which they are not entirely privy' (Bennett 1987: 9). The nosy neighbour, the recent widow, the over-enthusiastic actress and the over-attached son who is ragingly jealous of his mother's new 'friend' are all self-deceivers presenting their best face for the camera. *Talking Heads* brought Bennett new audiences on television, in theatres and in print.

Bennett works comfortably on every scale, from the intimacy of *Talking Heads* to the spectacle of *Wind in the Willows* (1991) at the National Theatre. The production was directed by Nicholas Hytner, and the process of adaptation and rehearsing the script began a long and fruitful partnership between writer and director. Hytner wanted to showcase the Olivier Theatre's technical facilities and encouraged Bennett to let his imagination roam while adapting the novel and to leave the practicalities to himself as director and designer Mark Thompson. The result was an outstanding success that played at the National for several years. Bennett and Hytner then collaborated on *The Madness of George III* (1991), which was made into a feature film, *The Madness of King George* (1994). Having begun life as a commercial playwright (*Forty Years On* was rejected by National Theatre dramaturg Kenneth Tynan on the grounds that it was too commercial) Bennett has become one of the stalwarts of the state-subsidized National Theatre and his return to the classroom with *The History Boys* (2004) provided the theatre and Bennett with his most successful play to date. It follows a group of 18-year-olds being prepared for entrance to Cambridge and Oxford Universities in the 1980s and the ideological and psychological battles being fought by their teachers over them specifically and over the meaning of education more generally. Charismatic Hector believes in education for its own sake, Mrs Lintott favours a solid grounding in facts, while Irwin, the young master brought in to prepare the boys, teaches them intellectual debating tricks. For all their sparkiness and wit, none of them fulfils Hector's dream of 'passing on' his enthusiasm

for learning – disappointment, as ever in Bennett's world, a natural companion to moments of happiness.

Throughout his career Bennett has managed to exist as both a public figure and a private man. There is an autobiographical slant to much of his work, and autobiographical elements have often been inferred even when not actually present. Commenting on several reviews of *Enjoy* (1980) that described it as courageous, Bennett drily noted in his diary 'since the central character is in drag throughout, this presupposes that I spend my evenings idly running my fingers along a rack of strapless evening gowns and adjusting my slingbacks. Now it can be told' (Bennett 1994: 109). Excerpts from his diary published regularly in *The London Review of Books* from the 1980s onwards provided tantalizing glimpses into his personal and professional life, including his relationship with his remarkable lodger, Miss Shepherd (who lived in a van on his driveway), later immortalized in the short story and subsequent play, *The Lady in the Van* (1999). Bennett makes his first appearance as a character in this play, not once, but twice, the two Alan Bennetts representing the writer recording events and the householder. In 1994 Bennett published *Writing Home* a collection of his diaries, book reviews and other writings on film, television, literature and culture. The diaries revealed Bennett's fears about politics and society, struggles with writing – which interestingly always seem to disappear when rewrites are needed in rehearsals – and his social life. In 2005, as a result of being diagnosed with advanced bowel cancer, he published a further set of diaries and writing, *Untold Stories*. Fittingly for a writer fascinated by Franz Kafka, Bennett's desires to put his affairs in order and a manuscript into the hands of his publishers provided the public with a candid account of his treatment, life with his partner and memories of his childhood. The transition from private to public man, to a 'national treasure' who could venture opinions on all controversial topics and be indulged, was complete. Bennett's latest play *People* (2012) criticized another national establishment, the National Trust, and its desire to provide a wipe-clean heritage environment for all. *People* played in the Olivier while two of his short stories adapted for the stage were being performed elsewhere in the theatre, with Alex Jennings as Bennett looking benevolent in a jumper and tweed jacket. Bennett's domination of the National (and national) stages reflect the way in which this apparently unassuming playwright's cuddly appearance has gone hand-in-hand with decades of acute social critique.

Kate Dorney

Key works

Bennett, Alan (1987) *Talking Heads*, London: Faber and Faber.
——(1991) *The Madness of George III*, London: Faber and Faber.
——(1996) *Plays: 1*, London: Faber and Faber.
——(2004) *The History Boys*, London: Faber and Faber.
——(2009) *The Habit of Art*, London: Faber and Faber.

Further reading

Bennett, Alan (1994) *Writing Home*, London: Faber and Faber.
——(2005) *Untold Stories*, London: Faber and Faber.
Bull, John (1994) *Stage Right: Crisis and Recovery in British Contemporary Mainstream Theatre*, London: Palgrave Macmillan.
McKechnie, Kara (2005) 'Alan Bennett', in John Bull (ed.) *Dictionary of Literary Biography*, Vol: 310, *British and Irish Dramatists Since World War II*, Waterville: Thomson Gale, pp. 3–18.

EDWARD BOND (1934–)

Bond is an auto-didact, a Marxist and a pacifist. A prolific writer of plays, poems, letters and commentaries, he is perhaps best known for the plays *Saved* (1965), *Lear* (1971), and *Bingo* (1973) and for his work in theatre for young people. A child of the Blitz, he grew up with first-hand experience of violence on an epic scale played out on a personal one. This experience intensified his conviction that violence was a manmade construct, and all the more terrifying for it. The threat and effects of violence dominate his work. His schooling was repeatedly disrupted by war and he left formal education at 15, undertaking manual and clerical work before doing National Service in 1953. Already influenced by his experiences of performances in popular music halls as a child, and by seeing celebrated actor-manager Donald Wolfit performing *Macbeth* – 'he put together what the bombs had broken apart' (Bond in Davis 2005: 4) – Bond got his dramatic education by going to theatre as often as his work would allow. He was particularly struck by the work of Bertolt Brecht and the Berliner Ensemble when they came to London in the mid-1950s, and subsequently modified and developed Brecht's ideas to formulate his own dramaturgical theory. Like Brecht, Bond's theatre is one of ideas, exploring violence, capitalism and the role of the writer in society through episodic scenes rather than conventional narratives: 'the play for Bond is a dramatized analysis of a series of events; it is

not the dramatization of a story' (Hay and Roberts 1980: 36). Bond coined the term 'aggro effect' to describe the purpose of violent scenes in his work. Aggro effects, e.g., the stoning of the baby in *Saved* and the torture of the soldier in *Lear*, are designed to shock the audience into a response, into feeling. Bond is at pains to distinguish it from both Brecht's 'alienation effect' and from Grand Guignol-style theatrical violence. The aggro effect was also used to great effect by Sarah Kane, a great admirer of Bond's work who suffered, as he did, from the critical establishment's initial assumption that their work was attempting straightforward realism rather than being tempered with symbolism.

Bond submitted his first plays to the Royal Court in 1958; they were not produced but he was invited to join the Writers Group, and in 1962 *The Pope's Wedding* (1962) was put on at the Court as a Sunday night without-décor performance. The first of what Bond would describe as his 'Question Plays' it shows a young man, Scopey, and the murderous consequences of his obsession with a local hermit, Alen. Scopey believes Alen holds the key to various local historical events and has withdrawn from society as a result. In fact, he is simply a lonely, withdrawn old man. *The Pope's Wedding* was followed by *Saved* (1965), which explored a detached and disaffected working-class society in which a group of bored and alienated youths stone a baby to death in its pram watched unchecked by the play's protagonist Len. The play proved a test case in the battle against stage censorship. It was produced as a private 'club performance' – this way the censor's office could not ban the performance as it was not in 'public' theatre – after Bond's refusal to acquiesce to the censor's demands to tone down the language, sex and violence. The performance caused a furore among the critics, who were divided over the play. Laurence Olivier, director William Gaskill and Bond himself defended the play, with the author provocatively, but in all seriousness, describing its final scene as 'almost irresponsibly optimistic' (Bond 1995: 309). *Saved* was followed by an even more controversial play, *Early Morning* (1969). It featured the Lord Chamberlain, Queen Victoria, Prince Albert, Florence Nightingale and a host of other eminent Victorians engaged in cannibalism, lesbianism and numerous plots, counterplots, coups and poisionings. Unsurprisingly, the play was originally banned outright by the censor and wasn't performed until after the formal abolition of censorship in 1968. In the meantime Bond was at work on a number of other projects including adaptations of Middleton and Chekhov, dialogue for Antonioni's film *Blowup* (1967), the screenplay for Tony Richardson's *Laughter in the Dark* (1968) and a

commission from Coventry Cathedral for its peace festival, the Brechtian parable *Narrow Road to the Deep North* (1968). Bond once observed in an interview: 'It would be very silly to think you could write about our society and not write about violence. It's a violent century' so the Cathedral and its mission to bring about peace was a fitting commission.[1] *Narrow Road* (1968) was later developed into *The Bundle* (1978), an examination of Stalinism.

Bond has undertaken various commissions over the years when the organization or occasion has chimed with his beliefs including *Black Mass* (1970) for the Anti-Apartheid Movement (in which Bond played Christ), *The Passion* (1971), commissioned by the Campaign for Nuclear Disarmament, *Stone* (1976) for Gay Sweatshop. A playwright driven by conviction, he has frequently commented on social and political issues through his work and has loudly condemned governments, theatres and individuals for abandoning their principles. Despite working closely with the Royal Court (with director William Gaskill), the National Theatre and the Royal Shakespeare Company, Bond's closest links now are with Théâtre National de la Colline in Paris, the Lyric Hammersmith in London, and Big Brum in Birmingham, UK.

Unlike his contemporary Harold Pinter, Bond produces lengthy commentaries on his work and engages tenaciously in critical and academic debate about it, and about the nature of theatre. Bond has described his prefaces as another means of raising the consciousness of his readers:

> The prefaces only rarely refer directly to the plays – but this is by design. I would like the reader of the prefaces to get involved in the problems about the world and then, by a sudden reference, to transfer his roused interest to the play. In this way he stops thinking of the play as a fantasy ... and sees (I hope) that it is really about aspects of his own life ...
> I don't want them to feel that my plays are a 'serious' exposition about life that can only be understood by footnotes. They can be verified by walking down the street ... So the prefaces just give the general ideas and problems behind the play.
>
> (Hay and Roberts 1980: 22)

Bingo (1973) dramatizes the failure of the writer to confront or resist society's iniquities. Subtitled 'scenes of money and death', each scene revolves around questions of money, property and the price they

exact, suffering and death. Set in Stratford-upon-Avon, the home of Bardolatry, the play shows the elderly William Shakespeare sitting in his garden seeking refuge from the realities of life. The local gentry want to enclose their land and evict the tenant farmers, resulting in them losing their homes and the means by which to feed themselves. The play is based on historical sources that show the intention to enclose land from which Shakespeare earned a tithe, but there is no record from the time as to how Shakespeare responded. Bond used this silence to imagine a course of action in which Shakespeare agrees to do nothing, neither opposing nor supporting the attempt, in exchange for a guarantee against loss of earnings. In the end, this inactivity haunts him and he dies asking himself 'was anything done?' Bond's notes record that he was keen not to be seen to criticize Shakespeare too overtly, but the pronounced passivity is a condemnation in itself. The play also challenges the conventional cosy picture of life in early modern England, but is at pains to show its realities: draconian law, hangings, bear-baiting and a mode of Christianity without any mercy or forgiveness. The play was first performed at the Northcott Theatre, Exeter, then at the Royal Court in London a year later where veteran Shakespearean actor Sir John Gielgud took the role of Shakespeare. It was revived by the RSC in 1977 and most recently at the Young Vic, London. *The Fool: Scenes of Bread and Love* (1975) engages with Shakespeare's opposite, the poet John Clare, a writer whose utter refusal to conform leads to misery, madness and death. Like Bond's later work, *Restoration* (1981) looks at complicity of the working classes in their oppression and the impact of the Industrial Revolution on rural life.

Throughout the 1970s and 1980s Bond experimented with theatrical form and worked increasingly with youth groups and teachers to discover new ways of making performance. He became increasingly interested in directing and realizing his own work and was able to develop this interest when he was awarded a Northern Arts Literary Fellowship at the universities of Durham and Newcastle in the UK in 1978. He wrote *The Worlds* (1979) during the fellowship, which was performed first by students from the two universities and subsequently by the Activists (the Royal Court's Youth Theatre). He published his first major collection of theoretical writings, *The Activists Papers*, with the playscript in 1980. From there he went on to write a new play, *Derek*, for the RSC's Youth Festival while working on *The War Plays* (1984–1985), a trilogy exploring nuclear war, which he co-directed. The

breakthrough in working with actors that Bond felt he made during this process led to the breakdown of his long association with the RSC who were unable, or unwilling, to accommodate his new working methods. Having had similar run-ins with the National Theatre and the Royal Court, Bond withdrew from institutional theatres and concentrated increasingly on working abroad, particularly with Théâtre National de la Colline, and with theatre in education (TIE) groups. In 1995 he began writing plays for Big Brum, a TIE company based in Birmingham. His first plays for the company, known as the Big Brum Quartet, are: *The Inland Sea* (1995), *Eleven Vests* (1997), *Have I None* (2000) and *The Balancing Act* (2003). Each of the plays shows a child coming to an understanding of ideology, situations and ethical decisions that must be taken. Bond's belief that drama is the means by which children come to know themselves, and therefore the world, means the plays offer difficult concepts and problems for their audience (children) to debate and understand. Passionate, contradictory, confrontational and compassionate, Bond is one of the only playwrights of the 1960s to sustain a profound engagement with academic criticism of his work and to work with directors and young people in order to advance his and their understanding of it.

<div align="right">Kate Dorney</div>

Note

1 Nicholson, Steve (2012) 'Introduction to Edward Bond', in Steve Nicholson (ed.) *Modern British Playwriting: The 1960s*, London: Methuen, pp.91–97 (quote from p.96).

Key works

Bond, Edward (1965) *Saved*, London: Methuen.
——(1971) *Lear*, London: Methuen.
——(1973) *Bingo: Scenes of Money and Death*, London: Methuen.
——(1978) *The Bundle: New Narrow Road to the Deep North*, London: Methuen.
——(1981) *Restoration*, London: Methuen.
——(1985) *The War Plays: Red Black and Ignorant, The Tin Can People, Great Peace*, London: Methuen.
——(1995) *At the Inland Sea*, London: Methuen.
——(1997) *Plays: 1*, London: Methuen.

Further reading

Bond, Edward (1999) *The Hidden Plot: Notes on Theatre and the State*, London: Methuen.

Coult, Tony (1978) *The Plays of Edward Bond*, London: Methuen.

Davis, David (ed.) (2005) *Edward Bond and the Dramatic Child: Edward Bond's Plays for Young People*, Stoke on Trent: Trentham Books.

Hay, Malcolm and Roberts, Philip (1980) *Bond: A Study of His Plays*, London: Methuen.

Stuart, Ian (ed.) (1994–2013) *Edward Bond Letters*, Vol. 1–5, London: Routledge.

MARINA CARR (1964–)

Born in Dublin and brought up in County Offaly in the rural Irish Midlands, Marina Carr began her playwriting career at the Abbey Theatre, Ireland's national theatre, with a rehearsed reading of her first play *Ullaloo* during the Dublin Theatre Festival in 1988. Her second play *Low in the Dark* was first performed at the Project Arts Centre Dublin in 1989. *Ullaloo,* an old Gaelic word meaning 'funeral lament', was subsequently given a full production at the Abbey Theatre, Peacock stage, in 1991. Other early works are *The Deer's Surrender* (1990) and *This Love Thing* (1991) – an unprecedented cross-border North/South co-production between Tinderbox, Old Museum Arts Centre, Belfast/Pigsback, Project Arts Centre Dublin. Each of these four plays is experimental in style, employing non-realist, absurdist dramatic techniques and surreal situations incorporating slapstick, role-play and gender-bending amid a zany sense of irreverence and cacophonous humour. Carr reserves publication and production rights of her early plays with the exception of *Low in the Dark,* reflecting: 'The first four plays are about stretching my limbs […] There was no focus, no central opinion or background knowledge in them, they were meant to be understandings of living and dying, all the big themes. Something instinctive was calling me along, a love of words and sounds.'[1] Carr's ongoing concern with sexuality, gender, existential questioning and the emotional landscapes of men and women are all explored in these early plays.

With 15 plays produced to date, Carr's work continues to be performed extensively both nationally and internationally in the US, Canada, South America and Europe as well as in Japan, South Korea and China. Carr has been writer-in-residence at the Abbey

Theatre, Dublin City University and Trinity College, Dublin, where she is Honorary Adjunct Professor of Theatre and has won a multitude of awards for her work, including the Susan Smith Blackburn Prize (1997).

Carr's plays can be considered feminist in that they explore female disaffection in terms of motherhood, the family and society at large where the oppressiveness of patriarchy is set against questions of women's agency. A number of her plays are loose reworkings of classical Greek plays and many confront the repressive aspects of recent and current Irish social history. Carr's 1990s 'Midlands Trilogy' comprising *The Mai* (1994), *Portia Coughlan* (1996) and *By the Bog of Cats …* (1998) are lyrical, character-driven dramas that centre upon women's experience in contemporary rural Irish settings. Carr's breakthrough drama *The Mai* was awarded Best New Play at the Dublin Theatre Festival 1994 and transferred to London and Glasgow, garnering a comparison with Eugene O'Neill. In *The Mai* we see four generations of Irish women set against the backdrop of Owl Lake – a site of solace, fulfilment and eventual death, for the Mai. A memory-play, *The Mai* combines poetic monologues incorporating folklore and rich natural imagery with contemporary dialogue and dialect interspersed with humour. The play focuses upon the life of 40-year-old Mai, her failing marriage and her relationship with her extended family. The omnipresent narrator of the play, Mai's daughter Millie, offers a reflective overview of the action and the structure is reminiscent of Brian Friel's 1990 play *Dancing at Lughnasa*. The play received its US premiere at the McCarter Theatre, Princeton, in 1996, directed by Emily Mann.

Portia Coughlan (1996) was directed by Garry Hynes and focuses on the life and death of 30-year-old Portia and her sense of alienation from the socially prescribed roles of wife and mother. Commissioned by Ireland's National Maternity Hospital, the play radically demythologizes the idea of the 'maternal instinct' and vociferously challenges oppressive patriarchy. Each of Carr's plays of the 1990s expresses unresolved female displacement, where the protagonist takes her own life. While some critics have expressed dissatisfaction that there are no positive outcomes for the female protagonists in these plays, the power of Carr's voice lies in her de-idealized acknowledgment that painful narratives must be addressed before transformation can occur. Carr reflects upon writers who display 'the wisdom and the circumspection needed when dealing with the dead or the past, with memory, knowledge. […] I think to

write like that shows incredible bravery on the part of the writer. It's about having the courage to sit down and face the ghosts and have a conversation with them.'[2] In the play Portia expresses resistance to stifling associations of woman with motherhood as inscribed within the 1937 Irish Constitution:

> Don'nen ya understan'! Jaysus! Ya thinche ah don wish ah chould be a natural mother, mindin' me children, playin' wud thim, doin' all tha things a mother is asposed ta do. Whin ah looche at my sons Raphael ah sees knives an' accidents an' terrible muhilations. Their toys is weapons for me ta hurt thim wud, givin' thim a bath is a lace where ah chould drown thim.[3]

Carr's next play, *By the Bog of Cats* ... (1998), perhaps her best-known and most widely produced, is a loose reworking of Euripides' *Medea* set in contemporary rural Ireland with Hester Swane, a traveller, as protagonist, and is an observation of female exile and alienation. In 2001, *By the Bog of Cats* ... was produced by San Jose Repertory Theatre, directed by Timothy Near, with Holly Hunter as Hester. The role was reprised by Hunter at Wyndham's Theatre, London's West End, in 2004 where it was nominated for an Olivier Award for Best New Play and has received a number of major international productions. Carr's next play, *On Raftery's Hill*, also directed by Garry Hynes in a co-production with Druid Theatre Company and the Gate Theatre Dublin, was produced in 2000 and also toured the US in the same year. Considered to be Carr's most controversial work, this play, set in the kitchen of a rural Irish home in the present day, opens up the brutal realities of incest and sexual abuse in the Irish family. Carr's next plays are *Ariel*, a version of Aeschylus' *Oresteia* (2002), *Woman and Scarecrow* (2006), *Marble* (2009), *The Cordelia Dream* (2009) and *The Giant Blue Hand* (2009). The latter three plays observe an interweaving of the dream-world with the everyday, where the unconscious life powerfully determines the action. In *16 Possible Glimpses* (2011), Carr explores her major themes through imagined 'glimpses' into the life of Anton Chekhov, while *Phaedra Backwards* (2011) is a return to the Greek world in a non-geographically specific reimagining of the Phaedra/ Hippolytus myth, which offers a powerful feminist renegotiation of the Aristotelian form and content of classical tragedy.

Carr's emergence as a playwright in the late 1980s coincided with increasing visibility for women in Irish culture, politics and theatre.

Up until that time it was widely regarded that women did not write or direct for the stage in Ireland, North and South. Carr is the first woman to have a sustained presence on the main-stages since Lady Augusta Gregory, co-founder of the Abbey Theatre, at the beginning of the twentieth century. The late 1980s saw the dawning of a more liberal and secular social agenda in Irish society. In 1991 the first female president of the Irish Republic, Mary Robinson, was inaugurated, signalling a new energy and (symbolic rather than executive) presence for '*mna na hEireann*' (women of Ireland). Newly elected President Robinson made a speech at the premiere of *This Love Thing* (1991) in Dublin and it was noted in the press that this was an exceptional moment for women in Ireland. The late 1980s was a period of transformation leading out of recession to legislative reform in the early to mid-1990s. Increased availability of contraception (to non-married people in 1985), the decriminalization of homosexuality (1993) and the right to divorce (1995) heralded a new era as did the onset of the 'Celtic Tiger' in the mid- to late 1990s, when Ireland became the fastest growing economy in the world. However, a conservative ethos was still prevalent; divorce was passed by a less than 1 per cent majority and abortion remains an illegal act. The 1990s saw the beginning of the decline of the monotheistic authority of the Catholic Church, which was offset against revelations of the horrendous sexual abuse of children by the Irish clergy resulting in a Redress Board being set up in 1999. Other 'hidden histories' of Ireland's recent past in terms of collusive Church and state abuse emerged in social discourse regarding the Church- and state-run 'Magdalene Laundries' – institutions that forcefully incarcerated unmarried pregnant women as unpaid laundry workers, often resulting in the illegal sale of their babies to families in the United States. The acknowledgment of such atrocities against citizens, and women and children in particular, are a part of Ireland's current negotiation with a darkly repressive and abusive past. The social changes that occurred in the early 1990s began a marked awareness of women's experience and contribution to society and are the backdrop against which Carr's challenging voice emerged in 1994.

Characteristic of Carr's dramaturgy is an easy congruence of multiple worlds – of the mutually informing realms of imaginative 'otherness' and the 'everyday', enabling a holistic sense of the familiar and the unquantifiable. In Carr's plays form and content are reflective, where memory and temporality are conceived as nonlinear, necessitating a poetic resistance to closure. Many of Carr's plays

contain ghosts or strange beings who embody a sense of 'intrinsic otherness' be it mythic, fantastic, grotesque or fairy-like, which, like her landscapes, are never fully real and never purely fully fictional. Landscape, nature and sites of water offer further realms of ontological resonance, particularly for the central female characters.

Carr's poetic language and engagement with realms of death, dreams, memory, the soul and the transformative power of storytelling, express alternative modes of processing experience. Such imaginative engagements with non-realism operate with visceral expressions of explicit social commentary in recognizably Irish contexts to contest conservative values and aesthetics.

One of the major dramaturgical through-lines of Carr's work is a critique of the tragedy of the unlived life where in her plays circularity and repetition reflect upon ideas of arrested development and lack of transformation. Following from Chekhov and Beckett, we see in Carr's theatre an exploration of the dehumanization of lack of fulfilment and senseless, meaningless repetition. In Carr, there is a plea to strive always for one's potential; to refuse the deathly waste of hollow existence. The theme of the 'living death' runs throughout her body of work, expressing the painful annihilation of self that occurs from dull apathy.

Melissa Sihra

Notes

1 Kurdi, Maria (2003) '"I Was Tired of the Sentimental Portrayal of Mothers": A Talk with Irish Playwright Marina Carr', *Modern Filologiai Kozlemenyek*, 5(2): 95.
2 Carr, Marina (1998) 'Dealing with the Dead', *Irish University Review*, Spring/Summer, p. 91.
3 Carr, Marina (1996) *Portia Coughlan*, London: Faber and Faber, p. 42.

Key works

Marina Carr (1999) *Plays: 1*, London: Faber and Faber.
——(2009) *Plays: 2*, London: Faber and Faber.

Further reading

McMullan, Anna and Leeney, Cathy (eds.) (2003) *The Theatre of Marina Carr: ' ... Before Rules Was Made'*, Dublin: Carysfort Press.

Sihra, Melissa (ed.) (2007) *Women in Irish Drama: A Century of Authorship and Representation (with a Foreword by Marina Carr)*, Basingstoke: Palgrave Macmillan.

Trench, Rhona (2010) *Bloody Living: The Loss of Selfhood in the Plays of Marina Carr*, Bern: Peter Lang.

JIM CARTWRIGHT (1958–)

Called 'British theatre's equivalent of a punk rocker' because of the way he challenges the rules of British playwriting, Jim Cartwright is difficult to pin down as a writer (Isaac 1995). His oeuvre includes examples of absurd drama, expressionistic writing, melodrama, social realism and magic realism, and he has written for the stage, film, radio and television as well as a novel. Coming from a working-class background in Lancashire that – unusually for playwrights of his period – did not involve going to private school or university, it is ironic that his plays continue to feature on school and university curricula in the UK. Seven of his stage plays are constantly in print and three – *Road* (1986), *Two* (1989) and *The Rise and Fall of Little Voice* (1992) – are regularly produced. Although best known for his playwriting, Cartwright began his career as an actor. After undertaking formal actor training in the 1980s, Cartwright became a founder member of a 'take-away style' theatre company that offered home performances of plays to order. Later, he took the main role in the premiere of his own play, *Prize Night* (1999). He has also directed work for stage and screen, including productions of his own plays such as the premiere of *I Licked a Slag's Deodrant* (1996) at the Royal Court.

Cartwright's work is celebrated for its vivid portrayals of northern social landscapes negatively impacted by the industrial decline, poverty and unemployment that followed the neo-liberal turn in economic policy in the UK in the 1980s. His playwriting exhibits a unique dramatic language that combines visceral poetry with moments of audience participation, bringing spectators into direct, affective encounters with life, struggling with and against suffocating circumstances. Cartwright's plays have been seen as uncompromising depictions of the 'grim north' of England but his work also celebrates the theatrical, exuberant and extraordinary experience that are folded inside bleak environments. Auditoriums become northern roads, clubs and pubs, and dramatic momentum is maintained by an episodic series of monologues and dialogues that support shared, intimate and often raucous encounters between performers and audiences. This is a quality deliberately sought by Cartwright, as illustrated by a comment

early in his career: 'Plays today are literary rather than theatre. They're rational. Arguing about things. Sorting things out. But in Ancient Greece you'd find 100 faces chanting at you. You couldn't ignore that could you? You'd be hit, stroked, lifted instead of wrangling around in your brain box.'[1]

Cartwright remains best known for his critically acclaimed, award-winning first play, *Road* (produced at the Royal Court in 1986), which depicts poverty and unemployment in a northern town. Staged as a promenade piece (with the stage and auditorium becoming the road and theatre bar transformed into a northern pub), the audience is led by maverick tour guide, Scullery, on a journey through one night on the road. Scullery greets the audience with a cry of 'Hold tight! Here we go! Come on! Watch the kerb missus! Road's coming around us!' (Cartwright 1996a: 9), introducing the immersive experience of the play repeatedly noted in the critical reception of the original production: 'you don't watch *Road* ... you live in it';[2] 'we stand in the middle, the play passes through us';[3] the audience is 'jostled by characters who leave us nervously craving a bath'.[4] An aspect of Cartwright's work that has received criticism, implied by some of the sentiment expressed here, is that it offers middle-class audiences (who dominate theatre audiences in the UK) voyeuristic glimpses of poverty and affirms negative stereotypes of the working class. In *Road*, the audience certainly do witness a series of lives worn down by relentless poverty: Clare and Joey, for example, go to bed and refuse food, dying in a joint suicide pact at the end of Act I – 'Every day's like swimming in ache'; 'England's forcing the brain out of me head ... The world really is a bucket of devil sick ... I bring up small white birds covered in bile and fat blood, they was my hopes' (Cartwright 1996a: 42–43). However, voyeurism is also parodied in the play: in her analysis, Una Chaudhuri notes that Scullery's opening invitation to observe life on the road, for example, is infused with irony, framing the spectator as a voyeur at the same time as hinting at the impossibility of remaining a detached observer by indicating the 'grotesque fun-fair ride' to come (Chaudhuri 1995: 47).

The character of the professor also gives the playwright an opportunity to juxtapose harrowing representations of poverty and unemployment with a celebration of the resilience of life on the road. After losing his job at the university, the professor came to the road to carry out an anthropological study some years ago, and now survives by buying and selling snippets of testimony. During Act I, the professor reads a testimonial on unemployment – 'It's like black water droppin'. You feel it in the chest' – and this is immediately

followed by a response from a character on the road that under-
mines any possible objectification (including pity) that might be
evoked here – 'You morbid bastard. Life's a spree, Prof. Me and
Dor we get our mouth round life and have a chew' (Cartwright
1996a: 24). The mode of spectatorship privileged by the play is
appreciation of and immersion in the raw, carnivalesque theatri-
cality that endures despite (and perhaps because of) circumstances.
The extraordinary ritual in the final scene provides the most
powerful example: here, four characters, Brink, Eddie, Carol and
Louise, come together at the end of the night. Brink invites the
audience to sit and explains 'We have a something that we always
do when outside gets to you' – 'You drink, you listen to Otis, you
get to the bottom of things and let rip.' The characters listen to
Otis Redding's Depression-era ballad 'Try a Little Tenderness'
while drinking quantities of wine (Cartwright 1996a: 78). Follow-
ing this each gives a speech saturated with rage, bitterness and loss,
and punctuated with unforgettable lines: 'England's in pieces.
England's an old twat in the sea. England's cruel. My town's scuffed
out'; 'POVERTY. Poverty wants me. He's in my hair and clothes.
He comes dust on me knickers. I can't scrape him off'; 'Why's the
world so tough? It's like walking through meat in high heels'
(Cartwright 1996a: 81–82).

Cartwright's interest in expressive theatricality as a mode of
endurance in a difficult world is sustained in his most commercially
successful play, *The Rise and Fall of Little Voice* (1992), originally
produced by the National Theatre and later adapted into a film. The
play was written for Jane Horrocks, whose skills in mimicry Cartwright
discovered when she appeared in stage and screen versions of *Road*.
The play takes place in the small terraced house of Mari and her
daughter, Little Voice (LV) – with the faulty electrics of the house
(sparks fly off plugs and there are frequent power cuts) symptomatic of
the conflict between mother and daughter. Mari is a larger-than-life
character with a propensity for drinking too much alcohol and coarse
language, trying to secure the affections of Ray Say, a failing theatrical
agent. LV is a withdrawn character who manages her mother's neglect
by retreating to her room to play her deceased father's record
collection. The audience witness Mari's encounters with Ray Say
alongside a tentative romance between LV and Billy, who has a passion
for creating light shows. When Ray Say hears LV's extraordinary
mimicry of the records, he manipulates her into performing at a local
club against her wishes. Following her rescue from the house (set on fire
by Mari while drunk in charge of an iron), LV confronts her mother and

the play ends with Billy creating a spectacular light show to accompany LV's final performance in the club after hours – this time sung in her own voice. The claustrophobic mother–daughter relationship is the centre of the drama, and sees both characters struggling to manage their expressive potential in a world that does not pay attention. This is played out against an oceanic emotional landscape provided by the legendary female singers of the record collection (Billie Holiday, Judy Garland, Marilyn Monroe, Shirley Bassey), who give full voice to their loss, rage, passion, desire, defiance and sorrow. LV's mimicry of the voices is an expressive outlet and also a form of self-protection; she says to Billy – 'you have lights. I have voices ... I sing in these voices. I ... I hardly know I do it. It's just for me. Comfort' (Cartwright 1996a: 225). Mari, in contrast, has an expressivity that has always been in excess of her circumstances – 'I was more than this dump I had to live in. In fact, my energy itself could have burnt this place down years ago' (Cartwright 1996a: 257). Mari's final, pathos-saturated lines, following her falling on LV's smashed records outside her burnt-out home, are quintessential Cartwright:

> Slithered at last into the dirt gut of the twat of life, upended in an alley. I knew in my true heart there was nothing else for it, no matter how hard I tried I could not avoid what fate had reserved for me all along, the famous 'Tart's end', an old girl left dirty on her belly in an alley, homeless and juiceless and toothless and solid stone cold alone.
>
> <div align="right">(Cartwright 1996a: 260)</div>

Alongside *Road* and *The Rise and Fall of Little Voice*, Cartwright has written numerous critically acclaimed plays for stage and screen, including *Two* (1989), a two-hander in which the actors take on a multitude of characters passing through a northern pub, and *I Licked a Slag's Deodrant* (1996), a lyrical dramatization of the isolation of a single man and prostitute. However, *Hard Fruit* (2000), a play about repressed sexuality, was not well received and perhaps accounts for Cartwright's long absence from writing for the stage in the following decade. He returned in 2012, writing two plays in quick succession, both as part of initiatives that extend an opportunity to participate in theatre to new audiences. *A Christmas Fair* (2012), inspired by the theatre space in a new cultural venue in Malton (North Yorkshire), features the audience sitting onstage watching the actors play villagers in the auditorium preparing for a Christmas fair (in the interval the audience participate in the fair). *Mobile*

Phone Show (2013), written for National Theatre Connections (which sees the National Theatre commission plays for young people from professional playwrights), shows Cartwright testing out his visceral stage language inside new modes of communication offered by the mobile phone, and also features a characteristic moment of audience participation.

Cartwright's influence can be seen on theatre-makers that immediately followed him, with *Road* credited as one of the forerunners of British playwriting in the 1990s (Sierz 2000: 29), and the experience of witnessing the original production of *Road* identified by two celebrated theatre-makers – Emma Rice, artistic director of Kneehigh Theatre, and British playwright Mark Ravenhill – as key to their respective decisions to work in the theatre (Rice 2010; Ravenhill in Little and McLaughlin 2007: 249). It is also possible to see Cartwright's portrayal of ordinary people with compassion, wit and emotion, and his representations of poverty and unemployment in ways that are ironic, poetic, celebratory and defiant – as a key influence on British television dramas such as *The Royle Family*, *Shameless* and *Phoenix Nights*.

Jenny Hughes

Notes

1 Francesca Turner, 'Sounds of the voices', *The Guardian*, 21 February 1989.
2 David Nathan, 'A road worth travelling', *Daily Mirror*, 20 June 1986.
3 Michael Ratcliffe, Review of *Road*, *The Observer*, 6 April 1986.
4 Martin Hoyle, Review of *Road*, *Financial Times*, 23 March 1986.

Key works

Cartwright, Jim (1996a) *Plays: 1*, London: Methuen.
——(1996b) *I Licked a Slag's Deodrant*, London: Methuen.
——(2000) *Hard Fruit*, London: Methuen.

Further reading

Chaudhuri, Una (1995) *Staging Place: The Geography of Modern Drama*, Ann Arbor: University of Michigan Press.
Isaac, Stephen (1995) 'A Director's *Road*', *Plays International*, April.
Little, Ruth and McLaughlin, Emily (2007) *The Royal Court: Inside Out*, London: Oberon.

Milling, Jane (2012) *Modern British Playwriting of the 1980s*, London: Methuen.

Rice, Emma (2010) 'The Best Performance I've Ever Seen', *The Observer*, 20 June.

Sierz, Aleks (2000) *In-Yer-Face Theatre: British Drama Today*, London: Faber and Faber.

CARYL CHURCHILL (1938–)

Caryl Churchill's first plays were written and staged while she was a student in the late 1950s. Since then, she has produced a body of work that – with its quality and variety – has established her as one of the major theatrical innovators of the era. During the 1960s, she mostly wrote for radio. In 1972, *Owners* opened at the Royal Court Theatre in London; since then she has written almost exclusively for theatre. After *Objections to Sex and Violence* (1975), Churchill began collaborations with several key theatre companies. With Joint Stock, she wrote *Light Shining in Buckinghamshire* (1976), *Cloud Nine* (1979), *Fen* (1983) and *A Mouthful of Birds* (1986); with the feminist collective Monstrous Regiment, *Vinegar Tom* (1976). Her experiences of the workshopping and collaborative research processes of both companies were formative, feeding much of Churchill's later work. These plays, as well as others from the 1970s and 1980s, such as *Traps* (1977), *Top Girls* (1982), *Softcops* (1984) and *Serious Money* (1987), are underpinned by a perspective that is explicitly socialist and feminist. They attest to Churchill's wide-ranging reading and critical thinking: they are influenced by her rigorous engagement with history, her sustained investigation of sexual politics, and the works of theorists such as Michel Foucault. Churchill's skills as a theatrical innovator are also much in evidence in this period. Her dramaturgies are complex, and often described as Brechtian; her work is emphatically and diversely non-naturalistic. Thus in the short play *Three More Sleepless Nights* (1980) she marked overlapping dialogue typographically, with a '/', a device that is now used as standard by many playwrights.

The early 1990s marked a shift in direction. Churchill began writing with a broader range of collaborators – dancers, opera-makers, students: *Icecream* (1989), *Mad Forest* (1990), *Lives of the Great Poisoners* (1991) and *The Skriker* (1994) are all shaped by these collaborations. Although Churchill did not turn her back on the socialist feminism of her earlier works, this period is marked by more stylistic experimentation. In 1997, the year of New Labour's landslide election victory, as well as *Hotel* (a collaboration with the performance company

Second Stride), *This is a Chair* and *Blue Heart* also received their first productions. The underlying concern of these pieces is an extended, at times destructive, experiment with form and language. The turn of the millennium also saw a turn in Churchill's work, with the extraordinary *Far Away* (2000) and *A Number* (2002) both creating sparse but evocative stage worlds. From the mid-1990s, Churchill's work has staged an urgent set of questions about the disaggregation of politics from everyday life, and this was most startlingly explored in her 2006 two-hander *Drunk Enough To Say I Love You?*, in which American foreign policy is mapped onto the syntax of a personal relationship. In 2009, Churchill's rapid response to an Israeli bombardment of Palestine, *Seven Jewish Children: A Play for Gaza*, became one of her most controversial works. In 2012, *Love and Information*, again staged – as the majority of her plays have been – at the Royal Court, demonstrated that Churchill is still challenging with both content and form: here, the company create more than 100 characters in snapshot scenes that build up a composite picture of contemporary life and its anxieties.

All Churchill's plays repay sustained and detailed analysis, although some offer particular insights into her interests and her impact. *Light Shining in Buckinghamshire* (1976) explores the Middle Ages and the revolutionary belief in the millennium that, according to Churchill's introduction, has been written out of history by a focus on the Roundheads and Cavaliers (Churchill 1985: 183). Churchill's interest in the complex history of the left, and the ways in which the privatization of the commons contributed to today's status quo, shape the play. It is a history play that emphatically speaks to the late twentieth century, but it is much more complex than that. 'The characters,' a note on the production tells us, 'are not played by the same actors each time they appear' (Churchill 1985: 184). Churchill's emphasis here is less on following a coherent story, than on reflecting 'the reality of larger events like war and revolution where many people share the same experience' (Churchill 1985: 184). In many other plays – *Cloud Nine*, *Top Girls* and *A Number* – she also explores the relationship between actor and character, in these cases by writing plays that involve actors playing multiple roles. While doubling enables a small cast to play a large number of characters, the ways in which it generates resonances, parallels and discrepancies are more significant than its pragmatic conveniences. Churchill is highly attuned to the ways in which theatre's complex meaning-making processes work; in *Light Shining in Buckinghamshire*, the emphasis on notions of collective experience map onto the play's

interest in a revolutionary moment when, although the power of private property and land ownership won in the end, serious alternative arguments were in the air. Like much of her work from this period, the play is interested in recovering voices that have been neglected or oppressed, and Churchill pays particular attention to the doubled oppression of poor women.

Top Girls (1982) and *Serious Money* (1987) launched scathing attacks on the Thatcherite ideals of the individual and the free market. *Top Girls'* critique of bourgeois feminism and exploration of the ways in which success for some comes at a cost to others is one of the most effective stagings of an intellectual argument through dramatic and theatrical form. *Serious Money* is slightly more complex. Written at a point when the financial sector was becoming increasingly, and problematically, dominant, Churchill wrote the play in verse, using free metre and rhyme as a way of capturing the pace, drive and the demented energy and logic of modern finance capital. Nevertheless, questions were asked about whether Churchill's satire was, in effect, sucked into the world it sought to critique – particularly as the Royal Court was (perhaps uniquely in its history) frequently full of stock traders and city business types during the production run, apparently enjoying watching themselves on stage.

Churchill's radical undoing of language is most extraordinary in *The Skriker*. A long opening monologue from the Skriker, *'a shapeshifter and death portent, ancient and damaged'* (Churchill 1998: 243), establishes her complex, idiosyncratic speech patterns, fairy-tale connections, and skittering associations and puns: 'Better forget them, not always be talking stalking walking working them over and understand still. Yes better forgotten rotten leave them alone. We don't need the knock kneed knead the dough re mi far away so there la di da' (Churchill 1998: 246). The play takes place in an already permanently ruptured world and it is its language, which free-associates itself almost out of control, that achieves this. The play explores damage: ecological, ideological and social. The Skriker is injured, hurt by the modern world. 'You people,' she says, 'are killing me' (Churchill 1998: 256); the ancient spirit rails vengefully against her world's destruction. Unsurprisingly, it is the play's young women who are caught in the fall-out.

Far Away (2000), a dystopian vision in which acts of violence become increasingly more acceptable, is consistently haunted by atrocity. From the masterful tension of the first Act, as Joan's questions gradually elicit information about the screaming people she has seen in her uncle's barn, to the chilling *'procession of ragged, beaten,*

chained prisoners, each wearing a hat, on their way to execution' towards the end of the second Act (Churchill 2008: 149), it moves to the final apocalyptic monologue with Joan's description of 'piles of bodies and if you stopped to find out there was one killed by coffee or one killed by pins, they were killed by heroin, petrol, chainsaws, hairspray, bleach, foxgloves' (Churchill 2008: 159). *Far Away* has some structural similarities to Sarah Kane's earlier *Blasted* (1995): both start from a seemingly naturalistic scene and trace a pattern of escalating destruction and horror that affects the very fabric of the text, although the end result is two very different pieces of theatre.

The assimilation of violence is made even more challenging in *Drunk Enough To Say I Love You?* (2006), a play which is both a damning critique of post-war American foreign policy and a formal experiment with how little is needed in order to understand a scene. The dialogue is elliptical, dipping in and out of a conversation, enacting an extreme compression of time. This creates technical challenges for the performers, and cognitive ones for the audience, as they follow the gist in terms of meaning, not the full development. But Churchill adds another layer of complexity. She crafts a linear emotional journey between two characters, but the content is an inventory of recent history and American foreign policy:

SAM: so now we need to prevent some elections
GUY: saves having to overthrow
SAM: South Korea, Guatemala, Brazil, Congo, Indonesia,
 Greece
GUY: I'm on it
SAM: overthrow only as last resort when things don't
GUY: ok
SAM: Iran Guatemala Iraq Congo
GUY: troops

 (Churchill 2008: 275–276)

This content is thematic, not chronological. History, like the dialogue, is compressed; the play's present tense is an amalgam of past moments. The proliferating historical information, out of context, and talked about as though it is part of a couple's love affair, is unsettling. At the same time, the use of historical moments within the continuous present tense of the piece aims to stage the argument that America's foreign policy, and the rest of the world's relationship to it, follows a pattern of strategy and behaviours that are not new, but go back to the end of the Second World War (1939–1945). It places

recent events, such as the war in Iraq, within this broader historical framework, embedding such events within the wider context by refusing chronology. This shuns any teleological inevitability, avoiding historical narrative. Instead, parts of the past coexist in the play's present, suggesting that these events are connected, and simultaneously implying that they are not past. In *Far Away*, the characters complicitly accept the violence of events that are not entirely in their control; in *Drunk Enough to Say I Love You?*, the isolated direction of atrocity suggests a disconnection between cause and effect at the highest level. It suggests that politics has become dangerously detached from its impact.

Churchill has remained committed to asking questions about power, visibility, and the voices that have been written out of history. In 2008, to mark her 70th birthday, the Royal Court put on staged readings of ten Churchill plays, directed by playwrights who she has influenced. These included Martin Crimp, debbie tucker green, Marius von Mayenburg, Joe Penhall, Mark Ravenhill and Winsome Pinnock. Her influence is vast, and she is a towering figure of post-war British theatre. And she continues to both push and pay her talent and her experience forward. For Vicky Featherstone's first season as artistic director of the Royal Court Theatre in summer 2013, Churchill provided the impetus and rationale, although not the writing, for 'Weekly Rep': six new plays produced over six weeks, with an ensemble of actors. Its conception highlights Churchill's attitude to both playwriting and to acting. She emphasized its value for the craft of the actors, working fast in a secure ensemble. Most significantly, positioning 'Weekly Rep' against an increase in development, readings, and redraftings in the wider British theatre culture, she stated that 'a play doesn't really exist till it's happened on a stage, and a writer learns more from that than from anything'.[1]

Rachel Clements

Note

1 www.royalcourttheatre.com/season/weekly-rep-open-court [accessed 10 June 2013].

Key works

Churchill, Caryl (1985) *Plays: One*, London: Methuen.
——(1990a) *Plays: Two*, London: Methuen.

——(1990b) *Churchill: Shorts*, London: Nick Hern Books.
——(1998) *Plays: Three*, London: Nick Hern Books.
——(2008) *Plays: Four*, London: Nick Hern Books.
——(2009) *Seven Jewish Children: A Play for Gaza*, London: Nick Hern Books.
——(2012) *Love and Information*, London: Nick Hern Books.

Further reading

Aston, Elaine and Diamond, Elin (eds.) (2009) *The Cambridge Companion to Caryl Churchill*, Cambridge: Cambridge University Press.
Churchill, Caryl (1988) 'The Common Imagination and the Individual Voice', *New Theatre Quarterly*, 4(13): 3–16.
Rabillard, Sheila Mary (ed.) (1998) *Essays on Caryl Churchill: Contemporary Representations*, Buffalo: Blizzard.
Roberts, Philip (2008) *About Churchill: The Playwright & the Work*, London: Faber and Faber.

HÉLÈNE CIXOUS (1937–)

Hélène Cixous was born in Oran, Algeria, with Jewish heritage and a multilingual family. A crucial figure in post-1968 philosophy, gender studies and cultural theory, the radical poetic practice evident in Cixous' 'fictions' – a deliberate blurring of boundaries between academic, theoretical and poetic writing – is matched by her engagement with educational structures. Professor of English, she was a founding member of the University of Paris VIII, established in response to post-1968 demands for change in higher education and in which she taught alongside Michel Foucault and Gilles Deleuze. Her poetic and political challenges to dominant constructions of gender, particularly those perpetuated in psychoanalytic discourse, informed her founding of the first centre for women's and gender studies (Centre d'études féminines) in Europe at the same institution in 1974. While Cixous' extensive international profile and interdisciplinary impact has been dominated by the reception of 'French feminism' and 'writing the body' (*écriture féminine*), increased translation of her prolific post-1980 output and of her theatre has expanded wider understanding of and access to her work. Her engagement with theatre began through a rejection of the dominant modes of representation of women on stage – a rejection dramatically reversed by her desire to engage with representations of history and through her encounters with the work of Ariane Mnouchkine and the Théâtre du Soleil. This continuing

collaborative practice remains among the most significant in contemporary European theatre.

The impact of Cixous' non-dramatic writing on Anglophone remappings of feminism and theatre has been extensive (see Harris 2011), yet her early plays remain rarely performed. These plays should be considered in the context of her wider politico-poetic project that challenges the metanarratives of patriarchal discourse, employing dense intertextual deconstructions of classical myth, the realist canon and psychoanalytical theory to construct subversive voices and figures of gendered resistance. Indeed her first public engagement with theatre was defiant. In her essay 'Going to the Sea (Mother)' ('Aller à la mer') published in *Le Monde* in 1977, Cixous attacks traditional theatrical representation as inherently patriarchal in its simultaneous suppression of women's voices and positing of woman as hypervisible victim and other. Cixous' combative response to such systems is reflected in the formal radicality of her early plays *Portrait of Dora* (*Portrait de Dora*, 1976, translated in 1979) and *The Name of Oedipus* (*Le Nom d'Oedipe*, 1978) that, in addition to their powerful retelling of such central myths of the feminine as that of Freud's case study of Dora and Oedipus' mother Jocasta, disrupt representations of fixed and unified subjectivities through the provision of multiple voices and character doublings. Cixous' Dora rejects Freud's (over)determination of her sexuality in an explicit de-theatricalization of his (primal) scenes and is conveyed through her explicit performance of a set of divergent voices that disrupt the dominance of the visual. Simone Benmussa's production of *Portrait of Dora* articulated the fragmented and performative identities of the text through a parallel 'dream work', dividing the stage into distinct temporal zones and employing dance and film sequences, directed by Marguerite Duras, to further disrupt both audience identification and linear narrative. This play and *The Name of Oedipus* met with positive critical reception that widely identified them as examples of new modes of feminist theatre.

In the early 1980s, following a pivotal encounter with Ariane Mnouchkine, Cixous' engagement with theatre went through a startling shift. Inspired by the experience of watching actors rehearse at the Théâtre du Soleil, the writing, practice and reception of theatre became utopian sites in Cixous' quest for forms of representation capable of thinking and representing difference outside of binary and hierarchical structures. Cixous' plays written since 1982 are dense, multilayered texts that combine new mappings of the dynamics of self/other relationships with an engagement with wider histories of

exile and persecution. These plays remain inseparable from the specific working practices of the Théâtre du Soleil and indeed have been rarely performed beyond this partnership. Cixous' interest in non-realist representations of history and the role of the theatre in fostering an active spectatorship form a remarkably coherent fit with the central aims and practices of this company, notably their investment in intercultural performance, opposition to naturalism and striking combination of the political aims of Brechtian theatre with an overwhelming sensual dramaturgy and performance. Cixous became a commissioned author for the company and, as such, a participant in their established practice of 'collaborative creation' in which their plays evolve over long rehearsal periods, a final text only emerging as the production opens.

Within this context, Cixous' theatre turns to address recent historical events – genocide and regime change in *The Terrible but Unfinished Story of Norodom Sihanouk, King of Cambodia* (*L'Histoire terrible mais inachevé de Norodom Sihanouk, roi du Cambodge*, 1985), the partition of India in *Indiad* (*L'Indiade ou L'Inde de leurs rêves*, 1987), and the corruption of corporate agencies in *The Perjured City or the Awakening of the Furies* (*La Ville parjure ou le reveil des Erinyes*, 1994). The plays on Cambodia and India create marked tensions between the representation of specific historical events, clear suggested analogies – India and the contemporary Kosovo conflict – and the metaphor-driven model of the Shakespearean history play to suggest a problematic historical sublime. The inclusion of mythical elements, intended to counter mass-media coverage and assert the monstrosity and tragic scale of contemporary events, is at its most powerful in *The Perjured City*. This play transposes the 1990s scandal of the knowing supply of HIV-infected blood to haemophiliacs in France to an unspecified ancient realm and centres on a mother whose two sons have died after infection. The struggle between the pernicious discourses of the legal, medical and political establishments and the mother's grief dominates the text, triggering strikingly contemporary concerns on choices between violent retribution – the vengeful rage of the Furies roused by the scale of injustice – and faith in democratic justice. The recurring metaphors of blood and contamination encourage reflection on constructions of national identity and the rise of right-wing groups in contemporary France.

The Perjured City's inclusion of the poet Aeschylus as protector of both the memory of the persecuted dead and the marginalized living provides an example of the increasing presence of writer-figures in Cixous' theatre. These characters provide a reflexive articulation of

Cixous' investment in what she values as theatre's negotiation between the past inscription of a narrative and the present moment of performance and catharsis. The struggle against Stalin's censorship and cultural oblivion of Anna Akhmatova and Nadezhda Mandelshtam in *Black Sail/White Sail* (*Voile noire, voile blanche*, 1994) and Snorri Sturlusson's attempts to rewrite the murderous events of the *Neibelungenlied* in *The Story That We Will Never Know* (*L'Histoire qu'on ne connaîtra jamais*,1994) assert the power of both writing and theatre to combat forgetting and provoke change. Both of these plays end with strikingly direct appeals to the audience to resist forgetting – to take up the challenge of being both observer of history and participant in an ongoing narrative.

All of the plays discussed thus far met with positive critical reception yet *Drums on the Dam* (*Tambours sur la digue*, 1999) received huge critical and public acclaim, winning three Molière awards and numerous international prizes. As with the majority of Cixous' theatre written for the Théâtre du Soleil it is very difficult to discuss the text in isolation from the company's defining production of it. The marionette has been present in Cixous' work since her study of Kleist, in which she identifies the marionette as a marker of the struggle between human agency and external forces that, she argues, informs all art. Her ontological investment in the figure of the puppet was matched by the Théâtre du Soleil's longstanding engagement with intercultural performance and culminated in the astounding creation of the puppet-actors of *Drums on the Dam*. Inspired by news coverage of floods in China, the play transports us to an unnamed land whose rulers, faced with the imminent collapse of a defective dam, decide to let the rural population drown and thus protect the urban elite. The play's densely populated plot presents an episodic accumulation of corruption, betrayals and revenge, resulting in the violent deaths of most of the central characters. However, the proliferation of murderous scenes owes much of its force not to the text but rather to the performative mode in which the actors are disguised, through costume and stylized movement as Bunraku puppets, controlled by veiled '*manipulateurs*' or koken. This production presents an excellent example of the complex interaction of theme and form in the work of Cixous with the Théâtre du Soleil. The concerns of the text with the erasure of human agency, the fragility of democracy and the potential of the artist to salvage something from catastrophe are embedded in the performance as the puppet-actors have no independent movement and restricted voices. The text was cut extensively to better represent the voice of puppets and the actor's

miniature replacements are finally picked from the flood waters by the puppeteer Bai-Ju. The fascinating tension between puppet-actor and manipulator presents at once a renewed vision of the multiple selves present in Cixous' first plays and a visceral embodiment of metaphors of agency and dependence.

Many of Cixous' plays are thus difficult to consider in isolation from the overwhelming impact of their productions with the Théâtre du Soleil and from the context of her wider writing projects. The central drive at the heart of Cixous' wider writing project is thus a rethinking of the relationship between self and other, and it is in her theatre that she has engaged most emphatically in recastings of personal, national and historical discourses of identity. In her quest to subvert dominant constructions of alterity and to build more positive representations of difference itself, Cixous has identified the sites of theatre as the most productive arena in which new intersubjective structures can be imagined and realized.

<div align="right">Julia Dobson</div>

Key works

Cixous, Hélène (1991) 'The Name of Oedipus', in Christina Makward and Judith G. Miller (eds. and trans.) *Plays by French and Francophone Women: A Critical Analogy*, Ann Arbor: University of Michigan Press.

——(1994) *The Terrible but Unfinished Story of Norodom Sihanouk, King of Cambodia*, trans. Juliet Flower MacCannell, Lincoln: University of Nebraska Press.

——(2003) 'Portrait of Dora' (trans. Ann Liddle), 'Black Sail White Sail' (trans. Donald Watson), 'The Perjured City' (trans. Bernadette Fort), 'Drums on the Dam' (trans. Judith G. Miller and Brian J. Mallett), in Eric Prenowitz (ed.) *The Selected Plays of Hélène Cixous*, London and New York: Routledge.

Cixous, Hélène and Clément, Catherine (1986) *The Newly Born Woman*, trans. Betsy Wing, Minneapolis: University of Minnesota Press.

Further reading

Cixous, Hélène and Fort, Bernadette (1997) 'Theatre, History, Ethics: An Interview with Hélène Cixous on *The Perjured City*', *New Literary History* 28(3): 425–456.

Cixous, Hélène and Jeanneret, Frédéric-Yves (2012) *Encounters: Conversations on Life and Writing*, London: Polity Press.

Dobson, Julia (2002) *Hélène Cixous and the Theatre: The Scene of Writing*, Oxford: Peter Lang.

Harris, Geraldine (2011) 'Après toutes ces elles/After All the Else: "New" French Feminisms Translated to the British Scene', in Clare Finburgh and Carl Lavery (eds.) *Contemporary French Theatre and Performance*, Basingstoke: Palgrave Macmillan, pp. 224–235.

MARTIN CRIMP (1956–)

A family sit around a dining table, bickering and finishing their Christmas dinner. With no warning, another character arrives; the tension increases. 'What are you doing here, Uncle Bob?' the mother asks. 'Well to be frank with you I've really no idea,' he replies. 'I thought I would just suddenly appear, so I did. I suddenly appeared' (Crimp 2012b: 19). This moment, early in the play *In the Republic of Happiness* (2012), contains in microcosm many recognizable features of Martin Crimp's writing: it is uncomfortable, dislocating, fractured, uncanny, precise and, in its apparent knowingness about its own theatrical constructedness, dryly funny.

Crimp's earliest stage plays, including *Definitely the Bahamas* (1987), *Dealing with Clair* (1988) and *Play with Repeats* (1989), premiered at the Orange Tree Theatre, Richmond, where Crimp was part of a writers' group. These plays owe something to Crimp's experience of writing radio plays, and in this early part of his career, both his interest in absurdism and a desire to worry at the seams of middle-class life are readily apparent. In the early 1990s, his plays started being produced by the Royal Court and elsewhere. Works such as *No One Sees the Video* (1990), *Getting Attention* (1991) and *The Treatment* (1993) marked a rise in his professional profile, and evidenced Crimp's desire to unpick further the constructions of contemporary urban experience. At around the same time, he also began working on translations, adaptations, and versions of plays from the European repertoire: Molière's *The Misanthrope* (1996 [1666]), Ionesco's *The Chairs* (1997 [1952]) and *Rhinoceros* (2007 [1959]), Genet's *The Maids* (1999 [1947]), Chekhov's *The Seagull* (2006 [1895]), and Botho Strauss' *Gross und Klein* (2011 [1978]) are just some of these. Crimp's plays are often said to have echoes of Beckett, Pinter and Churchill, but the influence of those he has translated and adapted is also apparent. In 1997, Crimp wrote *Attempts on Her Life*, a landmark work, both in the way in which it seems to encapsulate the *Zeitgeist*, and in its

formal experimentation. Since then, his position as a writer of sharp, formally taught (and often unusual) plays has developed, as has his reputation both within and outside the UK, through works such as *The Country* (2000), *Fewer Emergencies* (2005), *The City* (2008), *Play House* (2012) and *In the Republic of Happiness* (2012).

Crimp has said, emphatically, that '[f]orm follows function', and '[s]tructures are important ways of articulating ideas, or provoking ideas' (in Sierz 2006: 97, 104); his work can be divided into several categories that, although not entirely discrete, help us to think about his use of form. His plays tend to be set in either fictional worlds, recognizably contemporary but with an austere, precise edge, or slightly stranger environments in which the performers onstage narrate or develop a story that does not (necessarily) happen before the audience's eyes. His translations and adaptations work somewhat differently, and here the level and type of interventions that Crimp makes varies considerably. Although Crimp's oeuvre is varied, it is possible to identify a number of threads – thematic, formal, dramaturgical, ideological – running through it. He is a master of uncertainty and inference, shaping plays that are often both explicitly and implicitly unsettling. His language is pointed, often playful, frequently loaded, and he's adept at mixing semantic registers in revealing and often alarming ways. Running under everything he writes – although it has shifted closer to the surface in recent plays – is a deep concern with, and anger about, structural inequality.

Dealing with Clair (1988) is a play about middle-class greed. In the first scene, we meet Clair, an estate agent, in her bedsit, talking on the phone to her mother: 'Who knows *what* I'll do?' she says. 'Maybe make a killing and just … disappear' (Crimp 2002: 9). Mike and Liz are trying to sell their house, and receive an offer. A new potential buyer, James, is prepared to pay more, and to pay cash. The play follows the characters as the desire to get the best deal trumps behaving 'honourably'; it gradually reveals a rottenness in both the house and the couple. By the end of the play – in an echo of the disappearance of Susie Lamplugh, a UK estate agent who was reported missing in 1986 – Clair has vanished under mysterious and uneasy circumstances. In the penultimate scene, in a sinister parallel of the first, James is seen in Clair's flat, talking on the phone to Clair's mother, before the play turns to end with Mike and Liz, who have finally sold their house for an extremely high price. Crimp has described being particularly pleased with the 'false happy ending' that *Dealing with Clair* has, saying that '[t]he brighter and more cheerful it is, the more it hurts' (in Sierz 2006: 96); he created a similar effect in his next play, *Getting Attention*.

This ability to skewer middle-class mores and to find the cracks and fissures in apparently perfect family lives runs through Crimp's work. Where his plays are situated inside the home, this space quickly becomes dangerous, and oppressive. A later, very short satirical work, written in 2003 as a theatrical response to the war in Iraq, *Advice to Iraqi Women* lists the various ways in which children 'need' protecting from modern-day hazards such as 'the caps of felt pens' or cars 'without rear airbags'. *Advice to Iraqi Women* points to the redundancy of such mollycoddling tendencies in a country under attack. The piece implicitly highlights the fact that the 'potential war zone' and 'minefield' of home, garden, car are actually nothing compared to a real war zone. At the same time, however, in many of Crimp's plays, the home is a threatening, and a threatened, space; an edifice built on foundations that, under his scrutiny, start to crumble.

Attempts on Her Life (1997) is Crimp's best-known work to date. Its formal experimentation perhaps accounts, in some measure, for the mixed reviews its first production at the Royal Court, directed by Tim Albery, received. Katie Mitchell's 2007 revival at the National Theatre's Lyttelton generated a similar reaction: although some critics applauded the scale and scope of production and play, others were nonplussed, irritated. Nevertheless, these two major productions (and numerous student productions), the fact that the play has been widely translated and is popular in mainland Europe, and the scholarly reception of the piece mean that *Attempts on Her Life* is regarded as seminal by many. It is made up, as its subtitle tells us, of *Seventeen Scenarios for the Theatre*. Famously, lines are not attributed to particular speakers; the text contains no list of characters or specification for the number or kind of performers beyond the instruction that '[t]his is a piece for a company of actors whose composition should reflect the composition of the world beyond the theatre', a statement so nebulous that it might read more as a challenge, or a joke, than a requirement. The characters or performers narrate scenes rather than enact them. Crimp also uses this kind of form elsewhere: his trilogy of short pieces, *Fewer Emergencies*, and the second part of *In the Republic of Happiness*, are similarly constructed from narration or description rather than conventionally dramatized event or action.

Each scenario describes, or constructs a narrative around, someone/thing called Anne (or a variant – Anny, Anya, Annie, Annushka). Throughout the play's scenarios, the variety of possible characters, characteristics, personas or identities that are offered render her

problematic, multiple, impossible: she's a dead child, a terrorist, a car, a daughter, a porn actress, a wife and mother, a lover, a superstar, a suicidal artist and so on. There is an open question as to whether Anne 'herself' is ever present on stage: she is constructed, textually, entirely through others' words and imaginings. As the scenarios accumulate, Crimp creates a composite picture, not just of Anne, but of a mediatized world of consumer culture in which the proliferation of images and identities threatens to evacuate all meaning and all compassion. *Attempts on Her Life* is, perhaps more than any of Crimp's other works, deeply interested in language – it uses polyglossia, polyphony and a range of semantic registers and styles – and, together with the ways in which it constructs ideas and images, foregrounds the violence language can do.

Cruel and Tender (2004) is based on – or 'after' – Sophocles' *The Trachiniae* (c. 450–424 BC). Despite following Sophocles' structure, Crimp radically modernizes the play, in some surprising ways. Although, at the time of writing, the so-called War on Terror was extremely present, Crimp locates the war and its atrocities in Africa, and sets the play in the present. Although his setting avoids heavy-handed reference to the military campaigns that the UK was engaged in during 2004, Crimp explores the ways in which the language of the War on Terror permeates all aspects of life: Amelia (Crimp's Deianeira) describes children as 'tiny tiny terrorists/who refuse to negotiate', and tells the minister 'I'm starting to find the way you speak/an atrocity' (Crimp 2004: 7, 21). Right from the start, the play foregrounds the impossibility of this kind of war: in her opening speech, Amelia derides the 'apparent aim –/of eradicating terror' because,

> ... the more he fights terror
> the more he creates terror –
> and invites terror – who has no eyelids –
> into his own bed.

> (Crimp 2004: 2)

Bound up with this articulation of very current anxieties, *Cruel and Tender*, like *Attempts on Her Life*, uses images of supermodernity throughout: from the setting, '*in the General and Amelia's temporary home close to an international airport*' (Crimp 2004: stage directions, n.p.), to the housekeeper, beautician and physiotherapist, who take the place of the nurse and chorus, to the detritus of modern life – wine, magazines, exercise machines. Sophocles' play has connections

to ideas which Crimp had already explored, most obviously the husband bringing a woman he desires into the family home (which formed the central thread of *The Country*) but this piece – which was critically well-received – is particularly notable as an exploration of the hypocrisy and the terrible distances of contemporary warfare.

It is slightly ironic that *Attempts on Her Life*, which stages a critique of globalization, has, according to Aleks Sierz, made Crimp the 'most exportable playwright of his generation' (Sierz 2006: 48); this play also had a direct influence on a range of other writers including Sarah Kane. But Crimp's influence and significance for contemporary theatre is perhaps less to do with reputation and more to do with the challenges he poses. His work has an edge – acerbic, ironic, satiric. He has described himself as a sceptic, articulating this position as follows:

> [P]ostmodernism, it seems to me, is an embrace of the strange contradictions and even injustices which are so deeply part of our culture, both locally and globally, whereas scepticism is quite different because it does imply a moral position – not an ideological position, but a position of what you might think is right or wrong.
>
> (in Aragay et al. 2007: 60)

In Crimp's understanding, an ideologue is one whose position is entrenched, blinkered. His theatre, with all its fractured strangeness, attempts to create complex pictures – both in terms of form, and in terms of the characters and behaviours staged. This, for Crimp, is where the potential political power of theatre lies: in its hurts, in its knowing constructions, in its discomfort.

Rachel Clements

Key works

Crimp, Martin (2000) *Plays: 1*, London: Faber and Faber.
——(2002) *Face to the Wall & Fewer Emergencies*, London: Faber and Faber.
——(2004) *Cruel and Tender*, London: Faber and Faber.
——(2005) *Plays: 2*, London: Faber and Faber.
——(2008) *The City*, London: Faber and Faber.
——(2012a) *Play House and Definitely the Bahamas*, London: Faber and Faber.
——(2012b) *In the Republic of Happiness*, London: Faber and Faber.

Further reading

Angelaki, Vicky (2012) *The Plays of Martin Crimp: Making Theatre Strange*, Basingstoke: Palgrave Macmillan.
Aragay, Mireia et al. (2007) *British Theatre of the 1990s: Interviews with Directors, Playwrights, Critics and Academics*, Basingstoke: Palgrave Macmillan.
Sierz, Aleks (2006) *The Theatre of Martin Crimp*, London: Methuen.

ANNA DEAVERE SMITH (1950–)

Anna Deavere Smith has become one of the most celebrated performer/writer/academics on the US theatre, performance and education circuits. She writes across academic and performance contexts as well as performing in both marginal and mainstream theatres and media. Her work falls between embodied performance and theories of creative practice, playwriting and performance. Globally she is perhaps best known for playing Nancy McNally, the national security advisor in Aaron Sorkin's long-running political drama *The West Wing* (1999–2006), and more recently for her hospital administrator Gloria Akalitus in *Nurse Jackie* (2009–), as well as appearing in numerous films over the past 25 years. Deavere Smith has been nominated for and awarded numerous honours and prizes: these include nominations for the Pulitzer Prize for Drama (in 1993 for her 1992 *Fires in the Mirror* first performed in 1994) and for Tony awards for *Twilight: Los Angeles, 1992* (1994) – both plays were awarded prestigious Drama Desk awards. She was the recipient of the MacArthur Fellowship in 1996 – a prize also known as the 'Genius Grant' awarded to artists and intellectuals, which recognizes their contribution to the arts in the US; the Dorothy and Lillian Gish prize, one of the few highly remunerated arts prizes in the US, in 2013; and the National Humanities Medal in 2012, from the White House. Her engagement across the commercial world of theatre and television, in academic debate and the theorizing of practice, combined with her public work on human rights sets her apart as a new model playwright in the late twentieth and early twenty-first centuries. Deavere Smith believes that performers and theatre-makers have a social role as well as an artistic one, that performance is a cultural *and* political activity.

Born into a middle-class family in Baltimore, Deavere Smith's early education took place in the context of racial segregation. She was then one of the first generation to take part in a mixed-race educational 'experiment' before going on to graduate. She has since

been awarded numerous honorary degrees and been professor at educational institutes such as Stanford and Harvard Universities – where she founded the Institute on the Arts and Civic Dialogue promoting art that 'illuminates social conditions' – and at Tisch School of the Arts in New York.

The solo-performance texts or plays for which she is most celebrated are *Twilight: Los Angeles, On the Road: A Search for American Character* and *Fires in The Mirror*, both of which were germinated through an innovative process whereby Deavere Smith interviewed a wide range of commentators, witnesses and community members affected by divisive social events, themselves created by racial tension and a disaffection with state authority in the face of racially driven disharmony. These are essentially texts created through multivoiced, one-person performance where the language of the original inter-viewee is left unedited and frames the performance through its nuance, vernacular and 'realistic' qualities. The language is 'authentic' and this authenticity is further supported by Deavere Smith's perfor-mance style where she 're-creates' the physicality and delivery of the words as they were spoken to her in interviews about the experience of key events across the US. In her research she was looking to 'find America in its language', and in making the work her desire was to place herself in 'other people's words'.

This process, of interviewing and then enacting/embodying the interview/interviewee in performance, is an innovation pioneered by Deavere Smith as part of her research for performances through the 1980s and 1990s – the performances 'based on actual events' had the series title *On the Road: A Search for American Character*. The method operates around interviewing people who were either directly involved in the event, involved from a distance or simply those commenting on or providing their analysis of the event.

Twilight: Los Angeles is constructed in reference to the events sur-rounding the Rodney King verdict, which failed to condemn the police officers who had beaten a black man on arrest in 1991, even though they had been filmed doing so. The verdict in 1992 was the cue for three days of riots and civil unrest around the issue of racial inequality in Los Angeles, the shock waves from which rippled globally. In making the play, Deavere Smith interviewed some 200 people of whom about 25 were included in the stage version (although there is more material available in the printed version). *Twilight* operates through the juxtaposition of testimony, witness statement and cultural analysis. 'Characters' – not formulated as people on stage who interact with each other – include police

officers, black artists, street gang members, community officers, workers, politicians and scholars: Cornel West and Judith Butler both 'appear' in her work (see *House Arrest*, 2003). The text is formulated around people telling their stories rather than always necessarily commenting directly on either the Rodney King case or on racism in US judicial procedures. The 'characters' do not always immediately connect with or 'speak' to each other's testimonies, but the relationships, both between those on stage and the 'stories' they are telling or 'views' they are exploring, become interwoven, juxtaposed and, at times, intimately connected as the performance text moves forward. We sometimes return to characters at different moments in their testimony, their words have new resonances when they are remembered in the context of the recurrent motifs in words spoken by others later into the performance. The 'narrative' builds in a non-linear fashion, into a kind of bricolage where we are engaged by a number of multiple 'stage worlds' at once. The performance is centred on testimony that unpacks the 'sea of associated causes' for the riots, but rarely directly refers to cause and affect questions for the interviewees (Deavere Smith 1994: xviii). As an audience we build a layered and multifaceted picture of the event through the contrasting experiences and perspectives of the interviewees and in turn, through the embodied performance of them as 'characters' in an unfolding story. As such the timelines in the play are non-linear and the interwoven relationship between the past the present is complex and dynamic. While often praised for her virtuosity as a performer of her plays or performance texts, for her 'characterizations which fall somewhere between caricature, Brechtian epic gestures, and mimicry' (Reinelt 1996: 609), Deavere Smith is also a virtuoso in her capacity to shape and lift language off the page. In her more theoretical writings she stresses the importance for the theatre-maker of the process and action of listening and of the ability of language to shape experience. She often refers in her writing to the importance to her own work – as a 'listener', writer and performer – of her paternal grandfather's statement, 'If you say a word often enough it becomes you' (Deavere Smith 2001: 25). In the process of making a performance text, Deavere Smith lets the interview materials totally shape the flow of exploration and analysis – the words become the action: we hear the reverberative experience of racism and of civic corruption from different angles without there ever being any pointed authorial reference to a moral right or wrong.

The techniques used in the writing of *Twilight: Los Angeles* are repeated in *Fires in the Mirror*, a play centred on the Crown Heights

crisis in the early 1990s. For scholar Cornel West, Deavere Smith's text is the 'most significant artistic exploration of Black-Jewish relations of our time' (in Deavere Smith 1993: xvii). The text is built around an investigation into the different perspectives of two interconnected but embattled communities, in the wake of a tragic death of a young boy caused by a driver from a Jewish community, followed by the killing of one of their young men by the black community of which the young boy was a member. Deavere Smith does not edit out the uncomfortable racism, stereotyping or seeming disrespect of one community for another. As a result the play does not literally present the issue as one of black versus white or vice versa. Rather, one 'sees motion and one hears multiple symphonies' (Deavere Smith 1993: xxxvi) as the voices in the play take us from one community to another, from the past to the present, from eyewitness account to cultural analysis and so on.

Whilst these two plays were responsible for catapulting Deavere Smith into the public eye, others – such as her earlier *Piano*, with its linear narrative and scenic structure – show a more traditional side to her playwriting. The play was premiered in 1988 in San Francisco and in it we see a Brechtian sense of composition emerging and the ability to create a balanced analysis of complex political histories through the 'experience' of characters whose lives are tied in with and shaped by those histories. *Piano*, set in Cuba in the late nineteenth century, explores gender and power within a frame of an ultimately entwined European and US colonialism. The play operates through a powerful exposure of human investment in violence and inequality. Similarly, it is in part the investment in inequality that is further exposed in Deavere Smith's play about American politics generally, and the White House presidencies more specifically – *House Arrest* (1997). Here the last president of the twentieth century, Bill Clinton, is in the middle of the media explosion and the public furore about his relationship with Monica Lewinsky. *House Arrest* moves between this episode and an analysis of Thomas Jefferson's racism, and its relation to his historical position as someone who was pro-democracy and anti-slavery. Like *Piano*, it is a play for actors as opposed to a solo-performer. Equally it is a play in which Deavere Smith asks us to engage with what she calls '*reorganizations* of history – interactions *with* history ... metaphors *for* history' (Deavere Smith 2004: xvii).

Unusually for a playwright, Deavere Smith writes a great deal about the process of creating her plays and performance texts. Her two autobiographical and polemical works (Deavere Smith 2001, 2006) provide reflections on acting, on performing and on the state of late

twentieth-century theatre practice more generally. Her rejection of *modernist* approaches to acting (see Lyons and Lyons 1994) and her easy and continuous professional transitions between theatre (writing and performing), academia and public politics, mainstream film and media, make her unique as a practitioner. The shaping of the dramatic narrative through Deavere Smith's 'incorporated' performance (see Schechner, 1993) of the interview materials themselves in *Twilight* and *Fires* alters the nature of the authorial voice, in both these and *House Arrest*. This in turn reconfigures the relationship between form, genre, playwright, performer and audience and evidences the extraordinary innovations and artistic risks taken in her work.

Maggie B. Gale

Key works

Deavere Smith, Anna (1993) *Fires in The Mirror*, New York: Anchor Books.
——(1994) *Twilight: Los Angeles, 1992, On the Road: A Search for American Character*, New York: Anchor Books.
——(2004) *House Arrest* and *The Piano*, New York: Anchor Books.

Further reading

Deavere Smith, Anna (2001) *Talk to Me: Travels in Media and Politics*, New York: Anchor Books.
——(2006) *Letters to a Young Artist: Straight-up Advice on Making a Life in the Arts*, New York: Anchor Books
Deveare Smith, Anna and Martin, Carol (1997) 'The Word Becomes You: An Interview by Carol Martin', *TDR*, 37(4): 45–62.
Guinier, Lani and Deavere Smith, Anna (2001) 'Rethinking Power, Rethinking Theater: A Conversation between Lani Guinier and Anna Deavere Smith', *Theater*, 31(3): 31–45.
Lewis, Barbara and Smith, Anna Deavere (1993) 'A Circle of Confusion: A Conversation with Anna Deavere Smith', *The Kenyon Review* 15(4): 54–64.
Lyons, Charles and Lyons, James (1994) 'Anna Deavere Smith: Perspectives on her Performance within the Context of Critical Theory', *Journal of Dramatic Theory and Criticism*, Fall 1994, pp. 43–66.
Reinelt, Janelle (1996) 'Performing Race: Anna Deavere Smith's *Fires in the Mirror*', *Modern Drama*, 39(4): 609–617.
Schechner, Richard (1993) 'Anna Deavere Smith: Acting as Incorporation', *The Drama Review*, 37(4): 63–64.

SHELAGH DELANEY (1938–2011)

Shelagh Delaney made her name when she was barely 20 years old: her first and most commercially successful play, *A Taste of Honey*, was produced by Theatre Workshop in East London in 1958. Because of its setting, Salford, a northern working-class town where she had been brought up, she became associated with a style that critics writing at the time thought of as 'working-class realism'. Although widely recognized as having written one of the truly revolutionary plays of the 1950s, her reputation later attracted two linked myths that tended to overshadow her talent. It was claimed that without the creative input of its first director, the great Joan Littlewood, the script of *A Taste of Honey* would have remained unstaged and unremembered. There was also the mistaken belief that Delaney's writing career came to a halt in the early 1960s and that she produced little else of interest. In fact, she went on to write more plays, although mainly for radio and television.

Delaney can certainly be credited with a naturalistic attempt to capture an idiomatic speech that survives, even flourishes, in deprived circumstances. Structurally, too, her work allows working people to occupy the whole space of the drama without recourse to outside intervention or forced climaxes. The novelist Jeanette Winterson has rightly spoken not only of her 'muscular, taut language', but also the ways in which Delaney gave her characters 'operatic value'.[1] Above all, Delaney understood the new ways of thinking and speaking that developed in the post-war years, particularly among young urban people, and she found compelling and undoctrinaire ways of telling their stories.

It's said that Delaney wrote *A Taste of Honey* in reaction to Terence Rattigan's *Variation on a Theme* (1958), which she saw as a teenager and immediately felt that she could improve upon. There is symbolic truth in this anecdote since Rattigan had by the mid-1950s come to be seen as a middle-class dramatist catering for an audience cast in the same mould as himself, people who, for all their genuine troubles, tended to conduct themselves with genteel reserve. Obviously this is not true of *A Taste of Honey*, which features unmarried pregnant teenager Jo, the young black father of her unborn child, her hard-drinking 'good time girl' mother, her mother's new boyfriend (a 'spiv' in the terminology of post-war England) and a clearly gay art student. The play opens without much in the way of an induction. What we see, hear and are entertained by are a series of exchanges that are always sharp and witty. Neither implausibly stoical – a risk for working-class drama – nor so preoccupied with long-term political

action that immediate human issues are ignored, Delaney's characters display their strengths and weaknesses through their engagement in emotional, often rebarbative, relationships, demonstrating a capacity for self-expression lacking – or at least disastrously repressed – in the middle-class world of Rattigan.

Apart, perhaps, for its linear structure – which follows the progress of Jo's pregnancy – there's nothing naïve about Delaney's approach to playwriting. Indeed, she was always, in a way, a very literary writer. There are references to *Oedipus* and *Ghosts*. An invocation of *Othello* by Jo's black boyfriend is entirely self-aware. Critical agonizing as to whether the play should be categorized as 'realist', an implicit generic downgrading, misses the point. Like all long-lasting plays, *A Taste of Honey* can be staged in many ways and still be effective, and this is an indication of an essential integrity that responds to collaboration – beginning with Joan Littlewood.

It's difficult to discuss the impact of *A Taste of Honey* without some reference to Littlewood who, in her autobiography, recalls reading the original draft, and claims that she sharpened the dialogue, added snatches of popular song and had characters deliver lines direct to the audience, a technique associated with the music hall she so much admired. Audience involvement was further encouraged by the presence on stage of a traditional jazz band, which also helped to smooth the transitions between scenes. More recently academic historians have praised this first production for its subversion of a would-be realistic text and for the way in which it created a community within the theatre that reinforced the resilience of life outside.

By the 1980s *A Taste of Honey* had become a staple of UK education syllabuses in drama and there have been a number of 'study guides' that encourage students to appreciate the novelty of the language, the active presence – without patronage – of gay and black characters, the historical confusion between gayness and effeminacy, the difficulty many young people will have in establishing a different kind of relationship with their parents, finding their way as individuals in an unresponsive world. The danger with these thematic approaches, of undoubted value in the classroom, is that they reduce not only the complexity but the theatrical potential of the work.

Recent revivals have drawn attention to the many ways in which Jo's story can be told. When the play was staged at the Royal Lyceum, Edinburgh, in 2012, Mark Fisher wrote that 'the more Jo rebels against her wayward mother, the more she becomes like her'.[2] When the Crucible Theatre in Sheffield revived the play in the same year, Michael Billington found value in Katie West's performance because,

She never sentimentalises the character, allowing us to see that she can be whiny, wheedling, angry and scruffy. When Jo cries, 'I really do live at the same time as myself, don't I,' West gives rich resonance to one of the play's best lines.[3]

Although Billington thought that the production missed some of the 'vaudevillian bounce' (he was no doubt thinking of Littlewood), he was keen to insist that – even in its time – the play pointed to the future.

In 1961 the play was adapted and filmed by Tony Richardson and, inevitably, this version, which takes us out into the streets of Salford, turning the urban landscape into a questionable kind of cinematic poetry, is the one that most people have come to know. Nevertheless, there's a wonderful performance from Murray Melvin as the gay student and Rita Tushingham as Jo, by turn combative and outwardly impervious to all life can throw at her, inwardly terrified, continues to move and inspire.

Delaney's subsequent play, *The Lion in Love* (1960), concerns a family, and a whole community, in deep trouble as it tries to cope with the changing post-war world. Jesse, old, widowed, whatever patriarchal authority he once possessed now gone, has a middle-aged daughter Kit who has, in turn, a son, Banner, an ex-boxer, now returned home after a long and slightly mysterious absence, and an abrasive daughter, Peg. Although perpetually drunk and scrounging from others, Kit is fundamentally resilient and undeceived about life. Both of her children are anxious to leave the market world – Banner for Australia, Peg for London with her new would-be dress-designer boyfriend. Even Frank, Kit's husband, who has been having a longstanding affair with a neighbour, finally threatens to leave. Surrounding this beleaguered family unit are a couple who aspire to become professional dancers, a handful of ex-soldiers and a few other market traders, none of them doing well. The setting is based on a street-market with a bomb-site in the distance that recalls, perhaps, other works from the period such as the 1954 film of Wolf Mankowitz's novel *A Kid for Two Farthings* or Littlewood's one film, *Sparrers Can't Sing* (1962), but Delaney's view of the post-war landscape is more clear-sighted than most. Her characters share basic worries about houses and employment; the prodigal theme doesn't actually come to anything.

Littlewood has provided a brief, ungenerous account of how she was initially disappointed by the script and ended up not directing it. In the event the play was directed by Clive Barker, an actor who had previously worked with Theatre Workshop and who went on to a distinguished academic career. While Barker's production – and

probably Delaney's text – betray Littlewood's influence it also clearly demonstrated an alternative approach to the representation of working-class life. Instead of an improvising jazz band Barker, possibly inspired by Brecht, interspersed the action with folk ballads. Although easily denigrated as a progenitor of working-class soap opera (TV's *Coronation Street* was to begin in 1960), *The Lion in Love* has, in fact, an inexorable structure generated by a continual interplay between conflicting impulses to leave or to remain. This paradox was expressed most poignantly by Delaney herself in a TV documentary in 1960,[4] when she described Salford as both the 'beating heart of the city' and 'old, crumbling, neglected'. Along with her generation she was, she said, like a 'tethered horse' waiting to be released.

The pain and moral embarrassment of social change when it is driven by economics and governmental convenience rather than by communal need occurs elsewhere in her work. The screenplay she wrote for the film *Charlie Bubbles*, directed by the actor Albert Finney, and released in 1967, centres on the brief return by a successful London-based writer to his old home in Manchester. There are some good jokes – 'there are no chemicals in the muck you're eating' says a progressive mother to her children – and many contemporary set-pieces – a motorway service station, a football game – but most memorable is an excruciating scene in which the affluent author finds himself being served by an old friend of his father, reduced to working as a waiter in a 'luxury' hotel. *The White Bus*, a 1967 film directed by Lindsay Anderson, is even more clearly autobiographical – a documentary journey around Salford full of comedy and unlikely but authentic juxtapositions. Officialdom is mocked to its face, but so too is a pretentious Brechtian actor.

It's not easy to say why Delaney made the creative and professional decisions that she did in later years. Commissions may have been harder to come by; her personal life may have taken on other priorities. Her prose fictions suggest that concentrated major projects were not her forte. Although no longer in the public eye Delaney did keep on writing: screenplays, TV and radio drama. She produced the script for *Dance with a Stranger* (1985), a film about Ruth Ellis, the last woman to be hanged in Britain. For television there was *So Does the Nightingale* (1980) and *Don't Worry about Matilda* (1981). *The House That Jack Built*, adapted from a series of television plays broadcast in 1977, was staged on Broadway in 1979. However, some of the most convincing evidence that Delaney's gift never left her lies in the radio plays directed by Polly Thomas after 2000.

Shelagh Delaney showed the way forward for many writers: in a radio obituary Jeanette Winterson spoke movingly of coming up in

'the changing times that Shelagh Delaney made possible'.[5] By allowing people to speak for themselves Delaney 'made possible' not only Winterson but Claire Luckham, Pam Gems, Carla Lane, Simon Stephens, Lee Hall and countless others, some of them too young to remember her work. Although she recognized, along with UK playwright and contemporary Ann Jellicoe, that modern speech was essentially youth speech, her work always focused on moments of transition: from childhood to adolescence, from adolescence to adulthood, from middle-age to old age, finally in a moving late radio play, *Baloney said Salome* (first broadcast on Radio 4, 1 March 2012, repeated 23 November 2013), to what comes after old age. That these, the determining events in human life cannot be separated from the social environment in which they take place, only reinforces their personal significance. Shelagh Delaney's underlying concern is fidelity in changing times – fidelity to individuals, to family, to place, to oneself.

John Stokes

Notes

1 'Last Word', BBC Radio 4, 25 November 2011. Also see 'My Hero', *The Guardian*, 18 September 2010.
2 *The Guardian*, 24 January 2013.
3 *The Guardian*, 31 October 2012.
4 'Shelagh Delaney's Salford', BBC *Monitor*, 15 September 1960, directed by Ken Russell.
5 'Last Word', BBC Radio 4, 25 November 2011.

Key works

Delaney, Shelagh (1959) *A Taste of Honey*, London: Methuen.
——(1961) *The Lion in Love*, London: Methuen.
——(1964) *Sweetly Sings the Donkey*, London: Methuen [reprinted London: Penguin,1968].

Further reading

Bennett, Susan (2006) 'A Commercial Success: Women Playwrights in the 1950s' in Mary Luckhurst (ed.) *A Companion to Modern British and Irish Drama*, Oxford: Blackwell, pp. 175–187.
Dyer, Bernadette (1999) *Shelagh Delaney: A Taste of Honey*, Harlow: Longman.

Hattatt, Lance and Sale, James (1989) *A Taste of Honey*, London: Hodder and Stoughton.

Littlewood, Joan (1994) *Joan Littlewood's Peculiar History As She Tells It*, London: Methuen.

Loreto, Todd (1992) *Shelagh Delaney: A Taste of Honey*, Harlow: Longman.

Quilliam, Susan (1987) *Shelagh Delaney: A Taste of Honey*, Harmondsworth: Penguin Passnotes.

DAVID EDGAR (1948–)

Author of more than 60 plays, and a frequent contributor to national discussions around playwriting, cultural policy and politics, David Edgar is one of the most dominant and sustained voices in British theatre. His work encompasses stage, television and radio, agitprop and adaptation, historical epic, social-realism and contemporary commentary.

Edgar studied drama at the University of Manchester and trained as a journalist in Bradford with the intention to 'write plays in the evening'.[1] At Bradford he met Chris Parr, a fellow in theatre at the university whose job was to commission plays to encourage dramatic activity among the students. Edgar, at that time a Trotskyite, wrote a number of plays for Parr including *The White and White Springbok Show* (commenting on Apartheid during the South African rugby team tour of Britain and Ireland) and *The National Interest* (1971), a response to the first year of Edward Heath's Conservative government. This was the first show for The General Will, a political theatre company that specialized in agitprop plays focusing on economic issues. *Rent, or Caught in the Act* (1972) analysed the implications of the New Housing Finance Act through the medium of Victorian melodrama and musical acts, while *The Dunkirk Spirit* (1974) was a history of capitalism from World War II onwards. Edgar has described *Rent* as 'the most successful agitprop play I've ever done' because it played to audiences to whom the Act was directly relevant.[2] While working with The General Will, Edgar also had work produced in Edinburgh and at the Bush Theatre in London. *Tederella* (1971) borrowed pantomime form to lampoon Prime Minister Edward Heath's attempt to join the Common Market; *Dick Deterred* (1973) pastiched Shakespeare's *Richard III* to analyse Richard Nixon and the Watergate crisis.

In 1972 Edgar gave up journalism to be a full-time playwright. By the mid-1970s he was eager for new forms and new audiences: 'I got obsessed with slickness. I was fed up with seeing agitprop plays that

were messy, and I was increasingly thinking that the politics you could get across were very crude' (in Bull 2006: 442). Like other playwrights of his generation including Howard Brenton and David Hare, Edgar identified a shift in the audience for political work from the 'fabled working-class' to the 'student movement (or ex student movement) of the late Sixties [...] those who entered the public services – teaching, social work, probation service, journalism, the liberal professions'.[3] Edgar's work has been exploring what it means to be politically left-wing in Britain in the face of increasing erosion of the post-1945 social contract ever since. He made a decisive transition from agitprop to epic with *Destiny* (1976), which analysed the growth of fascism and racism in Britain.

The play begins at the supposed end of imperialism as the British leave India in 1947, then flashes forward to a by-election in the West Midlands where a crypto-fascist party grooms a local candidate. Edgar brilliantly shows how people from different backgrounds, with different political beliefs, have their observations and complaints translated into compelling fascist rhetoric during a local meeting. *Destiny* catapulted him into the mainstream: the far-right, racist National Front party had gained a substantial share of the vote in a by-election in Thurrock in Essex, UK, and Edgar, by now writing for the anti-racist magazine *Searchlight*, was able to point up other examples of the far-right gaining ground. The play had originally been produced at the Other Place, the RSC's studio space in Stratford-upon-Avon, but a gap in the London schedule gave the show a chance to transfer to the Aldwych Theatre where it was seen by more than 20,000 people. It was televised by the BBC in 1978. This exposure guaranteed the play an audience with precisely the kind of people who were susceptible to creeping racism and fascism but Edgar was also at pains to show the anti-fascist and racists movements how the 'enemy' worked by presenting three-dimensional, human characters rather than caricatures. *Maydays* (1983) employed the same techniques to show the slow and inexorable drift to the right of Marxist radical Martin Glass as a believable and unsensational journey.

Destiny showcased Edgar's use of Brechtian techniques to draw complex historical links and provoke debate among audiences: direct address; verse; short episodic scenes; fast lighting changes – all these elements allowed him to work on a broad historical and political canvas and to work in a mode that was discursive rather than didactic. He wrote a number of other works in social-realist mode after *Destiny*, including *The Jail Diary of Albie Sachs* (1978) and *Mary Barnes* (1978), both adaptations of autobiographical accounts. Jewish

South African lawyer and anti-Apartheid campaigner Sachs is imprisoned in solitary confinement without trial for 90 days at a time, continually re-arrested, interrogated and sleep deprived until he 'confesses'. *Mary Barnes* follows the progress of an experiment undertaken by 'anti-psychiatry' psychiatrists led by R.D. Laing to treat patients outside a clinical environment without drugs or electrotherapy. The community set up a residential centre in the East End of London and Mary Barnes, a schizophrenic nurse, is treated through regression and art therapy by Eddie, one of the resident psychiatrists. The patience and tenderness with which Eddie treats Mary finds its echo in Smike, the simple but, pure at heart, victim of Edgar's next major hit, *Nicholas Nickleby* (1980). An epic in every sense of the word, this adaptation of Charles Dickens' novel commissioned by the RSC and directed by Trevor Nunn and John Caird was an incredible feat of ensemble theatre and employed many techniques now overfamiliar to us from physical theatre including actors swaying and jolting to create the 'impression of a coach leaving'; swiftly amassing and dispersing to create crowd scenes and collective storytelling through the sharing out of lines. Part 1 begins with actors emerging from the audience to protest at new laws being introduced; there are frequent addresses to the audience, summarizing and describing key moments to move the action along and a cast of musical theatre proportions required to take on a huge number of roles. Edgar's note in the text drily records for 'the statistically minded, 39 performers played 123 speaking parts in 95 scenes' (Edgar 1990: 42). As well as warning contemporary audiences about the perils of the return to an age of Victorian certainties and capitalism, the play is also a celebration of theatre with some very funny self-reflexive jokes about the industry. When justifying the price of a ticket for his new show to an astonished patron, Nicholas protests it has 'a lot of people in it. *Slight pause.* And it is very long' (Edgar 1990: 174). The play was an enormous hit, transferred to Broadway in 1981 and was broadcast on television in 1982.

Throughout the 1980s Edgar worked on a number of large-scale dramas including *Maydays* (1983) and *Entertaining Strangers* (1985), a community play written at the invitation of playwright Ann Jellicoe, pioneer and organizer of community plays in Dorset. Edgar also attempted to break into television in the 1980s and his failure to do so was one of the factors in his establishing the first postgraduate course in playwriting at the University of Birmingham in 1989 to provide him with space and time to reflect on his craft. Edgar directed the course for ten years, organizing an annual conference on

theatre and writing during his tenure. Key papers from the conferences are collected in *State of Play: Playwrights on Playwriting* (2000), while his analyses and experience of playwriting is collected in *How Plays Work* (2009). In the same year, Edgar, who has had a long involvement with the Arts Council of Great Britain, the main funder and development agency for playwriting, was one of the authors of *Writ Large*, a report on the health of New Writing in British Theatre commissioned by the Arts Council.

Creatively refreshed, and politically galvanized by the fall of the Berlin Wall and the collapse of communism, Edgar embarked on an ambitious and impressive trilogy of plays. *The Shape of the Table* (1990), *Pentecost* (1994) and *The Prisoner's Dilemma* (2001) examine the transformation of Europe after 1989. Many playwrights of Edgar's generation – Alan Bennett, Tom Stoppard, Howard Brenton, David Hare – had links with writers and theatre-workers in Eastern Europe and had first-hand experience of the changing conditions. The confusion and ambivalence it caused is particularly evident in *Pentecost*, the middle play in the trilogy, which explores the fragmentation of political states and its effect on local, national and international relations. A fresco discovered in an unspecified Balkan country by a local museum curator becomes the centre of an international dispute about art history, cultural property, conservation and religion. English art historian Oliver Davenport, familiar with the old Eastern Europe, becomes unwillingly embroiled in the diplomatic and political farrago that ensues. The fresco is on the wall of a building which has variously been a church, a mosque, a warehouse and a 'Museum of Atheism and Progressive People's Culture', which only adds to the complexities around ownership and interpretation. When a group of international refugees take the art historians (and the fresco) hostage, demanding asylum in countries of their choice, a new and more dangerous political situation escalates, reflected in the profusion of different languages spoken and understood. Language is at the heart of the plays. Edgar and director Michael Attenborough workshopped the play with refugees and asylum seekers who could attest to the politics of language, how it functioned as a straitjacket, a mode of resistance and a weapon of revolution.

In 2003, Edgar produced *Continental Divide* (2003), a two-play examination of US politics commissioned by the Oregon Shakespeare Festival and Berkeley Repertory Theatre. Part 1, *Mothers Against*, shows a Republican candidate preparing for a television debate; *Daughters of the Revolution* shows a Democrat searching for the FBI informer who ruined his career. The plays transferred to the

Birmingham Repertory Theatre in Edgar's home city and then moved to London.

Since 2005, Edgar has returned to several of the themes that dominated his earlier work. *Playing with Fire* (2005) returns to racism and immigration in the aftermath of riots in Bradford after clashes between local Asian residents and the Anti-Nazi League with far-right groups (the National Front and British National Party). *Testing the Echo* (2008) returns to the ideas of nationality and belonging explored in *Pentecost* through the perception of immigrants to Britain preparing for the newly introduced citizenship test. His newest play, *If Only* (2013), examines the build up to Britain's coalition government in 2010.

<div align="right">Kate Dorney</div>

Notes

1 Megson, Chris (2012) 'Documents: David Edgar' in Chris Megson (ed.) *Modern British Playwriting: The 1970s*, London: Methuen, pp. 223–236 (quote from p. 223).
2 In Wu, Duncan (2000) 'David Edgar: *Pentecost*' in *Making Plays: Interviews with Contemporary British Dramatists and Directors*, Basingstoke: Palgrave Macmillan, pp. 112–145 (quote from p. 119).
3 Ibid, p. 121.

Key works

Edgar, David (1990) *Plays: 2*, London: Methuen.
——(1995) *Pentecost*, London: Nick Hern Books.
——(1997) *Plays: 1*, London: Methuen.
——(2004) *Continental Divide*, London: Nick Hern Books.
——(2009) *How Plays Work*, London: Nick Hern Books.

Further reading

Bull, John (1984) *New British Political Dramatists*, London: Macmillan.
——(2006) 'Left in Front: David Edgar's Political Theatre', in Mary Luckhurst (ed.) *A Companion to Modern British and Irish Drama 1880–1925*, Oxford: Blackwell, pp. 441–453.
Edgar, David (1988) *The Second Time as Farce: Reflections on the Drama of Mean Times*, London: Lawrence & Wishart.
Reinelt, Janelle and Hewitt, Gerald (2011) *The Political Theatre of David Edgar: Negotiation and Retrieval*, Cambridge: Cambridge University Press.

DARIO FO (1926–)

The award of the Nobel Prize to writer-performer Dario Fo in October 1997 was one of the most controversial in the award's near-100-year history. The Academy praised Fo for the way he 'emulates the jesters of the Middle Ages in scourging authority and upholding the dignity of the downtrodden', but their praise for Fo's political radicalism was not universally shared, particularly in his native Italy. Unsurprisingly, given Fo's lifelong taunting of the Catholic Church, the Vatican newspaper *L'Osservatore Romano* declared that 'to give the prize to an actor who is also an author of dubious texts – putting aside any moral consideration – beggars belief'. Their puzzled description of Fo as 'an actor' was at the heart of the widespread bewilderment in Italian literary circles that Fo had been awarded a prize for *literature*. 'He's a genius, a great man of the theatre,' said the critic Irene Bignardi, 'but I'm not sure this is literature.' Literary critic Alfonso Berardinelli explained: 'I'm not particularly fond of him as an actor but as a writer he is quite unacceptable.' Of his plays Giulio Ferroni, professor of Italian literature at University La Sapienza in Rome, noted: 'The writings are nothing outside their theatrical use, they have no stylistic density, they live only in the moment.' Fo himself brushed off these complaints, explaining that perhaps 'God is a jester too'.

Dario Fo has transgressed many of the boundaries in which European literature has often been confined: between aesthetic distance and direct political action, between high art and popular culture, between literature and theatre, between acting and writing. His works have redefined the role of the artist as a conduit for popular history, an educator, a commentator, a provocateur, a revolutionary. Born in Leggiuno Sangiano in Lombardy, northern Italy, Fo showed an aptitude for clowning and comedy from an early age and also for art, although his studies were interrupted by the Second World War (1939–1945), in which he briefly worked alongside his father for the Italian Resistance. After leaving college before completing his studies in set design and architecture he launched an acting career, scoring early success with his radio show *Poer Nano* (1951) in which the 'poor dwarf' of the title offered a history-from-below (literally), lampooning and burlesquing famous mythical, Biblical and literary stories to great popular acclaim. The success of *Poer Nano* led to a stage version and a series of other successful revues.

In 1951 he also met his great partner and collaborator, Franca Rame. They married in 1954 and, although their personal

relationship would go through highs and lows, their artistic partner-
ship was constant until Rame's death in 2013. They shared their
radical politics and Rame would bring a sharper awareness of sexual
politics to their work; in their *Open Couple* (1983), they satirized the
strains in their personal relationship but in *Female Parts* (1977–1983),
they placed women's experience at the heart of their theatre, includ-
ing most powerfully Rame's *The Rape*, an autobiographical account
of her state-sanctioned abduction and violation at the hands of right-
wing thugs in 1973. At the end of his Nobel Prize speech, Fo
declared 'believe me, this prize belongs to both of us'.

Fo and Rame's collaborative work went through a series of phases.
In the first 'bourgeois' phase, they worked mainly in mainstream,
commercial Italian theatres, like the Teatro Odeon in Milan. These
shows included *Archangels Don't Play Pinball* (1959), *Seventh
Commandment: Thou Shalt Steal a Bit Less* (1964) and *It's Always the
Devil's Fault* (1965), and the tone is usually broad, somewhat absurdist
farce, although they become increasingly political in character,
culminating in 1967's *Throw the Lady Out*, which was a large-scale
satirical history of the United States, specifically commenting on its
role in Vietnam, but ingeniously performed as a series of circus acts.
The clowning and circus techniques of *Throw the Lady Out* were
evidence of Fo's interest in Brechtian epic theatre, particularly in his
increasing preference for broad mask-like performance rather than
naturalistic characterization. Feeling that his political ideas could no
longer be explored in bourgeois theatre forms, in 1968 Fo and Rame
disbanded their existing company and formed Nuova Scena [New
Stage], a theatre collective, linked to the Italian Communist Party
(PCI). Nuova Scena produced a series of shows – *Grand Pantomime
with Flags and Small and Medium-Sized Puppets* (1968), *The Worker
Knows 300 Words, The Boss Knows 1000 – That's Why He's the Boss*
(1969) and *Chain Me Up and I'll Still Smash Everything* (1969), all
written by Fo. But his most enduring piece from Nuova Scena, per-
haps the most important show of his career, was *Mistero Buffo* (1969).

Mistero Buffo is a collection of one-person performances, mostly
reworkings of Biblical stories from the perspective of peasants and
serfs, satirizing the powerful and the accepted version of history,
adopting and adapting the style of the jesters and storytellers of
medieval Europe. The pieces resemble monologues but that is to
ignore the mischievous physicality that Fo brought to their perfor-
mance, their improvisatory nature – Fo would extend and elaborate
the stories in each performance – and indeed his use of 'grammelot', a
non-verbal comic language that resembles speech but, being

irreducible to actual words, both evades censorship and linguistic or regional divisions in his audiences. Most famous of the monologues, *Boniface VIII*, shows the notorious medieval pope of the title, with the help of cowering altar boys, adorning himself in the richly-jewelled vestments of office, until unexpectedly Jesus returns to Earth, at which point the pope comically and unsuccessfully attempts to divest himself of these trappings to appear humble and meek. Fo would return to this kind of physicalized, one-person counterhistorical performance in shows like *Tale of a Tiger* (1978), *Obscene Fables* (1982), *Johan Padan Discovers the Americas* (1991) and *Saint Frances the Holy Jester* (1999).

The late 1960s and early 1970s saw a wave of left-wing radicalism across Europe, not much of it organized or authorized by the established communist parties. Italy was no exception, and the sometimes violent battles fought out between left and right in what came to be referred to as the 'Years of Lead' saw a wave of left-wing activists seek forums for action beyond the PCI. Fo and Rame's dissatisfaction with Nuova Scena was both political and artistic and in 1970, they formed a new company, La Comune, first occupying an abandoned factory space in a working-class district of Milan, and later moving into the Palazzina Liberty (so named because it was owned by the London department store, Liberty's).

The plays produced by La Comune are among Dario Fo's most celebrated work. Liberated from the control of the PCI, they produced a wide range of revolutionary pieces in several forms, including left-wing popular revue – *I'd Rather Die Tonight Than Think It Was All In Vein* (1970) – to documentary theatre – *All United! All Together! Hold On – Isn't that the Boss?* (1971) and *Fedayn* (1972) – but the form in which they flourished most was a satirical form of farce. *Can't Pay! Won't Pay!* (1974) is set among a group of Italian housewives who deal with rapidly rising prices by a system of organized shoplifting, which they do behind the backs of their husbands. *Fanfani Kidnapped* (1975) and *Mamma's Marijuana is the Best* (1976) are farces dealing with parliamentary politics and the drug trade respectively. But the most famous play of the period and also of Fo's entire career is 1970's *Accidental Death of an Anarchist*.

The international success of this play is, at first glance, paradoxical, since it is one of the most historically and culturally specific of Fo's plays. In December 1969, a bomb exploded in a bank in Piazza Fontana, central Milan, killing 17 people and wounding many more. Although later evidence would link a fascist group to the bombing, the police immediately rounded up a large-number of anarchists on

suspicion of the crime; three days after the bombing, Giuseppe Pinelli, an anarchist railway worker, died after falling from the fourth-floor window of the Milan police station where he was being held. The contradictions that emerged in the police account are what gave Fo the idea for his play. *Accidental Death* follows a 'madman' who turns up at the Milan police station under the guise of an examining magistrate to straighten out the police's story: Fo generates great farce from the absurdities of trying to act out each of the successive statements and soon has them singing anarchist songs to demonstrate their sympathy with their dead prisoner. In the second half, a journalist has come to interview the police officers and now the madman takes on various disguises supposedly to support the police but in fact making clear their guilt. Further, the police inspector in charge of the Pinelli inter- rogation had, as the play opened, begun a case for libel against the left- wing newspaper *Lotta Continua*, and Fo was able to update the play on a daily basis as new contradictions and absurdities emerged from the courtroom. The play toured, often playing football stadiums, where Fo's extraordinary physicality and clownish appearance – with protruding eyes, nose and teeth – made him a kind of revolutionary cartoonist in La Comune's living newspaper.

Fo and Rame's growing fame meant it was increasingly difficult to keep La Comune together and when they lost the Palazzina Liberty, the company disbanded and Fo and Rame made a modified return to the bourgeois stage, although without abandoning their gift for radical farce. *Trumpets and Raspberries* (1981) was a farce about an imagined kidnapping of Gianni Agnelli, the enormously wealthy head of Fiat, while *The Pope and the Witch* (1989) imagines Pope John-Paul II undergoing an absurd therapy (to cure an equally absurd malady) by a witch and, after a series of farcical complications, ending up delivering a revolutionary encyclical. In the same period, sexual politics became more prominent in their work as evinced by shows like *Female Parts* (1977), *The Open Couple* (1983) and *Sex? Don't Mind If I Do* (1994).

In the 1990s and 2000s, Fo's creative energy showed no signs of diminishing. The best plays of this period – including *We All Fall Down!* (1990), *The Devil in Drag* (1997) and the anti-Berlusconi two- hander *The Two-Brained Anomaly* (2003) – show continuing invention and political vitality. Fo's book *Tricks of the Trade* [*Manuale Minimo dell'Attore*] (1987) combined genuine historical research with sheer invention to champion an unbroken tradition of popular performance. His public performances – including *Dario Fo Meets Ruzzante* (1993), *Free Marino! Marino is Innocent!* (1998), *The Great*

Pretender (2001), *Ubu Goes to War* (2003) – increasingly took the form of lecture-monologues. The diversity and range of his activities increased, standing for mayor of Milan in 2006 (under the irresistible slogan: 'Have no fear! I'm not a moderate!'), publishing a series of illustrated books on various Italian cities and various key artists, campaigning with Rame for the rights of the disabled and immigrants, and directing operas and farces at such prestigious theatres as the Comédie Française and the Amsterdam Muziektheater. Dario Fo remains the most famous playwright of post-war Italy. His work over six decades has been a continuing inspiration to political theatre-makers around the world for his ability to combine profound theatrical skill with the most powerful political efficacy.

<div align="right">Dan Rebellato</div>

Key works

Fo, Dario (1991) *The Tricks of the Trade*, trans. Joe Farrell, London: Methuen.
——(1992) *Plays: 1*, London: Methuen.
——(1994) *Plays: 2,* London: Methuen.

Further reading

Behan, Tom (2000) *Dario Fo: Revolutionary Theatre*, London: Pluto.
Emery, F. (ed.) (2002) *Research Papers on Dario Fo and Franca Rame*, London: Red Notes.
Farrell, Joseph (2001) *Dario Fo & Franca Rame: Harlequins of the Revolution*, London: Methuen.
Farrell, Joseph and Scuderi, Antonio (2000) *Dario Fo: Stage, Text, and Tradition*, Carbondale and Edwardsville: Southern Illinois University Press.
Jenkins, Ron (2001) *Dario Fo and Franca Rame: Artful Laughter*, New York: Aperture.
Mitchell, Tony (1999) *Dario Fo: People's Court Jester*, updated and expanded edition, London: Methuen.

MARÍA IRENE FORNÉS (1930–)

María Irene Fornés did not start writing plays until she was in her thirties. Over the next 40 years, she created a body of work – full-length and one-act plays, comic sketches, song lyrics, adaptations of canonical dramas, libretti for opera and musical theatre, site-specific

pieces – marked by an experimental approach to each new endea-
vour, a dogged commitment to her artistic vision, and a sustained
interest in using language and image to capture her sense of the
human condition. She spearheaded an innovative approach to play-
writing based on plumbing the writer's subconscious for raw material.
It often resulted in plays composed of short, fragmentary scenes
juxtaposed one after another in an impressionistic manner. While
never a popular success, she is widely regarded in artistic and
academic circles as a figure of major and lasting importance.

Born in Havana, Cuba, Fornés was the youngest of six children
raised by eccentric parents who fostered in her a natural curiosity
and an artistic sensibility. In 1945, not long after her father's death,
she emigrated with her mother and a sister to New York City,
her home for most of the rest of her life. In the mid-1950s, she
spent three years in Paris pursuing the life of an aspiring painter.
Back in New York, she gravitated to the bohemia of Greenwich
Village and its burgeoning avant-garde and counterculture. She
took up playwriting on a whim and soon found herself caught up
in the Off-Off-Broadway movement of the 1960s, less an
organized campaign than a mushrooming of free-wheeling venues
and rambunctious talents willing to make theatre on a shoestring.
Fornés was associated in particular with the Judson Poets Theater,
but she also worked with Joe Chaikin's Open Theater and had
work produced at La MaMa Experimental Theatre Club and other
downtown outlets.

For a brief time, her plays attracted attention in the commercial,
professional theatre in midtown Manhattan. In 1966, Jerome Robbins
directed a comedy titled *The Office* on Broadway, but it closed in
previews. Her one true hit came in 1969 when *Promenade* – an
expanded version of her 1965 musical collaboration with composer
Al Carmines and director Lawrence Kornfeld – ran Off-Broadway for
almost a year. After that, her plays were developed and performed
outside the mainstream, at alternative New York venues such as
Theater for the New City and INTAR, and in the studio spaces of a
few resident regional theatres around the United States. Her career
was shaped in part by her insistence from 1970 onward that she direct
the original production of each new play, which she did with
painstaking exactitude. In 1977, *Fefu and Her Friends* signalled a shift
in Fornés' playwriting, one that paved the way for a remarkably
prolific period in the 1980s when she wrote and staged new plays at
the rate of one a year. In 1999, the Signature Theatre in New York
produced a full season of Fornés plays, including the world premiere

of what proved to be her last play, *Letters from Cuba*. As Fornés entered her seventies and the twenty-first century, she gradually succumbed to worsening dementia that ended her career.

While *Promenade* brought Fornés the most attention in the 1960s, her one-act comedy *The Successful Life of 3* (1965) epitomizes her early work. Written in a rapid-fire series of ten short, episodic scenes, it presents the picaresque adventures of three cardboard cut-out characters: a handsome young man named He, a sexy young woman named She and a middle-aged man named 3. In Scene 1, they are strangers. In Scene 2, they go on a date, and by Scene 3, they have lived together for ten years and had lots of children. She abandons the two men; 3 goes into business, becomes a tycoon, turns to crime, becomes a gangster and then a do-gooder who steals from the rich to give to the poor. The action hurtles forward with the same impish insouciance that defines the characters. 'I can't stand the twins,' says She at one point. 'Why not?' asks He. 'They look too much alike,' She replies (Fornés 1971: 180). To great comic effect, they deadpan their way through ups and downs so precipitous as to make a mockery of narrative logic and the very notion of success and failure, and then they end with a 'Song to Ignorance' and its defiant refrain:

Let me be wrong
But also not know it.
Be wrong,
Be wrong,
And, oh, not to know it.
Oh! Let me be wrong.

(Fornés 1971: 199)

The Successful Life of 3 represents Fornés at her most boisterous and nonchalant, but behind the mask of indifference there is a hollowness that hints that something meaningful is missing.

Fefu and Her Friends (1977) is Fornés' single most important play. It became a touchstone of feminist theatre in the 1980s and a bellwether of Fornés' turn towards a more contemplative and more realistic style of playwriting. On the surface, it depicts a meeting of eight middle-class women who gather to promote 'art as a tool for education', but its true subject is how women disempower themselves by internalizing the forces of patriarchy and male oppression. The play takes place over three acts in the home of Fefu, an idiosyncratic woman who is outwardly gregarious but privately in turmoil. So, too, are the other women who meet to plan a fundraising event, especially Julia, who is

weak, confined to a wheelchair after a bizarre hunting accident and subject to delusions involving what she calls 'the Judges'. The play's unconventional Act II, comprised of four scenes set in four different rooms around Fefu's house, anticipated later innovations in site specific and immersive theatre. At the end of Act I, the audience is divided into four subgroups and guided to substages around the theatre for intimate two-person scenes in Fefu's kitchen, study, a bedroom, and on the lawn, before reassembling as one group for the third Act in Fefu's living room. In this and other ways, the play provokes questions about identity, subjectivity, and the potential of women to transform themselves as 'another species' that is mysterious, unpredictable, and as of yet undefined – if they can shed the psychic shackles of domination by men.

Fefu and her friends come together as a group to promote educational reform. Several masterful Fornés plays of the 1980s – *Mud* (1983), *Sarita* (1984), *The Conduct of Life* (1985), *Abingdon Square* (1987) – centre on female protagonists who are trying somehow to educate themselves. Each of them feels some variation of what Marion in *Abingdon Square* expresses as a feeling of 'drowning in vagueness ... I have no character. I feel I don't know who I am' (Fornés 2008: 19). *Mud* takes place in an unadorned wooden room that reflects the impoverishment of its rural inhabitants, Mae and Lloyd, dirt farmers who are mates in an animal-like way. Mae is illiterate and going to school to learn how to read so that she can fill up the hollowness she feels inside. Both *Sarita* and *Abingdon Square* present coming-of-age stories. Sarita is a Cuban-American girl growing up in the South Bronx who is the victim of her uncontrollable attraction to a lover who abuses and abandons her again and again. Marion is a child bride who marries a well-to-do gentleman old enough to be her father. When her schoolgirl fantasy of a clandestine love affair becomes a flesh-and-blood reality, she, too, is caught between an undeniable passion and a personal moral imperative.

In *The Conduct of Life*, Fornés' most overtly political play, it is the character of Orlando who is possessed by an absolute sexual desire. A Latin-American military officer who tortures political prisoners, he kidnaps a girl (Nena) off the streets, locks her up in his basement, and rapes her as his appetite demands. His unknowing wife Leticia, frustrated in a loveless marriage, memorizes political speeches and aspires to attend university, explaining 'I would like to be a woman who speaks in a group and have others listen' (Fornés 1986: 70). Here again, the pursuit of learning and the attempt to command

language is the perceived path to self-realization. Young or in mid-life, poor or privileged, these Fornés heroines are caught up in a process of coming to know, which is tantamount to bringing themselves into being. Their effort to articulate themselves and to achieve clarity, agency, a sense of identity and even a state of grace runs into obstacles that are formidable and bring them to ruin. The plays end in death and dying, but in the process they demonstrate Fornés' ontological interest in the conduct of life.

In the 1990s, starting with *What of the Night?* (1989), Fornés moved from central female figures caught in a crucible of emotion to focus on communities of characters struggling to survive in the face of moral, material and spiritual decay. 'Is this the end of the world?' asks Rob in *Terra Incognita*, revealing a millennial anxiety that runs through the later plays (Fornés 2007: 80). Three of them – *Enter the Night* (1993), *Terra Incognita* (1997) and *Letters from Cuba* (2000) – feature trios of caring friends whose bonds are strengthened and souls are troubled by the harshness that surrounds them. Lack of compassion – the capacity to feel as another feels – emerges in these plays as a primary reason why the future of civilization is in doubt. Still, there is a joy in life at the heart of these plays, reflected in part by characters who are artists. Rob in *Terra Incognita* is an amateur playwright. In *The Summer in Gossensass* (1998), Elizabeth Robins and Marion Lea are English actresses fascinated with Ibsen's *Hedda Gabler*. The three friends in *Letters from Cuba* are a dancer, a poet and a designer. The will to create – the will to use word, image and gesture to express a sense of being in the world – becomes a form of resistance against the forces that would destroy it.

Letters from Cuba earned Fornés her ninth Obie award, more than any downtown theatre artist except for Sam Shepard. Throughout her career, well beyond the movement itself, she remained the quintessential Off-Off-Broadway playwright, an outsider artist making work with whatever materials were at hand and insisting on the freedom to follow her impulses. Her legacy continues to be felt not just through her body of work but through her influence on playwrights and playwriting. She taught for many years at INTAR in New York, where her Hispanic Playwrights-in-Residence Laboratory helped to launch a generation of Latino/a playwrights, including Migdalia Cruz, Nilo Cruz, Eduardo Machado and Caridad Svich. She was a mainstay at the Padua Hills Playwrights Festival in Southern California and in great demand for short-term workshops and classes offered by universities and writers' groups all over the United States. Playwrights from David Henry Hwang to Paula Vogel to Tony

Kushner to Sarah Ruhl have acknowledged her influence. She became celebrated for a series of playwriting exercises designed to help writers access the unconscious mind as a source of inspiration and a reservoir of untapped experience.

The unconscious mind – as psyche, as imagination, as soul – was one of her most enduring subjects as well. While her plays demonstrate a genuine concern with various hardships and injustices of the material world (abuse of power, pollution and disease, subjugation of women, systemic poverty), she maintained a steady focus on the existential predicament of characters with an inchoate sense of self, struggling to balance will and appetite, ignorance and innocence, intimations of beauty and a better world to come with the harsh reality of the present.

<div style="text-align: right">Scott T. Cummings</div>

Key works

Fornés, María Irene (1971) *Promenade and Other Plays*, New York: Winter House.
——(1986) *Plays*, New York: PAJ Publications.
——(1992) *Fefu and Her Friends*, New York: PAJ Publications.
——(2007) *Letters from Cuba and Other Plays*, New York: PAJ Publications.
——(2008) *What of the Night? Selected Plays*, New York: PAJ Publications.

Further reading

Cummings, Scott T. (2013) *María Irene Fornés*, Abingdon: Routledge.
Delgado, Maria M. and Svich, Caridad (eds.) (1999) *Conducting a Life: Reflections on the Theatre of María Irene Fornés*, Lyme: Smith and Kraus.
Kent, Assunta (1996) *María Irene Fornés and Her Critics*, Westport CT: Greenwood Press.
Moroff, Diane Lynn (1996) *Fornés: Theater in the Present Tense*, Ann Arbor: University of Michigan Press.
Robinson, Marc (ed.) (1999) *The Theater of María Irene Fornés*, Baltimore: Johns Hopkins University Press.

BRIAN FRIEL (1929–)

Inarguably, Brian Friel is the most influential Irish playwright of the late twentieth century, whose dramaturgical achievements in terms

of form have influenced subsequent generations of theatre practitioners in Ireland well into the twenty-first century. Although he began his working life as a teacher, success in his part-time literary career in the 1950s as a short story writer (with publications in *The New Yorker* magazine) enabled him to move into full-time writing. His first dramatic works were for radio, produced by BBC Northern Ireland in 1958, but it was in 1964 with the Gate Theatre, Dublin, production, in association with the Dublin Theatre Festival, of his play *Philadelphia, Here I Come!* that Friel came to prominence as a major writer for the stage. The play became both a critical and commercial success, being the longest running Irish play on a Broadway stage on its transfer from Ireland. Just as John Osborne's play *Look Back in Anger* (1956) is often cited as being a watershed moment in British theatre, so, too, is *Philadelphia, Here I Come!* in Irish theatre. Although it does not coincide with any major moment of political crisis (as was the Suez crisis to Osborne's play), Friel's work spoke to the contemporary moment like no other play of its generation, touching on the nerve of perpetual emigration of Ireland's young people.

In many ways *Philadelphia, Here I Come!* encapsulates all the major themes of Friel's work, focusing on loss and most significantly on memory. The play's significant dramaturgical feature is the double embodiment of the central character Gar O'Donnell's public and private selves. On stage, two actors wrestle with the character emotionally: the public Gar quelling the desires, and sometimes rage, of his private self. The play takes place in the fictional town of Ballybeg, the setting of many of Friel's major plays, in his adopted County Donegal. It is set primarily in the living quarters at the back of a country shop run by Gar's laconic father, S.B. O'Donnell. The lack of communication between father and son is one of the central points of tension in the play as Gar's father cannot communicate to his son about anything other than the daily grind of running a business. The audience meets the action on the eve of Gar's permanent departure for the USA in which the two halves of Gar reveal how he refuses to turn into his father. The play also includes flashbacks to Gar's relationship with his girlfriend Kate and to a visitation from his US relatives who prompt his emigration. The interplay of Gar's two selves provides much of the comedy but this is offset by the affectingly tragic scenes in the play, between father and son, who try but fail to communicate what the imminent loss of each other will mean to them:

PUBLIC: What ever happened to that aul boat on Lough
 na Cloc Cor?
S.B.: What's that?
PRIVATE: Again!
PUBLIC: That aul blue thing that used to be up on
 Lough na Cloc Cor – an aul blue thing – d'you
 remember it?
S.B.: A boat? Eh?

 (Friel 1965)

Gar tries but his father fails to join him in a shared memory. In many
respects the play is highly political in its backdrop of emigration and
in its intergenerational misunderstandings. The play's more universal
reach resides in the fact that Gar does not need to emigrate financially
like so many young people from rural areas had to do in the past; he
does so for personal growth. The preceding decade (1950s) saw a
sharp rise in outward migration and provided a contextual resonance
to which this play spoke. Although outward migration was reversed
for more than a decade from the mid-1990s, the economic collapse of
the country from 2007 provided once more a renewed context for
the production of the play's central themes of love and loss.

Subsequent plays in the late 1960s and early 1970s continued these
themes of love and loss from the point of view of personal memory.
One of the most often performed plays by young people is the first part
of Friel's 1968 play *Lovers: Winners and Losers*. In *Winners*, we encounter
teenagers Joe and Mag revising for their exams on a hilltop and planning
their future, but we learn from two onstage narrators their subsequent
reality was less than ideal: Mag would become pregnant by Joe and both
would be expelled from their respective schools. Pregnancy out of
wedlock was a huge taboo in Ireland at the time and for Friel to stage
such a situation was a significant socio-political risk. The tragedy is
compounded further when the narrators reveal that the two young
lovers will be drowned in a lake. It is never explained if this was an
accident or if they committed suicide (another taboo subject). A further
taboo was broken by Friel's 1971 play *The Gentle Island* that featured two
of the first gay characters on the Irish stage and the play itself explores
homophobia and bigotry against a backdrop of the sterility of emigration.

Friel's most overtly political play was produced by the Abbey
Theatre in 1973 and focused on the then current conflict in Northern
Ireland. *The Freedom of the City* begins with an enquiry into the deaths
of three unarmed citizens who were killed by British security forces in
Derry and suggestions that they were lawfully killed because they

were armed. Flashback scenes reveal the reality of the situation in which three unarmed civilians sought refuge from the violence and tear gas in the mayor's parlour of Derry's Guildhall, only to be mistaken for terrorists occupying a civic building. The play was produced one year after the fateful events of what is now commonly known as Bloody Sunday in which 13 unarmed civilians who had been involved in a civil rights march in Derry were shot dead by soldiers of the British Parachute regiment. Here we see Friel's use of the memory trope to expose how the remembering of past events can be used for political purposes.

Friel's dramaturgical form took a new turn in 1980 with his play *Translations*, produced by Field Day, the company he set up together with actor Stephen Rea. The company's aim was to explore theatrically issues of national identity against a backdrop of the ongoing social and political crisis in the North, and the attendant violence of that crisis. *Translations* is set in a 'hedge school' in Friel's fictional Ballybeg, but this time in the 1830s at the time of the British Ordnance Survey mapping of Ireland, a mapping that was carried out as a military operation and involved the Anglicization of Irish place names that took no account of their meaning in Irish. Although the Irish characters speak English in the play, encounters with the British army clearly show that audiences are meant to read the Irish actors' English as the Irish language and this lack of understanding while speaking the same language provides an ironic moment of comedy in the play. The play centres on the schoolmaster Hugh who is devoted to the Irish language but also to Greek and Latin, and his two sons; Owen is assisting in the Ordnance Survey, while Manus stubbornly refuses to engage with the colonial project. Central to the drama is Lieutenant Yolland of the British Army who is educated enough to understand the level of destruction the Anglicized mapping is doing to the Irish language and culture. His passion for the culture and his desire to learn eventually leads to him falling in love with local girl Máire. Máire's Irish suitor Manus is angered by the emerging relationship between her and Yolland, although he fails to take any action other than to run away when Yolland goes missing. This escape by Manus is read as an act of guilt. The response of the British is to threaten the destruction of livestock and evictions and one of the most poignant scenes features dumb Sarah who tries to warn of the imminent danger. Sarah, dumb and mute like Kattrin in Bertolt Brecht's *Mother Courage*, symbolizes the effect of the colonial project.

While the dramatization of memory and the place of nostalgia in contemporary Irish theatre would be continued in Friel's writing, his

Tony award-winning 1990 play *Dancing at Lughnasa* would shift historical focus one century along from *Translations* to Ballybeg in the 1930s and feature another significant formal expression of what is suppressed. This is another memory play that features the contemporary intervention of Michael Evans who looks back in contextualizing monologues to his childhood growing up in the summer of 1936 when he was seven years old. He lived with his mother Christina Mundy and her sisters, all unmarried, as a child born out of wedlock (another taboo of that generation). The women's lives are caught in conflict; for some, love and perhaps marriage is still a possibility, while for others the possibility has been suppressed. They also live with their older brother, Father Jack, who has returned from Uganda where he had been working as a missionary. He returned suffering from malaria and experiencing a loss of faith. The other man to make a brief appearance is Welsh travelling salesman Gerry, Michael's father.

The women are captured at a time of imminent change. A new factory threatens the cottage sewing industry of the women, the elder sister's teaching position is insecure, and the men over whom the women fantasize never materialize apart from Michael's father's momentary visit. The adult Michael reveals how severe the change was to become but the flashback scenes provide an ironic counterpoint of possibility. Central to their lives is the arrival of a radio, which they call 'Marconi' (after the name of the radio manufacturer) and this brings intermittently into the house the sounds of the outside world to which the women at one moment of gay abandon engage in a wild dance around the kitchen, pagan-like in appearance and most definitely antithetical to the decorum that their religious education had trained them. The dance is one of the most celebrated moments of any twentieth-century Irish play in which words give way to the physicalization of desire. While Gar Private in *Philadelphia* voiced that inner desire in Friel's earlier work, here the women do not voice it but embody it. The unspoken and perhaps irrational is presented as a release from the strictures of a society desperate for change. But, as Michael reveals, the women are cast into the direst of economic circumstances and the play ends on a sombre note of reflection of innocent times. Lughnasa is a Celtic ceremony held in the month of August and featuring the lighting of bonfires, feasting and dancing. It is one of many pagan ceremonies that clash with Catholic teachings and their sober values. The external influences purveyed by the clearly foreign-named radio and the music it brings into the house is a direct challenge to the rationality of Christianity, as

demonstrated by the abandon of the women to it, and compounded further by Father Jack's loss of faith. Father Jack still speaks of Uganda as home, and Ballybeg and Ireland as foreign. As Helen Lojek notes, 'it is Ballybeg that has transformed the aunts, stunting their growth and possibilities so that only through Marconi's voodoo are they able to grasp again some sense of life's possibility and passion. The madness of dancing in the moonlight may be the only source of sanity left to them.'[1] But their moment of dancing release is in the private sphere of the home just as Gar Private's irreverent goading of his public self in *Philadelphia* is irreverently and transformatively locked in, with emigration the only route to escape. As many of Friel's plays shift from present to past, it is the monologue form of the direct address to the audience that truly drives home how much personal sacrifice ordinary Irish people have endured through time.

<div style="text-align: right">Brian Singleton</div>

Note

1 Helen Lojek (2004) 'Brian Friel's Sense of Place', in Shaun Richards (ed.) *The Cambridge Companion to Twentieth-Century Irish Drama*, Cambridge: Cambridge University Press, pp. 177–190 (quote from p. 188).

Key works

Friel, Brian (1965) *Philadelphia, Here I Come!*, London: Faber and Faber.
——(1981) *Translations*, London: Faber and Faber.
——(1990) *Dancing at Lughnasa*, London: Faber and Faber.
——(1992) *The Freedom of the City*, Oldcastle, Co. Meath: The Gallery Press.
——(1994) *Molly Sweeney*, Oldcastle, Co. Meath: The Gallery Press.
——(2001) *Faith Healer*, London: Faber and Faber.

Further reading

Murphy, Paul (ed.) (2009) *Irish Theatre International*, 1(2) (Special Edition: Brian Friel).
Pine, Richard (1999) *The Diviner: The Art of Brian Friel*, Dublin: University College Dublin Press.
Roche, Anthony (2006) *The Cambridge Companion to Brian Friel*, Cambridge: Cambridge University Press.
——(2011) *Brian Friel: Theatre and Politics*, Basingstoke: Palgrave Macmillan.

ATHOL FUGARD (1932–)

Athol Fugard's work is best known for having borne witness to the experience of black and white South Africans during the years of racial segregation known as Apartheid. His lengthy career in the theatre – which includes acting and directing as well as writing – extends back to the performance of his first extant play, *No-Good Friday*, in 1958 at the Bantu Men's Social Centre in Johannesburg. From early on, Fugard experimented with improvisational methods for devising drama, working against his country's Apartheid laws through his collaborations with black actors such as Zakes Mokae, John Kani and Winston Ntshona. Fugard made South African theatrical history by acting with Mokae in *The Blood Knot* (1961) and with the latter two he pioneered – in *Sizwe Bansi is Dead* (1972) and *The Island* (1973) – the distinctive genre of the South African 'workshop' play. In addition to his collaborative work exploring the experiences of black and mixed-race South Africans, Fugard has single-authored many plays chronicling the ways in which Apartheid has also affected whites, including *A Lesson from Aloes* (1978) and the autobiographically-based *'Master Harold' ... and the Boys* (1982). With the dismantling of the apartheid system from 1990 onwards, Fugard continued to investigate the psychological wounds it created in *Playland* (1992) but has also increasingly authored more 'inner', sometimes autobiographically based dramas such as *The Captain's Tiger* (1998) and *Sorrows and Rejoicings* (2002). In some of his more recent plays – notably *Victory* (2008), *Coming Home* (2009) and *The Train Driver* (2010) – he has highlighted the failure of the African National Congress (ANC) in government to improve the lot of the non-white majority and has given expression to what seems to be his growing disillusionment with post-Apartheid South Africa.

While Fugard's reputation is inevitably linked to his recording of the human consequences of South African Apartheid, another distinguishable aspect of his oeuvre has been his lifelong fascination with an existentialist vision that was initially inspired by his reading of Albert Camus. Fugard's preoccupations with chronicling the oppressions of Apartheid and exploring human behaviour in terms of selfhood and social role-playing have not only been juxtaposed but persistently interwoven. In his *Notebooks* he writes of how, at its best, the combined efforts of the writer and the actor can create 'the reality of a truly living moment in theatre' when 'we confronted the Nothingness of space and silence with our Being' (Benson 1983: 171). Although very much an artistic activist whose priority was to

show the human cost of Apartheid, Fugard has always absorbed his social and political agenda into his investigations of a larger existentialist sense of individual subjectivity and relationship.

The most powerful of Fugard's early, 1960s plays are *The Blood Knot* (1961) and *Boesman and Lena* (1969). Although both are firmly rooted in the discrimination and violence of Apartheid, Fugard was already framing its oppression within existentialist motifs. Zach and Morris, the differently pigmented brothers of *The Blood Knot*, spend much of the action role-playing various scenarios based on the playing of 'whiteness' and the 'difference' between them. Tied to Zach by the blood knot, Morris has decided before the action of the play begins to give up 'passing' as white and has returned to the limitations of life with his brother in their shared shack. What has made him do this, he says, was his dream visions of Zach's eyes, 'always wet with love, full of pity and pain' which made him turn his back on the prospect of freedom that passing as white gave him (Fugard 1978: 79). Rather than play the role in real life, he can now only play out difference in dangerous games featuring abuse and threat by the brothers. The significance of eyes, and of having someone witness to your life, is again a motif of *Boesman and Lena*. As Lena, the victim of apartheid but also of Boesman's violence, tells the old man: 'Eyes, *Outa*. Another pair of eyes. Something to see you' (Fugard 1978: 262). Even if it is only the uncomprehending old man or the dog that came to sit and watch her as Boesman slept, Lena demands that her suffering, victimized life be witnessed by another.

In *Sizwe Bansi is Dead* (1972) and *The Island* (1973), the two collaborative plays that secured Fugard's international reputation, the significance of role-playing is explored more concretely in the context of the severity of Apartheid oppression. In the first, John Kani played Styles, a former factory worker who now has a small township photographic studio, the 'strong-room of dreams' in which he helps his customers create the selves they wish to project to others. When he first enters Styles' studio, Sizwe (played by Winston Ntshona) has no idea of how to be expressive enough theatrically to image his 'dream' for his wife back in King William's Town. As the play demonstrates its own extraordinary use of theatrical versatility, the audience witnesses the process through which Sizwe Bansi has changed his identity to become Robert Zwelinzima. What makes this necessary is the Apartheid passbook system: Sizwe's passbook is invalid, unlike that of the dead man Sizwe and Buntu come across in the alley outside Sky's bar. Although Sizwe is deeply reluctant to disavow his true identity and adopt Robert's, Buntu finally persuades

him that in a society where, for whites, black men are interchangeable, such an extreme form of social role-playing makes sense in order to survive. The play ends on an optimistic note in Styles' studio, with the image of Sizwe Bansi, who is now 'dead', striding through the City of the Future as Robert Zwelinzima. *The Island* develops further the idea of the need for theatricality as a mode of survival in Apartheid South Africa, this time in an even more extreme context than in *Sizwe Bansi is Dead*. The place of the title is Robben Island, notorious for the prison that housed so many opponents and victims of Apartheid, including Nelson Mandela. If, in *Sizwe Bansi*, white South Africa is presented as indifferent to the individual identity of blacks, in *The Island* imprisonment on Robben Island threatens those who have resisted the system with annihilation of even their sense of selfhood. Although Winston (the actors kept their own names) will most likely one day lose all sense of his own identity – like another prisoner, old Harry – his initially unwilling participation in an improvised version of Sophocles' *Antigone* (c. 441 BC) allows him to overcome his despair at the fate that awaits him and to honour his commitment to the cause that has made him a prisoner.

From the mid-1970s Fugard turned from his collaborative 'workshop' productions with Kani and Ntshona to single-authored plays in which his dramatic writing became more introspective and sometimes explicitly autobiographical. Neither *The Road to Mecca* (1984), which marks Fugard's recurrent preoccupation with the artist-figure and the creative process, nor *A Place with the Pigs* (1988), subtitled *A Personal Parable* and generally understood to be Fugard's exploration of his alcohol dependency, are directly connected with the Apartheid experience. But *'Master Harold' ... and the Boys* (1982) combines the deeply personal with the human relations of Apartheid in a play that many reviewers and critics have regarded as his masterpiece. Based on an incident in Fugard's early life, when he insulted his mother's black servant who was also the closest companion of his younger years, *'Master Harold'* deals with a personal betrayal that is also the ugly internalization of Apartheid racism. What provokes Hally's action is the sense of shame and humiliation aroused in him by his drunken and crippled father, who is about to return home from hospital. Alienated from his own father, Hally turns his contempt onto his father-figure, Sam, rejecting his offer of forgiveness for the demeaningly racist joke he has targeted at his black friend. Sam reminds Hally of the occasion when they were flying a kite together and Sam refused to join him on the bench – the reason being, he now points out, that it was a 'whites only' bench. And he

warns Hally that, although he can choose to leave that bench any time he chooses, he is in danger of 'sitting up there by yourself for a long time to come, and there won't be a kite in the sky' (Fugard 1983: 58–59). In a play in which the image of ballroom dancing symbolizes a world of harmony, without collisions, the final image is of the two black servants dancing together as they prepare for their ballroom dancing competition, Hally having excluded himself from any possibility of reconciliation or togetherness.

The end of Apartheid and election of the ANC government in no way diminished Fugard's creative energy, even if the long hoped-for political change signalled for South African theatre generally the need for a radical change of artistic tack. Always a masterful exponent of small-cast, one-location drama, Fugard moved to writing plays often featuring only two or three characters and in which dramatic action is frequently subordinated to a primarily narrative drama in which memory, dreams, desires and guilt are in one way or another recurrent preoccupations. Much of his post-Apartheid drama is set in the Karoo, the semi-desert area in South Africa that is dear to Fugard's heart; in particular, the village of New Bethesda, where Fugard has a house, features almost as a character in its own right in plays such as *Valley Song* (1996), its 'sequel' *Coming Home* (2009), *Sorrows and Rejoicings* (2002), *Victory* (2008) and his most recent play, *The Blue Iris* (2012). This more recent drama has had a mixed critical reception, some reviewers finding Fugard's writing dramatically somewhat inert, overly symbolic and at times sentimental. But in his more successful efforts, for example *The Train Driver* (2010) – which the playwright himself considers among his most important plays – Fugard continues to combine the moral critique of South African realities with existential intensity that is characteristic of his best earlier work. Based on an actual event in 2000, the play focuses on a white working-class South African, Roelf Visagie, the driver of a train that has killed a nameless woman and her baby, and his search to find where she has been buried. He arrives at a squatter camp graveyard with only one intention – to stand over the woman's grave and curse her for what she has done to his life. Disturbed and confused, haunted by the vision of her eyes looking at his just before the train hit her, the driver is taken in by the old African, Simon, who digs the graves in the cemetery and who is concerned that the white man will become the victim of local gang members. Having gained some insight into the lives of the inhabitants of the squatter camp, Roelf finds the nature of his quest changing; no longer wishing to swear at her, he now wants to 'claim' the woman and child who were of so

little account in the 'new' South Africa that their bodies remained unclaimed and were buried where the nameless lie. But Roelf's symbolic act of burial of another nameless body, as if it were the dead woman's, ends not in his winning peace and a kind of reconciliation but in his death at the hands of the gang members and, in a final bitter twist, in Simon paying a dreadful price for his help to the white man.

Brian Crow

Key works

Fugard, Athol (1978) *Boesman and Lena and Other Plays*, Oxford: Oxford University Press.
——(1983) *'Master Harold' ... and the Boys*, Oxford: Oxford University Press.
——(1983) *The Train Driver and Other Plays*, New York: Theatre Communications Group.
Fugard, Athol, with Kani, John and Ntshona, Winston (1974) *Statements: Three Plays*, Oxford: Oxford University Press.

Further reading

Benson, Mary (ed.) (1983) *Notebooks 1960/1977 Athol Fugard*, London: Faber and Faber.
Walder, Dennis (2003) *Athol Fugard*, Tavistock: Northcote House Publishers.
Wertheim, Albert (2000) *The Dramatic Art of Athol Fugard: From South Africa To The World*, Bloomington: Indiana University Press.

JEAN GENET (1910–1986)

Genet is best known for being an orphan, criminal and homosexual. While these biographical details detract from the remarkable oeuvre of this playwright, novelist, filmmaker, political essayist and activist, they nonetheless offer a means with which to identify some of his theatre's main features.

The characters who populate Genet's theatre are, like himself, underprivileged, marginalized or dispossessed: criminals in *Deathwatch* (*Haute surveillance*, 1949), *Splendid's* (1953, published 1993) and *The Penal Colony* (*Le Bagne*, 1958, published 1994); servants in *The Maids* (*Les Bonnes*, 1947); revolutionaries in *The Balcony* (*Le Balcon*, 1956); people of African origin in *The Blacks* (*Les Nègres*, 1958); colonized

Arabs in *The Screens* (1961). *Saint Genet Actor and Martyr* (1952), by French philosopher Jean-Paul Sartre – a heavy influence on Genet – notes how Genet, an orphan, was of inferior status to the inhabitants of the village where he was fostered. Genet consequently rejected a world that had rejected him. Likewise, throughout his theatre, his characters challenge power hierarchies.

Genet's characters threaten hierarchies most notably through transformation. By putting on other figures' costumes, or reciting other people's lines, maids become mistresses, prostitutes become queens, plumbers become police chiefs. These theatrical role-plays and ceremonies highlight the ritualized nature of human identity, which comprises the enactment of social roles. Genet suggests that this performance of identity be foregrounded through highly stylized acting, costumes and set. And another key characteristic of his theatre is its anti-naturalism. In one of his numerous theoretical texts on theatre, 'Letter to J.J. Pauvert', Genet describes the importance of the concept of Catholic Mass, where a piece of bread becomes the body of Christ. When Genet began writing in the mid-twentieth century, European theatre was dominated by realism. Genet favoured Far Eastern theatre, where theatricality – the overt playing of roles – is accentuated with ornate costumes and choreographed movement. The spectator should simultaneously believe in the character, and see the actor, like the communicant consumes the body of Christ, and tastes the bread. Instead of a theatre that 'reflects too exactly the visible world, the actions of men', Genet aspires towards a theatre of metaphor, symbols, poetry (Genet 2003: 47). The representation of outcasts, transformation, the theatricality of identity, and an overtly stylized aesthetic, are thus elements that characterize Genet's plays, the most important of which are presented here.

Like Genet's novels *Miracle of the Rose* (1946) and *Querelle of Brest* (1947), *Deathwatch* (1949) treats the prison underworld to which Genet belonged until his presidential pardon in 1949. Three inmates share a cell. Green Eyes is a murderer, commanding the respect and awe of the other two, Lefranc and Maurice. However, Genet never resorts to type. Green Eyes is both tough and effeminate, performing dances and describing how he wore lilac in his hair when he committed the murder. In a game of domination and submission, his cellmates compete for his attention, culminating in Lefranc killing Maurice to impress Green Eyes. Each character attempts to control the others by acting in a dominant manner. The theatricality of their actions is highlighted, since the proceedings are watched through the door by a spectator, the Prison Guard. Never happy with his first

play, Genet redrafted it until his death, perhaps because he never attained a workable tension between its neo-classical unity – one space, and a couple of hours – and its poetic opaqueness, that refracts into a kaleidoscope of unanswered philosophical questions on abjection and saintliness, identity and performance. *The Maids* (1947), his most staged play, perhaps achieved this balance.

The Maids, too, displays an apparent neo-classical simplicity, taking place in one bedroom over one evening. Moreover, an Aristotelian plot seems to emerge in the opening scene: a maid, Claire, and her mistress, Madame, struggle to dominate each other. Who will prevail? Yet, Genet's play contains no readily identifiable conflict. Dialogue between maid and mistress shifts in tone. The reader/spectator realizes that Claire is Solange, play-acting her sister Claire, and Madame is Claire. Each night when the real Madame goes out, Claire and Solange – two maids – dress in her gowns and enact a fantasy, a kind of black mass, where one kills Madame. Since it is enacted nightly, the play's apparent linearity is replaced by an irresolvable circularity typical of Genet's contemporaries, Beckett and Ionesco. On this particular evening, the maids will proceed from fantasy to reality. Claire will poison Madame's tea, becoming an heroic assassin. Solange, although innocent, will accompany her to the penal colony. Together, they will form 'the eternal couple of the criminal and the saint' (Genet 1989: 63). But Madame breezes in and out, not taking a sip. Rather than being assured of their identities, the maids are determined by the whims and desires of others. Claire exclaims to Solange, 'I'm sick of seeing my image thrown back at me by a mirror, like a bad smell. You're my bad smell' (Genet 1989: 61). The maids' rehearsed and real hatreds of Madame blur in a fog of composite identities, as Claire steps into Madame's dress and drinks the poisoned tea. All behaviour is theatrical; no identity is clearly defined or stable.

With *Elle* (*She*, written 1955, published 1989) and *The Balcony* (1956), Genet's theatre turns from the personal existential crises of criminals and maids, to more political, social themes. In the first tableaux of *The Balcony*, an archetype of authority – Bishop, Judge, General – dons his ceremonial attire and wields his power over his subjects. In a key scene later in the play, the Bishop is to pose for a photograph, as if receiving Communion. Since he has no holy wafer, the Photographer takes the General's monocle and places it on the Bishop's tongue (Genet 1991: 76). As long as the image pleases, the tawdry reality behind it is irrelevant. And the reality is tawdry. The confusion of registers on stage – Bishop's robes and black lace; Judge's wig and whip – reveals the figures to be members of the

public enacting their sexual fantasies at Madame Irma's brothel. The discrepancy between image and reality becomes blatant when the Queen and her regime are deposed by rebels, and Irma and her customers succeed them. Queen, Bishop, Judge and General are in reality brothel madam, banker, clerk and gasman.

Unlike Irma's clients, the rebels supposedly do not play-act. However, they, too, are obsessed with image. Their leader Roger dresses in a replica uniform of his arch adversary the Police Chief, draws a knife, and castrates himself. However, instead of destroying his enemy, the Police Chief, Roger makes his image the object of fantasy, hastening his entry into the pantheon of figures most revered or reviled. This is significant, since the Police Chief is a more immediate symbol of authoritarian rule today than a bishop, judge or general. The play is a meditation on the theatricality of power, whether institutionalized or revolutionary. And since Genet's stage directions recommend that a chandelier – which features in the auditorium of many bourgeois theatres – be present throughout, he includes the audience in his philosophy of theatricality.

Genet's earlier plays are set in seemingly naturalist locations – prison, bedroom, brothel, hotel (*Splendid's*) – although the confusion as to characters' identities and the dizzying *mise en abyme* preclude simple naturalist readings or stagings. His late plays openly reject naturalism. In *The Blacks* (1958), time, space and plot are exploded into myriad poetic fragments. Are the blacks Africans or European immigrants? Are they located in a colonial past, in the 1950s reality of the US Civil Rights Movement or in today's context of racial discrimination? In *The Blacks* a company of black actors enacts a ceremony. Half play 'Negroes', who role-play the rape and murder of a white woman whose coffin is centre-stage under a white cloth. The other half play a White Court that conducts the trial of the Negroes. But all meanings in the play are multiple and contradictory. Is the assassination an act of retribution that will release the blacks from their servitude to white masters? Or does it merely endorse the stereotype of blacks as savages? After all, the Negroes partake in cannibalism and voodoo, and act in a hyper-sexualized manner. In *Black Skins White Masks*, postcolonial thinker Frantz Fanon describes how racial prejudices portray people of African origin as brutes and illiterates, whereas his peers included physicians, professors and statesmen. Do Genet's Negroes conform with the play's subtitle, *A Clown Show*, by enacting racist clichés until they become grotesque caricatures? Unlike the founders of the *négritude* movement – Léopold Senghor and Aimé Césaire – Genet resists defining what 'black'

means, even if his play bears this name. Rather, an instability of identity becomes an affirmative rejection of stereotype.

With *The Screens* (1961), the deconstruction of conventional theatrical form is taken to extremes. Sixteen sprawling tableaux, a cast of nearly 100 and an array of locations that Genet recommends be staged in the open air, create a panoramic poem from which certain narratives emerge. The Nettles family comprises Saïd, the poorest man in the region, his mother, and his wife Leïla, the ugliest woman. As the Nettles family falls increasingly into abjection, the prostitute Warda covers herself up in ever more sumptuous robes – a paradox for someone of her profession. Meanwhile, an uprising takes place against a colonial occupation. As in his other plays, Genet's characters cultivate their appearance. The colonial landowner wears padding to enhance his stature, and the soldiers bolster their thighs with sandbags. Even though *The Screens* is not set in any specified country, Genet's denouncement of the use of theatricality by those in power, notably the army, was so incendiary, that the play's Paris premiere (1966), staged only four years after the end of Algeria's war of independence from France, provoked the biggest riots in French theatre history.

The unique strength of Genet's theatre lies in the dynamic balance between his commitment to equality and democracy, identified in the works of political sociologist Lucien Goldmann or postcolonialist Edward Said; and the unstable meaning of his works, identified in deconstructionist readings like Jacques Derrida's *Glas* (1974). His plays offer a caustic critique of the ruling classes, racism, imperialism, but unlike his contemporaries Sartre, Camus or Brecht, he refused to prescribe the parameters of any new political or social order. In his Preface to *The Balcony*, he writes: 'It is not the function of the artist or the poet to find a practical solution to the problems of evil [...]. The work must be an active explosion, an act to which the public reacts – as it wishes, as it can' (Genet 1991: xiv).

Genet's plays have attracted some of the world's most important theatre-makers (see Bradby and Finburgh 2011): Louis Jouvet, France's foremost post-war director, who was the first to stage him (*Les Bonnes*, 1947); Roger Blin, also famous for staging Beckett (*Les Nègres*, 1959; *Les Paravents*, 1966); the Living Theatre (*The Maids*, 1965), Peter Brook (*Le Balcon*, 1960; *The Screens*, 1964); Patrice Chéreau (*Les Paravents*, 1983); Katie Mitchell (*The Maids*, 1999). Since in Genet's theatre, plot and character share centre-stage with costume, set and sound, he has shaped the twentieth-century art of *mise en scène*, where visual and acoustic features are central to theatrical expression. Genet never directed his plays, but wrote multiple texts on staging that,

far from providing answers to the practicalities of production, are poetic meditations on the status of artwork and artist. Genet's legacy spreads beyond theatre production. His resistance to Aristotelian linearity and psychological characterization has influenced generations of playwrights in France, notably Bernard-Marie Koltès, and abroad, like Heiner Müller and Caryl Churchill.

Clare Finburgh

Key works

Genet, Jean (1960) *The Blacks*, New York: Grove Press.
——(1962) *The Screens*, New York: Grove Press.
——(1989) *The Maids* and *Deathwatch*, London: Faber.
——(1991) *The Balcony*, London: Faber.
——(2000) *Théâtre complet*, Paris: Gallimard.
——(2003) *Fragments of the Artwork*, Stanford CA: Stanford University Press.

Further reading

Bradby, David and Finburgh, Clare (2011) *Jean Genet*, London: Routledge.
Finburgh, Clare, Lavery, Carl and Shevtsova, Maria (eds.) (2006) *Jean Genet: Performance and Politics*, Basingstoke: Palgrave.
Lavery, Carl (2010) *The Politics of Jean Genet's Late Theatre*, Manchester: Manchester University Press.
White, Edmund (1994) *Jean Genet*, London: Picador.

PETER HANDKE (1942–)

Peter Handke is an Austrian writer whose work spans many genres: he is a playwright, a novelist, a scriptwriter and essayist, among other things. It was his plays, however, that brought him to prominence in the mid-1960s, together with an outspokenness that would accompany his literary career. Handke's breakthrough came in 1966 when he lambasted the Gruppe 47, an association of post-war German writers, at their annual meeting in Princeton. His speech, that received much media coverage for its iconoclastic critique of well-respected novelists, proclaimed his arrival as an *enfant terrible*. Handke proceeded to realize his rhetorical promise with the play *Offending the Audience* (1966). From this time until 1973, he continued to push the boundaries of what a play could mean, but then stopped writing for

the theatre entirely for the next eight years. His return to the stage has been a chequered affair. *The Long Way Round* (1981) is a mystical meditation on art and nature, and was parodied by Elfriede Jelinek in a novel of 1985. Yet by 1992, Handke had another hit on his hands, *The Hour We Knew Nothing of Each Other*. His most overtly political play, *The Journey in the Logboat, or the Play about the Film about the War* (1999), dramatizes his sympathies for Serbia in the Yugoslavian wars and thus reduces the broader themes of the text itself by loading them with uncharacteristic value judgements. But Handke is an author one dismisses at one's peril. His *Storm Still* (2010), a title that quotes a stage direction from *King Lear*, won the most prestigious prize for new playwriting in the German-speaking countries, the Mülheimer Dramatikerpreis, and was voted 'play of the year' by Germany's *Theater heute* magazine in 2012.

Handke was awarded a prize for 'dramatists' in Mülheim, to add to his many for literature, yet it has often been difficult to call his work 'drama' at all. Hans-Thies Lehmann, in his groundbreaking study *Postdramatic Theatre* (1999; English translation, 2006), defines drama as being both concerned with representation and with structuring time. That is, actors represent characters and actions, the stage represents places and situations, and this all takes place in time schemes whose very nature generates conflicts and tensions. *Offending the Audience* is paradigmatic of Handke's dissatisfaction with the categories of dramatic theatre, and this can be seen in both the form and the content of the play. He asks that the text be performed by four nameless 'speakers'. The play itself is not divided up for the speakers' benefit, rather, Handke merely suggests that they all deliver roughly the same amount of text. Thus, from the outset, he removes the idea of 'character' from the production, and the actors become 'text-bearers'. They are charged with no task other than presenting the words to the audience for their response. His 'Rules for Actors' (Handke 1997: 3), published after the first production, emphasize how the actors should not assume represented identities but take attitudes and behaviour from everyday life, and integrate them into their performance. The words themselves are metadramatic musings on the very play the audience has paid to see. Nothing 'happens' and time is not organized as such. Instead the speeches merely succeed those that have gone before them. The organization of the text is, of course, deliberate, yet its ordering does not develop a plot or a story; instead it accrues ideas. These are often paradoxical: the audience is confronted by the diverse thoughts they might be having when viewing a play about watching a play. However, this is not a purely formal, timeless examination of

theatre. Handke asks questions of the theatre as he finds it in the mid-1960s. In addition, the section that is supposed to 'offend' the audience is a tirade of insults that are historically specific and refers in no small part to the Nazi period. The play certainly achieved its title's aim, and the premiere, immortalized on videotape, provoked a tumultuous reception of boos and cheers. However, in the light of developments in the theatre since that production, one may well ask whether the play would be of anything more than historical interest today.

Offending the Audience tells us much about Handke's subsequent theatrical output. His work is often formally challenging, at odds with the conventions of drama, takes language itself as its theme, has a covert yet undeniably political dimension and consciously acknowledges the presence of the audience. Such impulses can be found in two full-length plays written in Handke's major sustained period of writing for theatre. *Kaspar* (1967) radically retells the story of Kaspar Hauser, the young man discovered in Nuremberg in the early nineteenth century who had apparently grown up in total isolation. Rather than offering a dramatic biography, Handke takes Kaspar's *situation* as his starting point and asks how someone cut off from a world of language acquires the words, structures and usages to negotiate his environment. Over the course of 65 scenes, Handke drafts a process of language acquisition and pits Kaspar against a set of anonymous, offstage 'prompters' who appear to guide him through his difficulties but in fact use language to integrate him into society. Ultimately, Kaspar rebels in the only way he can: he creates nonsense combinations of words in a bid to short-circuit the linguistic logic imposed by the prompters. Yet his last combination, 'goats and monkeys', provides a final sting in the tail. The apparent gibberish, repeated until the stage curtain closes, is actually a quotation from *Othello*.

Kaspar is a cipher, like the speakers in *Offending the Audience*: he has no personality and cannot be considered a character in the traditional sense. Time is indeed structured in that the language-learning process is sequential but there is no 'plot' as such; this is a theatre of situation rather than dramatic tension. Politics also plays a role, as language is revealed not to be a transparent tool but a system that can imprison the subject in the interests of invisible social groupings. This is also a very personal politics: Handke is not concerned with parties or policies but the effects of society on the individual.

On the surface, *The Ride Across Lake Constance* (1971) would appear to have little in common with *Kaspar*. Six actors act out a series of bizarre and baffling episodes on a common set. They play with language and phrases, using them as weapons at times to flummox the others. A clue

to the similarity with *Kaspar* is made in the play's title, which alludes to a nineteenth-century folk ballad. A horseman wants to cross Lake Constance by boat in winter but actually traverses its frozen surface by mistake. When he arrives at his destination, his friends celebrate his achievement, yet once he realizes he has risked his life, he dies of fright. Such is the power of language on consciousness, and this connects the two plays thematically. They also share a lack of interest in the individual as individual. Handke deliberately chooses well-known German actors' names for his *dramatis personae* and notes that he could have taken any names, as long as it was clear that they were actors playing actors. In short, he was again concerned with a process of theatrical disillusionment: he did not want the spectators to be taken in by fictions of identity but invited them to focus on the exchanges themselves. This, like the dramaturgy of *Kaspar*, might sound most Brechtian and, to an extent, it is: Handke does not want the audience to get lost in the lives of characters and their escapades but to stand back and see the bigger picture. Handke did not employ any of Brecht's famous devices and distanced himself from what he perceived to be Brecht's political agenda. Indeed, Handke's politics are not attached to any particular ideology in these plays; he is interested in unmasking political processes rather than nudging the audience in any particular direction.

Handke's 'first phase' of work for the theatre was intense and produced a raft of formal experiments, as described above. Even when he wrote plays with characters, such as *They Are Dying Out* (1973) or *The Long Way Round*, the characters tend to speak in monologues that reveal less about their 'character' and more about rhetorical and poetic structures. The 'characters' are useful vessels for Handke to explore positions, ideas and philosophies rather than inner states or psychology.

His later work is not quite so pioneering and his experimentation is more genteel. *The Hour We Knew Nothing of Each Other* (1992) is a dumb-show, set on a piazza, over which no fewer than 400 figures silently parade. They vary from the recognizable people one meets every day to mythical and Biblical characters. Their sheer number signals Handke's unwillingness to judge the multitude but rather to turn the spectator, rather than the actor, into an interpreter, should he or she wish to accept that role. *Storm Still* (2010) is told by an anonymous 'I' and features 'my grandparents', 'my mother' and four of her siblings. Its form is that of a retrospective prose narrative with direct quotations from the narrator's family. Or at least that is how it seems, as the text sometimes attributes a line to a character 'or whoever'. The story is an unreliable *mémoire* and indicates this clearly throughout a text that flits between different times and mixes dream and reality. That is,

Handke is once again signalling the play's fictional status and inviting the audience to recognize this while watching. Set in Carinthia, Austria, the play carries more than its fair share of autobiographical details about Handke's Slovenian ancestors, yet the narrowness of the first-person perspective actually casts a broader vista on issues of history and national identity. The play is like a black mass or a séance, with figures recalled in a bid to deal with the tragedies the family suffered at the hands of the Nazis and afterwards. At its heart is the tension between the different languages of the speakers, between Slovene and the German imposed on them from above. The play becomes both a memorial to and an act against forgetting those at the margins.

Handke continues to write innovative works for the stage. However, while *The Hour* has proved popular in English-speaking university theatre departments and was staged at the National Theatre in London in 2008, interest has gradually declined in Handke's plays since his explosive entrance as a playwright in the mid-1960s. His ability to combine new forms with a masterly grasp and control of language made him hard to imitate. He can certainly be located in a distinctly Austrian theatrical tradition that treats the performance of language with scepticism. Yet his work cannot be directly linked to that of Hugo von Hofmannsthal or Karl Kraus who went before him, and neither could Jelinek nor Werner Schwab be considered his literary heirs. Handke remains something of a one-off: he was born into a rich literary tradition but remains an outsider; he can write personally yet still connect with larger political formations. Even as he approaches his autumn years, there is little to suggest that he has lost the desire to provoke the theatre and the audience.

David Barnett

Key works

Handke, Peter (1996) *Voyage to the Sonorous Land, or The Art of Asking & The Hour We Knew Nothing of Each Other*, trans. Gitta Honegger, New Haven: Yale University Press.

——(1997) *Plays: 1*, trans. Michael Roloff, London: Methuen.

Further reading

Coury, David N. and Pilipp, Frank (eds.) (2005) *The Works of Peter Handke: International Perspectives*, Riverside, CA: Ariadne.

Hern, Nicholas (1971) *Peter Handke: Theatre and Anti-Theatre*, London: Oswald Wolf.

DAVID HARE (1947–)

Invoking the nineteenth-century French writer Balzac, David Hare describes his purpose as a dramatist, at least in part, 'to provide society with its secretarial record' (Hare 2011: 65). The idea of Hare as a superlative chronicler of the times is resonant of a career that suggests a combination of both penetrating responsiveness, and curious compliance in the face of the shifting ideological coordinates that have shaped political, public and private life in the late twentieth century and early twenty-first.

A graduate of Cambridge University, where he was a student of the Marxist critic Raymond Williams, Hare emerged in the late 1960s as part of the countercultural and alternative theatre movement. Like his contemporaries David Edgar and Howard Brenton, he was part of a new band of activist theatre-workers. These were motivated, for example, by the failed promises of British post-war democracy and consensus; the threat of new forms of imperialism as demonstrated by the American incursion into Vietnam; and the multiple brutalities inflicted in the name of communism in the Soviet Union and Eastern Europe. Hare's early work combined both single-authored plays with collaborative and workshop-based forms of playmaking, and he also co-founded Portable Theatre (1968) and the innovative Joint Stock Theatre Group (1975). Alongside many of his contemporaries, Hare recognized, albeit with notable reservations concerning the politics of collectivism, how this new political climate invited a questioning not only of dramatic form, but also of the familiar *modus operandi* of subsidized mainstream and commercial theatre practices in the UK. Much of Hare's dramatic output in the 1970s – in plays such as *Slag* (1970), *Knuckle* (1974) and *Teeth 'n' Smiles* (1975) – combines contemporary English settings with the weapon of satire to connect personal desolation with the untested promises of emancipation. The action of *Slag*, for example, unfolds in a girls' boarding school, in which three women teachers, Ann, Elsie and Joanne, attempt to realize a radical feminist project. But their utopian dream can only founder because the separatism of the cause is untranslatable to the wider order of things. John Bull observes of *Slag* that 'it is no obvious sense *about* feminism or anything else. It is the sterility of the debate that is stressed' (Bull 1984: 64). Such a remark points to the dangers of reducing Hare's output, even the early plays, to the generic label of 'political theatre', and even to possible reasons for his relative easy assimilation into both the subsidized mainstream and commercial theatre sectors. Even the early play *Knuckle*, set in the Home

Counties, which pastiches the 'whodunit' and film noir to expose the depravities of capitalism, received its first production in the West End. In these formative works, there is a distinct sense of Hare, in his dramatization of individuals – moribund in bourgeois worlds – cultivating a form of political theatre that places at its centre not the Marxist/Brechtian mantra that 'social being determines thought', but the incessant and impossible struggle for individual agency in the face of social exigencies (see Bull 1984)

From the late 1970s onwards, the National Theatre in London regularly began to produce Hare's work, with the enhanced resources offered by a leading state-subsidized institution being directly reflected in the scale of plays. *Plenty* (1978) marked a significant turning point in this respect; a frequently celebrated example of a 'state-of-the-nation play', its post-Brechtian dramaturgy providing Hare with the opportunity to expand his canvas. The play maps, also through manipulating chronology (beginning in 1962 and ending in 1947), the personal collapse of its heroine Susan Traherne, within a series of private and semi-public encounters, closely played out against key national events such as the Festival of Britain and the Suez crisis. Within the timeframe of the play, Traherne is introduced in 1962, sitting over a naked male we later learn to be her estranged husband. The play then reverses to 1943 and we see Traherne working for British Intelligence in France. Scenes charting her slow descent then follow. *Plenty* ends in France, on Liberation Day in 1944, with Traherne extolling how a world, changed for the better, lies ahead. In its epic structuring and emblematic sparseness, *Plenty* certainly demonstrates the resilience of Hare's craftsmanship. But while the play might be read as a challenging dialectic on the fated inter-relationship between individuals and the histories they inhabit, it can also be seen – particularly in terms of its other discernible roots in English-styled dramatic realism – as a natural extension of Hare's 'politics of despair' (Chambers and Prior 1987: 179–188).

The onslaught of Thatcherism in the 1980s, combined with the collapse of democratic socialism as an ideological alternative, presented fresh challenges for Hare and his contemporaries. He not only moved with increasing ease between playwriting, directing and screenwriting, but also briefly turned away from 'England' as the principal source for his dramatic subject matter. *A Map of the World* (1983) is a comedy set in Bombay, and centres on a debate between left-wing idealism and the struggles facing the developing world, within a dialectic that explores the relationship between art and reality. Thematically connected, *The Bay at Nice* (1986) is set in 1950s

Soviet Russia, where Valentina, a former student of Matisse's from 1920s Paris, is asked to verify a painting thought to be by her former tutor – the lynchpin for an examination of the nature of truth, in both life and art. Here, David Hare – perhaps uncertain as to how to respond to the Britain of the 1980s – turns his attention to the life/art nexus, in a semi-reflexive mode of playwriting, a subject that more overtly criss-crosses his published lectures and essays, and a concern that has come into much sharper focus in more recent times. Hare's final dramatic offering of the decade was *The Secret Rapture* (1988), a brooding comedy of manners that places two sisters, the compassionate Isobel – a commercial artist – and the ruthless Marion – a Conservative junior minister – in a conflict that explores the possibilities of human virtue in a world governed by voracity and self-interest.

The early 1990s represented something of a renaissance for Hare. Under the artistic directorship of Richard Eyre, the National Theatre presented 'the trilogy', a five-year research project culminating in the simultaneous staging in 1993 of *Racing Demon* (1990), *Murmuring Judges* (1991) and *The Absence of War* (1993). The Church of England, the English judicial system and the British Labour Party provide the focus here for a careful examination of the various crises facing English institutions. For many commentators, the trilogy also represented a rebirth of political theatre, and particularly the 'state-of-the-nation play'. In *The Absence of War*, George Jones is the Labour Party's idealistic leader, but whose substance lacks style, and who cannot achieve electoral success in a highly mediatized political culture. In this respect the play carries a degree of nostalgia, and even extends Hare's earlier thematic preoccupation with the cul-de-sac nature of idealism. However, the play is also obliquely concerned about the gap between rhetoric and belief, language and truth. In one of the play's key moments, Jones is encouraged to speak about his true passions before the party faithful, but his words begin to fail him, and the leader is forced to return to the 'official' scripted speech. Such a moment is immensely instructive when considered in relation to other key aspects of Hare's dramatic practice.

Fanshen (1975), about the impact of communism on a Chinese village during the tumultuous prelude to the 1949 revolution led by Chairman Mao, takes its inspiration from a factual record.[1] Neo-Brechtian in form and, although utilizing agitprop and documentary theatre techniques that have their origins in Marxist-inspired theatre practices of the earlier twentieth century, *Fanshen* is by no means a

piece of didactic-styled advocacy of the Maoist revolutionary model. Indeed, at the time of its writing, the play invited pointed questions – the Chinese documentary narrative functioning along the lines of a Brechtian alienation effect – of English and European audiences, about the very possibility of the transformation of society. In 2009 Hare penned *The Power of Yes*; subtitled *A Dramatist Seeks to Understand the Financial Crisis*, and based on interviews Hare undertook with key figures and pundits connected to the 2008 global collapse, the play opens with the character of The Author (Hare, played by an actor) inviting the audience to join him on a journey to comprehend the causes of the crisis. Although more than three decades separate *Fanshen* and *The Power of Yes*, and they are the products of transparently different worlds, both foreground a preoccupation that traverses Hare's writing – concerning theatre's ways and means of engaging with 'the real' of the public and political spheres. *The Power of Yes* is an example of one of Hare's more recent forays into 'verbatim theatre', a kind of subgenre of documentary theatre that uses individuals' actual words – from recorded interview or other forms of transcript – which are then fashioned into a play to be re-presented by actors, often in the form of direct address. Verbatim theatre is often inspired by high-profile 'newsworthy' events that draw attention to social injustices. The practice has garnered particular attention, both in Britain and internationally, since the early 2000s, and it is not surprising that Hare has embraced it. It invites dramatists, theoretically at least, to let the utterances of individuals 'speak for themselves', unmediated by the authorial point of view. Thus, in *The Permanent Way* (2003) Hare acts as a conduit for an examination of the toxic and deadly impact of privatization on the British railways. Juxtaposing the testimonies of a range of individuals – including passengers, the grieving victims of rail disasters, union officials and politicians – *The Permanent Way* suggests a form of political theatre that is determined less by the ideological fixity of its author, as it is by the degree of responsibility placed upon audiences to fashion a response to the origins and consequences of, in this case, a national scandal. Hare is quick to defend verbatim theatre against the accusation that it is merely another form of journalism; he argues determinedly for how the theatrical rendition of real life testimony permits the possibility for allegory and metaphor. Interestingly, with *Stuff Happens* (2004) Hare consciously combined 'real speech' with imagined scenes and dialogue in order to investigate the 2003 Anglo-American-led invasion of Iraq. However, he is also deeply suspicious of any dramaturgical or theatrical strategy that might

prohibit the theatre's ability to render an evocative correspondence with everyday life. Hare's comments on adapting the work of Brecht are particularly revealing in this respect. He dismisses the 'paraphernalia of Brechtianism – the placards, the announcements, the forties German music ... The purpose of sandblasting away some of the layers that now cover these plays is not to soften their politics but to reveal them' (in Boon 2003: 138).

An accusation frequently levelled at Hare is that he does not sufficiently interrogate the implications of his method as a dramatist. He has even placed himself at the centre of his drama; thus *Via Dolorosa* (1998) is ostensibly about the Israel/Palestine conflict, but takes the form of a monologue-cum-testimonial, played by Hare, through which the dramatist is able to perform his own moral crisis. Taking the long view, Hare's dramatic practice is certainly a heterogeneous one. Over the past 20 years, the self-consciously political work has been accompanied by a steady trickle of 'well made' plays – such as *Skylight* (1995), *Amy's View* (1997) and *The Breath of Life* (2002) – that have also seen Hare enhance his commercial sustainability, in both the West End and on Broadway. Although it would be an error to separate out these numerous strands in critically appreciating the trajectory of his career, the body of work has established Hare as a major player in modern drama. Not least, David Hare continues to ask important questions about the interrelationship between theatre, politics and society.

John F. Deeney

Note

1 Hinton, W. (1997 [1966]) *Fanshen: A Documentary of Revolution in a Chinese Village*, Berkeley and Los Angeles: University of California Press.

Key works

Hare, D. (1991) *Writing Left-Handed*, London: Faber and Faber.
——(1996) *Plays: 1*, London: Faber and Faber.
——(1997) *Plays: 2*, London: Faber and Faber.
——(2003) *The Permanent Way*, London: Faber and Faber.
——(2004) *Stuff Happens*, London: Faber and Faber.
——(2005) *Obedience, Struggle & Revolt: Lectures on Theatre*, London: Faber and Faber.
——(2008) *Plays: 3*, London: Faber and Faber.
——(2011) *South Downs*, London: Faber and Faber.

Further reading

Boon, R. (2003) *About Hare: The Playwright and the Work*, London: Faber and Faber.

——(ed.) (2007) *The Cambridge Companion to David Hare*, Cambridge: Cambridge University Press.

Bull, J. (1984) *New British Political Dramatists*, Basingstoke: Macmillan.

Chambers, C. and Prior, M. (1987) *Playwrights' Progress: Patterns of Postwar British Drama*, Oxford: Amber Lane Press.

EUGÈNE IONESCO (1909–1994)

Since Eugène Ionesco is considered, notably by Martin Esslin, as a central figure in the 'Theatre of the Absurd', a label also attributed to Beckett, Pinter and the early Genet, it is important to understand this term, whether or not one subscribes to it. An 'absurdist' reading of Ionesco highlights his representation of the seeming pointlessness of life, which inevitably culminates in death. Death prevails across Ionesco's plays, and features in several of their titles: *Tueur sans gages* (*The Killer*, 1959); *Le Roi se meurt* (*Exit the King*, 1962). 'Absurdist' playwrights depict helpless humans, fated to live and die in a godless, hostile universe. This emphasis on suffering arises both from an existential scepticism about the purpose of life, and from these authors' historical backgrounds. The twentieth century witnessed wars and genocide on an unprecedented scale, and peace after World War II (1939–1945) brought only the Cold War's constant threat of nuclear holocaust. This context was particularly relevant to Ionesco. As a teenager, he moved from France to his native Romania, which was engulfed by Nazism, and then in 1942 back to France, which was by this time under German occupation.

While Ionesco's plays emerged from a devastated Europe, they never reference historical or geographical situations. Moreover, Ionesco insisted that it was not the playwright's function to deliver a message on how society should conduct itself (Ionesco 1964: 209–210). Unlike his contemporaries Brecht, Sartre or Camus, he refused to subscribe to party politics, maintaining that the real opposition was not between left and right, both of which committed abuses, but between human rights and totalitarianism. Life in Ionesco's works appears absurd because it leads to death and destruction, and because irrational impulses are inevitable human realities, which wreck attempts to solve society's problems through reform and revolution.

Rather than 'absurd', Ionesco himself preferred *insolite*, or 'strange', since his theatre presents the haunted world of dreams that, for him, constitutes a sharper form of consciousness than logic and reasoning. Indeed, nightmarish scenarios dominate his plays: in *Amédée, ou comment s'en débarasser* (*Amédée, or How to Get Rid of It*, 1954), an inflating corpse invades a whole apartment; in *Le Nouveau locataire* (*The New Tenant*, 1955), removal men deliver more and more furniture, until the new tenant is walled in.

Ionesco wrote more than 30 plays, of which the first are the most frequently staged: *La Cantatrice chauve* (*The Bald Prima Donna*, 1950), *La Leçon* (*The Lesson*, 1951), *Les Chaises* (*The Chairs*, 1952) and *Rhinoceros* (1959). *The Bald Prima Donna* features an apparently everyday scene in a middle-class household between the Smiths and their friends, the Martins. But as in all Ionesco's plays, the distinction between 'normal' and 'abnormal' blurs. This seemingly mundane scene is composed of nonsensical comments and events. The announcement that Bobby Watson is dead is met with surprise, whereas he has been dead for two years; the clock chimes six, then two, then 15. Some critics like Michel Corvin prefer the term 'New Theatre' to 'Theatre of the Absurd', since many post-war playwrights exploded the theatrical conventions of drawing-room dramas. According to Richard Coe (1968), Ionesco reinvented theatre specifically by introducing non-causal chains of words and acts, the play's title being an example. It is hard to imagine a bald female opera singer. In any case, there are none in the play.

The sense that the world is governed by no cause-effect logic is expressed notably through the play's language. Ionesco called it 'the tragedy of language', and it features mechanically repeated truisms, which Ionesco incidentally lifted from an English-language manual: 'The sand caught fire/the birds caught fire/The moon caught fire/The ashes caught fire ... ' (Ionesco 1964: 186–187). Set linguistic forms fail to communicate human thoughts and desires. Moreover, characters do not listen to each other, instead speaking in parallel monologues, and interrupting each other with irrelevant replies. Their only means of communication is naked aggression, characters resorting to screaming and raising their fists. The play ends by beginning all over, as this state of alienation, provoked by the characters' slavish repetition of words and actions, is inescapable. Ionesco translates abstract philosophical notions into literal, bodily projections on stage.

In *The Lesson* (1951), a pupil arrives at a teacher's house for tuition. The pupil is smiling and keen; the teacher is timid. He begins by asking the pupil simple mathematical questions, but his tasks become increasingly nonsensical. He ignores her repeated complaints about

toothache. He interrupts her with interminable monologues, and she lapses into a weary, morose state. His initial niceties cede to anger and aggression, and he finally stabs her to death. As with all Ionesco's plays, *The Lesson* invites allegorical interpretations. The teacher's maid hands him an armband, evoking Hitler's dictatorship. The maid is arguably the real source of power in the play, as she pushes the teacher to the ground. She reveals the fact that the girl is one of 40 murdered pupils, highlighting the mass killings committed by dictators, from Hitler to Stalin. The maid's lover is a priest, also implicating the Church in the violence. And when the pupil dies, her corpse lays with its legs splayed, raising issues of gender politics.

Like many 'absurdist' plays, *The Lesson* is circular: as it ends, the next pupil enters. We live only to suffer and die, and no amount of education will save us. However, Ionesco does not necessarily deny humans salvation. Metaphysical misery is sublimated into a celebration of the human potential for creativity and playfulness. His characters' language may proliferate uncontrollably and disintegrate into nonsense, but the resulting soundscape of rhythmically repeated words produces a joyous musicality liberated from the constraints of logic. Moreover, this nonsensical poetry often provokes laughter: comedy, too, liberates Ionesco's subjects from the potential misery of existence.

According to Ionesco's detailed directions, *The Chairs* (1952) takes place on a semi-circular stage surrounded by a dozen doors and windows. A decrepit man of 95 is asked by his wife, Sémiramis, to tell a story from his past. Illustrating the inane monotony of existence, she has asked him to recount this story every evening of their marriage. She laments that her husband could have been someone great – 'a chief president, chief king, chief doctor, chief marshal' – but has made nothing of his banal life. The story is one of failure, and the story itself is a failure, since the old man cannot recall the details. Perhaps as a final quest for glory, he decides to transmit a message to humanity, that will save the world. In a crescendo of activity, he and Sémiramis welcome invisible visitors of all ages and professions, whom they seat in chairs, brought in through the various doors. Once the throngs are seated, the much-anticipated Emperor arrives, but he is invisible. Next arrives the Orator, whom the old man has engaged to speak on his behalf, but he is mute, or speaks in incomprehensible stutters. As with Beckett's *Waiting for Godot*, a hope, belief or solution is sought, but never found.

This is a potentially pessimistic play. The couple are surrounded by water; they no longer speak to their son. Geographically and

generationally, they are alone in a world of vacuous repetition and stifling material accumulation. Boxed in next to a window by the amassing chairs and crowds, they jump out to their deaths. However, as with all Ionesco's plays, reality and dream, truth and falsity are indistinguishable. The couple say they have a son, and that they are childless; they welcome guests, who are invisible. Perhaps they are delusional or senile. However, rather than being seen as psychologically realist characters, they could be universal, mythical figures who illustrate the incomprehension of humans faced with the unfathomable enormity of existence. Concurrently they manifest hope, through their tenderness towards each other and their vitality, both physical and mental, since they host this albeit failed convention on the meaning of life. And again, apparent tragedy is compensated by comedy. The couple spend much of the play speaking to invisible visitors, providing playful scope for actors, and imaginative possibilities for spectators.

Rhinoceros (1959), too, presents a nightmarish scene, although its political significance is more evident than in Ionesco's other plays. A town is overcome by a plague, which turns its inhabitants into rhinoceroses. Ionesco provides an explanation of the play's genesis and signification in his *Notes and Counter Notes* (1964). When in Romania, he witnessed Nazism engulfing those closest to him. He describes it as a contagion – 'rhinocerositis' – that hardened the skin into a carapace, impenetrable to others' opinions. Avoiding historical specificity, Ionesco wishes his play to be a universal metaphor for 'the idolization of ideologies': any phenomenon – political, religious or other – that stupefies people into fanatically following, instead of thinking for themselves. He warns against ideologies that become idolatry to justify senseless cruelty and injustice. In *Rhinoceros*, characters firstly appear single-minded, but one by one, the colleagues, friends, even girlfriend of the main protagonist, Bérenger, mutate. Ionesco even implicates spectators in this rabid conformism since, when Bérenger describes the herd of rhinoceroses, he looks at the audience.

The only figure to resist the epidemic is Bérenger. Bérenger, who in some respects represents Ionesco, and who recurs across Ionesco's oeuvre – *The Killer, Exit the King* and *Le Piéton de l'air* (*A Stroll in the Air*, 1962) – is an unlikely hero: he is hungover, dishevelled and directionless. His unheroic disposition makes him an Everyman, somebody who could be, or inspire, anyone. Although average, his is exceptional. By resisting the rhinoceroses, he is the only person to preserve his singularity and, in literal terms, not to become dehumanized by conformity. Moreover, he not only prioritizes his own

individuality, but also respects that of others, showing conciliation and compassion towards friends and colleagues before they metamorphose. He is thus the only character with psychological depth.

According to Ionesco, Bérenger resists replacing one ideology with another, by maintaining his own uniqueness. But is Ionesco not naïve in assuming that Bérenger's commitment to independence does not itself become a doctrine? Ionesco has been accused of subscribing to right-wing anarchism, extreme individualism and anti-communitarianism, since he is sceptical of all collective movements. But perhaps Ionesco's politics are not entirely individualistic. His subjects attempt to coexist alongside the freedoms of others, Bérenger being an example of this humanism.

The first production of Ionesco's theatre, *La Cantatrice chauve* at Paris' tiny Théâtre des Noctambules, was a commercial failure that bemused spectators and infuriated critics. In terms of theatre history, however, it contributed crucially towards the wave of 'New Theatre' that systematically blew apart norms of plot, character, language and time. His anti-naturalist aesthetic has attracted directors from Orson Welles, who staged *Rhinoceros* with Laurence Olivier (Royal Court, 1960), to Théâtre de Complicite, who staged *The Chairs* (1998). He has also appealed to directors seeking to satirize political totalitarianism, the most notable example being Jean-Louis Barrault's *Rhinocéros* (1960), where the animal snorting was replaced with the sound of marching boots. Partly in honour of his contribution towards revolutionizing theatre, and also as a tourist attraction, the original productions of *La Cantatrice chauve* and *La Leçon* can still be seen in repertory at Paris' Théâtre de la Huchette.

The themes of the unreflective individual, and of the exploitation of power, which are hurled at the audience like hand grenades in Ionesco's earlier plays, are examined more comprehensively in his theatre from the late 1950s, where the confines of one single room cede to more expansive and fluid dreamscapes. Consequently, his later plays lose his earlier theatre's explosive force. Today, Ionesco has largely fallen from popularity in France, compared with his contemporaries Beckett or Genet, but continues to be read, studied and staged abroad.

Clare Finburgh

Key works

Ionesco, Eugène (1954) *Théâtre I*, Paris: Gallimard.
——(1962) *Rhinoceros, The Chairs, The Lesson*, London: Penguin.

——(1963) *Théâtre III*, Paris: Gallimard.
——(1985) *Théâtre II*, Paris: Gallimard.
——(1998a) *The Bald Prima Donna*, London: Samuel French.
——(2007) *Rhinoceros*, London: Faber and Faber.

Further reading

Coe, Richard (1968) *Eugène Ionesco*, New York: Grove Press.
Gaensbauer, Deborah B. (1996) *Eugène Ionesco Revisited*, New York: Twayne Publishers.
Ionesco, Eugène (1964) *Notes and Counter Notes*, London: Calder.
——(1998b) *Past Present Present Past*, Cambridge, MA: Da Capo.
Smith, Steve (ed.) (1996) 'Ionesco', *Nottingham French Studies*, 35(1).

TERRY JOHNSON (1955–)

Among contemporary British dramatists Terry Johnson may have the strongest claim to be an all-round man of the theatre – as director of musicals as well as straight drama, as adaptor of classics as well as contemporary material and as the writer of original scripts. He grew up near London and attended Birmingham University, where he studied playwriting, and his work reflects the fascination with American culture and with excitingly modern ideas typical of a graduate of his generation. Like many other young writers, his earliest work was staged at fringe venues; since then he has been involved with both London's commercial West End theatre and the more experimental drama associated with the Royal Court Theatre. As a writer, however, his most celebrated works are based upon imaginary meetings between historical figures – a dialogue technique that goes back to Plato. Johnson has the ability to turn historical figures into dramatic characters and philosophical conundrums into jokes. Above all, he appreciates the rich tradition of comedy and his tastes are evident in his career as a director, which has seen him work on plays by Joe Orton and Shelagh Stephenson as well as on adaptations of cinema classics including *The Graduate* (2000) and *One Flew Over The Cuckoo's Nest* (2004).

Johnson's most famous play *Insignificance* (1982) which was adapted for film, directed by Nicolas Roeg in 1985, co-opts four characters from relatively recent American history and sets them in motion. These are Albert Einstein, Marilyn Monroe, baseball player Joe DiMaggio and Joseph McCarthy, the ferociously anti-communist senator. By taking on these cultural monuments Johnson fictionalizes

people who have already achieved the status of celebrity. Although it would be perfectly accurate to describe him as an intellectual writer – since his ease with ideas is on a par with that of Tom Stoppard, Michael Frayn and Alan Bennett, who have also recreated important thinkers – Johnson likes to play with the popular image. He's not above creating a puppet effect simply because that works best with farce narratives. The play's ingenuity lies in the way in which Einstein's theory of relativity (which the actress seems to grasp intellectually) is reflected by theatre's demonstrable ability to manipulate time and space, to reverse causal events and capitalize upon the sparks of energy that can occur when one character's subjective perception of reality clashes with that of another. The critic Michael Billington wondered that if the ideas might sometimes be self-cancelling since 'if knowledge without understanding is a curse, isn't it pushing one's luck to give us so many pop-science demonstrations?' (Billington 1993: 187) but Billington's reservations can be countered by pointing to the sheer persuasiveness of those 'pop-science demonstrations'. Bubble-gum, for instance, becomes, just briefly, the model of the universe. When the McCarthy figure introduces the notion of 'solipsism' and the characters debate their 'reality' in relation to each other we are reminded that all dramatic characters are the projections of a playwright. Yet, Johnson, the invisible mastermind, never reveals his philosophical convictions, only his preoccupations – which invariably include the deeper possibilities of a comedy based on sex. Despite the presence of traditional business in *Insignificance* – the baseball player continually thinks that he's discovered his wife, the actress, in flagrante – this is set against a more modern and 'realistic' awareness of erotic complication. The actress, based on Monroe, is simultaneously aware of her sexual power, should she care to use it, and of her vulnerability to exploitation. Bodily complications are frankly present, including a miscarriage.

Another early work, *Cries from the Mammal House* (1984), is dedicated to the wild man of the alternative theatre, Ken Campbell, whom Johnson knew when they both worked in Liverpool. It is perhaps the strangest of all his plays, yet it already reveals some of his characteristic concerns. The first and third acts are set in a defunct zoo where redundant animals are being euthanized; the second takes place on the island of Mauritius and features satiric commentary on imperialism and the delusory nature of religion. Apart from the Mauritians – ironically anxious to get to England – the main characters, a couple in their thirties, their daughter, and a sibling, are deeply English in that they find it difficult to relate to one another

and find themselves frustrated by their sexual desires. Although its allegorical nature might link the play with, for instance, the work of David Mercer or Lindsay Anderson's later films such as *Britannia Hospital* (1982), what makes this unmistakably the work of Johnson is its extreme and often quite surreal theatricality. In some extraordinarily bizarre scenes humans, imitating chimpanzees, kangaroos, even a praying mantis, perform the rituals of animal courtship without much success. These moments are derived, perhaps, from the training exercises that drama students are sometimes asked to attempt. In the closing moments a concealed dodo is produced on stage and is heard singing. The extinct beast has apparently survived: a far-fetched image of hope as well as of the evolutionary dysfunctionality epitomized by the human zoo that constitutes English society.

Hysteria: Or Fragments of an Analysis of an Obsessional Neurosis (1993) resembles *Insignificance* in that it too acknowledges the ramifications of desire and features another imaginary conversation, this time between Sigmund Freud and Salvador Dali. Although the mainspring of the action is sexual, the political urgency is, if anything, even more pressing since the year is 1938. The play's structure is founded on an hallucination. Freud, a refugee in Hampstead, London, suffering from the cancer that will kill him, is given a morphine dose and dreams of a visit by the daughter of one of the 'hysterical' women he had analysed at the outset of his career. The daughter accuses him of abusing her for his own ends. The arrival of the surrealist painter Dali provides an opposing view of the world based on absurdity rather than rationality. The two men clash in a series of classically farcical events involving missing and mistaken documents, half-naked women locked in cupboards. The technical demands at the end of the play are exceptional: 'sounds of shunting trains compete with music; a drowning cacophony. Grotesque images appear, reminiscent of Dali's work, but relevant to Freud's doubts, fears and guilts. Freud is horrified as the contents of his unconscious are spilled across the stage.' Johnson's final *coups de théâtre* frequently require the absolute demolition of all that the theatrical imagination has constructed before and a return not simply to the mundane but to a world that feels less substantial than may have previously been the case.

Two subsequent plays explore English comic tradition in a spirit at once already culturally distant and warmly remembered. While *Dead Funny* (1994) features the erotic entanglements of suburban couples during the month in which Benny Hill and Frankie Howerd both died (April 1992), *Cleo, Camping, Emmanuelle and Dick* (1998) imagines shenanigans on the set of the famous *Carry On* series of films by

highlighting the relationship between Barbara Windsor and Sid James with Kenneth Williams and others in attendance.

Johnson's more recent work as a dramatist includes *Hitchcock Blonde* (2003), an extremely ambitious experiment that not only takes film as its subject matter but incorporates a considerable amount of video material within the live stage performance. The several interwoven plot situations take place within a range of locales and time periods: in 1999 a film studies lecturer discovers unknown reels of very early Hitchcock films; he examines these on a Greek island with the help of a student whom he wishes to seduce, which he eventually does; in 1959 a blonde woman acts as a body-double for Janet Leigh in the famous shower scene from *Psycho* and eventually strips naked to please Hitchcock who is paralysed by the experience despite her encouraging him with the carefully chosen line 'imagine I'm imaginary'; also in 1959 the same woman stabs her husband in a frenzy although he is eventually resuscitated. It additionally appears to be the case that enough of a 1919 film has survived to suggest that Hitchcock had been obsessed with blonde women long before *Psycho*. Each scenario involves a profoundly sexual but ultimately tragic confusion between image and reality, between violence, eroticism and – in the end – love. In this case the collapse of the apparatus of illusion occurs in a late scene between the blonde double and the voyeuristic director when she aims a cinema projector at him: 'The light blasts his face. They are surrounded with images, all the sequences unearthed. The scenery goes wild to the whirring of the projector. He scrabbles at the light. A gurgling scream.' This suggests a typically bleak view of male sexuality, although the play's ending is mildly ambiguous with the student wishing that the tutor might find satisfaction despite all the contrary evidence that sexual compulsions endlessly repeat themselves.

As its title intimates, *Piano/Forte* (2006) explores the nature of 'doubleness' often to be found in Johnson's work, but here the pairs are more entangled than ever before. The setting is a listed country house, now in disrepair, home to a dysfunctional family. There are two lookalike sisters in their mid-twenties: one is musical but traumatized, basically conventional, the other is volatile, promiscuous, living the hippy life. Their widowed father is a cynical and opportunistic Tory politician about to embark on his third marriage to a much younger and apparently empty-headed model. Any suggestions of Chekhov or of a traditional country house mystery are soon swept away by some outrageously bawdy talk and an Act closure involving aerial acrobatics that are spectacularly erotic even by

Johnson's standards. If this first Act is '*piano*', the second Act is distinctly '*forte*' with a much greater emphasis on death – the 'suicide' of the girls' mother, smashing of the pianist's hands (an echo perhaps of the post-war cinematic melodrama *The Seventh Veil* (1945)), and by the looming presence of a flock of starlings directly imported from Hitchcock's *The Birds* (1963). The playing of Chopin throughout contrasts with the morbidity and with images of sexual violence. And, in yet another overwhelmingly destructive climax, the birds take over the set.

Neither *Hitchcock Blonde* nor *Piano/Forte* has achieved quite the critical success of Johnson's previous work. This may partly be because, for all their technical ingenuity, both plays are more evidently taken up with the pathological aspects of heterosexuality. Of course, Johnson has always been aware of the close relation of sex to death, nor has sex ever provided his characters with a straightforward form of release, but now the critical worry is that an obsessive concern with sexual behaviour might actually reinforce conservative norms.

Johnson is a theatrical writer in the sense that in all his work ideas and action are inseparable. He has written of acting technique that it's 'not a foreign language or an exotic one, but a technical articulation of the elusively human. A good actor talks about actions like a builder-decorator talks about the nature of nails or the colour of paint' (in Caldarone and Lloyd-Williams 2004: xii). Equipped with his unique technical understanding Johnson has been able to show that age-old conventions can be adapted to modern usage, that there's no need for consistency of tone to achieve powerful dramatic effect, and that the surprising, even incredible, event is, in theatrical terms, almost always the most truthful.

John Stokes

Key works

Johnson, Terry (1982) *Insignificance*, London: Methuen,
——(1984) *Cries from the Mammal House*, London: Methuen.
——(1993) *Hysteria*, London: Methuen.
——(1994) *Dead Funny*, London: Methuen.
——(1998) *Cleo, Camping, Emmanuelle and Dick*, London: Methuen.
——(2003) *Hitchcock Blonde*, London: Methuen [in association with the Royal Court Theatre, revised edition London: Methuen, 2007].
——(2006) *Piano/Forte*, London: Methuen.

Further reading

Billington, Michael (1993) *One Night Stands*, London: Nick Hern Books.

Caldarone, Marina and Lloyd-Williams, Maggie (2004) *Actions: The Actors' Dilemma*, London: Nick Hern Books.

Dromgoole, Dominic (2000) 'Terry Johnson', in *The Full Room: An A–Z of Contemporary Playwriting*, London: Methuen, pp. 255–258.

Gilleman, Luc (2000) 'Terry Johnson's *Hysteria*: Laughter on the Abyss of Insight', *Theatre Symposium*, 16 (Annual 2008), 110–120.

Hornby, Richard (1996) 'Freudian Drama', *Hudson Review*, 49(1): 112–114.

Lacey, Stephen (2011) 'Terry Johnson', *The Methuen Drama Guide to Contemporary British Playwrights*, London: Methuen, pp. 284–302.

Llewellyn-Jones, Margaret (2001) 'Terry Johnson', *Dictionary of Literary Biography*, Vol. 233, 'British and Irish Dramatists Since World War II', Second Series, Farmington Hills, MI: Gale, pp. 173–181.

MARIE JONES (1951–)

Born into a working-class Protestant Loyalist family in Belfast, Marie Jones began her career in theatre as an actress. Disillusioned by the lack of roles for women, she co-founded Charabanc Theatre Company in Belfast in 1983 with four other actresses – Brenda Winter, Maureen McCauley, Eleanor Methven and Carol Scanlon (Moore). 'Charabanc', meaning an 'open-top day-trip bus', was active for twelve years (1983–1995) and during that time produced an extraordinarily popular body of 24 original shows that toured across the sectarian divide as well as to the US and Russia. The company produced plays that were written collaboratively by its members; however, Jones went on to become writer-in-residence. The five women sought to redress the balance by self-authoring roles that would also serve to express the previously occluded voices of Northern Irish women on the stage. The women of Charabanc mobilized their lack of agency through commitment, creativity and collective action. Central to Charabanc was a political focus to highlight the extraordinariness of ordinary, everyday life. To this end, the five co-founders sought to find stories that they could perform and approached playwright Martin Lynch to write sketches for them. Lynch immediately identified the irony and insisted instead that they write the scenes themselves and that he would help them. Thus began the dawn of an extraordinary output of plays in a rich collaborative process where, every Sunday in Marie

Jones' home, collected ideas, interviews and research were shaped and reshaped, reflecting the women's identities and engaging with the diverse social histories of their mothers and grandmothers. In Belfast Central Library the women first read about the 1911 Belfast mill-girls' strike. Some of these 'millies' were still alive in the 1980s and the actresses interviewed them as material for their first play *Lay Up Your Ends* (1983). A huge success, *Lay Up Your Ends* sets the tone of dynamism, professionalism and theatricality that became the hallmarks of Charabanc's creative practice. Brenda Winter observes:

> There is no doubt that the actresses equated their own sense of powerlessness with that of their subjects. Although they most certainly did not endure the grinding poverty or physical deprivation of the mill-women, they certainly did share their marginality and invisibility as women.
>
> (Winter 2008: 26)

Lay Up Your Ends was first performed at the Belfast Arts Theatre in May 1983 and there were queues around the block: Imelda Foley notes, 'begun as an experimental act of faith … it ended up playing to 12,000 people' (Foley 2003: 37). Marie Jones' and Charabanc's plays are known for vocalizing a sense of meaning, relevance and humour to the lives and experience of everyday situations and people's lives in Northern Ireland, particularly those of the underrepresented working classes and women in particular. Through their intense collaborative research and devising work, Jones' skill at writing for the stage began to emerge and she expresses the core of their theatre as being concerned with 'extraordinary, ordinary experience' (in Winter 2008: 130).

Although written in 1983, *Lay Up Your Ends* was only first published 25 years later. Here we can identify a major difference with another theatre company in the north at the time – Field Day. Co-founded by Brian Friel and Stephen Rea in 1980, Field Day produced an original, male-authored play once a year, beginning with Friel's *Translations*, and published their plays and political pamphlets contemporaneously. Due to the collaborative nature of Charabanc's work, complex copyright wrangles, so often a result of collaborative and devised work, made publication difficult. This has resulted in a paucity of critical attention to Charabanc's creative output, unlike that afforded to Field Day.[1] In *Lay Up Your Ends* we can see Charabanc's trademark sense of exuberance and theatricality. Of the early days, Jones says:

Then I didn't recognise myself as a writer – I was just somebody who wanted to act and I wanted to do plays that were relevant to me and the people around me, and so, in retrospect, it was a way of finding a voice and getting a place to start from. It was years before I would even call myself a writer. Even though I was penning all the material and I loved doing it, it was very much a function in order to allow me and the company to perform material which was real and important to us as actresses in Northern Ireland at the time.

(in Foley 2003: 30)

Charabanc's plays developed collaboratively from collecting lesser-known oral histories and focused on working-class concerns of people of all backgrounds. Jones says: 'There is no doubt that we were feminists in the sense that we were presenting women, and very strong women, who always formed the centre of the plays, which were about empowering women. That's feminism'(in Foley 2003: 30). However, in order not to alienate their audiences, the company did not state an explicit feminist agenda at the time: 'we didn't want to put [people] off by having any kind of labels, we just wanted to say that this is a play about ordinary people' (in Foley 2003: 30).

Jones is known for the 'broad liberalism' of her work, which sets out to question personal and political borders and boundaries, refusing definitions, agendas or allegiances (Foley 2003: 34). One of the effects of Charabanc's creative process, which, due to lack of resources, necessitated the actresses playing multiple, often cross-gender roles, was that an inherent theatricality of non-realist performativity was born. Jones reflects upon the significance of this for her development as a playwright:

Sometimes I think there has been a form and a style that have been imposed upon me because of the economics of theatre and I don't know if I could write a play with twelve characters, or thirteen or fourteen. Because I am so used to saying that I have three people here who can play everyone, I actually have to think that I can't have *that* person talking to *that* person because they are playing *that* person. They are playing both characters, so in a sense that restricts you, but it is also a good thing because it's a discipline.

(in Foley 2003: 35)

Charabanc's next play, *Oul Delph and False Teeth* (1984), expresses non-sectarian socialist ideology alongside a celebration of women, while *Now You're Talkin'* (1985) focuses on the contemporary lives of women and issues of class. *The Girls in the Big Picture* (1986) foregrounds the lives of women, marriage and the matriarchal sphere, bringing up questions of agency and changing social values and expectations across generations. Set on the balcony of one of the nationalist Divis flats, *Somewhere Over the Balcony* (1987) is an excellent example of Jones' unfolding formal theatricality and the company's only play to address the 'Troubles'. The play opened at the Belfast Arts Theatre in November 1987 to a mixed response due to what could be perceived as an ostensible trivialization of the sectarian conflict – the show opened just after the Remembrance Sunday bombing in Enniskillen and sensitivities were high among audiences. In this drama we encounter an absurdist rendering of the invasive, inhuman effects of war upon the family. All 'normal' expectations are inverted or suspended as the riotous becomes acceptable, enabling an 'institutionalised insanity' (Foley 2003: 44). With musical dialect and a complex sound-scape, the play is both a hilarious send-up of, and poignant observation upon, the anarchic realities of living in a warzone. All of the action is retold through the multiple perspectives of the three female protagonists Kate, Rose and Ceely. In this world, men lack individuation – sharing the same pet-name – 'Tucker' – while the women comment upon, mediate and filter the action. Violence is not permitted on stage, and so is not fetishized or objectified.

The Hamster Wheel (1990), Jones' only self-authored play while a member of Charabanc, explores women's roles in looking after disabled and sick people within the family and community. Jones parted ways with Charabanc in 1990. Her 1995 play *Women on the Verge of HRT* focuses on the themes of ageing and women's sense of redundancy and invisibility in the face of the menopause and related issues of sexual attractiveness and relationships. The play charts the emotional journeys of its protagonists Vera and Anna and cultural conditions of femininity and desire. *A Night in November* is Jones' one-man show where the Protestant male protagonist, Kenneth McCallister, sets out on a spiritual journey, encountering sectarian division along the way as he reconciles his own sense of bigotry to achieve a more open-minded state of being. The play was first produced by DubbelJoint for the West Belfast Festival, Whiterock, in 1994, and toured extensively North and South. Actor Dan Gordon memorably created the role of McCallister in a tour de force

performance that showcased Jones' brilliant theatricality – leading to her dramaturgical apex with the unprecedented international critical success of *Stones in his Pockets* (1996), where two actors play a multitude of roles. *Stones in his Pockets* was first performed at Whiterock, West Belfast, 1996, and again at the Lyric Theatre Belfast in 1999, directed by McElhinney with Conleth Hill and Sean Campion. The show toured extensively nationally and internationally and was nominated for two Olivier awards (Best New Comedy and Best Actor) in the West End and three Tony awards (Best Actor for both performers and Best Director) on Broadway in 2001. The play is a hilarious and clever deconstruction of commodifications of 'Irishness' where two extras on a Hollywood film in Kerry, *The Quiet Land,* decide to make their own film as an authentic counternarrative.

Jones co-founded Replay Theatre Company while still a member of Charabanc, which also produced a number of her plays, and formed DubbelJoint Productions with director Pam Brighton in 1991. With DubbelJoint, Jones' work began to explicitly address the 'Troubles' in Northern Ireland. *Hang All the Harpers*, a collaboration with novelist Shane Connaughton, was Jones' first play for DubbelJoint and was an ambitious piece which set out to map Irish culture, the language, the poetry from the Elizabethan era right up to the present day and how it survived within a colonialist culture. *Weddins, Weeins and Wakes* played at the Protestant Shankill Festival in 1989 and was rewritten by Jones and revived by the Lyric Theatre in 2001 and again explores economic and sexual tensions. In all of these plays we see Jones' dramatic originality and challenging renegotiation of literary realism. Jones lives and works in Belfast.

Melissa Sihra

Note

1 In 2006 the first collection of Charabanc plays was published; see Harris (2006).

Key works

Jones, Marie (1999) *Woman on the Edge of HRT,* London: Samuel French.
——(2000) *Stones in His Pockets* and *Night in November,* London: Nick Hern Books.
——(2008) *The Blind Fiddler,* London: Samuel French.
——(2010) *The Milliner and the Weaver,* in *Women, Power and Politics: Then,* London: Nick Hern Books.

Further reading

Foley, Imelda (2003) *The Girls in the Big Picture: Gender in Contemporary Ulster Theatre*, Belfast: Blackstaff Press.

Harris, Claudia (ed.) (2006) *The Charabanc Theatre Company: Four Plays – Inventing Women's Work*, Gerrards Cross: Colin Smythe Ltd.

Winter, Brenda (ed.) (2008) *Martin Lynch & The Charabanc Theatre Company: Lay Up Your Ends 25th Anniversary Edition*, Belfast: Lagan Press.

SARAH KANE (1971–1999)

Sarah Kane's career was brief but explosive. Her first piece, *Comic Monologue*, appeared in 1991, and her last, *4.48 Psychosis*, in 2000, a year after she committed suicide while undergoing treatment for depression. Her work has been the subject of intense critical attention since the 1995 premiere of *Blasted* at the Royal Court. A decade later, Aleks Sierz described Kane's critical stature in Britain: 'the iconic, but invisible in-yer-face playwright' – praised as a major writer, produced and studied across the world, but rarely revived in her own country (in Saunders 2009: 126). All Kane's work has been restaged in the UK since 2005, but criticism continues to be dominated by discussions of the first productions, perhaps because Kane herself was a very articulate and thoughtful practitioner who gave a number of interviews and workshops about her work and influences during her life, inadvertently providing a kind of 'authorized version'. This body of commentary, along with the circumstances of her death, dominates critical accounts of her practice as a writer and director.

Kane was intent on experimenting with form progressing from the blowing open of the well-made play structure in *Blasted* to *4.48 Psychosis* which ascribes neither characters nor, after the first section, stage directions. Kane cited Howard Barker, Samuel Beckett, Edward Bond and Harold Pinter as inspirational writers, noting: 'All good art is subversive, either in form or content. The best art is subversive in form *and* content' (in Stephenson and Langridge 1997: 130). She credited *Mad* (1992), a devised piece produced by Jeremy Weller and the Grassmarket Project, as providing her with a glimpse of how different theatre could be when it was experiential and refused to allow its audience to be passive spectators. *Mad* brought together professional and non-professional actors, including those with mental health issues, to explore the treatment of mental illness. The speed and force with which it did so encouraged her to evolve an economic, forceful

dramatic style, continually refining dialogue and stage directions to achieve a stark lyricism and extraordinary stage pictures.

After studying drama at Bristol University, Kane enrolled on the MA in playwriting at Birmingham overseen by David Edgar and taught by Clare McIntyre. Although critical of the course, it gave her the space to write a play (*Blasted*) and have the first Act produced in front of an invited audience. Literary agent Mel Kenyon was part of that audience, asked to read the rest of the play and subsequently offered to be Kane's agent. Kane became literary associate at the Bush from March to August 1994 while she completed *Blasted* and the play was produced in the Theatre Upstairs in January 1995 directed by James Macdonald. *Blasted*'s unflinching examination of violence on a domestic and international scale caused a furore.

The play, begun in 1992, started out as a play about an older man raping a younger woman in a hotel room. Watching the news during a break from writing she was struck by the reporting of the siege of Srebrenica and the atrocities carried out and decided to incorporate the extreme violence into the play. In the final version, the naturalistic hotel room is first invaded by a soldier and then blown apart by a bomb – replicating Kane's experience of connecting her first draft of the play to world events. Ian, the violent, racist tabloid journalist who rapes Cate, a vulnerable young woman, is blinded and raped in turn by a soldier traumatized by wartime atrocities. The soldier then kills himself, leaving Ian bleeding and blind. Time passes and eventually, after several attempts to commit suicide, Ian is so bored and hungry that he digs up the baby Cate had tried to rescue earlier on and eats it before burying himself with the remains, dying 'with relief' and then coming back to life. The violence is shocking but the play also has moments of tenderness and humour.

Jack Tinker, from reactionary newspaper the *Daily Mail*, rightly gauged the play would outrage *Mail* readers and the right-wing establishment, and his review went out under the headline 'This Disgusting Feast of Filth'.[1] Other critics were equally baffled if less prurient; Charles Spencer's review in the *Daily Telegraph* is representative of their inability to understand the link between events in the hotel room and in the world outside. He described *Blasted* as 'a lazy, tawdry piece of work without an idea in its head beyond an adolescent desire to shock'.[2] Like other critics, he was also obsessed with questioning the logic of events. Bond and Pinter, themselves victims of press outrage, came to Kane's defence. Now that the play is established as a modern classic whose form captures the disconcerting and horrific violence that was shown nightly on television screens

around the world during the Balkan War it is harder to see why the majority of theatre critics interpreted it as a sensationalist piece intent on cheap shocks. Kane had two theories: that her portrait of a morally bankrupt white middle-aged journalist touched a nerve with the white middle-aged journalists who made up the theatre-reviewing community and, more likely, that the critics were used to realist works and were thus unable to understand the symbolic aspects of it (a view shared by its director).

Her next play, *Phaedra's Love* (1996), marked her directing debut, and offered an opportunity for developing and realizing her desire for a predominantly visual theatre. It was commissioned by the Gate Theatre, London who had invited a number of writers to choose a well-known play to adapt. Kane chose Büchner's *Woyzeck* (which she later directed) but as the theatre was already planning a Büchner season, she had to think again. When her second choice, Brecht's *Baal*, was rejected because of the problems of negotiating with the Brecht estate, she hit on Seneca's *Phaedra*. Kane's version transposed the action to the modern age and shifted the focus from Phaedra to Hippolytus, the object of her obsession. Kane's Hippolytus is a fat, bored, sexually voracious (and STD-carrying) nihilist rather than the oppressively and obsessively pure figure of the original. His hatred of mendacity makes him cruel and he lives in self-imposed isolation eating, playing video games and masturbating. Only the prospect of death stirs him and he gladly confesses to Phaedra's accusation of rape as a means of bringing about his execution. On the brink of death at the climax of the play he smiles and declares 'if there could have been more moments like this' (Kane 2001: 103). Influenced by the baby-stoning scene in Edward Bond's *Saved* (1965), Kane was determined to show the multiple deaths rather than follow the ancient Greek practice of having them happen offstage. In her view, this was 'a lot easier than you would think […] audiences are really willing to believe something is happening if you give them the slightest sug-gestion that it is' (in Saunders 2009: 68).

She described *Cleansed* (1998) as being born of frustration at 'all this naturalistic rubbish' being produced (Rebellato 1998). Like *Phaedra's Love*, it is a play that embraces paradox on every level and explores the nature of obsessive love and cruelty, perhaps reflecting Kane's changing emotions during the writing of the piece. She began work on it in 1992, while being 'completely, utterly and madly in love' but also in the grips of depression, and wrote it in stages because 'the material was so difficult' (in Saunders 2009: 73). The play is set in a university where every space has become a space of torture and

murder. Love leads to violence and death in every instance and the stage directions demand a non-naturalistic treatment: characters are savagely and visibly beaten by unseen men, flowers burst out of the ground during moments of intense emotional connection and rats gnaw wounded bodies and severed limbs. The play was again directed by James Macdonald who worked with Kane and designer Jeremy Herbert to achieve a metaphoric approach to violence rather than a realistic one.

Crave, also produced in 1998, arose from Kane's role as writer-in-residence with new writing company Paines Plough (a post offered to her by fellow playwright Mark Ravenhill after he read *Blasted*) where she read scripts and ran the Writers Group. Artistic director Vicky Featherstone jokingly suggested that Kane (who wrote very slowly) should write a short piece for the company's *Wild Lunch* season when another playwright dropped out. Kane had read Rainer Werner Fassbinder's *Pre-Paradise Sorry Now* (1969) at Paines Plough while waiting for a meeting one day and it gave her the idea for *Crave*. Ken Urban suggests that: 'what Kane took from Fassbinder was the possibility of a play comprised of sound, devoid of standard ideas about character' (Urban 2011: 313). Kane also acknowledged the influence of Martin Crimp and Beckett in this play for voices in which the four speakers (A, B, C and M) recount past encounters, memories and feelings, sometimes in dialogue with each other, sometimes referring to their encounters with each other, and sometimes alluding to or quoting from Kane's earlier work and other literary sources. M wants a child and pursues a relationship with B. A is a self-confessed paedophile pursuing a relationship with C. Kane explained that the letters had meaning: A is abuser, but also author and Andrew (the actor she wrote the part for), B is boy, C is child and M is mother. The play is suffused with imagery and meditations on memory, light and dark, love affairs, childhood and abuse. Featherstone worked Kane hard to achieve the play's rhythmic, incantatory quality and focused the action on the speakers' voices, arranging the actors on chairs as if taking part in a talk-show. Like Beckett, Kane's work was moving to an economy of movement and intensifying in focus.

In *4.48 Psychosis* (1999) she pushed further still at the concept of the play as a written piece to be performed. The script has no characters or lines assigned to any speakers and although there are clearly passages of question and response she gave no instructions on how the piece should be performed. Macdonald used three actors for the premiere, but the play has since been produced with casts ranging

from one to seven. Produced posthumously, the play is often regarded as a dramatized suicide note but Kane was very clear about the work's purpose, telling Rebellato in 1998 that she was writing about a psychotic breakdown and working out how to make form follow content.

Like the writers whose work she admired and drew on for inspiration – Bond, Pinter, Caryl Churchill, T.S. Eliot – Kane's work is an endless source of fascination for practitioners and scholars. She made an intervention into how theatre could engage with the contemporary world in a lyrical but hard-hitting way. Macdonald describes her work giving 'the lie to a laziness in thinking which insists on the superiority of a certain kind of play ... kitted out with signposts indicating meaning, and generally featuring a hefty state-of-the-nation speech ... More than anyone, she knew that this template is no use to us now.'[3]

Kate Dorney

Notes

1 Tinker, Jack (1995) 'This Disgusting Feast of Filth', *Daily Mail*, 19 January.
2 Spencer, Charles (1995) *Daily Telegraph*, 20 January.
3 Macdonald, James (1999) 'They Never Got Her', *The Observer*, 28 February.

Key work

Kane, Sarah (2001) *Complete Plays*, London: Methuen.

Further reading

Rebellato, Dan (1998) Interview with Sarah Kane. www.danrebellato. co.uk/sarah-kane-interview [accessed 19 June 2013].
Saunders, Graham (2002) *Love me or Kill me: Sarah Kane and the Theatre of Extremes*, Manchester: Manchester University Press.
——(2009) *About Kane: The Playwright and the Work*, London: Faber and Faber.
Stephenson, Heidi and Langridge, Natasha (1997) *Rage and Reason: Women Playwrights on Playwriting*, London: Methuen.
Urban, Ken (2011) 'Sarah Kane', in Martin Middeke, Peter Paul Schnierer and Aleks Sierz (eds.) *The Methuen Drama Guide to Contemporary British Playwrights*, London: Methuen, pp. 304–322.
De Vos, Lauren and Saunders, Graham (2010) *Sarah Kane in Context*, Manchester: Manchester University Press.

ADRIENNE KENNEDY (1931–)

Adrienne Kennedy first emerged as a major figure in the Black Arts Movement in the 1960s, and over the course of nearly five decades has written more than 20 plays, essays, short fiction, a novella and a memoir, *People Who Led to My Plays* (1987). She is best known as a playwright, and for her first play *Funnyhouse of a Negro* (1964), a highly experimental, dream-like piece for which she won an Obie Award. In 1996, she received two additional Obies for *June and Jean In Concert* (1995), a stage adaptation of her memoir, and *Sleep Deprivation Chamber* (1996), and at the 2008 awards, she was honoured with a Lifetime Achievement designation. She has held academic positions at Harvard, Princeton, Brown, Yale and the University of California at Berkeley, and served as playwright in residence at the Signature Theatre in New York. Although she was writing during the Black Arts movement, her work departed significantly from the realism of contemporaries like Lorraine Hansberry, and because of this, she was often marginalized in the black arts community (Bryant-Jackson and Overbeck 1992: 189–198). While her work faded into obscurity in the 1970s, there was a resurged critical interest in her work in the late 1980s with the release of *People Who Led to My Plays*, and the Signature Theatre staged several of her plays during its 1995–1996 season when she was in residence. Other notable works include *The Owl Answers* (1965), *Electra and Orestes* (1972), *An Evening with Dead Essex* (1973), *A Movie Star Has to Star in Black and White* (1976), *Ohio State Murders* (1992) and *Mom, How Did You Meet the Beatles?* (2008).

Kennedy's work is heavily autobiographical, and because of its experimental and surrealistic nature, it is often challenging. Her mixed racial identity; the racism that she saw and experienced in her childhood in Cleveland, as a university student at Ohio State and during visits with relatives in Georgia, as well as her travels to Africa, England and Europe all inform her work. Despite the autobiographical focus, her plays still engage with larger cultural and political issues, namely race and violence. The most prominent feature of her work is fragmentation and disjuncture, with characters who have split selves and identities, placed in locations that are not bound by time and space, an approach evident first in her early one-act plays *Funnyhouse of a Negro*, *The Owl Answers* and *Rat's Mass* (1966). While many of her works examine feminine identity, she also draws on the experiences of black men in plays such as *Sun* (1968), dedicated to Malcolm X; *An Evening with Dead Essex* (1973), a

docudrama exploration of the Mark Essex case, a man who went on a murderous spree in New Orleans until police shot him down with more than 100 bullets; and her own son Adam's beating and arrest by a white police officer in *Motherhood 2000* (1994).

Critics have noted that Kennedy's work does not fit easily within one tradition, and perhaps her plays are best understood in light of their blending of elements of absurdism, expressionism, symbolism and surrealism. While Kennedy's early work comes before the black feminist drama usually considered to begin with Ntozake Shange's *For Colored Girls* (1975), she participates in a precursor to that movement, not only in breaking masculine models of realism but, as bell hooks has acknowledged, in her nascent attempts at articulating the struggles of feminine identity (in Bryant-Jackson and Overbeck 1992: 179–185).

Funnyhouse of a Negro (1964) came out of a workshop Edward Albee accepted Kennedy onto in early 1962, and it was first staged Off-Broadway at the Circle in the Square Theatre in 1963. The play follows the hallucinations of a mixed-race protagonist, the Negro-Sarah, battling her split personalities, described as 'one of herselves', including Jesus, the Duchess of Hapsburg, Queen Victoria Regina and Patrice Lumumba. The action takes place in one room, which Sarah imagines to be simultaneously a Hapsburg chamber, a chamber in a Victorian castle, a Harlem hotel room and the African jungle. Kennedy began writing the play during her travels to West Africa and Europe, an influence clear in Kennedy's use of a plaster statue of Queen Victoria in Sarah's room, reminiscent of a statue she saw in London, and the self Lumumba, the political leader who was assassinated while Kennedy was in Ghana, who is pictured in the play with his head split in two. Sarah is haunted by her white mother's institutionalization after being raped at the hands of her father, a black man, who she married but ceased loving.

The distinct racial signifiers of hair and skin colour appear throughout the play, as the various personalities don grotesque masks and wigs, and ultimately all lose their hair, a trope long associated with madness and usually interpreted in the play's context to also represent shame, guilt and the portent of death. Sarah yearns to be accepted into white culture, as she idolizes European royalty, poetry and symbols of whiteness, and she spurns the black side of herself. Unable to be fully accepted as white, she hangs herself at the play's end. Although it is still staged periodically, it is not produced widely, and many critics and audiences find it difficult and obscure. Still, its Obie award and the general recognition of the play as a milestone in

experimental theatre and an important racial allegory are evidence of the work's critical merit. The 1995 revival was received less favourably than her other plays that season, mainly because some reviewers felt the production fell short of the 'daring work' the play demands from actors and directors.[1]

The Owl Answers first premiered at the White Barn Theatre in Connecticut and had its New York premiere in 1965 at the Theatre de Lys. It also features a mixed-race protagonist, Clara Passmore, whose name not only calls to mind Sarah of *Funnyhouse of a Negro* in rhyme, but also seems to reference the act of racial passing. Like Clara, 'who is the Virgin Mary who is the Bastard who is the Owl', each character is simultaneously a series of other identities, and historical and literary figures, William the Conqueror, Shakespeare and Chaucer, appear as independent entities, or are subsumed into other characters, such as 'The Bastard's Black Mother who is the Reverend's Wife who is Anne Boleyn'. As in *Funnyhouse of a Negro*, the multiple settings transpose European and American geography and history.

Jeanie Forte notes that the play's 'ambiguity and near incomprehensibility' negate identification with one comprehensible self or narrative point of view, which communicates the nature of Clara's psychosis (in Bryant-Jackson and Overbeck 1992: 157–169). Still, some of Clara's biography emerges out of the obscurity: Clara is the bastard daughter of the richest white man in town, and a black woman who is his cook, who ultimately commits suicide. Clara's adoption by a local reverend and his wife provides her opportunity to become highly literate, like Sarah of *Funnyhouse of a Negro*, and develop elaborate fantasies about travelling to England with her father to see the sights she has learned about and to claim her ancestral privilege. However, Clara is repudiated when denied entrance to St Paul's Cathedral for her father's funeral, and he instructs William the Conqueror to leave her locked in the Tower of London. At the end of the play she transforms into an owl, the antithesis of the white bird that also appears in the play, a continuation of the bird imagery Kennedy carries from *Funnyhouse of a Negro* through many of her plays. Ravens, white doves and the owl appear in much of her work, symbols that have been interpreted as further emphasis on her black/white motifs, as well as potential representations of salvation or spiritual freedom through death.

Other than the stage adaptation of her autobiography, *A Movie Star Has to Star in Black and White* (1974) is probably Kennedy's most autobiographical play. Like her drama, her autobiography

People Who Led to My Plays deviates from genre conventions, presenting not a straight chronological narrative, but a collection of images, newspaper clippings, written vignettes, her childhood artwork, and photographs, not only of her family, but of the Hollywood stars Kennedy claims as major influences in her life, and who inhabit the world of *A Movie Star Has to Star in Black and White*. It was performed as a work in progress at the 1976 New York Shakespeare Festival and produced again in 1995 at the Signature Theatre. It too features a protagonist named Clara, who plays a 'bit role' next to her family members and recognizable film stars such as Marlon Brando, Montgomery Clift, Bette Davis and Shelley Winters. Most of Clara's lines – which focus on the story of her parents' history, her marriage, her first miscarriage and eventual first birth, and her brother's coma – are narrated by the stars, and her family's responses are spoken through them as well.

Once again, Kennedy draws on the juxtaposition of black and white in symbolic terms, and the driving force of the play seems to be the dilemma the black Clara has in identifying with cultural iconography that excludes her. Other critics have examined the crucial role that pregnancy plays, suggesting that Clara's side-lining represents her fears about negotiating her identity as an individual and aspiring playwright with motherhood. Because Kennedy combines her plot with a recognizable Hollywood milieu, readers and audiences may find this play more accessible than *Funnyhouse of a Negro* or *The Owl Answers*, and it was especially well-received during the revival at the Signature Theatre.

Kennedy's work requires the reader or viewer to abandon their expectations for traditional realistic and plot-driven drama, to develop a tolerance and appreciation for the obscure, and to make a commitment to close reading and analysis. These demands are partly what led Michael Feingold to claim in 1995 that with Samuel Beckett gone, Kennedy was the 'boldest artist' currently writing for the theatre.[2] Wading through the difficulties proves rewarding in many cases, and she provides one of the most unique voices in twentieth- and twenty-first-century theatre. Further, her achievements are important landmarks for African-American and feminist theatre and she is an important literary forerunner to black women playwrights like Ntozake Shange and Suzan-Lori Parks, who also break realist traditions. The autobiographical centre of her work reveals both Kennedy and larger aspects of the human condition to us, although not always in an immediately recognizable manner.

Casey Kayser

Notes

1 Willinger, David (1995) Review of *Funnyhouse Of A Negro* and *A Movie Star Has To Star In Black And White* at Signature Theatre Company, Joseph Papp Public Theatre, New York, *Theatre Journal* 48(2).
2 Feingold, Michael (1995) 'Blaxpressionism', *The Village Voice*, 3 October. Available at ProQuest Research Library [accessed 17 April 2013].

Key works

Kennedy, Adrienne (1990) *Deadly Triplets: A Theatre Mystery and Journal*, Minneapolis: University of Minnesota Press.
——(1992) *The Alexander Plays*, Minneapolis: University of Minnesota Press.
——(1996) *People Who Led to My Plays*, New York: Theatre Communications Group.
——(1998) *Adrienne Kennedy in One Act*, Minneapolis: University of Minnesota Press.
——(2001) *The Adrienne Kennedy Reader*, intro. Werner Sollers, Minneapolis: University of Minnesota Press.

Further reading

Bower, Martha Gilman (2003) *'Color Struck' Under the Gaze: Ethnicity and the Pathology of Being in the Plays of Johnson, Hurston, Childress, Hansberry, and Kennedy*, Westport, CT: Praeger.
Bryant-Jackson, Paul K. and Overbeck, Lori More (eds.) (1992) *Intersecting Boundaries: The Theatre of Adrienne Kennedy*, Minneapolis: University of Minnesota Press.
Kolin, Philip (2005) *Understanding Adrienne Kennedy*, Columbia: University of South Carolina Press.

BERNARD-MARIE KOLTÈS (1948–1989)

Bernard-Marie Koltès' plays are profoundly influenced by writers, (anti-) heroes and iconography from the English-speaking world and yet it has been in continental Europe that his influence has been most pervasive. France's pre-eminent director, Patrice Chéreau, premiered all but one of his major plays during the 1980s, effectively promoting Koltès as *the* French playwright of the decade. Furthermore, his early translators included significant or burgeoning writers who effectively promoted his work in their own countries – as in the case of Heiner Müller in Germany and Sergi Belbel in Catalonia. Koltès' reputation

may rest on only a handful of major plays – *Combat de nègre et de chiens* (*Black Battles with Dogs*, 1983), *Quai Ouest* (*Quay West*, 1986), *Dans la solitude des champs de cotton* (*In the Solitude of the Cotton Fields*, 1987), *Le Retour au désert* (*Return to the Desert*, 1988) and *Roberto Zucco* (first staged by Peter Stein in 1990) – but these have influenced playwrights, directors and performance artists both within France and beyond. Further plays were published during his lifetime and fragments of other works have been published posthumously along with interviews, letters and other writings in his native France.

Koltès' plays are distant from narrative-driven traditions of contemporary dramatic writing. The behaviour of his characters is constantly surprising, resisting the operation of psychological cause and effect that lies at the heart of much realistic playwriting. Koltès' plays celebrate unpredictability and that which lies unsaid; they have an antipathy to the realistic depiction of character habitually associated with method acting.

Equally Koltès doesn't ask *why* things happen but rather *how* actions are carried out. It is on this subtle difference that his work hinges and it is this characteristic that renders him a key dramatic innovator. For as the director Lluís Pasqual who has staged *Roberto Zucco* in Catalan, Russian and Spanish states: 'We've been asking "why?" for two thousand years. We have answers to the why from Freud, from Marx. It's an old question. What makes Koltès so important is he asks not the "why?" but the "how?"'[1]

Often perceived as an international playwright, a compulsive traveller whose dramatic locations encompass both a West African construction site (*Combat*) and the abandoned port of an industrialized Western city (*Quai ouest*), Koltès repeatedly insisted that his sole subject was France and its discontents. The Algerian War and its 100,000 casualties hover over *Le Retour* and the legacy of colonialism frames the West African construction site in which *Combat* takes place. Koltès' plays ostensibly inhabit the bleak urban environments of late twentieth-century capitalism and yet his rhetorical language removes his dramaturgy from the realm of the real. The intense dialogue that Koltès constructs in all his works is carefully worked from the idiom of ordinary speech with a charged tension that is established between the dialogue and the situation or environment in which it takes place. The texture of his dramaturgy betrays a plethora of voices: fragments displaced and designed anew, an archive of sounds, images and texts fused in a late twentieth-century context shattered by capitalism's insidious authority and colonialism's lasting vestiges.

Koltès' dramaturgical importance lies partly in providing two key metaphors for the contemporary stage, metaphors that are precisely the premises around which all his plays revolve. The first sees the contemporary world as a prison, an incarcerating space of oppressive observation in which all the characters are trapped. In this respect, Koltès effectively provides a theatrical environment for Michel Foucault's premises on the panopticon, the prison structure whereby power is exercised both through surveillance and the self-regulation that this generates.[2] Koltès often situates his works in environments where visibility is limited and characters seek protection. The unnamed protagonist in Koltès' dramatic monologue, *La Nuit juste avant les forêts* (*Night Just Before the Forests*, first produced in 1977), is being pursued by one or more unknown assailants; in *Retour*, Mathilde is subject to the vigilant observation of her brother and the conservatism he represents; in *Solitude* too the Dealer and Client move in and out of the shadows, articulating their wishes through metaphor and suggestion, through the coded language of a street culture where the reader remains an outsider. These are Beckett's tramps envisaged for the global age of travel and trafficking. Like Vladimir and Estragon in *Waiting for Godot* they talk of action but remain rooted to their derelict spot. The Client wants something, the Dealer has something to sell but the two can never settle on a point of common interest. The whole play functions as an investigation of the momentary split-second glance that brings the two men together. *Solitude* is not a story but rather the grounds for an encounter. The games played set up a series of traps that each character attempts not to fall into.

Koltès' dramatic world is populated by marginalized outsiders and bereft of compassion and romantic love. Indeed, in practically all his plays some character or other refers to the fact that love no longer exists – the Client in *Solitude* states it twice towards the end of the play – 'There is no love, there is no love' (Koltès 2004: 215) – and the Dealer refers to the appearance of love – 'but only the appearance' (Koltès 2004: 212) – as a mere tool in the struggle for acquisition. Koltès' theatrical premise involves characters who don't know what they want from each other. This is in effect how dramatic tension is realized in the writing. For Koltès, human relationships are not governed by love but rather by the metaphor of the deal. The deal is the basis for practically all relationships in Koltès oeuvre.

All his major plays revolve around business transactions of some form or other where all aspects of domestic life – even those supposed to be most private – are subject to endless negotiations that never

deliver the clean finale of resolution. Architectural arcs are built up through the interconnected deals that structure each of the plays. In *Quai Ouest*, fragments of information allow us to build up a skeletal past for Cécile, her family and those who float around them on the wasteland where the play's action evolves. Across two nights and the intervening day the inhabitants of this abandoned warehouse try to derive some gain from the arrival of Koch, his secretary and his luxury car while settling a series of old scores. Charles believes he owns Claire, Cécile believes she owns Carlos but he asserts his independence by renaming himself Charles. Rodolphe believes he owns the Kalashnikov but it passes through different characters eventually killing both Koch and Charles. In *Combat* (1983), Alboury comes to bury his brother and will not leave without the corpse, offering a narrative pulse to the play that is set against the petty bourgeois intrigues of Cal, Horn and Leonie. Alboury unravels Cal's world and Leonie has a similar effect on Horn's. In *Le Retour*, Mathilde and her children return to the small town world whose values are embodied by her brother and his cronies; their arrival serves as a catalyst for the ensuing action.

In *Solitude*, the narrative is distilled: arguments in their purest form tossed across the void of the stage by the two predatory antagonists, it opens with an epigraph written in a parody of bureaucratic or contractual language, pointing to a Balzacian view of society peopled by individuals all governed by a base need to buy and sell. In addition, it expresses this in terms that are deeply coloured by a late twentieth-century awareness of commerce as a global activity with a secretive life of its own, functioning in a twilight zone where it appears beyond the bounds of official control.

Movement, action and word each become strategic elements in the characters' attempts to control one another. It is this that leads to a humour that is habitually provoked by something quite unexpected – the parachutist that lands unannounced in *Le Retour*; bystanders meddling in a hostage crisis in *Roberto Zucco*. Koltès' humour straddles the absurd and the slapstick: as with the town officials in *Le Retour* and the brothel madam and police superintendent in *Roberto Zucco*. His plays are where the poetry of the everyday meets the literary conceit. They lurch from the banal to the extravagant. They are at once real life and not real life, the place/space where performance begins.

Exiles, foreigners and outsiders inhabit Koltès' dramatic landscapes. So many of his characters are 'on the run', so to speak, having left their homeland for a country where their 'difference' is both visible and audible. So many of Koltès' characters occupy a space between

cultures: Cécile in *Quai Ouest*, the Dealer in *Solitude*, Leonie in *Combat*, the unnamed narrator of *La nuit* all hover in the margins, to quote Giorgio Agamben 'nothing less than a border concept that radically calls into question the principle of the nation-state':[3] the displaced who form part of the global world's cultural imaginary.

Domestic strife is always symbolic of larger fratricidal, socio-economic and ideological battles. Families are the structures the protagonists flee from only to later return to them. In *Roberto Zucco*, the serial killer Zucco goes back to his mother only to have her deny he is her son. For Mathieu in *Le Retour*, families are simply about inheritance; coercive structures where misogyny is passed from father to son, children are raised through 'kicks and wise precepts' (Koltès 1997: 121), and fathers trapped forever in a destructive adolescence, a life spent with school friends indulging in conspiratorial games or, as in *Roberto Zucco*, in a drunken abusive rage. In both *Le Retour* and *Roberto Zucco* siblings betray each other; in the former a brother denounces his sister as a Nazi collaborator, in the latter he sells her into prostitution.

While Koltès' work is undeniably bleak, its linguistic dexterity and its humour – the author was, like Chekhov, convinced his plays were comic – gives it a playful quality. Cinematic resonances can be traced in the epic structure of *Roberto Zucco* – itself later spawning a film *Roberto Succo* (2001) – and the ghosts of his cultural heroes inhabit the world of his plays, from Bruce Lee to Robert De Niro: 'Dante speaking in the voice of Sam Shepard', wrote the *New York Times'* D.J.R. Bruckner in 2003.[4] The stage offered Koltès a fictional space where he could fabricate encounters between individuals who might not meet in what he termed 'real life'. Like Genet he also questioned what 'real life' might be, acknowledging that there was perhaps no space outside representation, no place that is not in some way a stage. Theatre was for Koltès a dying art[5] but through the very process of interrogating its conventions, discourses and paradigms, he was able to create a rare and bold theatrical beauty that has influenced playwrights from Britain's Mark Ravenhill to Catalonia's Sergi Belbel.

<div style="text-align: right">Maria M. Delgado with David Bradby</div>

Notes

1 Burke, Jim (1996) 'Out of Solitude', *City Life*, 4–19 December.
2 For Foucault's articulation of the panopticon, see Foucault, Michel (1985) *Discipline and Punish: The Birth of the Prison*, trans. Alan Sheridan, Harmondsworth: Penguin, pp. 170–228.

3 Agamben, Giorgio (1998) *Homo Sacer: Sovereign Power and Bare Life*, Stanford: Stanford University Press, p. 134.

4 Müller, Heiner (1980) 'Aucun texte n'est à l'abri du théâtre', *Alternatives Théâtrales* 35–36 (June): 12; Bruckner, D.J.R. (2003) 'Lost Souls in Search of Meaningful Connections', *New York Times*, 21 May.

5 Koltès, Bernard-Marie (1999) *Une part de ma vie. Entretiens (1983–1989)*, Paris: Minuit, p. 46.

Key works

Koltès, Bernard-Marie (1997) *Plays: 1*, ed. David Bradby, London: Methuen.

——(2004) *Plays: 2*, ed. David Bradby and Maria M. Delgado, London: Methuen.

Further reading

Bradby, David (1997) 'Bernard-Marie Koltès: Chronology, Contexts, Connections', *New Theatre Quarterly* 49: 69–90.

Delgado, Maria M. (2011) 'Bernard-Marie-Koltès: A Personal Alphabet', *PAJ* 98: 26–35.

Delgado, Maria M. and Fancy, David (2001) 'The Theatre of Bernard-Marie Koltès and the "Other" Spaces of Translation', *New Theatre Quarterly*, 66: 141–160.

Fancy, David (2004) 'The Darkness at the End of the Theatre: Chéreau, Koltès, Nanterre', *Contemporary Theatre Review*, 14(4): 68–82.

Mounsef, Donia (2007) 'The Desire for Language, the Language of Desire in the Theater of Bernard-Marie Koltès', *Yale French Studies*, 112: 84–98.

TONY KUSHNER (1956–)

Few, if any, playwrights of the last century experienced the seismic impact and rapid ascent into the major league as did Tony Kushner, as a result of the work that made his name. *Angels in America: A Gay Fantasia on National Themes* (1992), Kushner's instantly canonized two-play epic, remains his most significant achievement and seems destined to be the benchmark against which all of his past and subsequent outputs will be assessed. Despite the richness and diversity of his work (as playwright, adaptor, screenwriter, librettist, essayist and academic), it is due to *Angels* that Kushner has, among countless plaudits, been positioned as 'a rarity in American theatre – a socio-political dramatist' (Fisher 2001: 60), and lauded as 'one of America's most revered

playwrights ... the nation's voice for the turn of the millennium' (Vorlicky 2001: 1). In David Savran's view, the play was conferred with 'the unenviable position of having to rescue the American theater' (Savran 2001: 13).

In common with every 'overnight' sensation, Kushner's ascent was preceded by years of relative obscurity, but no lack of activity. Among numerous full-length and shorter works, his output has, to this point, included notable productions of the full-length plays: *A Bright Room Called Day* (1985), *Hydriotaphia, or The Death of Dr. Browne* (1987) and *Slavs! Thinking About the Longstanding Problems of Virtue and Happiness* (1994); as well as the libretto for *Caroline, or Change* (1994) and adaptations including Corneille's *The Illusion* (1988) and Brecht's *The Good Person of Setzuan* (1994). Considered as a whole, his plays 'offer a more staggering range of themes and characters than even the titanic *Angels* can encompass', sharing a predisposition to ask 'profound moral, social, spiritual and political questions' (Fisher 2001: 13).

Kushner's work is inexorably bound with his political convictions: he has spoken and written extensively about both, unflinching in his articulation of a political agenda and his 'serious desire to see the world change *now*' (Vorlicky 2001: 123). Expressing his longstanding alignment with Bertolt Brecht and the German critic and philosopher Walter Benjamin, Kushner has questioned the cogency of writing – and writers – that are not explicitly committed to interrogating the contemporary condition (see Vorlicky 2001: 123). However, Kushner's perceptions, and depictions of the present, are typically placed in juxtaposition with the dialectical forces of history, specifically American history, that of 'the violent eradication of Otherness' (Kushner 1995: 44). He sees little sense in dividing culture and (theatre) art, since 'all culture is ideological, political, rooted in history and informed by present circumstance. And art has to reflect this' (Kushner 1995: 44)

Both formally and thematically, the formidable scope and ambition of his work for the theatre confounds any attempt at succinct generic categorization: as well as Brecht, he has been compared to a pantheon of writers as distantly related as Tennessee Williams and Caryl Churchill. Notwithstanding the breadth of his intellect and erudition, and remarkable commercial and critical success, Kushner retains the persona of the inquisitive scholar and ceaseless innovator. With characteristic irreverence towards his own canonization (and ambivalent recognition of his detractors), he has demystified his writing process as analogous to cookery, ostensibly presenting himself as a chef more

concerned with the ingredients and flavour than the presentation of the dish. He proposes that 'a good play ... should always feel as though it's only barely been rescued from the brink of chaos ... from the mess it might just as easily have been'; that 'like a good lasagna [it] should be overstuffed: It has pomposity, and an overreach' (Kushner 1995: 61).

In *A Bright Room Called Day* (1985), Kushner harnesses Brechtian strategies to the development of his own dramatic style, rehearsing the epic structure, formal inventiveness and thematic complexity later seen in *Angels*, in particular its exploration of binary or dialectical relationships. The central idea, recurrent through his work, is that we examine the present through the example of the past (see also *Slavs!*, a play built from the characters and events Kushner was ultimately forced to eject from early drafts of *Perestroika*, the second part of *Angels in America*). Controversially – and in his own estimation, somewhat naïvely (see Kushner 1994: 172) – the playwright draws comparisons between Adolf Hitler and Ronald Reagan, juxtaposing, through a two-part structure, the ascending Nazi regime in 1933 Germany with the shift to the extreme right endured during the height of Reagan's presidency in 1985. In common with *Angels*, the play links the historical with the personal, dealing with the emotionally charged reactions of individuals as they struggle to come to terms with profound socio-political changes. Similarly, *Angels* is 'about people being trapped in systems that they didn't participate in creating', although Kushner summarizes his approach as 'the reverse of *Bright Room*; the characters need to create their own myths to empower themselves' (Vorlicky 2001: 16).

Angels in America was written between 1984 and 1985 during Ronald Reagan's presidency, a time in which Kushner 'despaired about America's ... homophobic response to the mounting devastations of the AIDS crisis'. The play 'presents the mid-1980s as a critical transitional period in the history of the nation' and reflects the era's 'angers, fears, absurdities, and hypocrisies' (Fisher 2001: 60). *Millennium Approaches,* the first of the two *Angels* plays, received a celebrated production at the UK's National Theatre in 1992 and opened on Broadway to similar acclaim in 1993, sending critics 'stumbling over one another in an adulatory stupor' (Savran 2001: 13), winning several major awards, among these the Olivier and Tony (both as Best Play), and the Pulitzer Prize for Drama. Later in 1993, the Broadway production was followed by *Perestroika*, which was, in the US and UK, performed in repertory with its predecessor and won a Tony award for Best Play.

Angels is episodic, rapidly paced and cinematically structured, principally shifting focus between two couples whose relationships have reached a point of crisis: a married pair, Joe and Harper Pitt, both Mormons, and a gay couple, Prior Walter and Louis Ironson. Through a complex, densely plotted series of assignations, both coincidental and imaginary (Joe and Louis meet, at work, in a courthouse restroom; Harper and Prior meet on the 'threshold of revelation' (Kushner 2007: 39) in a shared hallucination), the lives of the couples interconnect in ways that will severely test their ability to survive the crosscurrents of upheaval and transition, both political and personal, spiritual and sexual.

Merging and distorting our perception of present, past and future, *Angels* invites comparisons between the experiences of Jewish and gay communities, voicing Kushner's conviction that, through their suffering, characters will gain courage and enlightenment: their various crises may ultimately readjust their awareness of each other and the world for the better. *Perestroika*, 'a play about the difficulties of change' (Kushner 1995: 59), progresses towards a cautious sense of optimism, or 'a new definition of family' (Savran 2001: 17). Prior's final address: 'the world only spins forward. We will be citizens. The time has come' (Kushner 2007: 280) voices Kushner's suggestion that the play is ultimately 'about the extent of the community's embrace' (Vorlicky 2001: 21). Kushner's *Angel*, derived in part from Benjamin's meditation 'Thesis on the Philosophy of History' (see Savran 2001: 14), embodies the hallucinatory style of the piece, becoming his central metaphor, exemplifying 'the way that history moves into the future both in antithesis to the past, and yet bearing the past along with it'.[1]

Millennium Approaches introduces the gay couple in a private moment just after the funeral service for Louis' grandmother, where Prior reveals his HIV-positive status by displaying his first lesion. Fearing (and correctly predicting) his abandonment, Prior suggests that it is Louis' security he is loath to forgo: 'I can't find a way to spare you baby' (Kushner 2007: 28). Harper is agoraphobic and addicted to Valium; Joe struggles with his repressed sexual orientation; both are seeking means of escape from the misery of their inevitable estrangement. Through Joe's Republican political connections, their lives will collide with the play's most significant historical figure: Roy Cohn (1927–1986), the notoriously ruthless right-wing power broker who, as a young assistant US attorney, controversially secured a death penalty for Julius and Ethel Rosenberg (whose ghost, in *Perestroika*, appears to haunt and taunt Cohn as he lies dying of AIDS-related illness). Cohn, 'one of the most hateful men that ever

lived, a tremendously evil man' (Vorlicky 2001: 21) and 'the paradigm of ... Reaganism at its most murderous, hypocritical, and malignant' (Savran 2001: 18), provides Kushner with a *bona fide* monster whose apparent self-loathing, evidenced by his vehement denial of his own sexuality, might be the most frightening thing about him; perhaps he sees, in Joe, a warped and trembling reflection of his own homophobia.

The explicitly gay themes of *Angels*, which also manifest themselves through a particular comedic sensibility, propagated Kushner's full emergence as an identifiably gay writer (see Kushner 1995: 17). However, comedy is a serious business here, and certainly more than a sly wink to the initiated. The expression of *identity*, and particularly the facility to conceal or reveal it within language, is foundational to Kushner's use of comedy. We see this, for instance, during *Millennium*, in Cohn's chilling insistence, to his doctor, that he is not a 'homosexual'; and in the rapid-fire malapropisms of Louis and Joe's first encounter that serve to confirm to us Joe's own denial of his true sexuality.

The camp humour that ignites dialogue between the principal characters is driven by the same impulse that guides Prior's transformation through the adversity of his illness into the ultimate gay icon: the survivor. 'He sees himself,' Kushner states, 'as a fragile queen who isn't going to be able to bear up ... and he finds himself to be a tremendously strong person with great courage' (in Vorlicky 2001: 56). Arguably, Kushner's political colours are most vividly displayed in the presence of a subversive intertextuality. The references to Lewis Carroll, to Judy Garland and *The Wizard of Oz* (1939) acknowledge activism and transition, but also support Kushner's intention that if *Millennium* ends with 'wild fantasy', *Perestroika* is about 'finding their way back to reality' (Vorlicky 2001: 58). Their familiar stories of displacement and recovery provide a distant echo of Kushner's elegiac yearning for a version of utopia: 'like many Americans, I'm looking for home. Home is an absence, it is a loss that compels us' (Kushner 1995: 10).

The great achievement of *Angels* is, perhaps, Kushner's audacity in foregrounding the lessons learned through explicitly gay, subjective experience as universally – and enduringly – significant, 'as part of what is to be added to the fund of human experience and understanding, to the cosmologies, described and assumed, that we pass on to the next generation – upon which we hope improvements will be made' (Kushner 1995: 6). Having explored the notion of Kushner's apparent 'ambivalence', Savran concurs that 'on this issue the play is

not ambivalent at all' (Savran 2001: 36). Whether or not Kushner ever manages to eclipse the legacy of *Angels* with subsequent work remains to be seen, but it seems certain that whatever follows will serve to remind us that 'democracy is multicolor and multicultural and also multigendered' and should ultimately be concerned with the 'rediscovery of collective responsibility' (Kushner 1995: 29).

<div align="right">Shane Kinghorn</div>

Note

1 Worthen, William B. (2004) *The Wadsworth Anthology of Drama*, 4th edition, Boston, MA: Thomson/Wadsworth, p. 1208.

Key works

Kushner, Tony (1994) *A Bright Room Called Day*, New York: Theatre Communications Group.
——(1995) *Thinking About the Longstanding Problems of Virtue and Happiness: Essays, A Play, Two Poems and A Prayer*, London: Nick Hern Books.
——(2007) *Angels in America*, London: Nick Hern Books.

Further reading

Fisher, James (2001) *The Theater of Tony Kushner: Living Past Hope*, London: Routledge.
Savran, David (2001) 'Ambivalence, Utopia and a Queer Sort of Materialism: How *Angels in America* Reconstructs the Nation', in Deborah R. Geis and Steven F. Kruger (eds.) *Approaching the Millennium: Essays on Angels in America*, Ann Arbor: University of Michigan Press, pp. 13–39.
Vorlicky, Robert (ed.) (2001) *Tony Kushner in Conversation*, Ann Arbor: University of Michigan Press.

MARTIN MCDONAGH (1970–)

A London-born playwright of Irish roots, Martin McDonagh is probably the most commercially successful writer of the late twentieth century whose plays premiered on the Irish stage. He has achieved wide international acclaim for both his Irish-set plays and others, and has moved successfully into screenwriting, and won an Academy Award in 2006 for Best Live Action Short Film (*Six Shooter*).

McDonagh's career was launched in 1996 by Druid Theatre company, arguably Ireland's most renowned independent theatre company, based in Galway in the west of Ireland. The company's founding director Garry Hynes had returned to the company in 1995 from a stint at the helm of the Abbey Theatre, Ireland's national theatre, and found unsolicited scripts had been submitted to the company by the then unknown McDonagh. Those plays would later become known as 'the Leenane trilogy' as they were all set in an around the village of Leenane in Co. Galway and further west in Co. Mayo, and had some intertextual references to each other. Druid would later produce all three in repertory and tour the world with them. But the international commercial success of the plays was tempered with scepticism in academic circles; unsure of how to read the rural tropes, stereotypes and acts of violence in the plays, many critics inferred that they constituted a melodramatic throwback to a stage-Irish past, and thus a misrepresentation of a newly emerging globalized Ireland.

The first of the trilogy to be performed by Druid was *The Beauty Queen of Leenane* in 1996 for the newly inaugurated civic performance space in Galway, the Town Hall Theatre, and co-produced by the Royal Court Theatre in London. It would later transfer to the Walter Kerr Theatre on Broadway where it received four Tony awards, three for acting and one for Hynes' direction. The play itself received four awards including the Drama Desk award in 1998. It is set in a country kitchen, a setting familiar to Irish audiences as seen in the work of J.M. Synge at the beginning of the twentieth century (set in rural Wicklow and Mayo), and to the work of John B. Keane (set in rural Kerry) from the 1950s onwards. It also has resonances with one of Ireland's most celebrated late twentieth-century plays, *Bailegangaire* by Tom Murphy (1985), as both plays centre around a mother–daughter relationship. Maureen is the primary carer to her mother Mag and is trapped in her rural life, has dreams of marriage and escape, but is tied to her present situation by a combination of her mother's scheming and her own failure to make a move. Maureen gives her mother biscuits she doesn't like, suggests she will scald her and generally prepares the way for her subsequent violent action. Conversely, Mag interferes in Maureen's life, intercepting a letter from Maureen's suitor, Pato, in which he asks Maureen to go with him to America. But it is too late; Pato leaves without her and this pushes Maureen over the edge. During Maureen's monologue we see Mag rocking in her chair but at the end of the monologue she slumps to the floor, her head smashed. In production audiences never fail to be shocked

by the matricide, so unexpected in the Irish repertoire; not even Christy in J.M. Synge's *The Playboy of the Western World* actually succeeds in killing his father. A final scene immediately after Mag's funeral reveals Pato's engagement to another woman had left Maureen bereft. While she leaves home at the end, her destiny is neither certain nor positive. The ambiguity of the ending, coupled with the melodramatic manipulation of the audience, are key features of the play that Patrick Lonergan suggests aim 'constantly to confound [...] audience's expectations and assumptions [... revealing] to us our own capacity to be manipulated and deceived by lazy thinking, to be misled by our glib acceptance of the validity of over-familiar images and over-used literary conventions' (Lonergan 2012: 19). Further, it reveals how our amused acceptance of tales and threats of violence is confronted by the result of it.

The second and third parts of the trilogy see increasing levels of violence beyond the tales and offstage action in *Beauty Queen*. *A Skull in Connemara* and *The Lonesome West* were premiered in 1997 and entered in repertory with their forerunner. *A Skull in Connemara* focuses on a gravedigger's annual routine of disinterring bodies to make way for new arrivals to the graveyard. But there is a suggestion that the gravedigger, Mick Dowd, might have murdered his wife. Such is his reputation for violence, Mick appears predisposed to murder. Spectators who first laugh at tales of the disinterral of human remains are then confronted by Mick and his younger partner Mairtin smashing human remains on stage. Surrounded by violence, the local policeman Tom comically apes the tropes of Hollywood cops while ignoring all the signals of misadventure around him.

The Lonesome West features two middle-aged brothers surviving in a world of violence and retribution. Forced to live with each other after their father's death the two brothers enact seemingly endless rituals of getting on each other's nerves. Their lives are simple, yet comically absurd: Valene obsessively collects religious statues and has a fondness for the contraband drink poitín; Coleman has an obsession with eating and attends funerals to consume vol-au-vents and sausage rolls. But the play's dark twist reveals the depravity of the brothers; Coleman shot his father over a trivial remark and Valene shoved a pencil down the throat of Coleman's former girlfriend. Their attempts at reconciliation to aid the repose of the soul of Father Welsh, who loses faith and commits suicide, come to nought; the brothers conclude that irreconcilability is their only way to live. In this world of ceaseless cruelty as presented in the Leenane trilogy in which a crisis of faith in Church and state are glaringly evident, some

very tiny moments of affection, humanity and love between individuals are evident. These moments reveal fleetingly the potential for tenderness but it is not enough to stop the endless killing in the trilogy and for a priest to suffer a crisis of faith.

Two further West of Ireland plays move offshore to the Aran Islands (*The Cripple of Inishmaan* and *The Lieutenant of Inishmore*). A fourth play that would have created a tetralogy, *The Banshees of Inishfree*, has never been produced or published. The two extant Aran Islands plays are significant for their first productions. *The Cripple of Inishmaan* was first performed in 1997 at the National Theatre in London before the second and third parts of the Leenane trilogy were produced. Directed by Nicholas Hytner, the production was much more stylized than the Druid productions. In the opening shop scene, only rows of identical tinned peas were on display, a visual reference to the repeated minimalism of the subjects in the play's opening dialogue. The story revolves around the ambition of a young man, 'Cripple Billy', who dreams of escaping the drudgery and gossip of rural life and his own physical condition and becoming a film star with the advent of a Hollywood film crew to the island. But as Patrick Lonergan (2012: 61) states, it is a 'damning critique' of Robert Flaherty's celebrated 1934 documentary film *Man of Aran* and its misrepresentation of island life. In Scene 8 the film is shown on stage and the characters talk over and through it, pointing out its lack of realism and this points to the fact that it is Hollywood cinema that lacks a sense of realism brought into even sharper focus when Billy returns to the island having lost out in a screen test to an American actor who would 'play Irish'. But if there is any certainty of the message of the play it is that of the collusion in mythmaking by Hollywood cinema but also by those who consume it as well.

The Lieutenant of Inishmore is probably McDonagh's most controversial play, notwithstanding the criticism throughout his theatrical career of his apparent misrepresentations of Irishness. Although written at the same time as his other plays, it was finally produced by the Royal Shakespeare Company in 2001. The hesitation of producers and the opprobrium of critics are easily understandable given the extreme violence in the play and its central character being a former member of the IRA (at a time when tentative processes of a political settlement in Northern Ireland were being mooted).[1] Padraic has been thrown out of the IRA for being too mad and is first seen torturing a drug dealer but returns to Inishmore to discover that his cat, Wee Thomas, is dead. Comic attempts are made to blacken up an orange cat but Padraic eventually discovers the truth, kills the killer

as well as three INLA[2] agents who have been sent to murder him and proceeds to dismember the bodies on stage, while the real Wee Thomas saunters in to reveal that all the killing had been in vain. Underneath the black comedy and extreme violence there is a deep moral centre to the play in the scene of utter waste and carnage at the end, like in a Jacobean tragedy. But perhaps the time was not right and political violence still too real for it to be acceptable on stage in 2001.

His next play to be produced, *The Pillowman* (2004), eschewed all associations with Ireland and Irishness. In it short-story writer Katurian is interrogated as a suspect in a series of child murders that replicate his fiction, but as the interrogation unfolds and the stories enacted it becomes clear that Katurian and his brother Michal had grown up in a violent household that inspired the stories in the first place. Having smothered his parents the two boys survived alone, like the brothers in *The Lonesome West*. But another pairing of two detectives whose good cop/bad cop routine is overturned by the end of the play provides an interrogative context for the analysis of the interchangeability of love and abuse, and the instability of truth in both fiction and reality. While the play garnered rave reviews in London and on Broadway, McDonagh's 2010 play, *A Behanding in Spokane*,[3] attracted the wrath of critics for the racism of its central character and the perceived racist stereotyping of his first black character, as the thief of a severed hand. And this opprobrium brings us back to the initial critical reception of his Irish plays that ignored how McDonagh plays with stereotype to disrupt essentialist representations.

With their affront to Irish politics, religion, authority, animal welfare, disability and race, McDonagh's plays have been hugely controversial. This controversy should be set in the context of what Aleks Sierz described as 'in-yer-face' theatre,[4] and be compared to the plays of Sarah Kane, Anthony Nielson, Philip Ridley and Mark Ravenhill. His work should also be set in the context of contemporary Irish theatre as well, especially compared to the work of Marina Carr – for its rural violence – and of Conor McPherson and Mark O'Rowe – for its self-conscious playfulness with stereotypes. As these latter writers demonstrate in their work, just like Martin McDonagh, they are not setting out to write in a theatre/nation paradigm as many twentieth-century theatre histories in Ireland have sought to suggest, but rather to question the validity of a singular truth in any form of theatrical representation.

Brian Singleton

Notes

1 The Good Friday Agreement,1998.
2 Irish National Liberation Army, a splinter group of the Provisional Irish Republican Army.
3 First performed at the Schoenfeld Theater, New York.
4 Sierz, Aleks (2001) *In-Yer-Face Theatre: British Drama Today*, London: Faber and Faber.

Key works

McDonagh, Martin (1996) *The Beauty Queen of Leenane*, London: Methuen.
——(1997a) *The Lonesome West*, London: Methuen.
——(1997b) *The Cripple of Inishmaan*, London: Methuen.
——(1999) *A Skull in Connemara*, New York: Dramatists' Play Service, Inc.
——(2001) *The Lieutenant of Inishmore*, London: Methuen.
——(2003) *The Pillowman*, London: Faber and Faber.
——(2011) *A Behanding in Spokane*, New York, Dramatists' Play Service, Inc.

Further reading

Chambers, Lilian and Jordan, Eamonn (eds.) (2006) *The Theatre of Martin McDonagh: A World of Savage Stories*, Dublin: Carysfort Press.
Lonergan, Patrick (2012) *The Theatre and Films of Martin McDonagh*, London: Methuen.
Russell, Richard Rankin (ed.) (2007). *Martin McDonagh: A Casebook*, London: Routledge.

JOHN MCGRATH (1935–2002)

During one week in August 1994, John McGrath's stage adaptation of Neil Gunn's novel *The Silver Darlings* opened at the Glasgow Citizens Theatre; his monologue *Reading Rigoberta* about the life of Rigoberta Menchú, a political activist and campaigner in Guatemala, began at the Edinburgh Fringe Festival; *Mairi Mhor*, his film about a nurse from Skye who late in life began writing protest songs about the treatment of the Gaels, was screened at the Edinburgh Film Festival, where he also delivered a Bafta lecture, and he worked on *Carrington,* a film he produced about the painter Dora Carrington and author Lytton Strachey's relationship. A busy week typical of McGrath, whose

unbounded energy and vision facilitated a multifaceted career encompassing playwriting, directing, producing and theatre criticism. Equally, these cultural outputs signalled McGrath's commitment to local stories, national cultures and the promotion of global human rights. McGrath's prolific career as a dramatist and screenwriter was equally marked by eclecticism: he was a founding writer for the UK television series *Z-Cars* and wrote screenplays for *Billion Dollar Brain* (1967) and *The Dressmaker* (1988). In the theatre, his output spanned rock musicals (*Soft or a Girl?* 1971); didactic cabaret (*Lay Off*, 1975); the well-made play (*Swings and Roundabouts*, 1980); large-scale historical pageants of Scottish history (*Border Warfare*, 1989) and one-woman plays (*Watching for Dolphins*, 1991). He is most associated with the 7:84 company, which he co-founded with his partner Liz MacLennan and her brother David in 1971. Taking its name from a statistic that revealed 7 per cent of Britain's population owned 84 per cent of the nation's wealth, the company, which had English and Scottish divisions, produced some of McGrath's best-known works including *The Cheviot, the Stag and the Black, Black Oil* (1973).

McGrath's plays are united by a strong socialist impulse and a desire to speak to the socio-political issues of the day. However, his experience of *les événements* in Paris during 1968 strengthened his resolve to create dramas rooted in the history and contemporary experience of class activism, industrial militancy and identity politics. In addition to this subject matter, he began experimenting with a wide range of theatrical forms such as the rock concert, *ceilidh*, political pageant, monologue and carnival; and employed popular cultural forms such as variety, live music, stand-up comedy, satire and caricature in his plays. He used these as a means of attracting and entertaining his target working-class audience with plays written in a dramaturgical language that they could relate to not only in terms of content, but through an aesthetic that he argued would be familiar for a traditionally non-theatregoing audience. Equally, McGrath pioneered the extension of the traditional theatre environment to working-men's clubs, trade union buildings, work-based social clubs and village halls. Above all, he wanted to produce political works that facilitated 'a good night out' (see McGrath 1981).

McGrath's early playwriting sows the seeds of these later developments. Originally produced at Hampstead Theatre in 1966, *Events While Guarding the Bofors Gun* centres on the motivations and actions of seven men, some regular soldiers and others completing their compulsory period of National Service while stationed in Germany during 1954. An inexperienced, homesick 18-year-old, Lance-Bombardier Evans has been

put in charge of the rest of the disgruntled gunners who have been tasked with guarding an obsolete anti-aircraft gun. The play hones in on the night before Evans is due to return to England to embark on his officer training, providing his company can make it through the night without incident, but a combination of boredom, resentment and the reckless antics of manic Irishman Gunner O'Rourke ensure that his passage will be anything but smooth.

On the surface the play attacks the futility of warfare and the defunct British imperialist project in the post-war landscape of the Cold War, but it equally touches on other sites of conflict: between the Irish and English; Protestants and Catholics; the north and south and, of course, the simmering undercurrent of the British class system. The success of the play rests on McGrath's ability to ratchet up the tension, a mood heightened by the freezing, stark and claustrophobic conditions the men endure during their enforced cohabitation. Increasingly frustrated by the futility of their task and confinement, the men become tetchy and provocative in this testosterone-packed environment. Teetering on the edge of insanity, O'Rourke despises the ineffectual Evans, whose middle-class status and grammar school education has secured his superior military position rather than any innate talent. When O'Rourke gets uproariously drunk and jumps out of a window in a failed suicide attempt, it is as much an attack on Evans' plans as an embodiment of his nihilism. When O'Rourke's blood-stained, vomit-smeared abject body is dragged back onto the stage and when he dies after deliberately falling on his bayonet, he epitomizes the futility of the men's existence guarding a defunct object of an old-fashioned style war incompatible with the nuclear age. The themes of power, English imperialism, class privilege and the uses and abuses of the working class continually resurfaced in McGrath's playwriting, albeit in works that significantly departed from the conventional naturalistic theatrical apparatus of *Bofors Gun*.

7:84 Scotland's first production, *The Cheviot, the Stag and the Black, Black Oil*, which toured throughout the Scottish highlands and low-lands, is widely acknowledged as a landmark event in Scottish theatre history. Gerry Mulgrew, co-founder of Communicado Theatre Company, captured its impact:

> I'd never seen theatre like that in my life: spoken in our own Scottish voices and so full of music! It didn't seem like a play. Here was this explosion of joy, anger, politics, humour, everything, and with a *ceilidh* afterwards – it was quite extraordinary, a different kind of theatrical event.[1]

The Cheviot demonstrated that, henceforth in McGrath's career, creativity was a form of activism. Based on research into key events in Scotland from the Clearances to the discovery of North Sea Oil, the play was resolutely polemical and urged its audience to grasp the intersection of class and national politics crucial to the Scottish highlands, which it argued had been manipulated by the interests of landowners, industrialists and multinational corporations, with the help of their physical and ideological henchmen: the military, the police, the judiciary, newspaper proprietors and religious leaders. Yet, keen to avoid a 'lament syndrome', McGrath also celebrated incidences of resilience and fighting back: the survival of the Gaelic language; the foundation of the Highland Land League; the women who fought against eviction orders and tenants who promoted united action. More importantly, McGrath told these stories through an anarchic and joyous combination of variety, agitprop and *ceilidh* forms typical of the Scottish traditions of popular entertainment. The play is a rollercoaster of biting political satire against figures such as Patrick Sellar and James Loch, seen as justifying the callous land evictions from the Sutherland Estate in pursuit of profit. Readings from historical documents detailing the brutal treatment of tenants, hauntingly beautiful Gaelic laments of loss and eviction combine with rousing appeals for the audience to join in through the use of direct address, song sheets and the infamous dances held at the end of shows during which the performers and audience came together to drink, dance and share stories. *The Cheviot* is an inspirational piece of political theatre, which proved that the local could have global significance as it was translated and appreciated in countries across the globe.

The influence of feminist debate is central to several of McGrath's plays including *Trees in the Wind* (1971), *Yobbo Nowt* (1975) and the next play for discussion: *Blood Red Roses* (1980). Spanning a period from 1951 to 1980 and deploying dramaturgical strategies of naturalistic scenes interspersed with song, recorded announcements and direct address, this play traces the politicization of Bessie, a feisty young working mother from East Kilbride in Scotland as she tries to secure better working conditions at the factory that employs her, becomes a shop steward and eventually organizes an international strike against a multinational company. The play concerns the fight for international workers' rights, the erosion of class–consciousness and critiques the acquiescence of the Labour Party and Trade Union Movement to big business, but it also foregrounds the difficulties Bessie faces in a patriarchal environment, which includes the Labour

Movement. From an early school scene depicting girls only being informed about the centrality of marriage for their futures, to male workers undermining women's industrial action, McGrath explores the specificity of gender in determining hierarchical structures in familial, sexual and political realms.

In particular, McGrath's narrative represents the many contradictions inherent in the life of a working wife and mother. Indeed, much humour is generated by the vision of women juggling the demands of jobs, domestic labour and political activism, as when Bessie is trying to negotiate with an Italian trade unionist on the phone as her ineffectual husband, Alex, fails to control their children or when Janice has to abandon a picket-line to prepare her husband's breakfast. As the play unfolds, Bessie's personal life disintegrates and her marriage dissolves as Alex seeks comfort in a compliant, nurturing, non-political woman. On the surface, this would seem to suggest that an assertive woman is unable to juggle a successful domestic, working and political life, but McGrath is quick to undermine this interpretation. Bessie lives happily and productively without a man in her life and by the end of the play is pregnant following a fleeting relationship with a young lover. This development signals hope for the future alongside Bessie's older daughters who McGrath depicts as independent, politically aware young women who have benefitted from the ideological struggles of their mother's generation, although the wider context of a newly elected Thatcher government (1979) looms large.

McGrath translated all three of these plays into other media. His screenplay of *The Bofors Gun* was released in 1968; the television adaptation of *The Cheviot* appeared as part of the BBC *Play for Today* series in 1974 and Channel 4 screened his three-part adaptation of *Blood Red Roses* in 1985. Indeed, McGrath's willingness to transgress disciplinary borders is a substantial component of his legacy, as is his use of music and song as narrative vehicles. However, his influence as an ethical theatre-maker is most marked. McGrath and his collaborators signalled new ways of generating, executing and disseminating theatre to the widest possible audiences and his impact can be felt as much in an expanded conception of the touring circuit as in experimentation with dramaturgical structures. Hence, the configuration of the National Theatre of Scotland (2006) as a national theatre without walls owes much to McGrath's legacy; just as Gregory Burke's internationally acclaimed *Black Watch* (2006), which moves between Fife and Fallujah in its dynamic exploration of the Black Watch regiment is indebted to *The*

Cheviot's rich theatrical innovation and dramaturgical promiscuity. Moreover, McGrath's practice and ideas on audiences, theatrical form, subject matter and the political efficacy of theatre have proved influential for community and political theatre throughout the world, not least because he wrote *about* as well as *for* the theatre. His manifesto for popular theatre, *A Good Night Out* (1981); his biting critique of Thatcherism's impact on culture in *The Bone Won't Break* (1990) and his collected writings on theatre, *Naked Thoughts that Roam Around* (2002), all astutely interrogate the role of theatre in the context of class politics and local, national and political cultures: ideas that were central to the dramas he created as a playwright.

Nadine Holdsworth

Note

1 'Gerry Mulgrew', in Giannachi Gabriella and Mary Luckhurst (eds.) (1999) *On Directing: Interviews with Directors*, London: Faber and Faber, p. 106.

Key works

McGrath, John (1966) *Events While Guarding the Bofors Gun*, London: Methuen.
——(1981) *A Good Night Out*, London: Methuen.
——(1990) *The Bone Won't Break*, London: Methuen.
——(1996) *Six-Pack: Plays for Scotland*, Edinburgh: Polygon.
——(2002) *Naked Thoughts That Roam About*, ed. Nadine Holdsworth, London: Nick Hern Books.
——(2005) *John McGrath: Plays for England*, ed. Nadine Holdsworth, Exeter: Exeter University Press.

Further reading

Bradby, David and Capon, Susanna (eds.) (2005) *Freedom's Pioneer: John McGrath's Work in Theatre, Film and Television*, Exeter: Exeter University Press.
DiCenzo, Maria (2006) *The Politics of Alternative Theatre in Britain 1968–1990: The Case of 7:84 (Scotland)*, Cambridge: Cambridge University Press.
MacLennan, Elizabeth (1990) *The Moon Belongs to Everyone: Making Theatre with 7:84*, London: Methuen.

FRANK MCGUINNESS (1953–)

In a country that has been riven by political and religious divisions, not least by a very real border between British-controlled Northern Ireland and the independent Republic of Ireland, Frank McGuinness has been a major theatrical figure in reaching out sensitively to examine those divisions and suggest possible utopian processes of understanding between two nations, two sovereign allegiances and two religions. Further, his plays have consistently examined Ireland's long suppressed subjectivities, giving contestatory voice to the opponents of patriarchy, religion and politics. He has offered on the many stages of Ireland and abroad, strong female characters who challenge and contest masculinist notions of society and community, as well as a range of gay male characters who use the stage to first come to terms with their own sexuality and then to seek out a proud and significant role for themselves as statesmen in a progressive nation.

McGuinness has also contributed hugely to the translation into English of twentieth-century European drama (Brecht, Chekhov, Euripides, Ibsen, Lorca, Racine, Sophocles, Strindberg, Tirso de Molina, Valle-Inclán) that has premiered notably at the Abbey and Gate theatres in Dublin as well as the Royal National Theatre and the Royal Shakespeare Company in the UK. The premiere production of his translation of Ibsen's *A Doll's House* garnered four Tony awards in 1997. McGuinness has also made two significant adaptations of novels, Daphne du Maurier's *Rebecca*, which toured extensively in the UK in 2005, and the final story (*The Dead*) in James Joyce's 1914 collection entitled *Dubliners* (2012). His adaptations and translations have enabled him to explore the forms and conventions of modern European drama, as well as those of classical Greece. This exploration has clearly had a direct impact on his own dramaturgy that, for the most part, defies categorization but responds significantly to the moral dilemmas at the heart of his writing.

Donegal, the most northern county of Ireland, where McGuinness was born, was one of three counties of Ulster that were cut off from the rest of the province after partition in 1922. Crossing the border to Northern Ireland was a small journey geographically but a massive leap culturally and politically. That formation, at the edge of an independent republic but with a northern sensibility, was evident from his earliest writing. His first notable play was *The Factory Girls* (1982) set in a shirt factory of his hometown Buncrana and tells the story of five women who occupy the factory as they face the threat of redundancy. The strong female figures, that outwit their boss for the

most part with ease, use the opportunity to discover a sense of shared belonging outside the social structures of family and work in a largely patriarchal society. The female solidarity of the play was based on a world that McGuinness knew well and he dedicated the play to eight female relatives who had worked in the Fruit of the Loom factory in his hometown.

Crossing the gender divide to align himself with the women who sought solidarity against the oppressors of international capitalism as well as more local misogyny and patriarchy, McGuinness signalled his intent as a potent political dramatist. But his real breakthrough play in 1985 crossed another divide, that of the exclusively male world of the loyalism of Ulster Protestants, *Observe the Sons of Ulster Marching Toward the Somme*. As a Southern Catholic, this was no mean feat for McGuinness, given the context of civil war raging in Northern Ireland at the time. The First World War Battle of the Somme (1916) is a significant event in the history of Ulster Protestantism as the volunteers of the 36th (Ulster) Division of the British Army lost more than 2,000 on the first day of the battle, and are remembered by military historians as the most courageous of the assembled units of the Empire at the battle. The battle was important not least for the blood sacrifice of the sons of Ulster, but also for the significance of the date; 1 July, when the Ulster division was engaged at the Somme, was the first day also of the 1690 Battle of the Boyne when King William of Orange routed the Jacobite and Catholic army of England, a battle that is celebrated annually by the quasi-Masonic Orange Order that preserves the cult of William. The collapsing of time in the memorialization of Protestant culture also folded in the contemporary blood sacrifices of Ulstermen under siege by the contemporary campaign of the IRA. McGuinness' play features eight men from the six counties of now Northern Ireland on the eve of the battle wrestling with the significance of the imminent battle with Germany as a reflection of their continuing battle with Irish republicanism. The play is bookended by the leading character Pyper who reflects on the battle from a hospital bed in old age. But the play centres largely on time past. One of the most dramaturgically significant parts of the play, Part 3: Pairing, separates the eight individuals into pairs and crosses inter-county divisions as well as the various trades that separate them. They are all skilled tradesmen led by a doubting upper-class Protestant (Pyper) who is also suppressing his sexuality. A fairly latent storyline that runs underneath is the relationship between Pyper and working-class David Craig. Pyper's psychological dilemma is his inherited Anglo-Irish sense of social and

cultural supremacy that has to be preserved at all costs, and this leads to a psychological instability that is marshalled into action as he fights alongside the working-class opponents of Home Rule. He taunts his fellow Unionists, detests his inherited culture and yet he is able to connect with one of them, Craig, through his sexuality:

> PYPER: I would kill in their name and I would die in their name. To win their respect would be my sole act of revenge for the bad joke they had played on me in making me sufficiently different to believe I was unique, when my true uniqueness lay only in how alike them I really was. And then the unseen obstacle in my fate. I met you.
>
> (McGuinness 1996: 164)

The play was revived in 1994 on the main stage of the Abbey Theatre, Dublin and marked a significant moment in an emerging process of peace. It was attended by Northern politicians, including some Unionists, who endorsed the representation of Ulster Protestants by a southern Catholic writer. What no one dared mention was the gay undercurrent, since militarist loyalism was exclusively the domain of heterosexuality. The pairing of the eight characters was a dramaturgically bold step; male characters were forced to reveal themselves in intimate encounters with other men and this dramaturgical challenge enabled a range of masculinities to be revealed from underneath the hyper-masculine hegemony of the military. The other most significant dramaturgical feature was the staged collapsing of time as the men re-enacted a scene from the Battle of the Boyne, a re-enactment that has taken place since the cult of William was resurrected in loyalist communities in the eighteenth century. This re-enactment in which the victorious outcome is always assured stands as a poignant reminder of the fate of these soldiers of 1916, many of whom would not survive the next 24 hours in the Somme. In some ways the entire play harks back to the expressionist second Act of Seán O'Casey's First World War play *The Silver Tassie*, although that was rejected by the Abbey in 1928, as the time was not right for Irishmen to be identified or even acknowledged as contributing to the British war effort. Northern Protestants since partition have had no such reluctance to self-identify with Britain and the state acknowledges this contribution in memorials and public holidays. At its first revival in 1994, *Observe the Sons* captured the mood of a new generation that had been born into a civil war but were imagining a future beyond it.

McGuinness' play both spoke to and offered possibilities of engaging with 'other' religions, political allegiances and sexualities.

One striking feature of McGuinness' writing is the way in which he disassembles notions of the collective, such as Protestants in *Observe the Sons* and Catholics in *Carthaginians* (1988). He allows the individual to exist as an individual, pairs them often and then puts the collective back together. *Carthaginians* is set in a cemetery in Derry where three women and a gay man are encamped waiting for the dead to arise. The women have suffered personal loss while the gay man, Dido, joins them in solidarity, bringing provisions and a camp sense of humour. They are also joined at various times by three other men, each with a reason for suffering. The play undoubtedly references the infamous Bloody Sunday in January 1972 when a unit of the British Army opened fire on unarmed civil rights protestors, killing 13 of them. It was a tragedy that fuelled IRA recruitment and another two decades and more of civil war. It stands as monumental symbol of injustice and suffering in the Catholic community of Northern Ireland. The characters are haunted by the past, psychologically frozen at the moment of the tragedy and cannot move on, though they find sanctuary close to the souls of the dead in the hope of a transcendent release. Just as the re-enactment of the Battle of the Boyne in *Observe the Sons* obliterates the fears of the individual soldiers and marshals them into battle, an equivalent act of play in *Carthaginians* serves as a positive process for potential healing. Dido casts the characters in his playlet 'The Burning Balaclava' across gender, hilariously the homophobic and rough Hark plays a woman, while the women play the men. Dido takes on the role of a British soldier. There are rapid-fire scenes interrogating the senseless bigotry across communities in Derry and the play ends with everyone dead, including the soldier. There is, however, enormous slapstick humour to be found throughout. As Eamonn Jordan says, the purging of their grief 'is brought about by the perverse laughter of play and by their resistance towards the inappropriateness of Dido's bizarre text [...] that challenges preconceived and incongruous battle lines' that aims to find release 'through imaginative negotiation'.[1]

McGuinness' 1999 play *Dolly West's Kitchen* interrogates yet another taboo in modern Ireland: its neutrality in the Second World War. The eponymous character has escaped Mussolini's Italy and taken refuge in her hometown in Donegal, across the border from a country at war. But the war comes across the border in the form of Allied servicemen, the bisexual British Alec and the gay American Marco. We later learn that it is Dolly's mother Rima who invited

the men across the border illegally. Rima's ribald humour masks her long-term aim of confronting her children's fears and prejudices. Rima dies at the end of Act I and the second Act begins with a pairing of characters in which they confront those anxieties, Dolly's brother Justin, an extreme nationalist and Brit-hater who is forced to confront his own sexuality by Marco. Again McGuinness' dramaturgical structure works to confront prejudice and open up the possibilities of self-acceptance and an understanding of otherness. While some of his other work for the stage, such as *Someone Who'll Watch Over Me* (1992) – featuring three Western hostages in the Middle East – would achieve great critical acclaim, and his film adaptation of Brian Friel's *Dancing at Lughnasa* (1998) great commercial success, it is his plays that interrogate prejudice and propagate acceptance that perhaps are his greater achievement.

Brian Singleton

Note

1 Jordan, Eamonn (2000) 'From Playground to Battleground: Metatheatricality in the Plays of Frank McGuinness', in Eamonn Jordan (ed.) *Theatre Stuff: Critical Essays on Contemporary Irish Theatre*, Dublin: Carysfort Press, pp. 194–208 (quote from p. 204).

Key works

McGuinness, Frank (1986) *Observe the Sons of Ulster Marching Towards the Somme*, London: Faber and Faber.
——(1988) *Carthaginians*, London: Faber and Faber.
——(1988) *The Factory Girls*, Dublin: The Wolfhound Press.
——(1992) *Someone Who'll Watch Over Me*, London: Faber and Faber.
——(1996) *Plays: 1*, London: Faber and Faber
——(1997) *Mutabilitie*, London: Faber and Faber.
——(1999) *Dolly West's Kitchen*, London: Faber and Faber.

Further reading

Irish University Review (2010) 40(1), Special Issue.
Heusner Lojek, Helen (2004) *Contexts for Frank McGuinness's Drama*, Washington, DC: Catholic University of America Press.
Mikami, Hiroko (2002) *Frank McGuinness and His Theatre of Paradox*, Gerrards Cross: Colin Smythe.

DAVID MAMET (1947–)

After several years of working in New York's Off-Off-Broadway and Chicago's Off-Loop alternative theatre venues, Mamet burst on to the commercial theatre scene in 1977, when he had productions of *A Life in the Theatre* (1977) at Chicago's prestigious Goodman Theatre and *American Buffalo* (1975) on Broadway, as well as a hit production of *Sexual Perversity in Chicago* (1974) and *The Duck Variations* (1972) in London.

American Buffalo, which won the New York Drama Critics Circle award, had the greatest impact, establishing many of the elements with which Mamet's work has become associated. The most influential of these is his innovative dialogue, which has come to be known as 'Mametspeak'. Carefully crafted and rhythmic, his dialogue reflects Mamet's idea that speech is most often a means of getting something or a struggle for dominance rather than a medium of communication. The dialogue is intended to give the impression of everyday speech, often vulgar street vernacular, with its staccato rhythms and broken sentences, stutters, ellipses, repetitions, stichomythic exchanges and, most famously, its deft and musical employment of frequent expletives. Mamet's dialogue is the strongest element in the gritty representations of people in the workplace, often communities of men, for which he is known. The heightened realism of his theatrical style has been compared with that of Harold Pinter and Sam Shepard.

Mamet's work is far broader in scope than the general view of him suggests. Besides plays, he also writes screenplays, novels, essays and poetry, and he is a respected director and producer who has worked successfully in theatre, film and television. His plays range generically from *Boston Marriage* (1999), a parody of Oscar Wilde's comedy of manners, to *November* (2007), a political satire, to the expressionistic drama *Edmond* (1982), to the four plays he has described as classical tragedies, *American Buffalo*, *The Cryptogram* (1994), *Oleanna* (1992) and *The Woods* (1977).

Mamet's three best-known plays are *American Buffalo*, *Glengarry Glen Ross* (1983) and *Oleanna*. He has compared *American Buffalo* to Arthur Miller's *Death of a Salesman* (1949), and suggested that it is at heart a family tragedy and a play about betrayal. It begins with a scene in which Don Dubrow, the owner of a junk shop in a seedy neighbourhood, is teaching Bobby, the young drug addict he has taken under his wing, that loyalty is the central value for conducting oneself like a man, and there are no extenuating circumstances for the betrayal of a friend. The play consists of a series of betrayals, large and small. Don plans,

with Bobby, to steal the coin collection of a customer he believes has cheated him on the price of a buffalo nickel, and then cuts Bobby out when Don's friend Teach convinces him he should take over because Bobby is not up to the job. Don undermines Teach as well, but the ultimate betrayal comes when Don allows Teach to beat Bobby, telling him he deserves it, because he believes he has lied to him about doing the burglary with someone else. Don realizes the enormity of his betrayal when he discovers that Bobby was telling the truth. He finds that he has betrayed his friend for 'business', exactly what he was trying to teach Bobby not to do at the beginning of the play. As Mamet has said, Don realizes that 'rather than his young ward needing lessons in being an excellent man, it is he himself who needs those lessons. That is what *American Buffalo* is about' (quoted in Kane 2001: 67).

The critical response to *American Buffalo* showed little understanding of this theme, focusing more on the novelty of the language than the play's meaning. The attitudes of reviewers ranged from revulsion to high praise, from complaints about its scatology and blasphemy to appreciation for the virtuosity of its dialogue. There were also complaints that nothing happened in the play, which seemed to most critics to be merely about a small-time failed burglary, and that the obvious symbolism in the play, such as the buffalo nickel, did not add up to anything. In the years since *American Buffalo*'s premiere, academic critics have been particularly interested in the symbolism of the buffalo nickel and the economic implications of the play. Such criticism has also extended to Mamet's use of dialogue and, not least, the nexus of masculinity, language and power that is common to *American Buffalo* and many other plays by Mamet.

Glengarry Glen Ross (1983) is Mamet's most successful play, both critically and commercially. He has at various times described it as a 'gang comedy', in the tradition of Ben Hecht and Charles MacArthur's *The Front Page* (1928), and as a 'drama' to be distinguished both from tragedy and from the black-and-white morality of melodrama (Kane 2001: 119, 48). He has described the world of *Glengarry Glen Ross* as 'a society with only one bottom line. How much money you make' (in Gussow 1984). In the play the men in a real estate office, that sells worthless land to customers who cannot afford it, find themselves in a sales contest in which the one with the highest volume of sales wins a Cadillac, the second wins a set of steak knives and the two lowest lose their jobs. The play is most basically about a world in which absolute self-interest rules. It is divided into two acts, the first of which consists of three scenes set in a Chinese restaurant, in each of which a salesman runs a sales pitch on someone: Levene tries to get the office manager

Williamson to give him two new sales leads (potential customers) in exchange for a bribe; Moss tries to convince Aaronow to break into the office and steal the leads; Roma softens up James Lingk for a sale. In Act II, the office has been robbed, not by Aaronow, it emerges, but by Levene, but before he is found out, he helps Roma to trick Lingk out of getting his money back, and Roma informs Williamson of his scheme to get half of Levene's sales.

By the time *Glengarry Glen Ross* premiered at London's National Theatre in 1983, the 'Mamet play' was well-established, and audiences and critics expected its expletive-laced language, its seedy environment and its critique of American capitalism and business ethics. The London production, directed by Bill Bryden, emphasized the humour in the dialogue and the play's comic elements. Although, as Michael Billington suggested, the characters use language 'as a tactic, a weapon, a shield, a façade', the play is also a 'complex non-judgmental comedy about salesmen as simultaneously hucksters and dupes' (Billington 1983). Gregory Mosher's more biting 1984 Broadway production was seen as a comedy paced as farce that left the audience with a jarring sense of despair. Mamet's language was already taken for granted, and his rhythmic dialogue was compared to jazz, blues and other musical forms. The play was seen by many as an updating of *Death of a Salesman*, with the more vulgar success myth and harsher business world of the Ronald Reagan-dominated 1980s. A good deal of academic criticism has focused on the function of language in *Glengarry Glen Ross*, and on Mamet's treatment of gender, ethics, morality, capitalism and the American myth.

Oleanna (1992) is Mamet's most controversial play. A dystopian tragedy about the consequences of failed communication, it is set in a university and dramatizes the inability of a frustrated student, Carol, and a faculty member, John, who is anxious about the possibility of losing his job if he is denied tenure, to understand, or even listen to each other. Like many of Mamet's plays, it focuses on language and power. In the first Act, John has power over Carol because she may fail his course if she can't understand the educational jargon he uses in class. In the second, Carol has become empowered by the feminist language she's learned in her unnamed 'Group' and has made charges of sexual harassment against John to the tenure committee, which he unsuccessfully tries to persuade her to withdraw, finally resorting to physical restraint as she leaves his office. In the third, Carol has added the language of the law to her arsenal, for John's restraint of her can legally be defined as attempted rape, and she tries to use her power to force him to agree to a banning of his book. In the end, he is reduced to spewing

invective and beating her. Mamet has said that, as a tragic protagonist, John 'undergoes absolute reversal of situation, absolute recognition at the last moment of the play. He realizes that perhaps he is the cause of the plague on Thebes' (in Kane 2001: 119).

The historical context in which *Oleanna* was produced – and particularly the discussion of sexual harassment and the critique of political correctness by the American right in the wake of the accusations made against Clarence Thomas in the confirmation hearings for his appointment to the Supreme Court – was particularly influential on the play's initial reception. The criticism of the play after its 1992 premiere at the American Repertory Theatre in Cambridge, Massachusetts, tended to treat *Oleanna* as a play 'about' sexual harassment and generally saw Mamet as creating an unduly negative character in Carol and taking John's side against her. Criticism of Mamet as misogynistic and dismissive of women, which had emerged with earlier plays, came to a head with *Oleanna*, and the play was roundly attacked, not only by feminist critics but by many who felt that he had simply stacked the deck in John's favour. Mamet has resisted this accusation, insisting that there were many who believed the opposite, and in any event, that the play was not about sexual harassment, but about power and its misuse.

With distance from the historical moment, while gender and the 'culture wars' between left and right continue to be areas of focus, more perspectives on the play have opened up. The most influential of these, beginning with Christine MacLeod's 1995 article, is an analysis of the relation between language and power. A number of critics have also examined *Oleanna* in relation to its treatment of academia and to various educational theories, as well as comparing it to Eugène Ionesco's *The Lesson* (1951).

In the 20 years since *Oleanna*, Mamet's work has taken many turns, including a deepening interest in addressing his Jewish heritage, particularly evident in the three one-act plays in *The Old Neighborhood* (1998) and his nonfiction work, *The Wicked Son: Anti-Semitism, Self-Hatred, and the Jews* (2006). He has also had a good deal to say on the subjects of theatre and film over the years in such books as *On Directing Film* (1991), *Three Uses of the Knife: On the Nature and Purpose of Drama* (2000) and *True and False: Heresy and Common Sense for the Actor* (1997). In the twenty-first century, Mamet's work has been marked by more experiment with dramatic form and subjects, more direct political engagement, and a rather aggressive turn to the right in politics, as recorded in his *Village Voice* article, 'Why I'm No Longer a Brain-Dead Liberal' (2008).

Brenda Murphy

Key works

Mamet, David (1994) *Plays: 1*, London: Methuen.
——(1996a) *Plays: 2*, London: Methuen.
——(1996b) *Plays: 3*, London: Methuen.
——(2002) *Plays: 4*, London: Methuen.

Further reading

Billington, Michael (1983) 'Mamet Turns to the World of Salesmen', *New York Times*, 9 October: A6.

Gussow, Mel (1984) 'Real Estate World a Model for Mamet', *New York Times*, 28 March: C19.

Kane, Leslie (ed.) (2001) *David Mamet in Conversation*, Ann Arbor: University of Michigan Press.

MacLeod, Christine (1995) 'The Politics of Gender, Language, and Hierarchy in Mamet's *Oleanna*', *Journal of American Studies*, 29(2): 199–213.

Murphy, Brenda (2011) *Understanding David Mamet*, Columbia: University of South Carolina Press.

Nadel, Ira (2008) *David Mamet: A Life in the Theatre*, New York: Palgrave Macmillan.

Price, Steven (2008) *The Plays, Screenplays and Films of David Mamet: A Reader's Guide to Essential Criticism*, New York: Palgrave Macmillan.

ARTHUR MILLER (1915–2005)

The American dramatist Arthur Miller wrote more than 30 stage plays (as well as radio and screen scripts) in a career beginning in the mid-1930s and ending shortly before his death at the age of 89. His enormous reputation rests largely, however, on a handful of plays produced from the late 1940s until the 1960s, including *All My Sons* (1947), *Death of a Salesman* (1949), *The Crucible* (1953) and *A View From the Bridge* (1956). Although these are all powerful evocations and critiques of distinctly American experience, they have become modern classics, read, studied and staged in many languages around much of the world. Miller's widespread and continuing appeal, then, is based more than anything on his ability to dramatize lives and dilemmas that, while profoundly rooted in specifically American realities, can be perceived as universal and timelessly relevant to many modern societies.

In his valuable reflections on playwriting in general and his own drama in particular, Miller writes: 'I understand the symbolic meaning of a character and his career to consist of the kind of commitment he makes to life or refuses to make, the kind of challenge he accepts and the kind he can pass by' (Miller 1988a: 7). *All My Sons* (1947), Miller's first big critical and commercial success, centres on Joe Keller's decision to allow faulty engine-heads to leave his factory during the war, thus causing the deaths of the pilots flying the planes that contained them, and his willingness to let his business partner take the blame and go to prison while he was exonerated. Keller's actions represent his failure to commit himself to a larger relationship to his society than the welfare of his own family, so that he can see the 21 men his decision has killed as all being his sons. As it happens, he discovers in the course of the play that he has brought about the death of one of his own two sons, Larry, a pilot who, on discovering his father's guilt, has deliberately crashed his own plane. Combining dramatic technique learnt from Ibsen with the intensity of Greek tragedy, *All My Sons* dramatizes the downfall of a man and a family because of a decision to prioritize business over a larger commitment to the men fighting the war. Always a man of the left politically, Miller's play clearly implies that Joe Keller's priorities were those of many in American business in the war that had so recently finished, and that Americans had generally not appreciated the sacrifices made by their soldiers as they pursued their post-war dream of material prosperity.

Miller's original title for *Death of a Salesman* (1949) was *The Inside of His Head*, which indicates his desire to extend the Ibsenite realism of *All My Sons* into a form of dramatic expressionism that allows access to the subjective turmoil that is Willy Loman's inner life. Miller's aging, confused protagonist has a double commitment in life – to his family and especially his two sons Biff and Happy, and to his idea of selling as the way to achieve American success. Unlike Joe Keller, however, Willy has never achieved the success he has always aspired to, and in the ruthless world of American business he is no longer even employable. Although he can occasionally delude himself as to their potential, Willy's sons have always disappointed their parents and themselves in their inability to rise above mediocrity, Biff in particular – always Willy's brightest star – having repeatedly failed to hold down a steady job and even having been jailed for theft. Much of the play follows the process of Willy's mind as he remembers and imagines the past, alongside the realism of the scenes in the present with his wife Linda and the two visiting 'boys'. What emerges is more

than a story of personal confusion and failure; as the audience witnesses Willy's wandering, deluded imaginings and his pathetic attempt to deal with the realities of the here and now, it is invited to recognize the larger fissures opening up in the prevailing ethos of contemporary American life. Miller's directions for staging, as well as dialogue, juxtapose a suffocating urban alienation with the promise of America's green and wide-open spaces. Willy's patriotic rhetoric about American greatness is contradicted by his own occasional frustrated anger at the built-in redundancy of the things he has struggled to acquire and that define his life. And then there is human redundancy, the fact that individual aspiration to business success as the highest good is contradicted by the system's readiness to disgorge anyone and anything that no longer serves the all-powerful profit motive. Above all, the play insists that the commitment to an ethos of success thus defined obscures and subverts the fundamental value of love, either between parent and child or on a larger scale, as a genuine sense of social relatedness. Though Miller has Willy achieve at least a partial recognition of his son Biff's love for him in spite of everything, the play ends on the tragic irony that he can only conceive of furthering his dreams for them by pursuing his commitment to financial success to its *reductio ad absurdum* – committing suicide so that his family can claim the insurance money.

In 1952 Miller's close friend, the director Elia Kazan, appeared before a committee of the US House of Representatives, the House Un-American Activities Committee (HUAC), and named several members of the Group Theatre who had, like him, been members of the Communist Party. Although not named himself, Miller broke off his friendship with Kazan, who had directed the premiere of *Death of a Salesman*, and began work on what was to become *The Crucible* (1953), the characters and action of which are based on a witch-hunt in Salem, Massachusetts, in 1692. The play dramatizes the power of religious mass hysteria, manipulated for personal reasons, to destroy innocent people and disastrously affect an entire community. Although Miller thoroughly researched, and was careful not to depart from, the historical record, *The Crucible* was written to expose the nature and workings of the anti-communist paranoia that was sweeping America in the 1950s, fuelled by such committees as HUAC and notably the rabidly anti-communist senator for Wisconsin, Joseph McCarthy. Its protagonist, John Proctor, is a farmer whose wife, Elizabeth, has been accused of witchcraft by Abigail Williams, a former servant of theirs with whom Proctor has briefly had an affair. Sparked off by the alleged visions of Abigail and some of Salem's other girls, a full-scale witch-hunt, encouraged by the local clergymen and judges, is set in motion.

Proctor is horrified by what he sees going on around him but to save his wife he confesses to his adultery with Abigail. When he fails in this, Proctor is prepared to confess but he refuses to implicate others and, crucially, to allow his signed confession to be nailed up on the church, which would mean his having lost his 'name'. Miller's hero, flawed as he is, ultimately refuses – as Kazan and so many others of the playwright's acquaintances failed to do – to hand over his conscience to another, because of his realization that 'with conscience goes the person, the soul immortal, and the "name"' (Miller 1988a: 47). Not altogether surprisingly, Miller's stand in *The Crucible* brought him to the attention of the HUAC shortly after the play's premiere and again in 1956, when he appeared before the Committee but refused to divulge any names. He was convicted of contempt of Congress and blacklisted, although his conviction was later overturned on appeal.

The fourth play for which Miller is chiefly famous is *A View From the Bridge*, which was originally a one-act verse drama that was unsuccessfully premiered on Broadway in 1955 but later revised as a two-act prose drama and directed in London by Peter Brook in 1956, and subsequently often produced. Like Miller's previous major plays, *A View From the Bridge* dramatizes the protagonist, Eddie Carbone's, intense commitment, this time not to an idea but to his passionate love – at first avuncular but increasingly incestuous – for his orphaned niece Catherine, whom he and his wife Beatrice have raised. When Catherine falls in love with an illegal immigrant, Rodolpho, who is staying with Eddie and Beatrice, tragedy ensues. Disapproving of Rodolpho, whom he regards as effeminate, Eddie cannot bear to part with Catherine when she makes clear her intention of marrying her young suitor. As a result, he commits an unforgivable breach of the honour code of his Italian-American Brooklyn community, informing anonymously on Rodolpho's and his brother Marco's illegal presence and having them arrested by the immigration authorities. Eddie finally dies in a violent showdown with Marco, having destroyed his family, his love for Catherine and everything he previously held dear because of the passion driving him onwards.

Although none of them has achieved the classic status accorded those discussed above, the plays Miller wrote from the 1960s through to the end of the century continued to explore his central themes of commitment and personal responsibility in ways that sought to blend private actions with public significance. A distinctive way in which he did so was his experimentation with the expressionistic, 'inside of his head' form of *Death of a Salesman* to present the memories, imaginings, dreams and desires of a central

figure whose mental life usually includes at least some references to Miller's own life. This was notably so in *After the Fall* (1964), in which the character of Maggie obscured other aspects of the play's concerns by being so evidently based on Miller's relationship with the actress Marilyn Monroe, who died not long before its American premiere. But Miller uses a similar dramaturgy in other later plays, including *The Ride Down Mount Morgan* (1991) and *Mr Peters' Connections* (1998), as well as exploring his interest in memory in a variety of ways in *The Price* (1968), *The American Clock* (1980) and the double-bill *Danger: Memory!* (1987) – the latter made up of the two one-act plays, *I Can't Remember Anything* and *Clara*. Closely linked to Miller's dramatic treatments of the workings of memory is another of the distinctive preoccupations of his later work, which is with the Holocaust and the nature of fascism. This he explored in several plays, including *Incident at Vichy* (1964), *Playing for Time* (1986), based on Fania Fénelon's book *The Musicians of Auschwitz* (1979), *Broken Glass* (1994), as well as in *After the Fall* where the action is played out in the shadow of a concentration camp watchtower. Some of these later plays met with mixed critical and audience responses in America but were received much more enthusiastically elsewhere, especially in Britain. But there is no doubt that the major plays of the post-war years have established for themselves a genuinely global audience, with frequent revivals in America and elsewhere, including a groundbreaking production of *Death of a Salesman* in 1983 by the Beijing People's Art Theatre, which to Miller's delight recreated the tragedy of Willy Loman in a distinctively contemporary, Chinese image.[1]

Brian Crow

Note

1 Miller records the experience and its impact in his book *Salesman in Beijing* (1984), which he did with his photographer wife Inge Morath.

Key works

Miller, Arthur (1984) *Salesman in Beijing*, New York: The Viking Press.
——(1987) *Timebends: A Life*, London: Methuen.
——(1988a) *Plays: 1*, London: Methuen.
——(1988b) *Plays: 2*, London: Methuen.

Further reading

Bigsby, Christopher (ed.) (1990) *Arthur Miller and Company*, London: Methuen.

——(ed.) (1997) *The Cambridge Companion to Arthur Miller*, Cambridge: Cambridge University Press.

Brater, Enoch (2005) *Arthur Miller: A Playwright's Life And Works*, London: Thames & Hudson.

Martin, Robert A. and Centola, Steven R (eds.) (1996) *The Theater Essays of Arthur Miller*, New York: Da Capo Press.

HEINER MÜLLER (1929–1995)

Heiner Müller was born in Saxony, Germany, and died in the nation's capital, Berlin. In the early 1990s, he ironically commented that he felt privileged as a writer to have seen the demise of three states: Weimar democracy in 1933, Nazi fascism in 1945 and East German socialism in 1990. It is important that he stressed not only the sense of good fortune but that such historical upheaval benefitted him as an artist. History and politics pervade Müller's plays, and their significance is linked to Müller's often traumatic experiences of both fascism and socialism, and the influence of Marxism on his understanding of reality. Müller fell under Brecht's spell early and, despite having made an unsuccessful bid to join the Berliner Ensemble in the early 1950s, he did not sever his ties to Brecht's critical writing practices for the entirety of his career as a playwright. Müller's much-quoted adage 'to use Brecht without criticizing him is betrayal' (Müller 1990: 133) held true, in that Müller was keen to develop Brecht's dialectical dramaturgies while radicalizing them for a world that could no longer guarantee Brecht's worldview.

Müller started writing plays about the German Democratic Republic (GDR) in the late 1950s. *The Wage Sinker* (1957, translated into English as *The Scab*) took an uncompromising look at a socialist labourer whose productivity benefited society while worsening conditions for his fellow workers. Written in a heightened, often sententious language, Müller already signalled his sensitivity to the place of non-naturalistic speech on the stage. After the GDR government prevented the performance of two of his plays in the early 1960s, the playwright took up influences from mythology in a bid to comment on political structures. His rewriting of Sophocles' *Philoctetes* (Sophocles, 409 BC; Müller, 1958–1964) takes the three central figures as complex ciphers for the powerful pragmatist

(Odysseus), his eloquent subordinate (Neoptolemus), and the suffering yet resistant object of their interest (Philoctetes). The way in which the three figures (characters would suggest too psychological a formulation) behaved towards each other would re-echo in his dramaturgy from the early 1970s onwards: Müller became fascinated by fragments and the tensions he could fashion between them. *Germania Death in Berlin* (a montage assembled from scenes written between 1956 and 1971) aims to articulate historical contradictions in a condensed and lacerating manner, deploying pointed poetic language that lends the speeches a visceral quality. Yet even in this play, that mostly pairs a scene taken from German history with one set in the GDR, he inserts the 'Nocturne', a dumb-show of almost Beckettian economy, in which a shadowy character, who may be a puppet, experiences suffering so extreme that its mouth finally comes into being through its own scream.

The almost logical endpoint for Müller's predilection for contradiction and its possibilities is the play that is best known to the English-speaking world, *The Hamletmachine* (1977). This short piece, barely ten pages in length, is replete with quotation, pseudo-quotation and allusion, all designed to work as a complex texture of idea and counter-idea, image and counter-image, that proliferate over the course of the play's five scenes. Müller's fascination with history and the position of the intellectual, as represented by the centrality of motifs from Shakespeare's *Hamlet*, is played out intensively. Müller attributes no character to the dense text of the first scene. The first scene simply opens with the words 'I was Hamlet' without any clue as to who the speaker is in the present. The following four scenes feature similarly unusual treatment of their speakers. The play itself is a series of associative fragments in which each line adds to a texture at war with itself. Müller takes up and expands Brecht's idea of articulating social contradictions for the audience to judge. Here, contradictions burgeon to such a degree that the audience is swamped by them. Subjective impulses collide with particles taken from Europe's collective historical and cultural experience. In addition, Müller's refusal to tell the director or the cast how to stage the play relativizes the script's traditional centrality in the realization process: the creative team has to negotiate the text at a fundamental level to bring it onto the stage. Müller offers theatre-makers 'material' that is provocatively open, allowing for connections to emerge between actors and text rather than to impose 'readings' encoded in the play itself. In this way, his plays markedly diverge from those of Beckett, whose stage directions

appear to be non-negotiable for directors, especially when enforced by his estate.

Müller's decision to problematize the very question of who is speaking can be found in many of his plays, and this aspect betrays his interest in social situation rather than psychological coherence. Marx famously called the individual 'the ensemble of social relations',[1] and Müller was similarly keen not to overemphasize individual peculiarity. One of his most-performed plays, *Quartet* (1981), was inspired by Pierre Choderlos de Laclos' novel *Les Liaisons Dangereuses* (1782). It features two named characters, Valmont and Merteuil, who swap identities by role-playing a series of encounters so that it becomes unclear precisely who is speaking to whom. Müller then raised the dramaturgical stakes by offering what seems to be the description of a painting as the entire content of *Explosion of a Memory* (1984). A nameless 'I' only emerges in the final lines of the single block of text, attaching itself both to figures on the canvas as well as the frozen storm it depicts.

Müller continued to offer experimental plays in the 1980s, although *The Road of Tanks* cycle of five short pieces (1984–1988) gave the appearance of something more conventional. Here Müller returned to Brecht's idea of the 'learning play', a form in which a text dealing with difficult political issues was to be of more utility to the performers than to the audience. Each playlet meditates on a moment of trauma in the past. The cycle starts in 1941 with a Russian commander's decision to have a coward in his army executed to enforce discipline and ends with a socialist functionary in the GDR denouncing his son for supporting the Prague Spring of 1968. The playlets were a response, in part, to Mikhail Gorbachev's reforms in the Soviet Union. Müller chose to process particularly painful events as a way of confronting the past in order to approach the present. Like the first scene of *The Hamletmachine*, none of the playlets attributes a character to the text and thus, again, invites theatre-makers to act as dramaturgical arbiters. In this way, the five short pieces are very much involved in galvanizing directors themselves because they, perhaps in concert with the performers, have to divide the many impulses in the texts into sections. The production history of *The Road of Tanks* shows that some directors have chosen a dialectical split and used two actors for each playlet, while others have deployed larger ensembles to pick out nuance and to stage sections collectively in chorus.

Müller, a playwright who thrived and fed on the contradictions of a divided Germany, hit a creative impasse with the fall of the Berlin Wall in 1989 and the subsequent dissolution of the GDR in 1990. He found the 'post-ideological' political situation of the reunified

Germany so disorientating that he only completed one dramatic poem (*Mommsen's Block*, 1992) and one full-length play (*Germania 3*, 1995) before his death. It would be the task of younger playwrights, such as René Pollesch, Kathrin Röggla or Albert Ostermaier, to develop Müller's dialectical theatre for a new globalized context.

It is worth lingering on Müller's status as a 'postmodern Brecht'. To take the second word first: Brecht believed in theatre's power to refashion the spectator's consciousness by offering dialectical representations of the world. He sought to articulate contradictions on stage and invited the audience to leave the theatre and take a dialectical understanding back into their everyday lives. A dialectical world is one defined by instability, with new realities emerging from the tensions generated by contradiction. Brecht's optimistic view of change sat well with his understanding of recent history as the hard struggle from capitalism to socialism. Yet as postmodernity arrived in the second half of the twentieth century, socialism did not liberate the workers, and capitalism was nonetheless creating ever more inequality. Müller took up Brecht's emphasis on dialectical contradiction but did not share his historical hopefulness. Müller's plays stockpile contradictions and they explode like a nail-bomb: launching dangerous objects in all directions. While Müller shared Brecht's imperative to alter consciousness, he drove the idea of contradiction to an extreme – only if spectators could apprehend the enormity of changing the world could they have a chance of effecting it. Müller intensified Brecht's aims for plays and the theatre, and such ambitions became manifest in his radical dramaturgies.

As already mentioned, 'character' grew ever less important in Müller's plays because he preferred to articulate the individual's life against the vast backdrops of history and society, as an aggregate of experiences rather than as a personalized, psychological 'I'. In a telling note to *Waterfront Wasteland Medea Material Landscape with Argonauts* (1982), he wrote 'as in any landscape, the I is collective' (Müller 1995: 46). He thus asks for a very different kind of performance than that often associated with the theatre. Müller also favoured either loose plots, constructed out of disjunctive episodes, or no plot at all. In the case of the latter, audiences were confronted with the experience of angular texts and barbed language that was suggestive and contradictory, not stories. The final overarching quality of Müller's plays is their radical openness. There is often little clue as to how they are to be read or staged: the lack of individuation in the speakers, the connotative slipperiness of the language, and the difficult relationships between the scenes offer up the texts as unexplained provocations for directors and actors alike. Müller was also wont to write stage directions that could

not be staged literally. In the third scene of *The Hamletmachine*, for example, he asks for the Madonna with breast cancer to sit on a swing; later the cancer shines like a sun. Such an impossible detail was thus designed to challenge staging convention, and directors have chosen to have such lines read out or to use them as an associative springboard into more metaphorical realizations on stage.

The demands Müller puts on the theatre were a deliberate strategy. He was fond of quoting Brecht's dictum that the theatre likes to turn everything into theatre. That is, theatre tends to neutralize a play-wright's challenges by turning them into consumable commodities. Müller wanted his plays to provoke the theatre into creating new forms of performance to accommodate his unwieldy texts. As a result, his work has flourished in well-subsidized theatre economies, where experiment can take place with a reduced fear of empty houses and their financial implications. Consequently, Müller's influence has hardly been felt in the English-speaking world. However, in continental Europe in general, and in the German-speaking countries in particular, his work has been significant. The refusal to attribute play-text to a named speaker is most evident in the work of Nobel Prize-winner Elfriede Jelinek, and a penchant for constructing speeches out of the fragments of language can be found in many European playwrights from the 1980s onwards. Müller marks a departure from Brecht's careful articulation of contradiction into post-Brechtian dramaturgies in which contradiction can no longer be organized and controlled. In this, he laid the foundation for a new reception of Brecht and led by example by refining the nature of 'the political' in the theatre.

David Barnett

Note

1 Marx, Karl (1994) *Selected Writings*, ed. Lawrence H. Simon, Indiana: Hackett, p. 100; or Marx, Karl: 'Theses on Feuerbach', www.marxists.org/archive/marx/works/1845/theses/theses.htm [accessed 2 September 2013].

Key works

Müller, Heiner (1990) *Germania*, trans. Bernard and Caroline Schütze, New York: Semiotext(e).
——(1995) *The Hamletmachine*, *Quartet* and *The Road of Tanks*, in *Theatremachine*, trans. Marc von Henning, London: Faber and Faber.
——(2011) *Philoctetes*, in *Three Plays*, trans. Nathaniel McBride, Chicago: University of Chicago Press.

Further reading

Barnett, David (1998) *Literature versus Theatre: Textual Problems and Theatrical Realization in the Later Plays of Heiner Müller*, Frankfurt/Main: Peter Lang.

Kalb, Jonathan (1998) *The Theatre of Heiner Müller*, Cambridge: Cambridge University Press.

JOHN OSBORNE (1929–1994)

John Osborne is both unavoidable and irksome, a writer who went out of his way to cause trouble and succeeded. Ever eager to criticize the world around him he set about assaulting its sensibilities, including, if necessary, those of his audience. His earliest plays, *Look Back in Anger* (1956) and *The Entertainer* (1957), remain his most famous and critics maintain these are his most theatrically successful, at least in terms of their social impact. Yet, the later work sometimes achieves a uniquely unforgiving state of angst that reflects, via his surrogates, on the playwright himself. Remarkably, having come to public notice in the mid-late 1950s Osborne managed to sustain a career until the early 1970s. By the 1980s, however, he was having difficulty in placing his work and the subsidized theatre showed little interest in him. Osborne, who began as an actor in the repertory system, was essentially a man of the theatre and he knew first-hand a post-war atmosphere that attempted to cater for an intellectually exhausted, middle-class audience happy to return in their favourite entertainment to a more reassuring world. It was this tendency that he set out to combat by insisting on the primary importance of 'feeling' in every aspect of public and private life. Although associated with left-wing attitudes early on in his career, it's not surprising, given Osborne's theatrical view of life, that his politics often seem to amount to matters of style – of how people look, how they move and how they sound. His anti-heroes – a critical term much employed at the time – are extremely self-aware and anxious to hold centre-stage. Their means is the long speech or harangue. A mixture of self-disgust and boredom with their surroundings encourages them to improvise but, as they are brilliant observers of the contemporary scene as well as talented mimics, the plays always have a documentary value.

Osborne's narratives tend to be anti-climactic, relapsing back into a moribund stasis through which tiny but vital shafts of tenderness are sometimes glimpsed. Integrity is a hard taskmaster, truth-telling difficult to separate from revenge, and misery addictive. With personal

generosity in such short supply the only other relief is wit and Osborne can be a viciously funny writer. Nevertheless, even when he is at his most acute, there's often a bitter twist of misogyny. The sadistic delight he takes in contemptuous language takes on an additionally ugly tone when it is directed against women. This aspect of Osborne's gift is likely to cast a long shadow over his reputation and may well inhibit future revivals.

When *Look Back in Anger* appeared in 1956 at least one person in the audience thought that the characters were 'strongly reminiscent of the members of a provincial repertory company' (Griffiths 1981: 6-7). This was not a widespread reaction, however. Although some critics were repelled by the play, a few wanted to connect it with the experiences and attitudes of a whole generation. The most prominent of these was the *Observer* critic Kenneth Tynan who wrote '*Look Back in Anger* is likely to remain a minority taste. What matters, however, is the size of the minority'. Whether this single play set off a 'revolution' in the English theatre is a matter still debated by historians. What is clear is that it quickly attracted its own mythology which Osborne's public persona as an 'angry young man' did much to reinforce. The play was adapted for film in 1959, starring Richard Burton and directed by Tony Richardson.

Jimmy Porter, the hero of the play, is a recent graduate of a red-brick university who has decided to forgo the career options that might be available to him by manning a sweet stall in a Midlands town. He lives with his wife, Alison, and with Cliff, a close male friend, in 'a fairly large attic room, at the top of a large Victorian house'. It's a Sunday evening and the mood is lethargic although Alison is ironing and Jimmy is given to outbursts of rage directed at the world at large whose absurd misdoings, recorded in newspaper reports, he delights in reading out aloud. Although it is easy to consider subsequent events as a series of monologues delivered by Jimmy his motivation depends throughout on the presence of others. There is also – at least for the period – a strongly sexual atmosphere. Jimmy embarks on a brief affair with Alison's best friend, and he obviously relies on the moderate peacemaker Cliff for emotional security. A simple summary may make this seem a familiar plot based on adultery, and so it is. The vital innovation is that the situation is being lived out by such a *déclassé* group of people.

In a celebrated passage, Jimmy confronts Alison's upper-middle-class father with his out-dated Edwardian complacency. Given Osborne's later works this is a significant if misleading moment. The later Osborne frequently harked back to an English past he might

otherwise have been expected to despise. In *The Entertainer* (1957) Edwardian values of dignity and self-respect are represented by Billy Rice, a music-hall entertainer. Billy's middle-aged son Archie, also a professional comedian, is in desperate straits. His act is a pitiful anachronism; his family is in disarray. When it was first staged in 1957, *The Entertainer* achieved acclaim for the central performance by Laurence Olivier although subsequent revivals have shown that its overall technique is strong enough for others to impress in the role (Olivier also starred in the 1960 film version directed by Tony Richardson). The device through which a speech is directed at a silent but emotionally important addressee and consequently becomes a desperate monologue is now developed much further when, in a series of interpolated scenes, the speaker is Archie on stage delivering his professional patter. This time we, the audience, are the addressees as we witness Archie's family collapse around him – a son is killed in the invasion of Suez, an alienated daughter attends an anti-war rally, his forlorn wife turns to drink, his father collapses in an attempt to resuscitate his past career. In the process Archie becomes one of modern theatre's great truth-telling anti-types at the centre of a symbolic vision of social reality that undercuts all the official versions. Critics have always speculated on the influence of Brecht upon *The Entertainer*, but what is undeniable is the power of popular entertainment, in this case the music hall, to touch the raw nerves of history.

The other works Osborne produced in the later 1950s and early 1960s, although not always successful, were impressively varied. There was a misjudged musical, *The World of Paul Slickey* (1959), and a short-lived interest in historical dramas. A TV play *A Subject of Scandal and Concern* (1960) is set in the 1840s and based on the prosecution of the real-life secularist George Holyoake. Again we have a put-upon male, an intellectual outsider who on this occasion is being persecuted for professing atheism while arguing against the luxury of religion. The whole is framed as a TV documentary (the genre was in its early heyday) with a modern narrator whose voice-to-camera commentary connects material consumerism with the oppression of nay-sayers. The themes are freedom and forgiveness; the central dramatic event a long self-justificatory speech that has, ironically, a good deal in common with a sermon.

Any evidence that Osborne was seriously influenced by Brecht is more likely to be found in *Luther* (1961) which has a choric plain-man observer in the figure of a knight, a proto-capitalist in the form of Luther's father, and a devious papal bureaucrat. The accusation that Luther has an 'overstimulated conscience' could be levelled at any

number of Osborne's heroes. The play's major achievement is rhetorical, climaxing with a sermon in which Luther expresses his self-disgust through the deployment of scatological metaphors, relating in particular to constipation. This is not merely unexpected in a theatrical context; it captures the idea of someone at the mercy of his own human condition. Passion is again directed straight out at the audience – or congregation. Three years later came *Inadmissible Evidence* (1964) in which a solicitor, his professional and personal life a self-pitying shambles, once again rages at the contemporary world.

Osborne's inability to separate his view of the world from his view of theatre is apparent in two plays he wrote in 1968 inspired by his marriage to the actress Jill Bennett. In *Time Present* (1968), a woman is given the vituperative but witty 'Jimmy Porter role'. Offstage an actor of the old school is on his death-bed and with him, it is implied, his era. In *The Hotel in Amsterdam* (1968) a mixed group, all of them employees of a fearsome show-business figure known only as KL, escape to Holland on a collective jaunt. While the idea of an absent but still powerful presence may owe something to Pinter, the dominant onstage figure is clearly autobiographical: Laurie, a writer given to maudlin tirades. In one of Osborne's best-known lines, Laurie announces that writers 'need to be loved and cared for and given money'. By now Osborne's ire was directed at the consumerist pop culture that had replaced the tedium of the 1950s and yet in the age of sexual liberation he went on complaining about sexual mores of all kinds, including puritanism. If the presiding mood is Noël Coward with a hangover, Osborne's talent for abuse survives in some wicked passages from invented plays of the 1920s. More disturbing are the spleen Laurie directs at his working-class mother and some homophobic jokes.

Watch It All Come Down (1975) was the second and the last of Osborne's plays to be performed at the National Theatre, London. Once again we have a scene of domestic strife and a household that is symbolically transient in that the setting is a converted railway station. There are two male homosexuals and a moment of lesbian engagement. The language has changed since 1956 to the extent that the word 'fuck' is deployed, casually although with some precision. And the amount of physical violence has increased exponentially, most outrageously when a male character smashes his wife in the face. That Osborne should have inserted this at a time when the woman's movement was gaining attention was either due to his extreme insensitivity or a miscalculated act of cultural provocation. As so often with Osborne, it's hard to tell which. The play, which was poorly received, ends with local youths storming the middle-class citadel.

There's little in the play to suggest that it is worth saving – presumably Osborne's own feeling at the time. It certainly permeates *Déjà vu* (1991), Osborne's last play, which revisits *Look Back in Anger* 36 years on and in which Jimmy's most sympathetic ally turns out to be a stuffed teddy bear.

John Osborne showed the post-war theatre that it was possible to sustain a rhetoric that was modern in tone, culturally informed and never lacking in passion. In this respect, his many successors, for all their very different political allegiances, include several male writers who came to the fore in the 1970s, such as Simon Gray, David Hare, Howard Brenton and Dennis Potter. As David Edgar, another playwright of the younger generation, once put it: for characters in the tradition of Jimmy Porter, 'political change is an existential matter, part of the business of personally feeling right with the wrongness of the world, of setting an individual clock in accordance with out-of-joint time' (Edgar 1988: 140–141). The Osborne hero may be a natural orator but he doesn't have a prepared speech. In a welter of words he is at the mercy of himself.

<div style="text-align: right">John Stokes</div>

Key works

Osborne, John (1957a) *Look Back in Anger*, London: Faber and Faber.
——(1957b) *The Entertainer*, London: Faber and Faber.
——(1964) *Inadmissible Evidence*, London: Faber and Faber.
——(1975) *Watch It Come Down*, London: Faber and Faber.
——(1991) *Déjà vu*, London: Faber and Faber.

Further reading

Buse, Peter (2001) 'What does Jimmy Porter want? Osborne with Lacan', in *Drama+Theory*, Manchester: Manchester University Press, pp. 10–29.
Edgar, David (1988) 'The Diverse Progeny of Jimmy Porter' in *The Second Time as Farce*, London: Lawrence and Wishart.
Gilleman, Luc (2002) *John Osborne: Vituperative Artist*, London: Routledge.
Griffiths, Gareth (1981) *John Osborne: Look Back in Anger*, Harlow: Longman.
Heilpern, John (2006) *John Osborne: A Patriot for Us*, London: Chatto and Windus.

Sierz, Aleks (2008) *John Osborne's 'Look Back in Anger'*, London: Continuum.

Wandor, Michelene (2001) *Post-War British Drama: Looking Back in Gender*, 2nd edition, London: Routledge.

HAROLD PINTER (1930–2008)

Harold Pinter was born in East London to a Jewish family, educated at the local grammar school and, as a young man, he trained and worked as an actor. In the course of a long career he produced poetry, prose fiction and screenplays, and occasionally returned to acting, but it is as a playwright that he has been most influential. At first his plays attracted attention, often hostile, because they were set in unprepossessing, even squalid, locations, seemingly inhabited by inarticulate people incapable of maintaining a coherent conversation. The drama proceeded by way of digressive non-sequiturs and trivial unrelated observations while the situations, often violent, were unexplained, time and place unclear. Pinter himself often said, rather unhelpfully, that he started with an image rather than an influence or an idea and that this grew by mysterious means into a play. Nevertheless, critics soon found ways of placing Pinter within the post-war movement known as 'Theatre of the Absurd' and to make comparisons with other writers and literary enthusiasms of the period – Kafka, Sartre, Beckett, Ionesco. The alignment made sense in that it seemed reasonable to assume Pinter would have shared the tastes of his generation. That this was, in fact, the case became more apparent in some of his later works where he meticulously evoked a post-war culture. Looking back from a distance and appreciating Pinter's obvious comic gifts it's also possible to see his work as having something in common with UK radio comedy programmes of the 1950s, such as *The Goon Show*, with their fondness for language games. Pinter's developing career found him moving into different social environments and experimenting with forms of theatrical speech that, still unconventional in realistic terms, took on a strangely hallucinatory quality. His late, more politically outspoken years generated a number of short political plays that made their uncompromising point not in the style of agitprop but by manipulating opaque 'absurdist' techniques so that they reflect the faceless corporate brutality of the modern world – what Pinter increasingly saw as a contemporary form of imperialism.

Through works such as *The Birthday Party* (1958), *The Caretaker* (1960) and *The Homecoming* (1964), Pinter became recognized as the

master of theatrical uncertainty in a world where uncertainly is the weapon of brutal and violent circumstance. By dispensing with induction scenes and detailed character history, he placed increased emphasis on language as a weapon in its own right. Contests, invariably masculine, take place over possession of territory and, disturbingly, over the possession of women. He frequently invokes the ancient philosophical problem of verification – how can we prove the existence of what we have never seen or is no longer present? – and makes this a fundamental principle of his drama. For these reasons *The Room*, first staged at Bristol University in 1957, has often been said to contain the essence of early Pinter, and to be a blueprint for future work. The set is a single room in which occur, with no very apparent cause, a series of unexplained entrances and interventions and, climactically, an act of unmotivated violence. *The Birthday Party*, which followed and marked Pinter's London debut in 1958, is similar in many ways and among the most revived of all his plays. It begins with everyday banality as a seaside landlady offers breakfast cornflakes to Stanley, her sole guest, but it proceeds with a series of interventions from outside, from Lulu, a sexy neighbour, and a menacing pair of interlopers, Goldberg and McCann. Although their names might suggest that they belong to oppressed groups, Jewish and Irish respectively, the male pair set about terrorizing Stanley. When the play was revived in 1994 at the National Theatre, the British director Sam Mendes made sure that they initially seemed to be on the run themselves. In a celebrated sequence of haphazard cross-examination Goldberg and McCann subject Stanley to a barrage of questions to which there are no answers. Verbal torment changes into physical when Stanley's glasses are smashed, a scarf is tied around his head and he is made the scapegoat in a game of blind man's bluff. Frightening though this scene may be, Pinter gives the screw a final turn by having the landlady refuse to acknowledge what she has witnessed. Of course, we know the truth but, as a passive audience, we are unable to provide the evidence that the play's characters themselves deny.

A full-length play that achieved a long West End run in 1960, *The Caretaker* took Pinter's career a crucial step forward. Again the setting is down-at-heel – a room cluttered with objects, either derelict such as an old lawnmower or simply unexplained such as a statue of the Buddha. A bucket is suspended from the ceiling, and there's an iron bed. A tramp named Davies has been brought back to this room and offered hospitality by Aston, a young man in his early thirties whose manner is subdued, perhaps a little other-worldly. It will eventually

become apparent that Aston is suffering from some form of clinically recognized mental distress. Aston's younger brother is quite different – well turned out, focused, practical, full of future plans. Two speeches, in particular, caught the critical and the popular imagination: Aston's account of receiving electrical shock treatment (ECT) and Mick's description of his plans to redecorate the room in the best 'contemporary' style. A third motif, Davies' repeated complaint that he is unable to collect some unspecified but apparently crucial 'papers' from a man in Sidcup without a decent pair of shoes, became equally well-known. The play ends with stasis: threats that Davies must be thrown out hang in the air. Despite the lack of overall plot explanation, *The Caretaker* reflected any number of contemporary concerns, from worries that impersonal forces might be controlling the bodies and minds of ordinary people to an apprehension that the border between madness and sanity might be permeable, to what was by now a recognizably Pinteresque (a neologism beginning to enter the language) appreciation of the alienating strangeness of modern urban life.

Pinter's next full-length play *The Homecoming* (1965) had another working-class, specifically East London environment and revealed a further interest in criminality. A thuggish Cockney patriarch has three sons: two are still living at home, a third, Teddy, has emigrated to America where he has become a successful academic. Teddy and his bride, Ruth, return to his old home for a visit where, far from being treated as a prodigal, he is systemically abused by his brothers who eventually come to a sinister sexual arrangement with Ruth that sounds as if it will involve prostitution. The play ends with a tableau in which Ruth sits silent and relaxed in a chair, Madonna-like, with some of the men quite literally at her feet. Enigmatic tableaux were a theatrical resource that Pinter was going to continue to exploit and for all its violence and mood of degradation, *The Homecoming* – originally staged by the Royal Shakespeare Company and directed by Peter Hall – consolidated his reputation considerably. Nevertheless, it also drew attention to an aspect of Pinter's work that was to cause increasing disquiet: his representation of women.

All this while Pinter was writing film scripts such as *The Servant* (1963), *The Quiller Memorandum* (1966), *Accident* (1967) and L.P. Hartley's *The Go-Between* (1970), and directing plays by others from James Joyce (*Exiles* in 1970) to Simon Gray (*Butley* in 1971). When he turned to the theatre with work of his own it was with a series of plays set in middle-class milieus. This shift coincided with an increasing interest in memory and the tricks it can play. Typically these works of his 'middle-period' take on an atmosphere of precarious personal

reminiscence memorably defined by the surrounding culture. In *Old Times* (1971) it's classic films and high-class popular song; in *No Man's Land* (1975) it's more literary – the post-war world of little poetry magazines; while in *Betrayal* (1978), a play about an adulterous affair that is told backwards, it's the commercial publishing industry of the 1970s. There are some extremely powerful moments in these plays as well as some celebrated set pieces. In *Old Times* a trio – two women and a man – compete for one another's affection by crooning the songs of their youth. *No Man's Land* effectively comes to a halt when a man-servant launches into a monologue on the difficulty of negotiating a car in the one-way system surrounding Bolsover Street (which really does exist in London's West End). In each case a familiar world becomes strange. Pinter's interest in memory must have prompted his remarkable adaptation *A Kind of Alaska* (1982, televised in 1984), based on studies made by the neurologist Oliver Sacks, in which a woman wakes up from a sleep lasting nearly half a century. Her penultimate line, 'I think I have the matter in proportion', represents, perhaps, the most that can be hoped for when recovering from any severe lapse of consciousness rather than an ultimate sense of reality.

In the 1980s and 1990s Pinter's plays grew shorter, the language even more brutal. They can be roughly divided into two groups, although there are undoubtedly similarities among them all. On the one side, there are short political 'protest plays' in which, although they're not named, it's not difficult to identify the specific objects of Pinter's attacks alongside his detestation of oppressive regimes everywhere. On the other side, there are a handful of mid-length plays more difficult to relate to immediate events. Although not always so well-received as Pinter's now classic works, they may well be due revaluation. They include *Moonlight* (1993) and *Ashes to Ashes* (1996). *Celebration* (2000) reflects the greed culture of the post-Thatcherite years. Set in a pretentious restaurant, featuring a family party made up of a pair of gangster brothers – reminiscent of *The Homecoming* – and their wives, together with, at an adjoining table, a distinctly up-market couple, it effectively proceeds by violent four-letter insults. Coarse and sentimental by turn, the maunderings of the diners are broken into by an egregious waiter who makes completely unprompted 'interjections' recalling his grandfather who was appar-ently 'a drinking companion of D.H. Lawrence', 'a close pal of Ernest Hemingway', as well as a friend of various stars from old Hollywood. These parodies of literary memoir and biography, the stuff of cultural gossip, are among the most memorably funny moments in mid to late Pinter.

Claims that Pinter's work oeuvre always had a political dimension rightly stress the fact that a deep distrust of power in all its forms is present in everything he wrote. Although his experimental anti-realist techniques may have their origins in modernism, even in a writer like T.S. Eliot, Pinter is totally individual, his street-based theatre language unmistakable. He remained throughout committed to the unmasking of falsity and the unconcealment of truth. His inspirational influence is everywhere – among his near contemporaries such as Sam Shepard, David Mamet, even Caryl Churchill, and among a younger English generation that includes Martin Crimp, Patrick Marber and Jez Butterworth. In a tribute to his friend Samuel Beckett, who died in 1989, Pinter recalled what he had written of Beckett in 1954: 'He is the most courageous remorseless writer going and the more he grinds my nose in the shit the more I am grateful to him' (Pinter 1998: 58). Much the same could be said of the British theatre's continuing debt to Pinter himself.

John Stokes

Key works

Pinter, Harold (1959) *The Birthday Party*, London: Methuen.
——(1960) *The Caretaker*, London: Methuen.
——(1965) *The Homecoming*, London: Methuen.
——(1971) *Old Times*, London: Methuen.
——(1975) *No Man's Land*, London: Methuen.
——(1976) *Betrayal*, London: Methuen.
——(1984) *One for the Road*, London: Methuen.
——(1998) *Various Voices: Prose, Poetry, Politics (1948–2005)*, London: Faber and Faber.

Further reading

Batty, Mark (2001) *Harold Pinter*, Plymouth: Northcote House.
Billington, Michael (2007) *Harold Pinter*, London: Faber and Faber.
Gale, Stephen H. (ed.) (1990) *Critical Essays on Harold Pinter*, Boston, MA: G/K/Hall.
Gordon, Robert (2012) *Harold Pinter: The Theatre of Power*, Ann Arbor: University of Michigan Press.
Knowles, Ronald (1985) *Understanding Harold Pinter*, Columbia, SC: University of Southern California Press.
Raby, Peter (ed.) (2009) *The Cambridge Companion to Harold Pinter*, 2nd edition, Cambridge: Cambridge University Press.

MARK RAVENHILL (1966–)

The London premiere of Mark Ravenhill's *Shopping and Fucking* in 1996 represented, in hindsight, considerably more than the surfacing of an important new dramatic voice. The play's pugnacious yet playful title was mirrored in its tale of disaffected twenty-somethings, marooned in a rootless postmodern urban Neverland. Uncompromising and unapologetic, yet oscillating with seeming ease between linguistic and visual cruelty and comedy, *Shopping and Fucking* appeared to be unambiguously 'contemporary'. However, the play's critical and extended commercial success (a national and international tour, two West End runs and numerous overseas productions) not only marked Ravenhill as a potential 'pack leader' for a new generation of British dramatists – famously styled by Aleks Sierz as authors of 'in-yer-face theatre', a multifaceted form of 'experiential theatre' that simultaneously succeeded in capturing the temper of the times, and embracing such figures as Sarah Kane, Antony Neilson and Rebecca Prichard (Sierz 2000). *Shopping and Fucking*'s success – inducing the play's rapid assimilation into the canon of modern drama – also raised weighty questions about the contemporary dramatist's capacity to fashion dramaturgies that might be considered 'resistant to' rather than simply 'representational of' – or even worse, 'assimilationist of' – the unrelenting ideological monopoly of late capitalism. These matters continue to resonate in Ravenhill's playwriting career almost two decades on from *Shopping and Fucking*.

Of all the dramatists that Sierz considers in his 'in-yer-face theatre' thesis, it is Ravenhill – in spite of the fact that the manifold success of *Shopping and Fucking* has yet to be repeated – who now holds not only one of the leading but also perhaps the most distinctive presence both in the British theatre and internationally. This has been realized through a career that has taken the most unexpected twists and turns. Ravenhill was aged 30 when *Shopping and Fucking* was produced; after graduating in English and drama from Bristol University he spent almost a decade working on the London fringe theatre as a director, and only occasionally as a dramatist. His formative years as a full-time dramatist were strongly defined by collaborative forms of playmaking, in which the final solo-authored text was rendered through 'workshopping' and research with a director and actors. As the director of *Shopping and Fucking* and Ravenhill's subsequent *Some Explicit Polaroids* (1999), the influential Max Stafford-Clark had been signally fostering such working processes since the 1970s, and frequently with dramatists at the early stages of their careers.[1] This

process was mirrored in Ravenhill's collaborations with the Actors Touring Company and the director Nick Philippou on *Faust is Dead* (1997) and *Handbag* (1998), and on Nicholas Hytner's National Theatre production of *Mother Clap's Molly House* (2001, West End transfer 2002).[2] *Mother Clap*, 'a play with songs', a queer post-Brechtian romp employing dual timescales, verified Ravenhill's compulsive questioning of the possibilities of dramatic form and structure. The dramatist's response to having his work produced by a state-subsidized 'flagship' theatre might best be described as a period of dramaturgical (self-) reconnaissance, and one, albeit briefly, of relative invisibility.

Between 2001 and 2005 Ravenhill spent much of his energies engaged with the National Theatre's Connections Festival, a project aimed at enabling young non-professional actors, school groups and companies to perform specially commissioned work by professional dramatists. If Ravenhill's natural habitat appeared to be in the workshop, then the Connections project permitted a more solo, even conventional method to inculcate itself into his playwriting practice. However, the Connections play *Citizenship* (2005) is immensely revealing in approaching an understanding of Ravenhill's oeuvre. Demonstrating sharp sociological and linguistic observations of the modern English teenage life world, the play appears, initially at least, to be a smart realist comedy. In the dramatization of the journey to sexual awakening of the teenage figure of Tom, Ravenhill borrows from the German Expressionist *Stationendramen* – the 'passion play' form in which the hero's passage to spiritual epiphany is fashioned on the New Testament 'Stations of the Cross' taken by Christ in the Easter story. While the play partly thrives on audiences' 'recognition' of the represented action, the *Stationendramen* form also permits Ravenhill to create *Citizenship* at a remove from a secure and localized (English) type of realism. Like so many of the figures in Ravenhill's earlier plays, Tom is at sea, disconnected from the world around him, and here an expression of '[t]he sexualised teenager [as] a recurrent icon of the global marketplace' (Ravenhill 2008: xi).

As Ravenhill's comments here rightly suggest, *Citizenship* is a play that is considerably greater than the sum of its parts. In several respects, it can even be seen as a thematic extension of *Shopping and Fucking*. The motifs of absent fathers, drug-abuse and the instability of identity and sexuality inform both of these plays. On one level, *Shopping and Fucking* is also, like *Citizenship*, an eminently accessible play. The story of Mark, Lulu, Robbie and Gary carries a fairy-tale-like clarity in its telling. It certainly seems a world away from the work of some of Ravenhill's contemporaries – such as the proto-modernist experiments

of Sarah Kane, or Martin Crimp's overt challenges to the keystones of dramatic convention. The play's exterior realism – as seen in the snappy and frequently truncated verbal exchanges, or the sequences of microwaved food-feeding that top and tail the play – might suggest the imaginative reproduction of observed experience. Even the shocking and explicit sex sequences have discernible motivations in terms of character and dramatic action. But *Shopping and Fucking* also has the potential effect of dislocating the securities of spectators. As Dan Rebellato observes, although the original production gained highly positive critical notices, 'there was real disagreement about how the play actually worked', and that what the play actually represents is 'a new kind of theatrical engagement with politics', one that eschews the forms of political drama developed by the likes of Howard Brenton and David Edgar in the 1970s and 1980s (Rebellato 2005: xiii). Indeed, the play demands consideration in terms of its response to the failure of radical left-wing politics, the rise of consumer society and a yearning for a new kind of value-system precipitated by postmodernism (Rebellato 2005: xiv–xx).

It is this profusion of provocations, both explicit and implicit, in Ravenhill's work that prove immensely challenging when it comes to finding the appropriate critical discourse(s) for examining the plays. For example, Ravenhill's connecting thread is the effects globalization (Rebellato 2001), and also the troubled relationship between tragic form and the postmodern condition (Carney 2013: 231–266). More selective groupings of the plays reveal other possibilities; for example, *Shopping and Fucking, Some Explicit Polaroids* and *Mother Clap's Molly House* suggest an 'AIDS trilogy', charting the journey from an initial 'culture of fear and silence' through to how new drug therapies introduced in the 1990s offered life-enhancing possibilities (Saunders 2012: 185). And if there is a kernel to Ravenhill's dramaturgy, this has been problematized, at least in part, by his work over the past decade. Since 2005 he has not only been hugely prolific, he has also pursued his practice through new forms of collaboration, and through utilizing a range of dramatic and performance forms. For example, *Product* (2005, created for subsidized UK company Paines Plough and for an international tour), an acerbically comedic response to the nature of narrative and 'representation' in a post-9/11 world, was conceived by Ravenhill as a 'virtual monologue' for himself to perform. *Shoot/Get Treasure/Repeat* (2007, originally published a section each day in *The Guardian*),[3] is a kind of quantum expansion of the thematic concerns of *Product*, an epic cycle of 17 short plays concerning the War on Terror. For *pool (no water)* (2006) Ravenhill collaborated with the company Frantic Assembly, producing not so

much a 'play' as a 'text for performance' – as he also did with *The Experiment* (2010), which the dramatist also played as a monologue. He also penned *Dick Whittington* (2006) as a pantomime that stayed true to the traditional form. There have also been excursions as a librettist into opera and contemporary music theatre, as in *Ten Plagues* (2011), performed by the singer Marc Almond.

Although it would be erroneous to seek to identify a singular dramaturgical cornerstone to these collected works, there are certain recurring themes and motifs. The subject of 'evil' has become one of Ravenhill's preoccupations, and how we might come to comprehend it within our current ideological universe (Ravenhill 2004, 2013: xii). There is also the subject of 'illness', of the challenge of dramatically and theatrically representing damaged and ravaged bodies without falling into cliché (Ravenhill 2013: xii). Interestingly, these are also subjects that carry a haunting presence in *Shopping and Fucking* too.

Ravenhill's own instructive commentaries on his playwriting practice also suggest another recurrent concern (Ravenhill 2004, 2006). Questioning the purpose of narrative, even the very act of storytelling itself, seems hardwired in to his dramaturgy. Although Ravenhill's abilities as a storyteller are not to be doubted, the plays also question the reliability of narrative (and its manifestations in memory and history) as a means of forming a coherent connection between the human subject and her or his world. In *pool (no water)*, for example, a group of artists and friends recount the brutal exploitation of their injured and unconscious (and more successful) former comrade as the raw material for an artwork herself. But while the retelling of their story disturbingly arouses pointed questions about the potential inhumaneness of artists and their work, the jealousy and cruelty wielded by success and the susceptibility to destructiveness among groups and friends, the quasi-confession-like narrative form of *pool (no water)* ends in the ambiguous realization of privatized liberal dignities. It would be too easy to read this as a form of authorial intervention, as an admission by Ravenhill of the impossibility of ethically responsible human agency and living in the contemporary world. However, such cynicism is countermanded when we consider how the work represents an invitation to audiences to deliberate on how the means by which we make sense of the world are part and parcel of the challenges faced within contemporary life. Under postmodernism, the grand narratives of history and progress may have been dethroned, but the compulsion to narrate persists. In *Shoot/Get Treasure/Repeat*, this dimension to Ravenhill's work manifests itself in a cycle of plays that are a response to the excessive mediatization and news overload

around the War on Terror – a complex contemplation on the rela-
tionship between a real world epic narrative of recent history, and
how individual life stories operate within this. Significantly, Ravenhill
also frames the piece as a retort to the preponderance of con-
temporary verbatim or documentary theatres (a form he has also
worked with), of the need for 'a poetic and therefore ... more
political sensibility than "journalism" allows' (Ravenhill 2013: ix).

Ravenhill's working practice as a dramatist also informs an under-
standing of the trajectory of his playwriting. The constantly evolving
working contexts, his work as a performer, not to mention his roving
life as a cultural commentator, reveal a constant questioning of his
terms of engagement. And although rightly acknowledged as a thor-
oughly contemporary dramatist, his work is powerfully influenced by
wide-ranging theatrical and cultural histories. However, it would be
mistaken to perceive such apparent absence of fixity (early attempts to
label Ravenhill as 'gay dramatist' proved fruitless) as a form of suc-
cumbing to a relativist postmodern world. Indeed, it is in his articu-
lation of the very modern experience of absence and dislocation, and
the ideological prohibitions to ethical human agency, that distinguish
Mark Ravenhill's contribution to modern drama.

<div style="text-align: right">John F. Deeney</div>

Notes

1 See Roberts, P. and Stafford-Clark, M. (2007) *Taking Stock: The Theatre
of Max Stafford-Clark*, London: Nick Hern Books.
2 *Mother Clap's Molly House* was initially developed with acting students at
the London Academy of Music and Dramatic Art (LAMDA).
3 Originally titled *Ravenhill for Breakfast*. A small section of each play in the
cycle was published each day in *The Guardian* newspaper, to coincide
with the 'script in hand' rehearsed readings for the Edinburgh Fringe.
This added to the event-like quality of the cycle, but also demonstrated
how the War on Terror demanded forms of dramatization that trans-
cended its value simply as 'news'. The revised cycle was presented in full
productions across London in 2008, in a range of venues. This method of
presentation emphasized the onus being placed on audiences to negotiate
the fragmentary form of the piece.

Key works

Ravenhill, Mark (2001) *Plays: 1*, London: Methuen Drama.
——(2008) *Plays: 2*, London: Methuen.
——(2013) *Plays: 3*, London: Methuen.

Further reading

Carney, S. (2013) *The Politics and Poetics of Contemporary English Tragedy*, Toronto: University of Toronto Press.

Deeney, John (2015) *Ravenhill: Routledge Modern and Contemporary Dramatists*, London: Routledge.

Ravenhill, Mark (2004) 'A Tear in the Fabric: The James Bulger Murder and New Theatre Writing in the "Nineties"', *New Theatre Quarterly*, 20(4): 305–314.

——(2006) 'Me, My iBook, and Writing in America', *Contemporary Theatre Review*, 16(1): 131–138.

Rebellato, D. (2001) 'Introduction', in Mark Ravenhill, *Plays: 1*, London: Methuen Drama, pp. ix–xx.

——(2005) 'Commentary', in Mark Ravenhill, *Shopping and Fucking*, London: Methuen Student Editions, pp. xii–xliii.

Saunders, G. (2012) 'Mark Ravenhill', in A. Sierz, *Modern British Playwriting: The 1990s*, London: Methuen, pp. 163–188.

Sierz, A. (2000) *In-Yer-Face Theatre: British Drama Today*, London: Faber and Faber.

YASMINA REZA (1959–)

Yasmina Reza is one of the most globally successful playwrights of the late twentieth and early twenty-first centuries. Born in France of Iranian and Hungarian parentage, she both attended university and trained with Jacques Lecoq in Paris. After a relatively short career as an actress, Reza turned to playwriting and received Molière awards for her early works *Conversations After a Burial* (1987) and *The Winter Crossing* (1989). *Art* (1994), premiered in France and then re-produced by actor Sean Connery, transferred to London's West End in 1996 where it ran for more than 2,000 performances, and to New York in 1998 where, again, it had a prolonged production run on Broadway. *Art* received both Olivier and Tony awards for Best New Play. Other works by Reza, such as *The Unexpected Man* (1998), *Life x 3* (2000) and *A Spanish Play* (2004), were less successful. However, *God of Carnage* (2006) won both Olivier and Tony awards for Best New Play and was transformed into a film scripted by Reza and directed by Roman Polanski in 2011. Yasmina Reza's plays have been translated into more than 30 languages and have broken records for production runs in both the UK and the USA. She occasionally still works as an actress and is also a successful novelist – her novels include *Hammerklavier* (1997) and *Happy are the Happy* (2013) – as well as a screenwriter and writer of non-fiction.

After following Nicolas Sarkozy during his election campaign in 2006–2007, she published *Dawn, Dusk or Night: a year with Nicolas Sarkozy* (2007), which focused on the 'politician's obsession and hunger' – the book caused a media sensation in France.[1]

Reza has attracted little academic attention or critique and, while one might associate this with the, still extant, prejudices against certain 'types' of playwrights – she is French, a woman, and successful in the commercial sector – it is odd that someone whose work has been so popular with audiences has been so readily dismissed. Amanda Giguere suggests that this is because Reza's work is seen to appeal to those for whom entertainment at the theatre is more important than intellectual stimulation (Giguere 2010). In fact, Reza's proven commercial viability – most of her plays have premiered without state funding or subsidy – means that she sits outside the traditional critical frameworks for 'intellectual worthiness'. Western critics tend to operate on the basis that to be 'commercial' in theatre is to lack intellectual or philosophical sophistication – Reza's work contains both.

Reza's plays in production have been generated through a sustained artistic partnership with a number of practitioners such as the UK director Matthew Warchus and designer Mark Thompson. Christopher Hampton, himself a playwright and screenwriter, has been responsible for translating her plays into English and for undertaking a collaborative relationship with Reza in terms of adapting the plays for different cultural contexts. Reza writes from the perspective of having worked as an actress and her plays can be characterized as actor-centred, with small casts and austere sets – '*A single set. As stripped-down and neutral as possible*' (*Art*); '*A train compartment … Nothing realistic. Air. Space*' (*The Unexpected Man*); '*A living room. No realism. Nothing superfluous*' (*The God of Carnage*). The emphasis on text, written from a deep knowledge of how language works on stage, is in part why her work attracts 'star' casts, for whom the plays might be seen as professional vehicles to take them, for example, from screen to the more intimate environs of theatre – the late James Gandolfini, Jeff Daniels, Albert Finney and many other high-profile performers have appeared in productions of her plays.

While Giguere notes that Reza's plays work through disruption of expectation, through what she calls a 'breach', where often language fails in its communicative function, other critics such as Carroll have noted Reza's use of philosophical questions about the shape and process of friendship, or the meaning of 'civilized' behaviour (see Giguere 2010; Carroll 2002). Certainly, the majority of her plays explore the limitations of language in the bid to express emotion and

the use of language as a kind of weapon in either friendship (*Art*), or in the battlegrounds of heterosexual marriage and domestic strife (*Life x 3*, *The God of Carnage*). The plays are also structured as musical compositions – the duet (*The Unexpected Man*), the waltz (*Art*) and the quartet (*Life x 3*, *The God of Carnage*) – where speech is consciously embellished, fractured and language repeated through the play with compositional structure, rhythm, pace and tone. Often her characters deny the possibility that language can represent immediate or true meaning, and question the ways in which it is used to hide, cover or negate raw emotion. In a number of her plays, characters are developed in terms of their ability to manipulate and control relationships through their power over language: this is particularly so in the case of *Art*.

Premiered in Paris Reza's *Art* (1994) is a theatrical phenomenon – running for years in London and in New York, with regular cast changes, and star performers waiting in a queue to take on the role of one of the three men who argue over the relative merits of a 'modern' painting for the duration of the play. With one set where the scenes switch back and forth between Serge, Marc and Yvan's homes, the play breaks the fourth wall convention by having the characters talk directly to the audience – explaining what they are doing or talking about their feelings as the plot unfolds. Serge, a successful professional, has bought an expensive modern painting, an 'Antrios', which is almost entirely white. His friend Marc finds it impossible to understand why he has spent so much money on such a painting and feels that somehow the purchase of the painting signifies the end of their friendship. He cannot understand Serge's liking for 'modern art', finds his railings about it pretentious, finds him too easily coerced into believing in the value of abstraction and sees the painting as symbolic of Serge's desire to display his heightened social status. Marc is even more dismissive of the fact that their mutual friend Yvan – about to marry for the first time and who has newly become a stationery salesman – is unwilling to completely negate the aesthetic value of the painting, and in fact rather admires Serge for the fact that the painting makes him happy. The play is built around an argument about modern art – one critic even commented that Reza had written a play that was deliberately 'anti-art' (see Giguere 2010) – but more, it is fashioned around revelations about the power dynamics and the emotional contortions of modern male friendship. As the plot progresses, the characters all heavily criticize each other's sexual partners, careers and familial failings. Throughout, the battle is conducted with a constant eye on the painting until Serge invites Marc to vandalize it with one of Yvan's pens. Their relationship,

'destroyed by word and deed' (Reza 2005: 68), is renewed on what Serge calls a 'trial basis' – the play ends where Marc looks afresh at the painting and instead of seeing a sea of white, sees 'a man who moves across a space and disappears' (Reza 2005: 69). The play explores in part the paradox of both the divisive and the conciliatory power of art: through the disagreement about the painting the men deconstruct and then reconstruct their relationships with sharpened wit and, at one point, physical as well as verbal violence.

The making and remaking of relationships, and the construction in the imagination of characters that never actually appear in the plays are themes that run through a number of Reza's works. In *The Unexpected Man* (1998) a woman is confronted on a train journey with an author she has often imagined, having read a great deal of his work. The duologue sees them both discussing with the audience, how they might 'read' each other as both strangers on a train and as an author and his 'fan'. They do not speak to each other until near the end of the play, where he pretends not to be the author of the book she is reading and she only reveals that she knows who he is at the last moment. Reza also formulates a series of pictures of characters that never appear – the dead father in *Conversations*, the female partners in *Art* and the children in *Life x 3* and *The God of Carnage*. She creates the layers of a world without having to represent it concretely on stage – there are both thematic and structural echoes of Chekhov here. All the plays are set around singular events – a burial, a meeting on a train, the purchase of a painting, a dinner party and so on. Her mixture of non-realist sets and the manner in which language dominates the stage space perhaps sets Reza apart from many other playwrights whose work might be considered equally 'commercial'.

Reza's plays almost entirely focus on the middle classes: comfortable, heterosexual, white and middle-aged, yet she is not in the least beholden to an uncritical treatment of them. Like Chekhov, she foregrounds their self-centred hypocrisy, their self-absorption and their unremitting sense of entitlement. In *Life x 3* (2000), a quartet with three movements, two couples spend an evening together. Because of a mix-up with dates, the planned dinner party guests arrive a day early, the cupboards are empty and so they are treated to a series of snacks – chocolate finger biscuits, Cheez-Its – and wine. The evening is structured around various arguments in which power-plays between husband and wife, work colleague and work colleague, are punctuated by the voiced demands of Sonia and Henry's only child who refuses to go to sleep. The scene is repeated three times – the three movements – and in each all the characters

take on a slightly different attitude to the events of the scene, which pretty much remain the same. A crisis in masculinity runs as a current in much of Reza's work, and here this crisis is framed by a competitive professional environment, in which Hubert has power over Henry, but Sonia (Henry's wife) appears to have some sort of sexual power over Hubert. Similarly, the level and dynamics of sexism among middle-class males as exposed by Reza is heightened in a middle-class world where powerful men have partners who appear passive and lack command over language, and powerful women have partners with whom they are consistently disappointed. In *The God of Carnage* (2006), this is certainly the case. Here the couples fight over how to articulate and then deal with their two children in the aftermath of a fight in which one has been hit and injured by the other. While the evening begins relatively harmoniously, it descends into a torrent of clashing ideologies and violent insults. As the crescendos rise and fall, the rhythm is interrupted by a persistent series of phone calls between Allain's law firm representing a pharmaceutical company, and his wife Annette vomiting and then imbibing more and more alcohol. Civilization turns to carnage as the couples fail to reach consensus as to how they should handle the fight between their children.

Yasmina Reza's plays all have an innate intelligence, pulling apart – at times more gently than at others – the niceties of middle-class propriety, ripping away at the surface of ideological complicity to reveal the often savage nature of human relations. Many of them are written in the tradition of the great comedy writers of the twentieth century: she has much in common with Chekhov and Coward. Considered by some to be rather 'Boulevard' – French, bourgeois, commercial – her plays in fact have a lasting cultural resonance across continents.

Maggie B. Gale

Note

1 Sela, Maya (2013) 'Between Sarcozy and Sarcasm: Playwright Yasmina Reza on What Makes a Person Powerful', *Haaretz.com* [accessed 24 July 2013].

Key works

Reza, Yasmina (2005) *Plays: 1*, London: Faber and Faber.
——(2008) *God of Carnage*, London: Faber and Faber.

Further reading

Carroll, Noel (2002) 'Friendship and Yasmina Reza's Art', *Philosophy and Literature*, 26(1): 199–206.
Giguere, Amanda (2010) *The Plays of Yasmina Reza on the English and American Stage,* Jefferson, NC: McFarland and Company, Inc.
Mateo, Marta (2006) 'Successful Strategies in Drama Translation', *Meta: journal des traducteurs*, 51(1): 175–183.

PETER SHAFFER (1926–)

Peter Shaffer began his writing career as a novelist, and wrote plays for radio and television, before turning to the theatre. His first stage play was the award-winning family drama *Five Finger Exercise* (1958; *London Evening Standard* Drama Award, 1958; New York Drama Critics Award, 1959). This instant success confirmed his career as a dramatist.

Five Finger Exercise is set in an isolated cottage in the English countryside. Shaffer uses an outsider – Walter, a young visiting tutor from Germany – to reveal the horrors of what on the surface looks like a standard British family. His presence (and juvenile sexuality) attracts the mother, Louise, a pretentiously arty woman who despises her husband, Stanley, as a materialistic philistine. She has also turned her teenage daughter, Pamela, against the father, while their son, Clive – a closet homosexual – is an object of Oedipal desire for his mother, as well as being a bone of contention for both parents: Louise wanting him to study literature at university, while Stanley insists he should apprentice in his furniture factory. To intensify the family trauma, Pamela seeks to relieve her tension through playing incestuous games with Clive. Enter the tutor: mother and daughter compete sexually and emotionally for the young man, while the son is conflicted by an unacknowledged sexual attraction.

Signally, the title of the play refers to a musical exercise, which gives this family drama a metatheatrical dimension, even if it remains subtextual. The four family members and outsider substitute for the five fingers (four fingers and a thumb) of a pianist, while the exercise concept suggests Shaffer is playing with stereotypical dramatic elements. And indeed, even if disguised by the middle-class and British context, the name and philistinism of the father echoes the dominant male, Stanley, in Tennessee Williams' iconic *A Streetcar Named Desire* (1947). At the same time, the term 'five finger exercise' had been used by a nineteenth-century American preacher, Walter

Scott – co-founder of the Pittsburgh Christian Church (Disciples of Christ), whose history Shaffer may have come across while studying in the States – to describe a method of proselytizing and conversion; and possibly echoing this, a review of a subsequent production of *Five Finger Exercise* referred to it as 'a new version of the Passion story'.[1]

This was an early, if unrecognized, indication of Shaffer's major theme, focused on in his three best-known works: *The Royal Hunt of the Sun* (1964), *Equus* (1973) and *Amadeus* (1979). As Shaffer himself pointed out, 'all three pieces share a common preoccupation with worship and man's attempts to acquire or murder a special divinity' (Shaffer 1984: x) – and indeed, the same theme was explored in other, less successful plays: *The Battle of Shrivings* (1970), and continued the sequence with *Yonadab* (1988) and *Gift of the Gorgon* (1993).

While Shaffer continued to write comedies throughout his career – *Black Comedy* (1965), *White Liars* (1967), *Black Mischief* (1983), *Lettuce and Lovage* (1987) – an explicit religious seriousness entered his work in response to the new National Theatre, founded in 1963. The director John Dexter accepted Shaffer's *The Royal Hunt of the Sun* (1964), the first new play to be performed by the National Theatre. While Shaffer's comedies are generally naturalistic in form, like *Five Finger Exercise*, this play united avant-garde opposites from the 1920s, combining Bertolt Brecht's epic alienating structure, with Antonin Artaud's total theatre and emotional involvement.

As his 'Author's Notes' declare, Shaffer intended this to be '"Total" theatre, involving not only words but rites, mimes, masks and magic' (Shaffer 1964: viii). The play includes a narrator – a page-boy and therefore doubly an observer – who looks back on the action from old age as history, and as a young man acts out what he describes, thus doubling with one of the figures in his tale. This frame was a typical distancing device – derived from Brecht's epic theatre, which had made a major impact in London with the tour of the Berliner Ensemble just eight years before. Indeed, Shaffer reused the narrator frame in several of his subsequent plays, most notably *Equus* and *Amadeus*. However, in *The Royal Hunt of the Sun* this distancing device created a harsh dissonance with the striking visual and aural images of the action in the original production. These images were largely wordless. For example, a mime of the 'great massacre' in which a wave of Incas with barbaric headdresses rise and are cut down by the Spanish *conquistadores* to 'savage music' and compellingly pulsating drumming – a dance of slaughter ending with a vast blood-stained cloth dragged out from the huge golden sun, back stage

centre, representing the Inca empire; or the symbolic rape of Peru represented by the Spanish soldiers tearing the gold from the sun-icon, leaving it black and empty.

While the religious element predominated – although in fact denied by the failure of the Inca Emperor Atahuallpa's resurrection – there is also a political dimension, to the play. Worked through sub-liminally, the historical plot of 'how one hundred and sixty-seven men conquered an empire of twenty-four million' (Shaffer 1964: 1) represents the contrast between the two dominant political systems of the time, capitalism versus communism, in a 'conflict of two immense and joyless powers': the competitive individualism of Spain against authoritarianism and the material plenty of Peru. In a sense, then, capitalist drive overcomes communist power – a surprising forecast of the Soviet Union's dissolution several decades later. Yet there is also a sense in which the conflict is sexual, with the Spanish leader, Pizarro, personifying aggressive masculinity while Atahuallpa is presented as passive and androgynous, and the conquest taking on the nature of penetration and rape. This perspective of exotic femininity of course also suggests the colonial attitude later to be defined as Orientalism.[2] But in essence *The Royal Hunt of the Sun* represents the search for God – Atahuallpa believing himself to be the son of the sun-god, while the page/narrator writes the word 'God' on his fingernail – and this search occupies both Shaffer's other major plays.

Both *Equus* and *Amadeus* are also based on factual events, whether from newspapers or history – although *Amadeus* is also partly based on a highly fictional 1898 Pushkin/Rimsky-Korsakov opera, *Mozart and Sal-ieri*. Both also have increasingly dominant narrators. In *Equus* (1973) the narrator, Martin Dysart, is a psychiatrist who encourages his patient – a local stable-boy named Alan Strang who has viciously blinded six horses – to relive his experience as therapy, and who interprets Strang's actions as well as becoming emotionally involved, to the extent of suf-fering a 'very explicit dream' of himself cutting out children's entrails in a ritual of divination as 'a chief priest in Homeric Greece' (Shaffer 1977: 107). In *Amadeus*, the narrator Salieri is presented as a hack composer on his deathbed, reliving his competition with genius in the shape of Mozart, driven by his guilt for having murdered his rival by poison. Even more so than in *Equus*, the narrator is the protagonist in his own story. But – playing on Mozart's middle name, Amadeus or 'beloved of God' – this play too becomes a search for the divine, transposed into music. Both the stable-boy of *Equus* – whose violence against the horses is triggered by his sexual impotence – and the highly sex-ualized young Mozart are characterized as abnormal: the boy being

traumatized and in emotional torment, while Mozart is presented as asocial, anally fixated, 'an obscene child' with a high-pitched maniacal giggle (Shaffer 1984: 20).

In both plays the narrator/victim pairing is shown to be, at least subliminally, as a false and destructive father/son relationship. Very much like the psychiatrist, in being the only person who truly appreciates Mozart's music, Salieri is also shown as warped by jealousy, even as insane. His memories are clearly seen as self-serving justifications, even though the images on stage, which we see through his eyes, underline Mozart's genius – for example, with Salieri hidden in an armchair being clearly equated with Cherubino in Mozart's opera *The Marriage of Figaro* (1786). At the same time, the search for God is defined very differently. In *Equus*, the divine is encapsulated in horses (anticipating the highly popular 2007 National Theatre *Warhorse*) presented as skeletal iron shapes around a human body to evoke 'endless archetypal images that stretch back beyond the Stone Age' in a Jungian perspective evoking centaurs or the horse of Revelations,[3] creating 'a stable of Superhorses to stalk through the mind' (Shaffer 1977: 8).

By contrast, in *Amadeus*, the divine is presented in terms of human beings. Salieri believes himself to be God's instrument, having dedicated his music to God in a bargain that (according to him) will ensure his fame as a composer. His music only serves a society he despises; and the true divine appears (as he reluctantly recognizes) in the *idiot savant* Mozart, whose compositions Salieri perceives as the voice of God. The problem is that the vision we see – and the image of Mozart as a malignant child – is Salieri's view, since he is the narrator, conjuring up each of the scenes in his own defence and justification, which makes the performance of Mozart's music during the play increasingly (and deliberately) distorted: from Salieri's admiration of early piano pieces, through Mozart's insulting parody of one of Salieri's pieces, to the travestied vision of the performance of *The Magic Flute* (1791) or the *Dies Irae* (*Day of Wrath*) of Mozart's *Requiem* (1791–1792). Yet the distorted music effectively draws the audience into Salieri's vision.

Strikingly, the whole play becomes modelled on Mozart's operas, with Salieri's version of Mozart's father being projected into the stone Commandatore of *Don Giovanni* (1787) as well as the high priest Sarastraso of *The Magic Flute*, while the motif of masks and intrigues of *The Abduction from the Seraglio* (1782) and *Figaro* are built into the action. Thus, the form of Salieri's obsession in fact glorifies the rival whose destruction obsesses him; and it is Mozart's music that effectively draws spectators into the play (otherwise distanced by the dominance of the narrator-frame).

Wildly popular, as well as winning eminent prizes when first produced, Shaffer's work initiated a thrust towards 'total theatre' combined with deeply philosophical themes that were picked up by other British playwrights and theatres. When *Equus* was restaged in 2007 at London's National Theatre, one reviewer remarked 'it still has the air of an exciting, unusual theatrical event. Shaffer brought ritual back into English theatre; and for that we can all be truly grateful.'[4] However, revived again on Broadway in 2010, it was judged as too closely associated with 'the youth culture of the late 60s and early 70s'.[5] The movement Shaffer promoted outpaced his work, so that when *The Royal Hunt of the Sun* was restaged by Trevor Nunn in 2006 (again at the National Theatre), reviewers found it outdated stylistically, even though they pointed out that its themes had gained contemporary relevance: 'There's piquancy in seeing it now, when a conquest that called itself a salvation can be viewed through the prism of the invasion of Iraq, so that the sixteenth century Spanish offer of Christianity looks very like the twenty-first century promise of democracy, and the hunger for oil resembles the desire for gold.'[6] Yet his three major prize-winning plays – all filmed and reaching out to a popular audience – remain in the repertoire, particularly *Amadeus*.

Christopher Innes

Notes

1 Carey, John (1970) *The Listener*, 30 November: 928.
2 The classic colonial attitude was given its definition in Said, Edward (1978) *Orientalism*, New York: Vintage.
3 Shaffer, Peter (1975) *Vogue*, February: 192.
4 Billington, Michael (2007) *The Guardian*, 28 February.
5 Isherwood, Charles (2010) *The New York Times*, 25 June.
6 Clapp, Susannah (2006) *The Observer*, 16 April.

Key works

Shaffer, Peter (1960) *Five Finger Exercise*, London: Hamish Hamilton.
——(1964) *The Royal Hunt of the Sun: A Play Concerning the Conquest of Peru*, London: Hamish Hamilton.
——(1967) *Black Comedy*, New York: Stein and Day.
——(1974) *Shrivings: A Play in Three Acts*, London: Deutsch.
——(1977) *Equus*, Harmondsworth: Penguin.
——(1984) *Amadeus*, Harmondsworth: Penguin.

——(1988) *Lettuce and Lovage: A Comedy in Three Acts*, London: André Deutsch.
——(1993) *The Gift of the Gorgon*, London: Viking.

Further reading

Cooke, Virginia and Page, Malcolm (eds.) (1987) *File on Shaffer*, London: Methuen.
Gianakaris, C.J. (ed.) (1991) *Peter Shaffer: A Casebook*, New York: Garland Publishing.
MacMurraugh-Kavanagh, Madeleine (1998) *Peter Shaffer: Theatre and Drama*, New York: Palgrave Macmillan.
Russell Taylor, John (1974) *Peter Shaffer*, ed. Ian Scott-Kilvert, Harlow: Longman/British Council.

SAM SHEPARD (1943–)

As a playwright, Sam Shepard remains best known for a series of family dramas written during the late 1970s and early 1980s, which enabled him to be pigeonholed as an inheritor of the canonical American dramatic tradition of domestic realism. His embrace by the establishment was epitomized by the Pulitzer Prize awarded to *Buried Child* (1978), but it is worth noting that this remains the only Shepard play ever to appear on Broadway (and that not until 1996, in a short-lived production). For all his fame as a writer and film actor, Shepard has always been an experimental dramatist, whose weirdly unsettling plays exhibit little concern to cater for commercial tastes. Indeed, his initial emergence as a playwright was inseparable from the context provided by New York's emerging Off-Off-Broadway theatre scene of the 1960s. This was a 'free theatre' in every respect: plays were staged in churches, cafés and lofts, and nobody charged for tickets, so Shepard was under no obligation to worry about what might or might not 'sell'. In later work, he would strategically adopt recognizable dramatic genres, but the family home as dramatic setting was only one stop on a personal creative journey that has taken in many other contexts, while realism is a form he has borrowed only in order to subvert its premises.

Shepard's first influence as a playwright was Samuel Beckett – a factor that plays itself out in his work in two key, related respects. On the one hand, his drama is marked by an ongoing attempt to explore and articulate a fundamental sense of existential mystery about life itself. On the other, there is the urge to use language as a

performative means to express and perhaps expand the possibilities of being. As a young man fascinated by jazz music, and skilled as a drummer, the appeal of Beckett's rhythmic dialogue was for Shepard as much musical as literary and his work suggested freedom from formal dramatic conventions. At the age of just 21, having recently moved to New York from his Southern California home, Shepard began writing short, one-act plays such as *Cowboys* (1964), *Chicago* (1965) and *Red Cross* (1966), distinguished by their rhythmic, linguistic inventiveness and surrealistic sensibility. Initially mundane situations – a street, a bathtub, a motel room – are transformed as the plays depart into bizarre, dream-like territory. Convinced of Jack Kerouac's dictum that the first draft is always the most authentic, Shepard pursued spontaneous creativity wherever it led him.

Over time, however, he became dissatisfied with his free-form approach, as his stream-of-consciousness began leading him back to the same old places. Shepard became increasingly aware that, as an American growing up in the post-war years, his imagination had been colonized, even before he had any conscious say in the matter, by the colourful, throwaway culture of drive-in movies, TV serials and billboard advertising. During the later 1960s, he began to embrace and confront this kind of pop-cultural detritus – populating his plays with cowboys and Indians, rock stars and spacemen, and even, in *Forensic and the Navigators* (1967), suggestions on the best ways to eat Rice Krispies. With this shift towards theatrical pop art, however, the existentialist underpinnings of Shepard's aesthetic remained constant: within bewilderingly cartoonish theatrical landscapes, he presented figures searching for some kind of personal authenticity. In the best and last of these pop fantasies, *The Tooth of Crime* (1972) – a fusion of science fiction and Greek tragedy – the 'old king' Hoss, a leather-clad rocker, has his throne usurped by the young pretender Crow, a proto-punk 'gypsy killer'. This is a world in which the 'pop charts' are geographic charts of American territory, fought over by stars who are also murderous gangsters. Hoss is losing faith in this commodified 'game', yet his own sense of self is built on sand, memories of his youth little more than pop-culture leftovers. He has nothing stable to fall back on when attacked by Crow, who proves unnervingly frank about his own utter superficiality.

Tooth was written during a three-year spell living in London, where Shepard had moved to escape the imploding New York scene. By 1975, however, he had relocated again to San Francisco, where he began a close, highly productive relationship with the Magic Theatre. His enigmatic plays of the mid-1970s exhibit a concern to plumb,

ever deeper, the unsolvable mysteries of personal identity in relation to the language and culture that shape it. Indeed, in *Angel City* and *Suicide in B Flat* (both 1976), he self-consciously borrowed tropes from the *noir*-ish detective mystery. He was also conscious, however, of a profound difference between creating a sense of true mystery and merely mystifying one's audience. His shift of focus to the family drama, with *Curse of the Starving Class* (1977), was thus in part an attempt to render his work more accessible, even as it extended his existing concerns. To really explore the mysteries of identity, he realized, one must confront the ways in which one is shaped by one's upbringing.

Shepard's versions of domestic realism explicitly challenge the traditional, generic expectation that reliable truths will gradually be revealed through the mechanics of plot. For him, there are no neat, rational explanations for the workings of family that would not also misrepresent or distort its complexity. Thus, plays such as *Curse* and *Buried Child* (1978) present families rooted in the gothic grotesque as much as Ibsenite naturalism. Characters conduct conversations by yelling at each through walls or down stairs, they argue over disputed fragments of shared memory, they conduct repetitive chores with hypnotic deliberation, and bring things indoors that should by rights remain outside – a real, live lamb; the disinterred corpse of a long-dead baby. Within these *unheimlich* homes, young male characters functioning as proxies for the young Shepard struggle in vain for reliable understandings of their family's erratic behaviours. Caught up beyond themselves, these sons ultimately find themselves turning into echoes of their troubled, alcoholic fathers.

This sense of masculine identity crisis is further focused in *True West* (1980) and *Fool for Love* (1983), both of which explore themes of duality or split consciousness. In the former, two starkly contrasting brothers meet in their mother's Los Angeles home: Austin is a successful family man and screenwriter, his brother Lee a small-time criminal and desert drifter. Each seems to crave what the other has, but does not want, and during the course of the play the brothers exchange roles. This reversal is executed so deftly that it is both psychologically plausible, and yet – once completed – plainly contrived and theatrical. The illusion of realism, along with that of stable identity, is thus subverted from within.

Fool for Love provides a kind of male–female counterpart to the masculine duality of *True West*, by exploring the passionately twisted love affair between half-siblings May and Eddie. In a claustrophobic

motel room also haunted by the ghost of their 'old man' (whose violence toward women Eddie is in danger of perpetuating), Shepard stages a confrontation between what he described as the male and female sides of his own psyche – although the play was also inspired in part by the profound sense of connection he felt with his new partner, the actress Jessica Lange. In his next play, *A Lie of the Mind* (1985), an ambitious drama simultaneously following two families in contrasting landscapes, Shepard extends this interest in 'the female side': the damaged Beth attempts to piece her life back together both by adopting a degree of empowered masculinity when she tries on a man's shirt as if experimenting with new identity options, and by turning to Frankie as a gentler version of her husband, his violent brother Jake. In the film *Far North* (1988), written and directed by Shepard for Lange, who stars, the menfolk of a Minnesota farm family are reduced to the level of comic, foolish old men. Here, the beleaguered but resilient women take centre-stage.

During the mid-1980s, Shepard was widely hailed as the Renaissance man of American drama. In addition to his theatrical accomplishments, he received an Academy Award nomination for Best Supporting Actor in *The Right Stuff* (1983), and co-authored Wim Wenders' Palme d'Or-winning film *Paris, Texas* (1984). His ubiquity during this period, however, created some discomfort for this intensely private artist. In part to escape publicity, he moved to the country with Lange, but in doing so he also ended his longstanding relationship with the Magic Theatre. His prolific output as a playwright had always been dependent on having specific theatres to write for and, without such connections, his theatrical output since the mid-1980s has become more sporadic – although he has also published a number of well-received short prose collections.

Shepard's later plays have adopted a number of styles and approaches. Some, such as *Simpatico* (1994) and *The Late Henry Moss* (2000), have played intriguing variations on established tropes from his family dramas: in the latter, for example, two brothers sit drinking alongside the stiffening corpse of their father, quizzing visitors in an attempt to find out exactly how he died – as if a rational explanation will somehow defer their sense of loss. Shepard appears here to be revisiting memories of the early 1980s period when his own father – an air force veteran – gradually drank himself to death in lonely seclusion. Yet he also introduces supernatural overtones that echo his underappreciated 1992 film *Silent Tongue* (a western concerning the unburied corpse of a Native American bride). The

mystery of mortality itself has thus become a key element in some of his later work, but equally, Shepard has at times brought a surprisingly politicized edge to his playwriting. Both *States of Shock* (1991) and *The God of Hell* (2004) are vaudevillian satires written in response to the two US invasions of Iraq, under Presidents Bush Senior and Junior. The former, set in an American family restaurant as tracer fire lights up the scrim behind it, provides an intriguing twist on *True West*'s sense of mutual identity crisis, by suggesting that America, as a nation, can only define itself in negative relation to a demonized other. 'I miss the Cold War with all my heart,' one character remarks, as if to explain why Saddam Hussein's Iraq had so quickly replaced the declining Soviet Union as national enemy. In the play's central, quasi-familial relationship, the hawkish general attempts to convince his wheelchair-bound, war veteran 'son' Stubbs that his sacrifices have been worth it – even as Stubbs maintains that he was in fact shot down by 'friendly fire'. A full-scale food fight ensues.

Shepard's interest in applying a bleakly ironic approach to vaudevillian theatricality is also apparent in one of his most recent plays, *Kicking a Dead Horse* (2007). Commissioned by Dublin's Abbey Theatre, and performed by Irish actor Stephen Rea, with whom Shepard had first worked back in 1974, this monologue-based piece also points back to the foundational inspiration of Beckett, as Hobart Struther is depicted astride the grave he has attempted to dig for his dead horse. The ostensible setting is 'the lone prairie' of the American West: what is he doing out here in the middle of nowhere, Hobart asks himself sardonically – searching for 'authenticity'? Trying to reconnect with 'the wild'? And isn't this, in fact, the stage of a theatre, a place of artifice? Hobart is the classic, down-mouthed clown, performing his routine in full knowledge of the audience's presence. Perhaps he is also the ageing Shepard, doubting the value of even writing another play – 'kicking a dead horse' – while deftly encapsulating his entire theatrical project.

<div style="text-align: right">Stephen Bottoms</div>

Key works

Shepard, Sam (1984) *Fool for Love and Other Plays*, New York: Bantam.
——(1997) *Plays: 2*, London: Faber and Faber.
——(2012) *Fifteen One-Act Plays*, New York: Vintage.

Further reading

Bottoms, Stephen (1998) *The Theatre of Sam Shepard*, Cambridge: Cambridge University Press.

Roudane, Matthew (2002) *The Cambridge Companion to Sam Shepard*, Cambridge: Cambridge University Press.

Shewey, Don (1997) *Sam Shepard*, Cambridge, MA: Da Capo Press.

WOLE SOYINKA (1934–)

The Yoruba Nigerian Wole Soyinka (Akinwande Oluwole Soyinka) is generally regarded as being, with Athol Fugard, Africa's most distinguished and accomplished dramatist. Since the late 1950s, Soyinka has fulfilled the role of public intellectual and self-appointed spokesman for the Nigerian, and sometimes African, people. In addition to his work in the theatre, he has published poetry, novels and a wide variety of literary and more generally socio-political writings, as well as being a regular broadcaster in Nigeria and abroad. His outspoken opposition to a succession of Nigerian and other African regimes and leaders earned him imprisonment and periods of voluntary or forced exile as well as international recognition, culminating in his winning of the Nobel Prize for Literature – the first African writer to do so – in 1986. Soyinka has used the stage to make fierce satirical assaults on the abuse of power in Africa, by colonial authorities, by traditional leaders and by post-independence politicians and the military. At the same time, his plays have explored a major preoccupation of his non-dramatic writing, which is on what basis African nations can achieve stability, justice and progress given their history of colonial domination and neo-colonial subordination in the contemporary world order.

On his return home from studies in England in 1960, Soyinka formed a company, the 1960 Masks, and with them produced *A Dance of the Forests* to coincide with the Independence Day celebrations. *A Dance* heralded some of Soyinka's central themes as well as his pioneering of a dramatic form that combines contemporary realism in the observation of African behaviour and language with an eclectic and highly personal recourse to traditional folklore and mythology. Going against the grain of popular rejoicing and optimism at Nigeria's liberation from colonial rule, Soyinka warned his audience not to close their eyes and ears to the fact that African history has been – and could yet again be – marked by the brutal and tyrannical exercise of power. His warning proved prophetic. As

Nigeria slid quickly into ethnically based factionalism and power-seeking, and ultimately a vicious civil war, Soyinka repeated and deepened his satirical critique of African leadership and its lust for power in such plays as *Kongi's Harvest* (1965), *Madmen and Specialists* (1971), *Opera Wonyosi* (1977), *A Play of Giants* (1984), *From Zia, With Love* (1992) and *King Baabu* (2001). In essays collected in *Myth, Literature and the African World* (1976) and *Art, Dialogue and Outrage* (1988), Soyinka argued that the counterweight to power and the basis for progress in a just society is for Africans creatively to adapt their own tradition, with its metaphysical and ritual framework. His satirical political plays, then, have been interspersed – and sometimes combined – with drama that is more metaphysical, more obviously tragic in tone, and that characteristically explores the significance of myth and ritual action. These include *The Strong Breed* (1963), *The Road* (1965), *The Bacchae of Euripides* (1973) and his most anthologized and discussed play, *Death and the King's Horseman* (1975). Soyinka has occasionally eschewed his complex, sometimes obscure dramaturgy, usually targeted at university or arts centre-based audiences, in plays such as *The Lion and the Jewel* (1958), the Brother Jero plays (1960 and 1974) and *Requiem for a Futurologist* (1983), which, in dealing with the lighter, comic side of serious issues, have proved more accessible and thus more popular with Nigerian audiences of all kinds.

As in some of Shakespeare's plays, *A Dance of the Forests* (1960) is constructed around the opposition between the urban (and urbane) and the forest or other place where nature prevails. The Gathering of the Tribes, Soyinka's analogue for Nigeria's Independence celebrations, proceeds in the town, overseen by official celebrants who wish the festivities to pay homage to the illustrious forebears, who should be seen to 'symbolize all that is noble in our nation' in a display of magnificent pageantry. But instead of glorious ancestors, the wisdom and power of nature, figured by Forest Head (masquerading in human form as Obaneji) and the lame Aroni, contrives the visitation to the human community of 'two spirits of the restless dead', the Dead Man and his still-pregnant wife, whom the organizers of the festivities have driven out of the town and spend much of the play hunting down on the edges of the forest. The implication is that the modern African nation-state, and specifically Nigeria, is being inaugurated by public festivity that deliberately excludes the negative elements in the actual historical record, although there are natural and spiritual forces at work that ultimately compel the encounter between the 'restless dead' and the living, however unwilling. The representatives of the latter are all linked in their previous lives with the

Dead Man and Woman, in the court of the despotic Mata Kharibu some eight centuries previously. The small group, including the carver Demoke, is led ever deeper into the forest as they are brought to judgment and potential regeneration. And it is Demoke, aided by his spiritual patron Ogun, who performs the redemptive but potentially self-sacrificing act of saving the Half-Child, the Dead Woman's long-unborn child now given potential life, in the ritualistic masque-like sequence that climaxes the action. The only possibility of a genuine breakthrough into a new era of history depends on the recognition of guilt and expiation – Demoke himself has a murder to expiate – that may, possibly, lead to a different kind of awareness and behaviour.

In *A Dance* it is the artist who potentially redeems his people through his Ogun-inspired willingness to sacrifice himself. In *The Strong Breed* (1963) it is Eman the teacher who follows in his father's footsteps as the ritualistic 'carrier' and dies seeking to restore to spiritual health a community to which he does not even belong by taking upon himself the burden of its sins and guilt. Soyinka's protagonist has lived a wandering, exiled life in his desire to elude his father's prophecy that, despite himself, he will one day be compelled to embrace his 'strong breed' inheritance as a ritualist. What compels him, ultimately, is an ethical decision: he refuses to tolerate the villagers' choice of the simpleton Ifada as their ritual scapegoat, on whom the community can conveniently heap and then disavow its ills. Contrary to the village leaders' conception of the ritual act as a purgation to preserve and strengthen the status quo, Eman acts from the conviction that the scapegoat must be both willing and knowing. His ethical confrontation with the old order is a symbol of the need for revolutionary transformation – and, significantly, his ritual action results in the village leaders being deserted by their erstwhile disciples.

Soyinka's best-known and critically most acclaimed work, *Death and the King's Horseman*, develops further the basic pattern of action and meaning established in earlier 'metaphysical' plays like *A Dance* and *The Strong Breed*. The ritual protagonist of the play should be Elesin Oba, the king's horseman, whose duty and honour it is to commit ritual suicide so as to accompany the dead king's spirit home to the world of the ancestors. But Elesin fails to perform the act before he is arrested by the colonial authorities, apparently because his will 'was squelched in the spittle of an alien race, and all because I had committed this blasphemy of thought – that there might be the hand of the gods in a stranger's intervention' (Soyinka 1984: 212). It then falls to his son Olunde, the modern young African who has gone to England to study

medicine, to return and, instead of burying his father, commit the ritual act of self-sacrifice himself. Olunde's tragic heroism, like Eman's in *The Strong Breed*, lies in combining the desirable things that modernity can offer with a commitment to traditional belief and practice that is primary and non-negotiable. In his previous plays, Soyinka had often pointed to the flaws in the traditional order, but here he presents that order as radically vulnerable to forces associated with the presence of colonial modernity. The lyricism that marks the play's opening modulates into a profoundly elegiac tone at its end. Elesin's unborn child offers hope for the future but the dominant tone is of lament; as the Praise-Singer accuses Elesin: 'we placed the reins of the world in your hands yet you watched it plunge over the edge of the bitter precipice' (Soyinka 1984: 218).

Although Soyinka's dramatic achievement is widely acclaimed, some of his work has been negatively viewed, especially by Marxist Nigerian intellectuals. *Death and the King's Horseman*, in particular, while praised for its dramatic power and the lyrical brilliance of its dramatic language, has been criticized – notably by the leading Nigerian critic Biodun Jeyifo – for its metaphysical deployment of notions of honour and leadership that appear to be based on a patriarchal and feudalist code of ethics associated with a discredited traditional ruling class (Jeyifo 2001: 96–97). And while his political activism and personal courage is much admired, his recourse to myth and ritual associated with tradition has in general aroused suspicion, especially among the younger generation. The playwright Femi Osofisan, for example – although in some ways much influenced by Soyinka – is notably sceptical about traditional spirituality in his work, preferring to use the Nigerian stage to promote a class-based exposé of the status quo. From another direction – those whom Soyinka has stigmatized as the 'neo-Tarzanists' (Soyinka 1975) – he has been criticized for what is seen as his over-dependence on Western dramatic models and his cultural elitism. The master, on his part, although expressing his allegiance to some form of socialist humanism, has evidently been profoundly irritated by what he clearly regards as the ideological naivety of such criticism. In any case, his reputation among Nigerian theatregoers, given that country's troubled history and failures of political leadership, probably rests more on the trenchant satirical plays, revue sketches and agitprop pieces in which he has consistently pilloried Nigeria's, and more broadly Africa's, leaders for their often grotesque abuses of power. If Soyinka had in mind early nationalist leaders-turned-despots such as Nkrumah and Hastings Banda in *Kongi's Harvest*, in

Opera Wonyosi (a version of Brecht's *Threepenny Opera*) his fire was turned on the absurd but murderous Jean-Bédel Bokassa of the short-lived Central African Empire and, more recently, Nigeria's most recent and depraved of military despots General Sani Abacha, in *King Baabu*, based on Jarry's *Ubu Roi* (1896). Complicit in their regimes, these plays assert, have been corrupted members of the educated elite and leaders of the institutions of civil society such as the churches and unions.

The growth of postcolonial and intercultural theatre studies has done much to give Soyinka a wider audience; and his plays are now quite regularly produced outside of Nigeria, especially in the United States where the writer has spent a good deal of time in recent years. His global reputation as a playwright secure, Soyinka has come to be, increasingly, a public intellectual with an international rather than a merely Nigerian or even African profile. In such publications as *The Burden of Memory, The Muse of Forgiveness* (1999), he has taken his cue from post-Apartheid South Africa's Truth and Reconciliation Commission to broaden his analysis of the continent's disfigurement by the historical exercise of power and to explore the place of reparations and reconciliation in the process of 'identifying all possible routes to social harmonization' (Soyinka 1999: 25). In the BBC Reith Lectures for 2004, Soyinka extended his analysis of the nature, roots and effects of power in the contemporary world in the larger context of the global climate of terror and fear that has dominated political agendas since 11 September 2001. In these public utterances, as well as through his dramatic oeuvre, Soyinka has indeed fulfilled his dictum of 1967 that the artist in Africa should be 'the voice of vision in his own time' (Soyinka 1968: 21).

Brian Crow

Key works

Soyinka, Wole (1973) *Collected Plays 1*, Oxford: Oxford University Press.

——(1976) *Myth, Literature and the African World*, Cambridge: Cambridge University Press.

——(1984) *Six Plays*, London: Methuen.

——(1988) *Art, Dialogue and Outrage: Essays on Literature and Culture*, Ibadan: New Horn Press.

——(1999) *The Burden of Memory, The Muse of Forgiveness*, New York: Oxford University Press.

Further reading

Gibbs, James (ed.) (1981) *Critical Perspectives on Wole Soyinka*, London: Heinemann.

Jeyifo, Biodun (ed.) (2001) *Perspectives on Wole Soyinka: Freedom and Complexity*, Jackson: University Press of Mississippi.

Soyinka, Wole (1968) 'The Writer in a Modern African State', in Per Wästberg (ed.) *The Writer in Modern Africa*, Uppsala: Scandinavian Institute of African Studies, pp. 14–21.

——(1975) 'Neo-Tarzanism: The Poetics of Pseudo-Tradition', *Transition*, 48: 38–44.

TOM STOPPARD (1937–)

Ever since the premiere of *Rosencrantz and Guildenstern Are Dead* (1967) at the National Theatre in London, Tom Stoppard has ranked as one the most significant contemporary playwrights. Writing 'comedies of ideas' that are filled with intelligence, theatricality and linguistic virtuosity Stoppard has enjoyed both critical and commercial success. Remarkably, nine of his 11 major plays have won a Best New Play award in either London or New York. Likewise, Stoppard is the rare writer who can rightly claim that cornerstones of his canon come from five different decades.

Born in Czechoslovakia as Tomáš Straüssler, Stoppard arrived in England at the age of eight when his widowed mother remarried. Although an intellectual playwright, Stoppard never went to university, leaving school in 1954 after completing his O-levels. He worked first as a newspaper reporter and then as freelance writer, penning approximately a dozen scripts, numerous episodes of a radio drama, as well as theatre and film reviews. Since the success of *Rosencrantz*, Stoppard has composed a major new play approximately every four years, with the intervening years filled by writing smaller plays, adaptations, works for radio and television, as well as film scripts. An avid reader, Stoppard's major plays often stem from intellectual ideas, with characters and plots then being devised for their ability to convey those ideas.

Stoppard's writing has frequently followed a cyclical pattern of creation. Typically, he has found an area of interest, thematically or artistically, which he has explored over a number of years, often starting with a minor work and culminating in a major work or works. Once he feels he has sufficiently explored that theme or executed that style he moves on to a newfound interest. *Rosencrantz*

and Guildenstern Are Dead culminates his pre-success work. Not only does it revise the urtext *Rosencrantz and Guildenstern Meet King Lear* (1964), it also 'perfects' the style and themes of *The Gamblers* (1965). Like its antecedents, *Rosencrantz* uses Beckettian stichomythic wordplay balanced by philosophical monologue, as it examines existential issues surrounding truth, fate, death, role-playing, and the nature of identity.

Rosencrantz's worldwide success gave Stoppard time to explore new territory, and *Jumpers* (1972) and *Travesties* (1974) fall into the second cyclical period. Thematically, *Jumpers*' predecessor is the short television play *Another Moon Called Earth* (1967), while *Travesties*' thematic antecedent is the radio play *Artist Descending a Staircase* (1972). *Jumpers* and *Travesties* share an artistic style: disorienting prologues, dauntingly long but comic monologues, and a series of scenes that mingle highbrow and lowbrow jokes with unexpected bits of music, dance, parody and the debating of intellectual ideas; in short, both plays have a veneer of flashy showmanship and an innovative style that strives to be entertaining, funny and surprising, while also trying to discuss serious ideas. Thematically, *Jumpers*, set in a fictitious, indeterminate time after the British have landed on the moon, is 'a farce whose main purpose is to affirm the existence of God. [It is] a farcical defence of transcendent moral values [and] an attack on pragmatic materialism.'[1]

Playing off plot points from Oscar Wilde's *The Importance of Being Earnest* (1895), *Travesties* consists of the fictional, fractured memories of a minor British consular figure, Henry Carr, and his interactions with novelist James Joyce, Dadaist leader Tristan Tzara and Russian revolutionary Vladimir Lenin while all four were in Zurich during World War I. While *Travesties* displays Stoppard's linguistic and theatrical virtuosity, it also explores Stoppard's own internal debate: what is an artist? What are the possible roles, functions, and aims of the artist? What is the position of the artist in society? What is the relationship between revolutionary art and revolutionary politics? Overall, the play affirms Stoppard's view that the artist does not need to justify him/herself in political terms. Ironically, after asserting this view, Stoppard proceeded to pen plays that were overtly political, plays that dealt with the ramifications of Lenin's ideology in action.

Between major plays Stoppard writes for other media, composes adaptations and pens works for non-mainstream theatre venues. A number of these 'minor' works include some of Stoppard's most innovative and effective writing. In particular, his concern for human rights abuses in the Soviet Union and Czechoslovakia manifested itself in *Every Good Boy Deserves Favour* (1977), a work written to be

performed with the London Symphony Orchestra, and the award-winning television play *Professional Foul* (1977). Since these plays directly confront social issues, critics hailed them as marking a new, more mature Stoppard, a playwright who would be serious and politically engaged. Stoppard responded that he was always morally if not politically involved. Both works contained a concern for universal human rights, and on the personal level, Stoppard became politically involved in trying to secure the rights of dissidents in Czechoslovakia and the Soviet Union.

While Stoppard confined his overtly political works to his non-major plays, he moved away from the flashy showmanship of *Jumpers* and *Travesties* to explorations of modified realism. Thematically, *Night and Day* (1978) explores journalism and offers a passionate defence of a free press. Artistically, the play's emphasis on a narrative through-line, a complex female character and the exploration of love and sexual relations are taken to a higher degree of execution in *The Real Thing* (1982). The title, *The Real Thing*, refers to a love affair that is destined to last and to the discrepancy between reality and appearance. While the play broaches Stoppard's perception of the 'real thing' in art, politics and writing, it is first and foremost a witty, intelligent romantic comedy focusing on the joys, pains and emotional dynamics of adult love relationships. Overall, *The Real Thing* is Stoppard's most mainstream work; it is also his most autobiographical as the parallels between Stoppard and his politically conservative playwright protagonist, Henry, are numerous.

After exploring modified realism, Stoppard turned to the world of science for his inspiration. The Cold War spy thriller *Hapgood* (1988) uses the quantum physics mystery of the wave/particle duality of light as a metaphor for human personality: the idea that a person has a public self and a submerged self. Stoppard's metaphor is a statement that individuals are comprised of complex, even contradictory, personalities that add up to the whole person. While *Hapgood*'s metaphor is relatively simple, the play itself (mingling a tangled spy plot with discussions of quantum physics) is one of Stoppard's most complex.

Audiences had difficulty following *Hapgood*'s intricate plot, and the play had less humour than a typical Stoppard play, and so when he returned to the realm of science for *Arcadia* (1993), Stoppard addressed these problems, focusing attention on crafting an engaging storyline filled with jokes. Furthermore, *Arcadia* represents the joining together of the *Jumpers/Travesties* stylistic display of an intellectual concept with *Night and Day/The Real Thing*'s more emotional, narrative style. Stoppard comments: '*Arcadia* is as full of theses as

anything I've ever done, but if I hadn't found my way into a kind of detective story, none of it would have been worth a damn dramatically. I think it's the first time I've got both right, the ideas and the plot.'[2] Considered by many critics to be Stoppard's masterpiece, *Arcadia* is a literary detective story with scenes that alternate between the early 1800s and the present, until the final scene when the two eras share the stage. Through the story, Stoppard explores romanticism versus classicism and the new maths/science of deterministic chaos and its demonstration that systems in nature are often unpredictable but not random. Overall, *Arcadia* suggests that the coexistence and interdependency of seeming opposites is fundamental to the way the world, life and humans operate. It also dramatizes Stoppard's worldview of life being comprised of a complex, dynamic interaction of randomness, determinism and metaphysics.

Indian Ink (1995), an elaboration of his award-winning radio play *In The Native State* (1991), is an anomaly among Stoppard's major plays in that its core content was not intended for the stage. Like *Arcadia*, both the stage and radio versions involve a satire on academics and a narrative alteration between past and present. Focusing on a female poet, *Indian Ink* joins with *The Invention of Love* (1997) to mark a different phase of Stoppard's career. These two works are more character-driven. Also, unlike previous efforts, both plays are intimately connected to British culture. Both look back to glory days of England, the Empire in India and Oxford in the Victorian era.

Written in dream-memory form, *The Invention of Love* is Stoppard's impressionistic biography of A.E. Housman, the pre-eminent classics scholar of his era who was also a minor poet. While many ideas are explored in the play, *Invention* is character-driven, with the ideas emerging out of Housman's biography. Stoppard's attraction lay in Housman's two sides: the poet's creative mind and the classical scholar's analytical mind. Like the metaphor that informs *Hapgood* and *Arcadia*, one sees Stoppard's continuing interest in the duality of the human temperament and the reconciliation of seeming opposites.

While *Invention* marks Stoppard's first in-depth use of biography, his follow-up, *The Coast of Utopia* (2002), embodies the use of historical figures on an epic scale. Written in the spirit of Chekhov, but with the scope of Tolstoy, *The Coast of Utopia* is Stoppard's most ambitious work, an over eight-hour trilogy (*Voyage*, *Shipwreck* and *Salvage*) that examines nineteenth-century Russian intellectuals. Set amid the intellectual fervour of the Romantic Revolution and budding socialism of the mid-1800s, the play examines the men who helped transform tsarist Russia, including the freeing of the serfs. At

different points centred on the anarchist Mikhail Bakunin, the literary critic Vissarion Belinsky and the socialist Alexander Herzen, *Coast* sweeps across 35 years of social and political history and the lives of the men who made it.

The Coast of Utopia's interest in social and political theory carried over into Stoppard's next play, *Rock 'n' Roll* (2006), only now the setting is modern and informed by the personal subtext of the divide between Stoppard's birth country, Czechoslovakia, and his adopted homeland, England. The play begins with the Prague Spring of 1968 (when the Soviets crushed the burgeoning freedoms of the Czech people) and ends with the overthrow of communism in Czechoslovakia via the 1989 Velvet Revolution. The story also moves between the awakening political consciousness of Jan, a rock *'n' roll-loving Czech dissident, and his former mentor, a Marxist don at Cambridge. Jan's exuberant declarations of his love for England and its tradition of freedom reflect Stoppard's own feelings; likewise, the don's wife offers a passionate rebuke of his materialist, mechanistic views as she champions the metaphysical mystery of being human.*

In his 11 major plays, Stoppard explores a variety of subjects and a diversity of styles. He offers a heady mixture of intellectual inquiry, a liberal dose of comedy and some palpable human emotion. Through these works, Stoppard articulates a worldview in which life contains a high degree of relativity but in which there is also some sort of absolute truth or metaphysical essence that is beyond our grasp to comprehend fully. Stoppard continually shows a world in which things are simultaneously both this and that, and where there is a dynamic interplay between absolute and relative values.

John Fleming

Notes

1 Tynan, Kenneth (1979) 'Withdrawing with Style from the Chaos', *Show People: Profiles in Entertainment*, New York: Simon and Schuster, pp. 44–123 (quote from p. 93).
2 Spencer, Charles (1993) 'Stoppard, Master of the Play on Words', *Daily Telegraph*, 8 September.

Key works

Stoppard, Tom (1967) *Rosencrantz and Guildenstern Are Dead*, London: Faber and Faber.
——(1975) *Travesties*, New York: Grove Press.

——(1982) *The Real Thing*, London: Faber and Faber.
——(1993) *Arcadia*, London: Faber and Faber.

Further reading

Delaney, Paul (ed.) (1994) *Tom Stoppard in Conversation*, Ann Arbor: University of Michigan.
Fleming, John (2001) *Stoppard's Theatre: Finding Order Amid Chaos*, Austin: University of Texas.
Kelly, Katherine (ed.) (2001) *The Cambridge Companion to Tom Stoppard*, Cambridge: Cambridge University Press.
Nadel, Ira (2002) *Tom Stoppard: A Life*, New York: Palgrave Macmillan.

debbie tucker green (DOB UNKNOWN)

Very little is known about debbie tucker green's age, background or personal life, except that she has Jamaican in her heritage and worked as a stage manager for ten years before becoming a playwright. She maintains that such personal details are irrelevant for understanding her work and thus rarely gives interviews or attends post-show discussions, insisting that the work should stand for itself rather than be explained by her. Since her first two plays were produced in quick succession in London in 2003, tucker green has become widely acknowledged as one of the most unique theatrical voices of the early twenty-first century. Her theatre plays have been produced at London's mainstream venues, including the Hampstead Theatre (*born bad*, 2003), the Soho Theatre (*dirty butterfly*, 2003 and *trade*, 2006), the Young Vic (*generations*, 2007), the Royal Court (*stoning mary*, 2005, *random*, 2008 and *truth and reconciliation*, 2011) and the National Theatre (*nut*, 2013). *random* was adapted for BBC Radio 3 (2010) and the television adaptation, which she directed herself (Hillybilly Television/Channel 4, 2011), won the 2012 Bafta for Best Single Drama.

tucker green's place within the milieu of twenty-first-century British playwrights is secured by the critical acclaim and attention that is paid to her work as a legacy of 'in-yer-face' plays that depict the selfish, individualistic, nihilism of contemporary 'Cruel Britannia' and links to portrayals of trauma and global violence in political verbatim plays that respond to issues arising from the War on Terror and the Iraq War. She interrogates a range of local and global human rights concerns including domestic violence, incest, poverty, AIDS, child soldiers and death by public stoning in Africa, female sex tourism in

the Caribbean and fatal teenage stabbings in London. However, rather than portraying these concerns within the conventions of contemporary British political theatres, such as issue-based social realism or documentary theatre, tucker green focuses on the emotional aftermath of violence and abuse on her characters and highlights how apathy, inaction and selfish individualism amount to complicity in contemporary human rights abuses. tucker green's plays are also unique within the context of British black playwriting because she moves away from explicit explorations of racial and/or sexual identity politics and the form of her writing breaks with the conventions of social realism that is the predominant form of representation in most contemporary black new writing.

As well as connections to British playwriting genres, tucker green cites influences from black music, poetry and performance, such as poet and playwright Ntozake Shange, the 'urban' R&B and rap music of Jill Scott and Lauryn Hill, and the poetry of Louise Bennett. These musical and poetic influences are apparent in her distinctive style of sparse, phonetic, rhythmical and repetitious dialogue, which is simultaneously stylized and yet captures the rhythms of real speech through the overlapping and fragmentation of sentences. Full stops, commas, hyphens, slashes, ellipsis, brackets, italics are used to indicate rapid speech, interruptions and overlaps, to emphasize a particular word, sarcasm, long pauses, momentary pauses and so on and 'beats', 'pauses' and 'active silences' – where character names are listed without speech – are scripted into the writing to signal to the actors how to punctuate the rhythm of the dialogue. Sacha Wares directed *trade, generations* and *random,* and describes the intricate punctuation in tucker green's writing as 'a code [… ,] a bit like musical notation – instructions on the page that tell the performer when to pause, when to slow down, when to speed up, what to give an accent on and so on'.[1]

Casting and staging devices further underline tucker green's provocative dramatizations of the emotional aftermath of disturbing, traumatic and violent incidences to raise important questions about personal and political human rights in the contemporary world. A breakaway from the conventions of social realism means that her plays use very few explicit stage directions and are mostly produced on bare stages with little set and very few props that would firmly situate them in a specific geographical or cultural location. Characters are named mostly by function – Mum, Dad, Husband, Wife, Sister, Brother, Teacher, Child Soldier and so on – which distances them from the associated cultural specificity of certain names; however,

tucker green is directive about how her plays should be cast, simultaneously creating a sense of specificity and 'universality'.

stoning mary (2005) depicts three stories that are typically associated with sub-Saharan Africa. A couple argue over who should have the one prescription that they can afford for AIDS treatment, another argue about how their son was taken away to become a child soldier, and in a third narrative strand, Older Sister visits Younger Sister – the eponymous Mary – who is awaiting death by public stoning for killing the child soldier who murdered their parents. tucker green's stage direction '*The play is set in the country it is performed in. All characters are white*' (tucker green 2005a: 2) compels audiences to consider how they might respond if these concerns that we associate with a distant over there were happening right here. In *trade* (2006) three black actresses play the parts of two white woman tourists, a local black woman and a host of male characters, to dissect issues around (white) female sex tourism in the Caribbean. These casting directives create connections between here and there, between Britain and the Caribbean and/or Africa. Similarly, *random* (2008) is ostensibly about the epidemic of fatal teenage stabbings in London in 2007 and, while the characters' accents and observations identify them as black British-Caribbean, the fact that all of the parts are played by one black actress also infers a sense of multiple identities that transcend the specifics of race and gender.

A central trope throughout tucker green's oeuvre is a concern with how silence amounts to complicity in domestic violence and world atrocities. Thus a concern with the silence of witnesses who fail to act is a dynamic that recurs throughout her work. *dirty butterfly* (2003) depicts two black people hearing their white neighbour (Jo) routinely being domestically abused on a nightly basis and refusing to intervene because they are more concerned with the impact that it is having on their lives. That one female refuses to help another, even when confronted with visible evidence of the abuse as Jo bleeds heavily from between her legs, exemplifies how tucker green particularly channels notions of silent complicity through a feminist discourse about the lack of solidarity between women in contemporary societies. *born bad* is similarly concerned with 'betrayal, in women betraying women',[2] depicting a 'Dawta' confronting her Mum and two Sisters for their silent complicity in her father's incestuous abuse. In *stoning mary*, Younger Sister's angry condemnation of the 'womanist bitches' (tucker green 2005a: 61) who failed to sign the petition to stop her public execution is spoken to the audience who are positioned as witnesses standing around the front of the horseshoe-shaped stage for the Royal Court production. A lack of female solidarity is paramount

when Older Sister gives away her ticket to the public stoning, breaking her promise to support her younger sibling, and in the play's closing image when the Child Soldier's 'MUM *picks up her first stone*' (tucker green 2005a: 73). In *random*, Sister visits the makeshift murder shrine erected at the spot where Brother was stabbed to death and she condemns the reluctance of eye-witnesses to come forward. Mum's first response on hearing the news of her son's murder is 'Mi dawta [...] Mek mi phone mi dawta' (tucker green 2008: 27), but the women become more and more isolated from each other in their experienced grief. As Aleks Sierz's review identifies, '[a]lthough the family is black and the parents have been written as if they were migrants rather than British born, it is interesting that their grieving is so typically English. Heads down, and made dumb by shock and despair, both Mum and Dad prefer silence and solitude to cussing and company.'[3] Sierz's observation is one indication of how tucker green uses the specificity of casting a black actress/family to explore the 'universal' emotional experience of grief.

Analyses of tucker green's plays emphasize the aesthetic innovations of her writing and explore how her plays interrogate important, topical, social issues. But the two main repeated criticisms are that the stylistic elements overwhelm the impact of the issues on audiences and that her plays would work better on radio than they do in the theatre. Dominic Cavendish's review of *dirty butterfly* complains that 'their Ali G-style patois [...] teeters the weighty subject matter on the brink of ridiculousness'[4] and Ian Johns suggests that 'her mannered poetic-demotic style risks making the audience feel equally disconnected with what's happening on stage'.[5] Of *stoning mary*, Johns writes: 'It's a neat chic style but feels at odds with the horror and desperation of the stories before us. [...] The style and staging of *Stoning Mary* ultimately makes its concerns easier, not harder, to ignore.'[6] Michael Billington claims: 'Words alone do not make drama: what one craves is a marriage between action and language' and he maintains that the play 'feels more like an acted poem than a fleshed-out play'.[7] Several reviewers suggested that *random* would work better on radio or in the more intimate Theatre Upstairs at the Royal Court because it is a one-woman play and was produced without décor and/or lighting changes on a bare stage. Billington asserts that 'fine writing is not the same as drama. Too much is described not shown: you go to the theatre, after all, to see things happening.'[8]

Such critical responses show how the expectations of social realism overwhelmingly govern the reception of contemporary British new writing. Moreover, they overlook how casting and production devices are used to implicate live theatre audiences as witnesses and how

'active silences' are filled with gestures or confrontational looks between characters that add further layers to the performance. *trade*, *stoning mary* and *random* make their strongest impact through live theatre productions in which the audience experience the visual effect of black actresses playing white women and white actors performing stories associated with Africa. *truth and reconciliation* (2011) depicts victims confronting perpetrators about how their actions caused death and loss in five countries with a history of atrocities of war and genocide – South Africa, Rwanda, Zimbabwe, Bosnia and Northern Ireland. Seating the Royal Court audience on the same hard wooden chairs as the characters sit on and placing some of the characters among the audience is one of the dramatic devices used to blur the boundaries and actively position spectators as witnesses to the tribunal confrontations. These dramatic devices exemplify tucker green's contribution to early twenty-first-century British playwriting through the unique integration of poetic wordplay, repetition and casting devices to make audiences *see* and *feel* the emotional impact of a range of topical contemporary social issues. Merging influences from contemporary British playwriting and black music and poetry is key to her portrayal of black issues for predominately white audiences.

Lynette Goddard

Notes

1 *random* background pack, Royal Court Theatre, London, 2008.
2 Sierz, Aleks (2006) 'Interview with debbie tucker green', http://archive.today/5Odvd [accessed 26 May 2013].
3 Sierz, Aleks (2008) *Tribune*, 21 March.
4 Dominic Cavendish (2003) *Daily Telegraph*, 4 March.
5 Ian Johns (2003) *The Times*, 6 March.
6 Ian Johns (2005) *The Times*, 7 April.
7 Michael Billington (2005) *Guardian*, 6 April.
8 Michael Billington (2008) *Guardian*, 11 March.

Key works

tucker green, debbie (2003a) *dirty butterfly*, London: Nick Hern Books.
——(2003b) *born bad*, London: Nick Hern Books.
——(2005a) *stoning mary*, London: Nick Hern Books.
——(2005b) *trade and generations*, London: Nick Hern Books.
——(2008) *random*, London: Nick Hern Books.
——(2011) *truth and reconciliation*, London: Nick Hern Books.

Further reading

Aston, Elaine (2008) 'A Fair Trade? Staging Female Sex Tourism in *Sugar Mummies* and *Trade*', *Contemporary Theatre Review*, 18(2): 180–192.

——(2011) 'debbie tucker green', in Martin Middeke, Peter Paul Schnierer and Aleks Sierz (eds.) *The Methuen Drama Guide to Contemporary British Playwrights*, London: Methuen, pp. 183–202.

Goddard, Lynette (2007) *Staging Black Feminisms: Identity, Politics, Performance*, Basingstoke: Palgrave Macmillan.

——(2009) '"Death Never Used to be For the Young": Grieving Teenage Murder in debbie tucker green's *random*', *Women: A Cultural Review*, 20(3): 299–309.

MICHEL VINAVER (1927–)

The contemporary, the everyday, the ordinary, are terms that define Vinaver's theatre; they feature in titles of his plays from *Aujourd'hui ou Les Coréens* (*Today or the Koreans*, 1956), to *L'Ordinaire*, meaning 'the ordinary' (*High Places*, 1981). Vinaver was a central figure in the *Théâtre du quotidien* ('theatre of daily life'), a wave in French theatre that appeared in the 1970s. His theatre focuses on routine events in the lives of ordinary people. In *La Demande d'emploi* (*Situation Vacant*, 1971), a man looks for a job; in *Les Travaux et les jours* (*A Smile on the End of a Line*, 1979), secretarial and clerical staff deal with customer services. Speech is colloquial, situations commonplace. His theatre could inherit from nineteenth-century naturalism, except for one crucial difference: rather than language being at the service of character and situation, these elements are pieced together from fragments of rich, poetic, complex text. Vinaver has forged a unique path in French theatre, combining acute social, political and economic commentary with restless artistic experimentation.

Vinaver distinguishes between 'machine plays', where cogs move in a predetermined direction, namely a plot that leads to a logical conclusion; and 'landscape plays', which include his own, where valleys and peaks can be crossed via a range of routes: multiple shifting situations, themes and leitmotifs, kaleidoscopic micro-description. Vinaver cites as important influences Anton Chekhov's *The Cherry Orchard*, where coherent narrative cedes to divergent intrigues and non-verbal scenic elements; and Alfred Jarry's *Ubu-Roi*, where chronology and psychology are exploded into myriad facets.

Since plot and character are not priorities, focus falls on language in the theatre of Vinaver, and of several of his French contemporaries, notably Valère Novarina and Noëlle Renaude. Vinaver describes his technique as that of a painter or musician, since the textures and rhythms of language are as important as its semantic meaning. One of his most important influences is T.S. Eliot's modernist poem 'The Waste Land' (1922). Like Eliot, Vinaver composes a mosaic of discontinuous fragments lifted from different sources, notably daily newspapers. His play *Portait d'une femme* (*Portrait of a Woman*, 1984) comprises newspaper articles on the trial of a woman accused of murdering her ex-lover, interspersed with fictional flashbacks. *Quotidien* means both 'daily life' and 'daily newspaper', and like the avant-garde artist Marcel Duchamp, another key influence, Vinaver lifts 'readymade' excerpts, and recycles them. And like Eliot, and indeed like his French contemporaries Bernard-Marie Koltès and Jean-Luc Lagarce, Vinaver combines colloquial everyday formulations with expressionist poetry and mythical archetypes to create a rich idiom that accommodates both low and high culture. In his many theoretical writings, published as *Écrits sur le théâtre* (1982), he refers to these various fragments as 'raw material' and describes how he juxtaposes them to create 'interlacing' (Vinaver 1982: 123–134). Processes of montage, collage, interruption and repetition weave a linguistic texture where different lines of dialogue do not necessarily correspond to each other, but intertwine, overlap, refract. Again likening himself to a musician, Vinaver compares this technique to baroque polyphony, where several voices sing independent melodies simultaneously. For him, theatre, as opposed to other literary forms, is particularly appropriative, since it can orchestrate a multitude of voices.

For Vinaver, the effect of this juxtaposition of fragments is that the banal or monotonous become astonishing. In 'Auto-interrogation', which prefaces his plays in English translation, he explains that he is inspired not only by Chekhov, Duchamp and Eliot, but also Brecht, and the visual artists Jean Dubuffet and Robert Rauschenberg (Vinaver 1997b: xv). For them, montage enables unexpected associations and ironic coincidences between fragments that are removed from their habitual contexts, and that thereby dislocate objects from their mystified and supposedly eternal meanings, and distance spectators from their intellectual and affective habits.

Vinaver thus combines social commentary with dramatic experimentation. 'Interlacing' also enables him to illustrate how the political and personal are intertwined. His first play, *The Koreans*, is set during the Korean War, and *Les Huissiers* (*The Ushers*, 1957) and *Iphigénie*

Hôtel (*Iphigenia Hotel*, 1959) treat France's Fourth Republic and the Algerian War of Independence. More recently, *11 September 2001* (2001) presented the 9/11 terrorist attacks on the USA. Rather than capturing the 'summit' of a situation, his plays view history via the immediate reality of everyday people. In this respect Vinaver is political, since he pits the disenfranchised against powerful institutions. However, unlike his early literary mentor, Albert Camus, he has always avoided affiliation to a political party. Rather, he resists synthesizing the inchoate reality of life, or the heterogeneous fragments of his theatre, into an ideological totality especially since, for him, the playwright has no more authority than the spectator. Rather than a militant, Vinaver describes himself as a 'jester' who, like filmmakers Charlie Chaplin or Jean-Luc Godard, entertains, and says the unsayable, exposing injustices and demystifying the absurdities of conventionally accepted social systems with humour (Vinaver 1997c: xviii). The title of his play *Dissident, il va sans dire* (*Dissident, Goes without Saying*, 1976) indicates his commitment to non-conformism. More than the theatre of 'absurdist' playwrights like Beckett and Ionesco, Vinaver's shifting perspectives enable spectators to draw conclusions on politics and society.

Par-dessus bord (*Overboard*, 1972), written in the earlier part of Vinaver's literary career, features many of the themes and techniques contained in his other works. With around 50 characters and 30 locations, and spanning about seven hours in production, it is his most ambitious work. It provides a panorama on the capitalist boom of the 1960s, viewed comically through the prism of an outmoded family-run toilet paper company challenged by an aggressive US competitor. With its modern product, the American multinational at first seems certain to win. However, its French counterpart is galvanized into action, creating the new 'Moss and Heather' brand designed to give defecation a fresh image. Like *Mythologies* (1957), the seminal text on the semiotics of the modern world by Vinaver's friend Roland Barthes, *Overboard*, and also *À la renverse* (*Backwards*, 1979), demystify the aura surrounding consumer products. In spite of the French company's image makeover, in the final stages of the play, the American corporation buys it up.

Vinaver is in the unique position of both being a playwright, and having worked for the US razor company Gillette for nearly 30 years (1953–1982), rising to director and managing more than 1,000 employees. He believes firmly that money, the workplace, employment and unemployment profoundly affect human relations, whether public or private. Like Vinaver, *Overboard*'s central character,

Passemar, is both French business executive and a playwright, in fact of *Overboard* itself. Inspired by Aristophanes' comedies, where the author confronts the audience with his artistic problems, Passemar's metadiscourse (largely omitted from the English translation) enables Vinaver to expose the spectator to the complexities of representing the world in art, also debated in the play by the dance troupe and jazz musicians.

In the manner of nineteenth-century French naturalist novelist Honoré de Balzac, the six movements of the play present different social strata, from the manager, to salesman Lubin who loses his job as a result of the company's makeover, to his daughter who is in love with jazz player Alex – a Jew previously imprisoned at Auschwitz – to US image consultants Jack Donohue and Jenny Frankfurter. As in all Vinaver's plays, the everyday is spliced with the ancient, the mundane with the poetic. The dance company choreographs a piece based on the Norse legend of Ases and Vanes, a tale of hostility and reconciliation that mirrors the competition between the companies. Language, too, alternates. Marketing speak, office jargon, salespeople smooth-talk and a host of other idioms jostle against each other. Vinaver claims that characters are 'both crushed by a system and in complete communion with it' (Vinaver 1982: 286). The economic world of *Overboard* is not in direct conflict with the commercial world. Rather, they fissure each other and interlace with each other.

As with almost all his plays, in *Situation Vacant* (1971) Vinaver reflected the economic and cultural environment in which he wrote. Following the 1960s boom years, the 1970s encountered economic crisis and austerity measures that reduced government expenditure. The play examines the effects of this harsh economic reality on the personal relations between Fage, a middle-aged sales director who has recently been sacked owing to rationalization in his company, and is interviewed by Wallace for a job in a travel company; his wife Louise, who is frustrated with their loss of financial security; and Natalie, their left-wing daughter. The irreverent buffoonery of *Overboard* cedes to a more contemplative tone, and a recognition of the cost to individual workers of ruthless capitalism, of which Vinaver, a managing director, was all too aware. But it is not so much the play's economic thematics that stand out, as its highly original aesthetic. It is the central piece in Vinaver's 'Chamber Theatre', which, unlike his 'symphonic' plays such as *Overboard*, contain only a handful of characters. These include *Dissident, Nina, C'est autre chose* (*Nina, That's Something Else*, 1976), *Les Voisins* (*The*

Neighbours, 1984) and *A Smile on the End of the Line* (1979). Like chamber music, *Situation Vacant* stages a composition of four voices, each with an individual tone. The crosscutting voices, staged in 30 'variations', examine from multiple viewpoints how individuals and families are bound to the world via economics.

With *Portrait of a Woman* and *L'Émission de télévision* (*The Television Programme*, 1988), Vinaver turns his attention to the individual's relationship to the French justice system. In *Portrait*, Sophie kills her former lover. The reality of the event seems to be replaced by what the judiciary wishes to hear. Not only Sophie is is trial, but also representation itself, and the ways in which the imaginable, sayable and verifiable can elude it. In *The Television Programme*, both legal and media representation are scrutinized. Unusually, Vinaver places a dramatic event centre-stage – Monsieur Blache's murder. The first half of the play alternates between scenes taking place before and after the murder, which feature Monsieur Blache and his wife, and their long-term friends Monsieur and Madame Delile. Both Blache and Delile have lost their jobs. They are approached by television researchers Adèle and Béatrice, who are preparing a chat show on long-term unemployment. Blache delights in playing to the cameras, while Delile is wary of how television distorts reality, and rivalry and resentment creep in between these age-old friends. After the murder, Delile is suspected by the magistrate of the crime, but in a darkly humorous moment, Adèle and Béatrice threaten to humiliate Delile publicly on their chat show if he does not finish filming before his arrest. The question of how media images construct and transform reality into entertainment are all the more relevant today in the age of reality TV. Vinaver's plays view individuals and institutions from multiple viewpoints, whereas the judiciary and media present simplistic one-dimensional versions.

From the beginning, Vinaver was staged by some of France's most prominent directors, including Jean-Marie Serreau, Antoine Vitez, Jacques Lassalle and Robert Cantarella, and hosted by France's leading venues, notably the Comédie-Française (*L'Ordinaire*, 2009), where it is rare for living authors to be staged. In the UK, Sam Walters, director of the Orange Tree Theatre in Richmond, London, has staged no less than five of Vinaver's plays. Vinaver himself is adamant that any visual effects used in staging his plays should serve solely to enhance the spectator's aural appreciation of the text, which he describes as a cantata or oratorio. For this reason, he disapproved of Roger Planchon's production of *Overboard* (1969), which for him swamped his text in lavish stage effects.

Rather, he preferred Walters' minimalist in-the-round stagings, which enabled fortuitous echoes to emerge from the multitude of simultaneous voices.

David Bradby, author of the most important English-language study of Vinaver, states that no other playwright has examined in such detail the impact of economics on daily life. The business-world term *company* derives from the Latin 'one who eats bread with you'. Vinaver's theatre asks what economic, social, cultural and personal conditions are required for humans to live together.

Clare Finburgh

Key works

Vinaver, Michel (1997a) *Plays: 1*, London: Methuen.
——(1997b) *Plays: 2*, London: Methuen.

Further reading

Bradby, David (1993) *The Theater of Michel Vinaver*, Ann Arbor: University of Michigan Press.
Elstob, Kevin (1992) *The Plays of Michel Vinaver: Political Theatre in France*, New York: Peter Lang.
Ubersfeld, Anne (1989) *Vinaver dramaturge*, Paris: Librairie théâtrale.
Vinaver, Michel (1982) *Écrits sur le théâtre*, Lausanne: L'Aire.
——(1997c) 'Auto-interrogation', in *Plays 2*, London: Methuen.

PAULA VOGEL (1951–)

Playwright Paula Vogel has been making waves with her work since the early 1970s, as a scholarship student at Bryn Mawr College, where she wrote a play about the collapse of civility and structure at an all-women's college, using William Golding's novel *Lord of the Flies* (1954) as a model. It was well received by the students and faculty, but the administration chose not to renew her scholarship. She transferred to Catholic University, not exactly, she has said, the easiest place in which to be an outspoken lesbian feminist.[1] She first established her talent for playwriting as a graduate student at Cornell University, when she won the 1977 National Student Playwriting Award for her play *Meg*, but she did not gain widespread recognition until 1992, with *The Baltimore Waltz*, a play inspired by her late brother Carl Vogel and his battle with AIDS. She won an Obie

award for *The Baltimore Waltz*, and found immense success with *How I Learned to Drive*, which was first produced in February 1997 Off-Broadway at the Vineyard Theatre. *How I Learned to Drive*, which presents taboo issues like paedophilia and incest in frank and complex ways, was honoured with multiple awards, including a second Obie and the 1998 Pulitzer Prize for Drama. Vogel has held academic positions at Brown University and served as playwright-in-residence at the Signature Theatre in New York. She is currently the Eugene O'Neill Professor of Playwriting in the Yale School of Drama, and playwright-in-residence at the Yale Repertory Theatre. Her other major works include *Desdemona, A Play About A Handkerchief* (1979), *The Oldest Profession* (1981), *And Baby Makes Seven* (1984), *Hot 'n' Throbbing* (1994), *The Mineola Twins* (1996), *The Long Christmas Ride Home* (2004) and *Civil War Christmas* (2008).

Vogel's work engages explicitly with feminist themes, and she often treats serious issues such as paedophilia, gendered violence, and women's sexuality in surprising and irreverent ways. She has said that feminism, for her, 'means being politically incorrect' (Savran 1996: xii). This approach gives us plays like *The Oldest Profession*, which follows a group of five aged prostitutes in their seventies and eighties who still make their living as working girls, characters she modelled and named after her own grandmother and great aunts, who were never prostitutes.[2] Both *Meg* and *Desdemona* are feminist revisions of historical events and literary texts that have marginalized or excluded women. Vogel's plays reflect her study of Bertolt Brecht and his alienation effect, which uses techniques that ask the audience to accept the artificiality of theatrical performance, to render the commonplace strange, and to do so in ways that lead the audience to question and potentially work to change social conditions. Her use of non-linear chronology, projected images on slides, music, voiceovers, a Greek chorus, and the narrator's direct address to the audience in *How I Learned to Drive*, or the simulation of the cinematic filming process called for in *Desdemona*, provide striking examples of her use of the alienation effect.

Arguably Vogel's most successful play, *How I Learned to Drive* (1997), chronicles the main character Li'l Bit's experiences with her Uncle Peck, who teaches her to drive, but also utilizes these driving lessons as opportunities to prey on her sexually and psychologically. Li'l Bit tells her story from the vantage point of a 35-year-old woman, moving in a non-linear fashion between the first driving lesson, when she was 11 years old, to her eighteenth birthday when she terminates the relationship, up to her present adult perspective,

when it becomes clear that the metaphor driving has provided for sexual experience throughout the play now extends to Li'l Bit's ability to navigate life, to put herself in the driver's seat, and ultimately, to survive the trauma of incest and molestation. Vogel's head-on treatment of taboo topics led reviewers to describe the play as 'challenging' and 'uncomfortable', and to warn audiences they would 'squirm', but they agreed that the discomfort is worth the final reward the play offers.

Many critics comment on how Vogel builds the complex dynamics of Li'l Bit and Peck's relationship through a non-chronological approach, and how she leads her audience to sympathize not just with Li'l Bit, but with Uncle Peck, who, despite his horrific actions, is never figured as solely vile. The focus on his struggles with alcoholism, the implication that he too was victimized as a child, and the fact that he is the only family member who cultivates Li'l Bit's growth in an authentic way all contribute to a portrayal of Peck as more than a simple paedophile and predator. Vogel's play gives us perspective, not about the harm inflicted on us by those who love us, as she corrected one interviewer, but about the love we receive from the people that harm us.[3]

Before Vogel knew her brother Carl was HIV-positive, she turned down an invitation to travel to Europe with him. The Baltimore Waltz (1992) represents that imagined excursion in seemingly reversed, humorously distorted form: instead it is main character Anna, not her brother Carl, who is sick. She has contracted Acquired Toilet Syndrome (ATD) from the toilets at the elementary school where she teaches, and they must travel to Europe for special treatment, which may involve drinking her own urine. Vogel has acknowledged that the structure of the play is modelled on Ambrose Bierce's An Occurrence at Owl Creek Bridge (1890), a story in which all of the action ultimately occurs only in the mind of a man about to be hanged. Like Bierce's text, the final scene of The Baltimore Waltz reveals that the trip to Europe Anna has imagined with her brother Carl never occurred; in fact, it is not she who is ill, but her brother, and he has succumbed to the disease.

The surreal and farcical tone reaffirms the action of the play as merely a dream sequence. Carl constantly carries a white rabbit, and Anna reacts to her impending death with lust, romping all around Europe with absurd types of foreign men because, unlike HIV/AIDS, ATD is not transmitted sexually. Vogel is no doubt parodying misunderstandings, irrational fears and stereotypes surrounding AIDS transmission, as well as hope for potential treatments and cures, but

her play's tribute to her brother is undoubtedly a serious one. When it premiered at the Circle Repertory Theatre, the play's dream-like quality led Frank Rich to call it 'dizzying' and he let on that several Circle Rep subscribers walked out during a critics' preview performance. Yet, ultimately he expressed admiration for Vogel's attempts, claiming that the play's final effect is justified by the tragedy which inspired it.[4]

Hot 'n' Throbbing is an important example of Vogel's feminist and political impulse, and its reception representative of the discomfort or outrage her work has often produced. It was first staged in 1994 and published in *The Baltimore Waltz and Other Plays* (1996), in which it is preceded by a polemic by Vogel on domestic violence and censorship in the theatre. It has been produced only a handful of times and closed early on Broadway, after running just under a month. Vogel grounds the play in her concern that 'there is no longer a place for audiences to come to a civic space – the theatre – to confront the disturbing questions of our time' (Vogel 1996: 231). Charlene, the woman in the play, has divorced her abusive ex-husband Clyde, and left a menial labour job to write and produce erotic entertainment designed for women, the scripts of which are often narrated by the Voiceover, a sex worker who dances and performs in a glass booth on the stage. There is also a Brechtian male Voice, who acts alternately as the sex club bouncer, disc jockey, quotes from classic Joyce and Shakespeare texts and takes on a variety of masculine voices that are generally interpreted as representative of the discourse of male power and control. The sexual worlds of Charlene's curious teenage daughter, Leslie Ann, and her masturbating son intermingle with her writing, which she continues to insist is not pornography, but adult entertainment.

When Clyde returns to the home, drunk and threatening, Charlene shoots him in the behind. Despite his injury, the two sit and drink coffee and talk, alternating between reminiscing, bickering and kissing. The action escalates, with Charlene and Clyde's words, rhetoric associated with contemporary understandings of domestic violence, echoed and finally taken over by the Voiceover and the male Voice, and culminates in Clyde's violent rape and murder of his ex-wife. Both Charlene and Vogel seem determined that a woman can write graphic, sexually violent material without reifying objectification, but it is not a premise that the other characters, critics or audiences easily accept. In addition to questions about the definition of pornography, the play interrogates empowerment and victimization; the association between sexuality and violence in contemporary culture; and control and complicity in violent relationships.

Paula Vogel's work challenges audiences to consider deeply political and complex issues, and she presents them in non-traditional, unexpected ways. While she critiques larger societal problems, she also critiques, responds to and rewrites other texts, reworking Shakespeare's women into agents rather than victims in *Desdemona*, and responding to the structure and characterization of David Mamet's *The Duck Variations* (1972) in *The Oldest Profession* (Savran 1996: x). She contributes an explicitly feminist voice to the American theatre, but it is a unique type of feminism, one that asks questions rather than answers them, and tests limits of decorum and the politically correct. Further, she boldly challenges theatres and artistic directors to make production choices that push boundaries, and she remains committed to restoring the theatre as a space for explorative and transgressive discourse. She also contributes an important openly gay voice to the American theatre, exploring issues like the AIDS epidemic explicitly in *The Baltimore Waltz*, and implicitly in works that feature gay, lesbian or bisexual characters or that parody or deconstruct traditional gender and sexual identities.

Casey Kayser

Notes

1 Abarbanel, Jonathan (2007) 'A Talk with Paula Vogel', *Windy City Times*, 21 November, www.windycitymediagroup.com/lgbt/A-Talk-with-Paula-Vogel/16679.html [accessed 30 March 2013].

2 Parker, Mary-Louise (1999 [1997]) 'Interview with Paula Vogel', in Betsy Sussler (ed.) *Bomb: Speak Theater and Film*, New York: New Art Publications, pp. 1–11.

3 Holmberg, Arthur (1998) 'Through the Eyes of Lolita: Interview with Paula Vogel', American Repertory Theater, 18 September, www.american repertorytheater.org/inside/articles/through-eyes-lolita [accessed 21 April 2013].

4 Rich, Frank (1992) 'Play About AIDS Uses Fantasy World To Try to Remake the World', *New York Times*, 12 February, www.nytimes.com/1992/02/12/theater/review-theater-play-about-aids-uses-fantasy-world-to-try-to-remake-the-world.html [accessed 21 April 2013].

Key works

Vogel, Paula (1996) *The Baltimore Waltz and Other Plays*, New York: Theatre Communications Group.

——(1997) *The Mammary Plays: How I Learned to Drive and The Mineola Twins*, New York: Theatre Communications Group.

——(2005) *The Long Christmas Ride Home*, New York: Dramatists Play Service.

——(2012) *A Civil War Christmas*, New York: Theatre Communications Group.

Further reading

Friedman, Sharon (2009) *The Feminist Playwright as Critic: Paula Vogel, Anne-Marie MacDonald, and Djanet Sears Interpret Othello*, Jefferson, NC: McFarland.

Post, Robert M. (2001) 'The Sexual World of Paula Vogel', *Journal of American Drama and Theatre*, 13(3): 42–54.

Savran, David (1996) 'Loose Screws: An Introduction', in Paula Vogel, *The Baltimore Waltz and Other Plays*, New York: Theatre Communications Group, pp. ix–xv.

——(1999) *The Playwright's Voice: American Dramatists on Memory, Writing, and the Politics of Culture*, New York: Theatre Communications Group.

——(2003) 'Paula Vogel as Male Impersonator', in *A Queer Sort of Materialism: Recontextualizing American Theater*, Ann Arbor, MI: University of Michigan Press, pp. 187–204.

Shepard, Alan and Lamb, Mary (2002) 'The Memory Palace in Paula Vogel's Plays', in Robert L. McDonald and Linda Rohrer Paige (eds.) *Southern Women Playwrights: New Essays in Literary History and Criticism*, Tuscaloosa, AL: University of Alabama Press, pp. 198–217.

TIMBERLAKE WERTENBAKER (1946–)

One of the most frequently cited facts about Timberlake Wertenbaker is that she was raised in the Basque country; this meant exposure to English, French, Spanish and Basque languages, and it is not surprising that she has been a prolific translator and adaptor of texts from Sophocles' *Oedipus* (1992) to nineteenth-century Czech playwright Gabriela Preissova's *Jenůfa* (2007). As a former expatriate in politically disputed territory, she is also clearly aware that communication is invariably political. 'One thing they would tell you as a child was never to say anything because you might be betraying someone.'[1] This sentiment could be uttered with equal aptness by the love-tormented outsider Phaedra in Wertenbaker's translation of Euripides' *Hippolytus* or the immigrant Alexander in *Credible Witness* whose English lessons for asylum seekers teach them to 'cry' for the suffering they cannot forget. The focus from her first plays in the early 1980s to those at

major subsidized theatres is on 'translation' in its literal meaning of 'carrying across'. While Wertenbaker's characters are typically engaged in shifting social spheres, languages or discourses, ' translation' might equally be used to describe the relationship between play and audience. Confronted with a retelling of history or myth, the spectator is pushed into reimagining the familiar, into sharing an alien perspective. Wertenbaker's plays have been performed all over the world and it is to the world that they speak.

Of her early subject matter she noted: 'If you write things in the past, you free them of people's prejudices ... you can be more imaginative in the past' (Stephenson and Langridge 1997: 136–145). Her use of what the audience may initially think familiar offers both political and dramaturgical surprises. *The Grace of Mary Traverse* (1985), for example, begins as hilarious bourgeois-feminist *Bildungsroman* as its heroine learns to be a lady – 'Dare to walk, but leave no trace' (Wertenbaker 2002a: 71). But it goes on to shatter this easy laughter as Mary's growing empowerment is corrupted; she instigates the Gordon Riots, not from political conviction, but as an exercise of her new-found ability to 'net the future' (Wertenbaker 2002a: 138). In doing so she learns to manipulate a discourse of racism as close to the Brixton Riots, in London, in the 1980s as it is to the anti-Catholic uprising of 1780.

In her retelling of the Greek myth of Procne and Philomele, *The Love of the Nightingale* (1989), the chorus are briskly confrontational on the subject of myth and gender relations. Yes, says one, you will read this as a story 'about men and women' (Wertenbaker 2002a: 315). In 1988 it would be impossible to avoid such an assumption; not only is the play part an upsurge of energy among feminist playwrights, but it also shows the aftermath of rape with terrible realism. Nevertheless, the chorus 'translate' us into a broader perspective: to ignore the political role of silence, they warn, to be 'beside the myth'. This use of shifting perspectives has proved controversial; reviews of *The Love of the Nightingale*[2] commented unfavourably on its contemporary allusions to violence towards women 'in the car parks of dark cities' and on Wertenbaker's major change to the story: rather than showing Procne killing her son and feeding him to his rapist father, she allows the dead child to speak and indeed to have the last words in the play: 'Didn't you want me to ask questions?' (Wertenbaker 2002a: 354). Wertenbaker is not 'dramatizing' myth but drawing on the tradition of Greek theatre: it was for the Athenian playwright to offer the *polis*, the city-state, a fresh image of what it thought it knew, often through the voices of women, foreigners and those silenced by the dominant power.

Our Country's Good drew critical plaudits and awards and remains Wertenbaker's most performed play. However, it has also proved a site of often bitter academic dispute. The true story of the convicts who performed the first play in Australia in 1788, Farquar's *The Recruiting Officer*, it shows the transformative power of theatre; the most telling moment is when the brutalized prisoner Liz suddenly finds a voice and announces her 'endeavour to speak Mr Farquar's lines with the elegance and clarity their own worth demands' (Wertenbaker 2002a: 272). Undeniably, the Royal Court production was a paean to the power and the educational value of theatre in an age of swingeing cuts to arts funding. To its detractors, especially some postcolonial scholars, the joy of the convicts launching into their production indicated that the theatre had integrated them into the language of a bourgeoisie complicit in the 'more brutal aspects of colonisation'.[3] However, alongside this translation of the convicts into a new dignity we also see 'silence' of the kind the chorus speak of in *The Love of the Nightingale*. The action is punctuated by soliloquies by a single chorus figure, a nameless Aborigine who sees the ship as 'a dream no one wants' (Wertenbaker 2002a: 249), and dies of the plague brought by the colonists. At no point does his story intersect with that of the convicts; but although inaudible and invisible to the officers who admire, classify and briskly shoot down the unfamiliar fauna, he is heard by us. Despite critical generalizations on both sides about the play, it is clear that for Wertenbaker art is not 'redemptive' in the sense of a panacea. Rather, it is a discourse that vibrates against imposed silence. It does not transfigure, but it does offer a way to assert, or to interrogate, identity.

For Biddy, the most radically transformed character in *Three Birds Alighting on a Field* (1992), the discourse of art begins as a means to 'become more interesting' (Wertenbaker 2002a: 378) and aid the social-climbing ambitions of her wealthy Greek husband. Their floundering individualism appears at first to fit perfectly into its context: a bleakly funny 1990s perspective on the art world of the 1980s, where a beleaguered gallery tries to save its fortunes with an artist who encapsulates 'England'. 'He has to be alive?' 'For the moment. To give interviews' (Wertenbaker 2002a: 368). But Biddy's encounter with painting and the painter is more than a comic tale of an innocent abroad. Biddy, her husband Yoyo, and the artist Stephen Ryle in fact ask broader questions: what does it mean to be English? What does it mean to be good? What is the moral function of art? These prove to be inextricably linked. No sooner does the audience enjoy mocking the absurdity of English cultural codes – tweeds, puddings, gentlemen's

clubs – than Yoyo is broken by his efforts to master them and, dying, is defined by a more resonant code: an Orthodox priest symbolizes his eternal worth with candles. Stephen's return to painting is prompted by a vision of an England edging out of sight, to be captured, 'As it vanishes' (Wertenbaker 2002a: 414). The corrupt Romanian skulking the galleries in pursuit of grants makes an impassioned attack on the genteel leftism that expects him to personify romantic revolution. 'You forgive your own evil because you say it's built into capitalism, but we are not allowed'(Wertenbaker 2002a: 437). To express one's identity through culture is seen to be a necessary part of one's humanity, but the cost of choosing a medium through which to do it has endless potential for social, political or psychic disaster.

Wertenbaker's later plays have had a muted reception – in part, perhaps, because they offer even fewer opportunities to focus on a strong 'central' character. *The Break of Day* (1995), a companion piece to Max Stafford-Clark's production of *Three Sisters*, drew what she has described as critical 'vitriol'.[4] Chekhov's play of exile and longing shows characters in personal stasis while their world teeters on the edge of change. Wertenbaker's characters congratulate themselves as *agents* of change; as the play opens their reminiscences of 1970s feminism parody a Chekhovian exposition – 'There you were, an all-female band, and I was the only woman reporter on a rock magazine ... hunger, confidence, all those possibilities'(Wertenbaker 2002b: 8). In an England rejecting their values, with its declining welfare state, inadequate students and impoverished theatre, they set about building families in a kind of smug, end-of-history despair. Ironically, however, this generation that proclaimed 'the personal is political' find their reproductive politics intersecting with history as it happens. Tess tries to conceive through state-of-the-art technology. Nina goes to Eastern Europe to find a child. Enmeshed in a web of relations between races, the remnants of communism, nascent capitalism and the Church, she is unable to adopt a clear (superior) stance to its corrupt bureaucracy because it aids, as well as hinders, her project. Increasingly, her love for an individual child, rather than an abstract ideal about motherhood, drives her into undreamed-of alliances. Meanwhile Tess' desire transforms all around her into objects of consumption: as her actor-husband Robert rehearses Vershinin, exploring the 'slit of hope' he embodies in Chekhov's play, Tess snaps that he should make money in TV to finance her treatment. 'If it weren't for your sperm, I'd leave you,' she states (Wertenbaker 2002b: 77). But if these privileged and wealthy friends shock us, the play is concerned less with our personal response to them than with their place in a now

unavoidably globalized web of relationships. Their selfishness makes them naïve but the power of their desire ensures that they (and we) are continually adjusting to a world where borders are in flux and communities are remade and translated. Everyone in *The Break of Day* is part of that movement; no grand narratives provide answers. At the end of *Three Sisters* Olga cries, 'If only we knew!' Tess asks to 'understand what's happened' – a simpler wish, but, as Robert tells her, 'You could even say that's hopeful' (Wertenbaker 2002b: 98).

As an actor, Robert perhaps shares Wertenbaker's conviction that theatre is 'some kind of cultural skin … the edge between the interior world we inhabit of poetry, language, music, and the exterior public world of other people, a crowd, a group, a *polis*' (Wertenbaker 2002b: ix). As she constantly negotiates that fine edge she continues to challenge and surprise.

Frances Gray

Notes

1 O'Mahony, John (2004) 'It's All So Political', *The Guardian*, 30 June.
2 See, for example, *The Financial Times*, 10 November 1988; *Independent*, 11 November 1988.
3 Buse, Peter (2001) *Drama+Theory*, Manchester: Manchester University Press, p. 169. See also Wilson, Ann (1991) *'Our Country's Good*: Theatre, Colony and Nation in Wertenbaker's adaptation of *The Playmaker*', *Modern Drama*, 34: 22–34.
4 Quoted by Susan Carlson in E. Aston and J. Reinelt (eds.) (2000) *The Cambridge Companion to Modern British Women Playwrights*, Cambridge: Cambridge University Press, p. 146.

Key works

Wertenbaker, Timberlake (2002a) *Plays: 1*, London: Faber and Faber.
——(2002b) *Plays: 2*, London: Faber and Faber.

Further reading

Bush, Sophie (2013) *The Theatre of Timberlake Wertenbaker*, London: Methuen.
Carlson, Susan (1993) 'Issues of Identity, Nationality and Performance: The Reception of Two Plays by Timberlake Wertenbaker', *New Theatre Quarterly* 9: 35.
Milling, Jane (2011) *Modern British Playwriting: The 1980s*, London: Methuen.

Roth, Maya and Freeman, Sara (eds.) (2008) *International Dramaturgy: Translation and Transformation in the Theatre of Timberlake Wertenbaker*, Berlin: Peter Lang.

Stephenson, Heidi and Langridge, Natasha (1997) *Rage and Reason: Women Playwrights on Playwriting*, London: Methuen.

TENNESSEE WILLIAMS (1911–1983)

Thomas Lanier Williams, who adopted the given name of Tennessee, was born in the Episcopal rectory of Columbus, Mississippi. His dramatic evocations of the American South brought him playwriting fame. A Pulitzer Prize-winning dramatist, Williams dominated mid-twentieth-century playwriting in the USA with his depictions of sexually charged and often violent worlds. In a series of plays that began with *The Glass Menagerie* (1945) and includes *A Streetcar Named Desire* (1947), *The Rose Tattoo* (1951), *Summer and Smoke* (1948), *Cat on a Hot Tin Roof* (1955), *Suddenly Last Summer* (1958) and *Night of the Iguana* (1961), Williams combined popular success on Broadway with serious critical attention. Although dismissed by critics at the time of their first productions, Williams' late plays, such as *The Milk Train Doesn't Stop Here Anymore* (1963), *Two Character Play* (1973) and *Red Devil Battery Sign* (1976), are now reappraised by directors and critics through productions employing theatrical practices less tied to the conventions of realism.

Widely regarded as a realistic playwright skilled in the crafting of poetic dialogue and vivid dramatic action, Williams sought to break realism's powerful hold on the American stage. A literary playwright, Williams first wrote poetry and short stories. It has been suggested that it was a production of Henrik Ibsen's *Ghosts* in 1931 that turned his attention to writing for the theatre (Spoto 1985: 37–38). Other playwriting influences include August Strindberg and Anton Chekhov. Indeed, critics of *The Glass Menagerie* noted the kinship between Williams and Chekhov as chroniclers of lost souls and societies in the midst of enormous upheaval. The American poet Hart Crane, Austrian poet and novelist Rainer Maria Rilke and British novelist D.H. Lawrence were also powerful influences. Hollywood made financially successful feature films of many of his plays,[1] but Williams dismissed virtually all of the films because of the cuts and changes the censors demanded. Nonetheless, the films brought him great wealth, which financed a restless existence drifting between New Orleans, Florida's Key West, New York City and Europe. Williams struggled to come to terms with his sexual identity and

frequently explored characters who broke conventional rules of sexual decorum. Although he was a disciplined writer who worked every morning, the strains of success and the easy access to prescription medications – frequently washed down with alcohol – contributed to the decline of his reputation during the last 20 years of his life; collaborators describe his difficulty focusing on and revising new dramaturgical ideas (Spoto 1985: 352). In his *Memoirs* (1975), Williams called the 1960s his 'stoned decade' and, while he continued to write until his death in 1983, his later plays failed both critically and commercially, as reflected in the movement of initial productions from Broadway to Off-Broadway and then to Off-Off-Broadway theatres such as the Jean Cocteau Rep.

Williams announced in the published production notes accompanying *The Glass Menagerie* that he sought to break what he considered the rigid conventions of realism and replace them with a 'more plastic' form of theatre in which *mise en scène* played an active role in creating the play (Williams 1971: 131). It is interesting to note that critics widely regard *Menagerie* to be autobiographical. Siblings Tom and Laura are surrogates for Williams and his sister Rose, the mother figure Amanda is modelled on Williams' own mother, Edwina, and the Gentleman Caller is based on Jim O'Connor, a friend of Williams (Spoto 1985: 114). The play primarily focuses on Tom, who in a series of episodic scenes alternates between participating as a character and providing narration. The use of direct address is one of the ways Williams moves the play away from conventional realism. The stage directions inform readers that this is a 'memory play and therefore non-realistic' (Williams 1971: 145). Williams breaks with the objective viewpoint that realism typically utilizes. Tom clearly recounts the story from his subjective perspective when he describes the play as 'memory'. The text also calls for a series of scene titles and visual images to be projected on the set, another strategy for distancing the play from realism that appears to be inspired by Piscator's living newspapers and Brecht's *verfremdungseffekt*. In Tom's final speech, he acknowledges that, while he has separated himself from the family geographically, he remains psychologically haunted by the spirit of his sister, providing an unresolved ending rather than the neat resolution typical of conventional realism. Tom's sentiment, comparable to Williams' deep love for his sister Rose and his guilt about the prefrontal lobotomy she endured after he left home, finds its way in many guises into his plays throughout his career.

Williams' most acclaimed play, *A Streetcar Named Desire* (1947), has been highly regarded on both stage and page for its depiction of

the liminal socio-cultural world of the New Orleans French Quarter. Blanche's first line sets up a series of metaphors that encapsulate the play's plot: 'They told me to take a streetcar named Desire, and then transfer to one called Cemeteries and ride six blocks and get off at Elysian Fields' (Williams 1971: 246). The duality of Dionysius whose gift of wine can bring both pleasure and madness permeates this world. Similarly, the play's Dionysian sexual passion leads both to ecstasy (desire) and destruction (cemeteries) while the inexorable passage of time juxtaposes Blanche's poetic dream of Elysian Fields with the decay of the Quarter. The plot embodies the complex structure and climax of Aristotelian drama, but Williams alters its proportions to his own dramatic ends. While the play fits no standard definition of tragedy, Blanche's struggle with Stanley endows her with the status of a tragic figure. Introduced as an unsympathetic and pretentious snob, she becomes more sympathetic as she mentally disintegrates over the play's 11 scenes. Following the rising action of scenes 1–6, the brutal reversal stretches over scenes 7–9 culminating in the violent climax when Stanley rapes Blanche at the end of scene 10. The painful extended denouement of scene 11 reveals the irrevocable change in the lives of the central characters.

Camino Real (1953), set in an end-of-the-road port city that amalgamates qualities from ports around the globe, presents a world characterized by toxic economic inequality backed by the police power of a surveillance state. This non-realist play confused audiences and failed on Broadway. Structurally, Williams utilizes two episodic plots; one concerning Kilroy's participation in a contest to become the chosen hero when the moon restores the virginity of the gypsy's daughter; and the other concerning the over-the-hill lovers Casanova and Marguerite Gautier. The cross-generational friendship of Kilroy and Casanova loosely connects the two plots. The play combines a collage of characters, imagined, historic and borrowed from other famous works of fiction, in scenes that mix genres – including parody, farce, slapstick, black comedy, grotesque, heroic tragedy and melodrama. *Camino Real* ends with a character announcing that 'the violets are breaking the rocks' offering the hope that love, kindness and art might eventually triumph over the evils derived from the economic and political inequities of capitalism (Williams 1964: 329).

A critical and popular success on stage and screen, *Cat on a Hot Tin Roof* (1955), like most of Williams' plays, defies easy categorization. While the play combines familiar constructs of realism, such as the domestic interior and family drama, with the compact notions of

tragedy borrowed from the French neo-classicists, Williams violates the conventions of both genres. The play subversively manages to break the fourth wall in subtle ways that undermine the apparent realism of time and place. Furthermore, Williams provides none of the characters with the stature of a neo-classic tragic figure. Maggie enters at the beginning of the play and reports, 'One of those no-neck monsters hit me with a hot buttered biscuit so I have t' change!' (Williams 1991: 1), summarizing in a single line the entire situation of the play. Williams dramatizes the demise of the traditions of gentility from the Old South, embodied in Maggie and portrayed in the family's relationship to their black servants and employees; and in the concurrent rise of the crass but moneyed world of the new South as epitomized by Goober, Mae and their 'no-neck monster' children. The play provides continuous action on the evening of Big Daddy's birthday. A shared hatred for 'mendacity' enables Big Daddy and Brick to each force the other to confront his own illusions. Brick informs Big Daddy that his doctors have concealed from him the news of his impending death. Big Daddy confronts Brick about his inability to cope with the suicide of his best friend Skipper. Brick views this relationship as a sort of Platonic ideal of love without *eros*, an image undermined by the insinuations that Brick might be in denial of a strong erotic component to the friendship. However, Williams deliberately leaves the question of Brick's sexual orientation ambiguous. Williams sets the play in a single room (significantly the former bedroom of gay lovers Peter Ochello and Jack Straw, now occupied by Maggie and Brick whose marriage is in trouble). Critic David Savran argues persuasively that the bedroom represents the metaphoric closet of 1950s gay men, a place where one is continually spied on and that never seems to successfully lock out the world (Savran 1992: 109). Williams mixes these struggles for money and webs of personal denial, leading to an unresolved ending that undermines the audience's expectation for the tidy ending typical of mid-century realistic drama. Will Maggie and Brick transform her lie that she is pregnant into the truth? Or will she continue to be a cat on a hot tin roof?

Thirty years after his death, Tennessee Williams' position as one of the finest English-language dramatists of the mid-twentieth century remains secure. Southern novelist and fellow Mississippian William Faulkner, in his speech accepting the Nobel Prize in 1949, endorsed what he called the old verities of love and honour and pity and pride and compassion. Williams wrote of those same verities, and along with Faulkner and writers such as Eudora Welty, Flannery O'Connor and Carson McCullers, created a genre that has been called

'Southern Gothic', a literary movement both dark and humorous that captured the last days of Southern chivalry. Williams endeavoured to wean American audiences away from their love of conventional realism and its ties to the literalism inherent in nineteenth-century naturalism, and managed to achieve a successful balance between non-realist dramaturgical structures and recognizably lifelike characters. Not unlike the late plays of August Strindberg, Williams' late stylistic experiments created challenges in production that remain mostly unmet. This was exemplified in the Chicago-based Goodman Theatre's 2012 production of *Camino Real*, directed by Calixto Bieito, that *New York Times* critic Charles Isherwood contends 'finds an even more baffling story inside an already perplexing play'.[2] Nonetheless, directors continue to attempt to balance the realistic and anti-realistic elements in Williams' plays. Although one can discern the dramatist's linguistic influences in the works of Lanford Wilson, Beth Henley and others, none of these writers achieve his raw emotional power. Christopher Durang demonstrated that the Williams style is a ripe target for parody in his play *For Whom the Southern Belle Tolls* (1994), but no one has been able to replicate his dramatic universe. Williams' compassionate and humane voice remains uniquely his own.

Stephen Berwind

Notes

1 Most notably *A Streetcar Named Desire* (1951, directed by Elia Kazan, with a cast including Marlon Brando, Paul Newman, Vivien Leigh and Kim Hunter) and *Cat on a Hot Tin Roof* (1958, directed by Richard Brooks, with a cast including Elizabeth Taylor, Paul Newman and Burl Ives).
2 http://theater.nytimes.com/2012/04/07/theater/reviews/calixto-bieito-adapts-camino-real-at-goodman-theater.html?pagewanted=all&_r=0 [accessed 22 November 2013].

Key works

Williams, Tennessee (1964) *Three Plays*, New York: New Directions.
——(1971) *The Theatre of Tennessee Williams, Volume 1*, New York: New Directions.
——(1972) *The Theatre of Tennessee Williams, Volume 2*, New York: New Directions.
——(1975) *Memoirs*, Garden City, NY: Doubleday.
——(1991) *The Theatre of Tennessee Williams, Volume 3*, New York: New Directions.

Further reading

Gross, Robert F. (ed.) (2002) *Tennessee Williams: A Casebook*, New York: Routledge.

Leverich, Lyle (1995) *Tom: The Unknown Tennessee Williams*, New York: Crown.

Londré, Felicia Hardison (2004) 'Poetry in the Plumbing: Stylistic Clash and Reconciliation in Recent American Stagings of *A Streetcar Named Desire*', *Cercles: Revue Pluridisciplinaire du Monde Anglophone*, 10: 124–135.

Murphy, Brenda (1992) *Tennessee Williams and Elia Kazan: A Collaboration in the Theatre*, Cambridge: Cambridge University Press.

Savran, David (1992) *Communists, Cowboys and Queers: The Politics of Masculinity in the Works of Arthur Miller and Tennessee Williams*, Minneapolis: University of Minnesota Press.

Spoto, Donald (1985) *The Kindness of Strangers: A Life of Tennessee Williams*, Boston: Little, Brown and Company.

AUGUST WILSON (1945–2005)

August Wilson had a huge impact on American and African-American drama and theatre during his lifetime. Garnering numerous awards, including two Pulitzer Prizes for Drama, Wilson gifted American theatre with his 'Twentieth Century Cycle' of plays, through which he represents each decade of the modern African-American experience. Through the plays *Jitney* (1979), *Ma Rainey's Black Bottom* (1982), *Fences* (1983), *Joe Turner's Come and Gone* (1984), *The Piano Lesson* (1986), *Two Trains Running* (1990), *Seven Guitars* (1995), *King Hedley II* (2001), *Gem of the Ocean* (2003) and *Radio Golf* (2005), Wilson explores the effects and affects of slavery and emancipation on a people who were seemingly voiceless and invisible, but ever proving their invincibility. *Ma Rainey's Black Bottom* (1982), which focused on the musicians who comprised the band for the famous blues woman Gertrude 'Ma' Rainey, was Wilson's first commercially successful play. It earned a Tony award for Best Play, a Drama Desk award for Outstanding New Play and the New York Critics' Circle award for Best American Play.

Each play in Wilson's dramatic canon is integral to his 'Twentieth Century Cycle', but five of these works reflect the thematic ideologies and cultural histories that illustrate his artistic goals. *Gem of the Ocean*, *Joe Turner's Come and Gone*, *Fences*, *Seven Guitars* and *King Hedley II* are five of the works that comprise the 'Pittsburgh Cycle'. Each play is set within the borders of Wilson's childhood

hometown, the Pittsburgh, Pennsylvania Hill District, and it is within this setting that Wilson chronologically begins his African-American history lesson.

Gem of the Ocean (2003) explores the post-Reconstruction lives of African-American men and women, as they sojourned northward in search of escape from the chains of the Jim Crow South. This work traces the paths that characters Citizen Barlow and Black Mary take from psychological and spiritual bondage to freedom with the guidance of Aunt Ester, the oracle for the entire Hill District. Citizen comes to Aunt Ester's home to have his 'soul washed' because of a crime that he committed, but this also leads to the accusation and eventual suicide of an innocent man. Through Citizen and Aunt Ester, Wilson presents the history lesson that illustrates his canon's overall theme – 'finding one's song' (see Wilson 1991), or rather identity, by first reclaiming one's past. Aunt Ester uses her powers of memory to help Citizen understand that his cleansing must first begin with his knowledge of his people's journey through, and survival of, the middle passage and slavery. This journey is expressed verbally by way of the African and African-American vernacular practices of song and storytelling; Aunt Ester shares her history with Citizen and, as a result, forces him into a trance-like possession of this memory in which he imagines himself enchained on a slave trafficker. After Citizen emerges from the trance, he has become, in essence, born again and equipped to recognize that his soul and identity are intact. At the drama's conclusion, Citizen demonstrates his new identity and purpose by donning the hat and carrying the walking stick once worn by the drama's spectacle character,[1] Solly Two Kings. Solly is an activist who fights for those who cannot or will not defend themselves. It is this identity that Citizen assumes, and thus, as his name implies, he becomes an activist-citizen of twentieth-century American and African-American culture.

Gem of the Ocean chronologically begins the cycle and introduces Aunt Ester as its galvanizing mother figure. The play is set in 1904, when Aunt Ester claims to be 285 years old. In Wilsonian time, she will live until the age of 367, when she dies in 1985 in *King Hedley II*. Aunt Ester's character challenges presumptions that Wilson's works are heavily laden treaties on black masculinity, and that women are peripheral characters. Thus, *Gem of the Ocean* appropriately begins Wilson's dramatic lesson that one must find solace and purpose in order to locate one's identity, and acknowledges the significance of African-American women as the backbones of the culture.

Gem of the Ocean is historically situated within the Great Migration, but Wilson fully characterizes this historical and cultural phenomenon in the drama *Joe Turner's Come and Gone* (1984). Set in 1914 within the boarding house of Seth and Bertha Holly, the play opens with a 'battle' between a Southern transplant's cultural practices and a Northern African-American's critique. The drama's spectacle character, Bynum, sacrifices a pigeon and pours its blood into the form of a circle. Seth Holly, the Northern-born African-American character, complains about this practice, but his wife, Bertha, asks that he allow Bynum to continue, for she recognizes the significance of Bynum's actions. Bynum is a root worker, a twentieth-century conjure man, who possesses the gift of binding people together. The play's historical context is also informed by an important examination of the late nineteenth- and early twentieth-century's convict labour system. The drama's main character, Herald Loomis, is abducted on his way home from a church by the post-slavery convict labour advocate Joe Turner. Turner kidnaps Loomis and forces him to work on his farm for seven years, freeing him on his (Turner's) birthday. Upon his release, Loomis returns home, only to find his wife gone and his daughter in the care of her maternal grandmother. Loomis and his daughter journey northward to find his wife, for Loomis believes he will then reconnect with the identity that he once knew. It is Bynum who – as Aunt Ester does for Citizen in *Gem of the Ocean* – ushers Loomis back to an understanding of his history and that of his ancestors in order to 'find his song', his identity. Bynum emerges as Loomis' oracle, singing the folk song 'Joe Turner's Come and Gone'. Bynum knows that this song and Loomis' eventual recognition that he cannot escape his past are needed to help him to begin to live again. As the drama concludes, its plot revisits the drama's initial disharmony between Judeo-Christian beliefs and practices, and Bynum's African religious practices. During one of the most challenging moments in the play, Loomis slashes his chest and rubs the blood on himself, thus signalling that he is alive and now he can stand on his own. This action is both a reflection of African and Judeo-Christian cleansing practices – which allow Herald Loomis, like Citizen Barlow, to find his song.

Fences (1983), which earned Wilson his first Pulitzer Prize, is the play at the centre of the Twentieth Century Cycle, and it is the most critically lauded and universal. Again, identity is a central theme, but it now carries enhanced subtlety as Wilson introduces Troy Maxson, an African-American Everyman character, into the Pittsburgh Hill District. Like Citizen and Loomis, Troy is also a

Southern migrant; he is married with family and employed as a trash collector. Troy's struggle resides not so much in finding his identity, but understanding how his identity has been formed and its effects on his children. Troy is a 'big man', who embodies Wilson's cycle's resilient spirit of the men and women who have populated the Hill District. Like Citizen and Herald, Troy travels northward in search of a life free from the perils of the south, but finds that the utopia he seeks, while free of Jim Crow racism, is riddled with poverty, homelessness and violence. Theft permits Troy to feed his family, but his criminality leads to a murder and a 15-year incarceration. After serving his time, Troy gets a second chance at life with a new family; he has, however, missed out on his dream – to play base-ball – and finds steady employment as a trash collector. Troy's identity appears to be intact in comparison to many other characters in Wilson's canon, but it has been shaped by a legacy of father–son conflict, motherlessness and longing. Hence, as Troy attempts to rear his own children, he can only share the lessons that he has learned, thus compelling his children to find ways to define them-selves outside and beyond him. *Fences* is filled with compelling moments, but one of the most telling is when Cory, Troy's younger son, asks him why doesn't he like him. As opposed to an anticipated fatherly response, Troy demands to know what love has to do with responsibility. This moment illustrates Troy's past and motivates Cory to eventually flee from his father in search of a world beyond his grasp. It is upon Cory's return on the day of Troy's funeral that Cory learns that as much as he has attempted to kill off his father's legacy, he is another version of his father. *Fences* differs from *Gem of the Ocean* and *Joe Turner's Come and Gone* because, by the 1950s, African-Americans were beginning to benefit from some of the promises of the American dream. Most importantly, this play is set on the cusp of the Civil Rights Movement. Change has come, but recognizing who one has become in the wake of these changes is the challenge that Wilson poses in this work.

Seven Guitars (1995) and *King Hedley II* (2001), set respectively in 1948 and 1985, serve as fitting frames for *Fences*. Both plays cele-brate and trace the blues and contemporary song-story form, rap music, which the characters use to express their varied histories. *Seven Guitars* features both blues men and women, and introduces the reality of displaced intra-cultural violence. The play's main character, Floyd 'School Boy' Barton, has found his identity in the blues, but Floyd is stagnated because, although the music is his own, he is still controlled by mainstream rules and commercial powers.

His frustration, similar to Troy's in *Fences*, leads to crime and death at the hands of Hedley, this work's spectacle character. In sequel-like form, *King Hedley II* continues the legacy that Hedley's son, King Hedley II, will inherit 35 years later in the same yard and house where his parents resided. This play is set during the Reagan era, against the backdrop of crack cocaine and an increase in black-on-black crime. The drama's titular character, King, is the son of King Hedley I (*Seven Guitars*). However, it is this identity that follows King Hedley II, a convicted felon who kills a man because he refused to call him 'King'. Wilson also exposes King's desire to have a legacy, a child, and his subsequent battle with his wife Tonya; who refuses to give birth to a child who she may have to identify in a morgue – yet another sacrificial lamb in the cycle of self-inflicted slaughter. King fights for his life, and the life of his unborn heir, but then becomes a victim of the very violence that his wife wishes to combat and he avoid. His mother accidentally kills him, but his death, according to Stool Pigeon, the drama's griot/spectacle character, is not in vain, for King is truly a king.

August Wilson's legacy is one that will continue to be celebrated. His examination of twentieth-century African-American culture provides numerous opportunities to witness dramatic discussions of African-American history.

<div style="text-align: right">Ladrica Menson-Furr</div>

Note

1 For a discussion of spectacle characters in Wilson's plays, see Shannon, Sandra (1993) 'Blues, History, and Dramaturgy: An Interview with August Wilson', *African American Review*, 27(4): 539–559.

Key works

Wilson, August (1985) *Ma Rainey's Black Bottom*, New York: Plume.
——(1990) *The Piano Lesson*, New York: Plume.
——(1991) *August Wilson: Three Plays*, Pittsburgh: University of Pittsburgh Press.
——(1993) *Two Trains Running*, New York: Plume.
——(1997) *Seven Guitars*, New York: Plume.
——(2002) *Jitney!*, New York: The Overlook Press.
——(2005) *King Hedley II*, New York: Theatre Communications Group.
——(2008) *Radio Golf*, New York: Theatre Communications Group.

Further reading

Elam, Harry (2006) *The Past is Present in the Drama of August Wilson*, Ann Arbor: University of Michigan Press.

Nadel, Alan (2010) *August Wilson: Completing the Twentieth-Century Cycle*, Iowa: University of Iowa Press.

Shannon, Sandra (1996) *The Dramatic Vision of August Wilson*, Washington, DC: Howard University Press.

INDEX